HOW TO READ BIBLE STORIES AND MYTHS IN ART

Decoding the Old Masters
from Giotto to Goya

PATRICK DE RYNCK

ABRAMS, NEW YORK

translation YVETTE ROSENBERG
editing PAUL VAN CALSTER
design PASCAL VAN HOOREBEKE
cover design DARILYN CARNES
typesetting ANAGRAM, GHENT
colour separations DIE KEURE, BRUGES

on the cover
Botticelli, *The Return of Judith*, c. 1470–72
(detail; see p. 237)

Library of Congress Cataloging-in-Publication Data

Rynck, Patrick De, 1963-
How to read Bible stories and myths in art: decoding the old masters,
from Giotto to Goya / by Patrick De Rynck.
p. cm.
ISBN 978-0-8109-8400-4
1. Bible—Illustrations 2. Mythology, Classical, in art. 3. Painting,
European. I. Title.
ND1422.E85R96 2009
704.9′47–dc22
2008028734

Printed and bound in China
10 9 8 7 6 5 4 3 2 1

HNA ▌▌▌▌▌
harry n. abrams, inc.
a subsidiary of La Martinière Groupe

115 West 18th Street
New York, NY 10011
www.hnabooks.com

7

Preface

13

Note to the Reader

14

How to Read Bible Stories and Myths in Art

Man is an animal that tells stories

—with apologies to ARISTOTLE

PREFACE

It is stating the obvious to say that the Bible and Graeco-Roman mythology and history have had a major impact on Western art. Many of the ancient stories have been illustrated by the greatest painters of all time in works that rank among the most outstanding masterpieces of art. Far into the 19th century, history painting – the representation of scenes from history, mythology or the Bible – was considered the most prestigious and the most difficult genre of all, and its exponents were by definition highly versatile artists with the skill to evoke emotions and ideas and bring their characters to life. In short, they could tell stories in paintings. This book is about those ancient stories and the wonderful paintings that help to keep them alive.

THE STORIES

The paintings discussed in this book were based on just a few ancient sources, each a compilation of stories. One is the Tanakh comprising the sacred books of ancient Israel and the earliest writings of Judaism, which together form the Old Testament of the Christian Bible. The OLD TESTAMENT contains the first accounts of human life, the origin and history of the people of Israel and their relationship with God. From a Christian point of view – and that was the view of the European painters discussed in this book – these stories are about the world before the advent of Christ. In a Christian context many of them are understood as prefigurations of events in Christ's life.

The NEW TESTAMENT centres on the life of Jesus Christ. It comprises the gospels of Matthew, Mark, Luke and John, each containing a personal account of Christ's life and teachings; the Acts of the Apostles, which describe the founding of the first Christian communities, and several epistles to some of those communities from the apostle Paul and other early followers of Christ. The New Testament concludes with a vision of the future and the end of the world in the Book of Revelation, also known as the Apocalypse of John.

The Bible, written between 800 BC and AD 200, is the Book of Books for both Christians and Jews, though they hold different views regarding its content. Moreover, Christians among themselves have different ideas about what constitutes canonical scripture. There are writings that only some denominations accept as authoritative. The Roman Catholic Old Testament, for instance, includes a number of texts such as the Books of Tobit and Judith, which are not included in the Hebrew or Protestant bibles. Countless non-biblical manuscripts about

Christ, the Virgin Mary and the apostles were written in early Christian times, and they too have left their mark on art, as we shall see in this book. Many of them describe episodes from Christ's childhood and youth or from the life of his mother Mary, and some also contain lengthy accounts of Christ's later suffering. The term APOCRYPHA is used for any collection of scriptural texts that falls outside the canon.

Stories from GREEK AND ROMAN MYTHOLOGY AND HISTORY have come down to us in the works of numerous Greek and Roman writers such as the Greek epic poet Homer (c. 800 BC), the Roman historian Livy (59 BC–AD 17) and the Latin poet Ovid (43 BC–AD 18). The appearance of mythological subjects in European art can be attributed in the first place to Ovid's *Metamorphoses*, a compilation of mythological stories of mostly Greek origin. Even in classical times, abridged versions of the myths, along with others known from manuscripts that have since been lost, were collected and published in the form of compendia. Two mythographers whose work has partly survived are the otherwise unknown Apollodorus (1st or 2nd century AD) and Ovid's contemporary Hyginus.

THE PAINTINGS

Artists drew on this legacy of ancient treasures to illustrate religious, mythological or historical narratives, the overwhelming majority of which were commissioned by influential clients. The circumstances that affected their work over the five centuries spanned by this book obviously differed significantly, as did the status and aspirations of their clients, the envisaged function of a given painting, and the relationship between the work and its original source. But those matters are dealt at length with in countless publications.

Most paintings illustrating events from the lives of Christ and his family and disciples were intended for religious purposes: they were made for churches and monasteries or for private devotion. The earliest painters based their work on biblical stories, but also, as we have seen, on apocryphal writings as well as translations, adaptations, interpretations, additions and medieval variants. In the mid-16th century the Roman Catholic Church, on the authority of the Council of Trent and in response to the Protestant Reformation, determined what was allowed and what was prohibited in art. From then on, painters of religious subjects were required to adhere exclusively and more strictly to the biblical source. But not everyone complied. Those who did not paid a price, as we know, for example, from the difficulties Caravaggio experienced with some of his paintings. Yet, at the same time certain apocryphal additions – like the presence of the ox and the ass at the scene of Christ's nativity (see p. 63) – had already become inextricably embedded in the conventional repertoire of pictorial imagery.

Paintings of episodes from the New Testament may be thought of as a bible for the illiterate: those who were unable to read the stories could see them in paintings, prints, miniatures, sculptures and other forms of art. Some Christians

ascribed to painted stories the same value as written texts. The text and the image complemented each other. The purpose of religious paintings was not only to edify and enlighten, but also to stir the emotions, instil faith, offer comfort, and inspire devotion. That was specifically the case in the 16th and 17th centuries, when the Roman Catholic Church launched a counter-offensive against the Protestant Reformation. Art, and especially painting, was a weapon in its struggle to strengthen the conviction of believers and keep them on the right path.

Stories from the Old Testament, as we have seen, were often understood by Christians as prefigurations of episodes in the New Testament. For example, the manna that miraculously fell from heaven to sustain the starving Israelites (see pp. 260–261) was believed to be the Old Testament counterpart of the Eucharist, when bread and wine, according to Roman Catholic doctrine, are transformed into the body and blood of Christ (see pp. 112–113). In the same vein, David's victory over the giant Goliath (see p. 166) was understood as a prefiguration of Christ's triumph over Satan (see pp. 90–91). When Protestants propagated the reading of both Testaments of the Bible from the 16th and 17th centuries onwards, Old Testament stories gradually gained more prominence in art as episodes in their own right. This is reflected in the work of Rembrandt and his pupils, and other Dutch painters.

Paintings of Greek and Roman myths or historical events were obviously not produced in a religious context. They began to appear in the 15th century, with the revival in Italy of an interest in the civilizations of ancient Greek and Rome and a new appreciation of classical art, which from then on set the standard. Botticelli's famous paintings featuring Venus are among the earliest examples of the use of mythological subject matter in painting (see pp. 334–335). The genre became increasingly popular from the 16th century onwards and served a variety of purposes. The ancient stories were interpreted in moralistic terms and used for edification. For the cultural elite they were interesting topics of conversation. And mythological characters offered a pretext to paint and legitimately pore over nudes. Or people with wealth and influence might identify with classical gods or heroes and want to possess paintings of them, in some cases modelled on themselves. Hercules was one of the favourites. Mythical love stories, like Cupid and Psyche (pp. 300–305), decorated bedrooms; risqué scenes were reserved for the eyes of the owner's close friends; and other stories were purely for entertainment and aesthetic enjoyment. Episodes from Roman history highlighted the virtues and accomplishments of heroes of the past and were intended to serve as examples for others to follow. But as much of our knowledge about the origins of these paintings has been lost in the course of time, it is often uncertain whether or not these works carried an underlying message.

WORD AND IMAGE
This book explores the relationship between stories from ancient sources and the paintings that tell those stories. Comparing the two should not create the wrong

impression. It is not as if painters dissected every word of the Greek, Latin or Hebrew texts and then reproduced them literally on panel or canvas. Or as if the 'pictures' were simply illustrations to the text. Nothing could be further from the truth. Erudite artists like Rubens, who was fluent in Latin and corresponded in several European languages, were the exception rather than the rule. Most painters were unable to read the original texts in the first place. They may have read the stories in more recent translations, adaptations, abridged editions or compendia. Numerous volumes of this kind were available and many of them were illustrated. But what they certainly did know, either at first hand or from prints, were the illustrations of these stories by their famous contemporaries or predecessors. From the 16th century on there was a flourishing market for wood-cuts and engravings of paintings by masters of the past and present. In the course of time, many of the stories came to be associated with iconographic tradition, a set of images, motifs or symbols that made them easier to recognize and under-stand. Moreover, modern handbooks were in circulation which gave instructions for depicting temperaments, traits, emotions and actions. In short, the ancient stories came down to artists along many highways and byways. Two exception-ally influential medieval books which helped to spread those biblical and mytho-logical tales were *The Golden Legend (Legenda aurea)* by Jacobus de Voragine (1229–1298), a hagiography that includes stories about Christ and the Holy Virgin, and Boccaccio's *On the Genealogy of the Gods (Genealogia deorum gentilium)* of 1360–70, a sourcebook on the complex pantheon of the classical gods.

Paintings functioned as independent works of art, not derivatives of a text. They are neither better nor worse than the text: they are different. Artists and their patrons often used stories to convey a message that was appropriate to their times, but which was perhaps not expressed in the original text. And to do this, they used myths and mythical characters, but also, in a different way, stories and characters from the Bible. The liberties an artist could take obviously varied sig-nificantly, depending on historical circumstances, the demands of the client, and the nature of the subject. Even so, it is well worth examining these paintings in relation to the original texts. By comparing the two, we can see how much they resemble or differ from one another, and also understand why.

COMPILATION

Preparing a compilation of this kind is above all a matter of making choices between countless paintings and as many stories from the past. This story begins around AD 1300, with the Tuscan masters Giotto and Duccio, whose work pro-foundly revolutionized the art of painting. It concludes with Goya and Turner in the early 19th century, when painters were starting to break with tradition and develop a totally new kind of imagery through which they projected their ideas on the world and not the other way round. The end, however, has nothing to do with the end of religious or mythological art. Far from it: the Bible and mythology continue to inspire painters to this day. The paintings selected for this book are spread evenly over time, but cover mainly the 15th, 16th and 17th

centuries. All but a few are in public collections. They represent the work of artists from what are now France, Germany, Great Britain, Italy, the Netherlands and Spain. Some were included in my *How to Read a Painting* (2004), but here they are examined from a different angle. Most of them are famous paintings by the great masters, but the selection also includes a few surprising names and works. And though the stories will also be familiar to many readers, scattered among them are a few lesser-known gems. One of the factors taken into account in selecting these stories was their length and suitability for abridgement. Most are illustrated by a single painting, but some of the more popular themes are represented by up to five, which makes it possible to trace shifts of emphasis in both interpretation and style. How painters depicted these stories, however, needs no explanation here: that is essentially the subject of this book.

I am indebted to all who have contributed to this book, for which I of course take ultimate responsibility. I am deeply grateful to Paul van Calster, Ann Dierick, Yvette Rosenberg and Peter Ruyffelaere. I will have accomplished my purpose if the reader is inspired to explore the stories behind narrative paintings and discover the moving, shocking, humorous and sometimes risqué details they contain.

<div align="right">

PDR

LEUVEN, 21 APRIL 2008

</div>

NOTE TO THE READER

This book is arranged ALPHABETICALLY under the names of the main characters of a narrative or series of narratives.* The advantage of this system is that different episodes from the life of Christ, for example, can be examined in chronological order under the headword 'Jesus Christ'. In some cases this approach leads to unexpected combinations, as in the case of *The Origin of the Milky Way*, which is categorized under the entry 'Hercules'. For the reader's convenience, the book contains a comprehensive index with cross-references.

The names of gods, heroes and historical characters are given in their LATIN forms, as mythological stories have for the most part come down to us through the works of Roman writers like Ovid. This also corresponds to the vast majority of paintings, whose titles, in line with the Renaissance tradition, more often than not reflect the Roman/Latin component of our classical heritage (for one of the rare exceptions, see p. 314). In the light of the above and to maintain the flow of the narrative, references such as 'Jupiter (*Gk.* Zeus)' have been avoided as far as possible. Readers may consult the index for the name of the Greek counterpart of the Roman goddess Ceres or the Roman alter ego of Heracles, for instance, and for much more information besides. For the sake of consistency, preference has also been given to the Latinized or Anglicized spelling of the names of Greek authors and historical figures such as Herodotus, Philostratus, Apollodorus, Homer.

Most of the excerpts from biblical texts are cited from the New King James Version. The relevant passages from Greek and Latin texts were translated by the author especially for the Dutch version of this book. The English translation of those passages is accordingly based on the Dutch. The list of sources contains information about the publications in which previously published text material originally appeared.

* *A few exceptions have been made, for example in the case of 'Babel', where the Tower of Babel is in fact the principal 'character'.*

ABRAHAM

Rembrandt, 1606–1669
Abraham and the Three Angels, 1646
Panel, 16.5 x 21.5 cm
Private collection, United States of America

The brightly lit angel in white represents God. He is the only one shown from the front and appears to be announcing the birth of Sarah's son.

After God revealed to the 99-year-old Abraham that his wife Sarah would bear a son and that his name was to be Isaac (literally 'he laughs'; Genesis 17), he appeared to him again in the woods of Mamre.

Then the Lord appeared to him by the terebinth trees of Mamre, as he was sitting in the tent door in the heat of the day. So he lifted his eyes and looked, and behold, three men were standing by him; and when he saw them, he ran from the tent door to meet them, and bowed himself to the ground, and said, 'My Lord, if I have now found favour in Your sight, do not pass on by Your servant. Please let a little water be brought, and wash your feet, and rest yourselves under the tree. And I will bring a morsel of bread, that you may refresh your hearts. After that you may pass by, inasmuch as you have come to your servant.' They said, 'Do as you have said.' So Abraham hurried into the tent to Sarah and said, 'Quickly, make ready three measures of fine meal; knead it and make cakes.' And Abraham ran to the herd, took a tender and good calf, gave it to a young man, and he hastened to prepare it. So he took butter and milk and the calf which he had prepared, and set it before them; and he stood by them under the tree as they ate. Then they said to him, 'Where is Sarah your wife?' So he said, 'Here, in the tent.' And He said, 'I will certainly return to you according to the time of life, and behold, Sarah your wife shall have a son.' (Sarah was listening in the tent door which was behind him.) Now Abraham and Sarah were old, well advanced in age; and Sarah had passed the age of childbearing. Therefore Sarah laughed within herself, saying, 'After I have grown old, shall I have pleasure, my lord being old also?' And the Lord said to Abraham, 'Why did Sarah laugh, saying, "Shall I surely bear a child, since I am old?" Is anything too hard for the Lord? At the appointed time I will return to you, according to the time of life, and Sarah shall have a son.' But Sarah denied it, saying, 'I did not laugh,' for she was afraid. And He said, 'No, but you did laugh!' / GENESIS 18:1–15

One of the angels lifts food to his lips. Abraham observes the tradition of hospitality by offering his guests a meal. Rembrandt illustrated a series of moments from the story: the washing of the angel's feet, the announce-ment of Isaac's birth, and the meal.

The 90-year-old Sarah listens attentively – perhaps with a smile – from the doorway in the background. As a woman, she would not have joined the men at table.

The hospitable Abraham is an old man when this mysterious encounter with God takes place. His guests have settled themselves at a small table in the shade of a gnarled old tree: they met 'by the terebinth trees of Mamre', the Bible says. Abraham takes water to wash the feet of one of the three angels. The tent mentioned in the Bible has been replaced by a house. God's announcement of the birth of Abraham's son Isaac was interpreted as a prefiguration of the Annunciation in the New Testament (see p. 246). Early on, the three angels were understood to represent the Holy Trinity (God the Father, Christ the Son and the Holy Spirit). Rembrandt's painting, which is the size of a print, has seldom been shown in public.

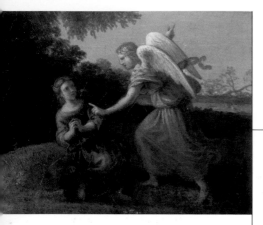

ABRAHAM

Claude Lorrain, 1604/05–1682
Landscape with Hagar and the Angel, 1646
Canvas, 52 x 42 cm
The National Gallery, London

'And the angel of the Lord found her by a fountain of water in the wilderness.' The angel appears to be admonishing the pregnant and frightened Hagar and at the same time urging her to return to Abraham's house.

Having remained childless and knowing that she was past childbearing age, Sarah persuaded her husband, the 86-year-old Abraham, to lie with her Egyptian handmaid Hagar. Their son was called Ishmael. Thirteen years later, Sarah miraculously conceived and gave birth to Isaac.

Now Abraham was one hundred years old when his son Isaac was born to him. And Sarah said, 'God has made me laugh, and all who hear will laugh with me.' She also said, 'Who would have said to Abraham that Sarah would nurse children? For I have borne him a son in his old age.' So the child grew and was weaned. And Abraham made a great feast on the same day that Isaac was weaned. And Sarah saw the son of Hagar the Egyptian, whom she had borne to Abraham, scoffing. Therefore she said to Abraham, 'Cast out this bondwoman and her son; for the son of this bondwoman shall not be heir with my son, namely with Isaac.' And the matter was very displeasing in Abraham's sight because of his son. But God said to Abraham, 'Do not let it be displeasing in your sight because of the lad or because of your bondwoman. Whatever Sarah has said to you, listen to her voice; for in Isaac your seed shall be called. Yet I will also make a nation of the son of the bondwoman, because he is your seed.' So Abraham rose early in the morning, and took bread and a skin of water; and putting it on her shoulder, he gave it and the boy to Hagar, and sent her away. Then she departed and wandered in the Wilderness of Beersheba. And the water in the skin was used up, and she placed the boy under one of the shrubs. Then she went and sat down across from him at a distance of about a bowshot; for she said to herself, 'Let me not see the death of the boy.' So she sat opposite him, and lifted her voice and wept. And God heard the voice of the lad. Then the angel of God called to Hagar out of heaven, and said to her, 'What ails you, Hagar? Fear not, for God has heard the voice of the lad where he is. Arise, lift up the lad and hold him with your hand, for I will make him a great nation.' Then God opened her eyes, and she saw a well of water. And she went and filled the skin with water, and gave the lad a drink. / GENESIS 21:5–19

Ishmael is regarded as the father of the Arab nations.

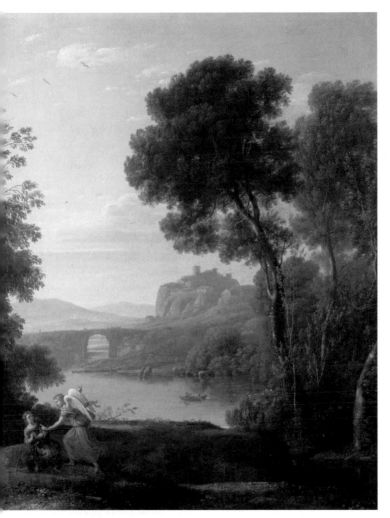

The story of Hagar and Abraham is more complicated than it would seem from the biblical passage cited above. When Hagar discovered that she was expecting a child – thirteen years or more before she was sent away – she became contemptuous of Sarah, while Sarah tormented Hagar and drove her into the wilderness. An angel told Hagar to return and urged her to be obedient in future. He also promised her a long line of descendants. Claude Lorrain represented the story in one of his typical landscapes, with trees framing a balanced composition, golden Italian light, a few classical buildings in the distance, and in the foreground the diminutive main characters – in this case Hagar and the angel.

The landscape is anything but a desert or wilderness. It recalls the hilly countryside around Rome, bathed in the radiant glow of the late afternoon sun. Claude Lorrain was a consummate master at rendering light.

ABRAHAM

Guercino, 1591–1666
Abraham Banishing Hagar and Ishmael, 1658
Canvas, 115 x 154 cm
Pinacoteca di Brera, Milan

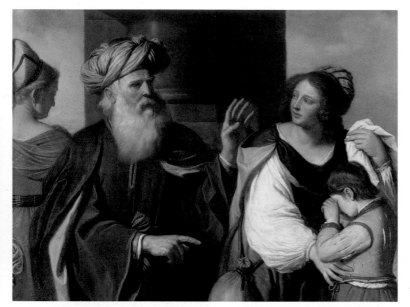

Guercino concentrated on four of the five main characters in the episode; only young Isaac is not present. There is little in the way of décor, and the work could hardly be more different from Claude Lorrain's (p. 17), even though it dates from around the same time. From left to right, we see Sarah, Abraham (as usual with a grizzled beard and a turban), Hagar (with a purse at her side) and Ishmael, who weeps inconsolably.

Abraham's hands express his ambivalence: he is reluctant to banish Hagar, but his wife Sarah insists that she must leave. With his right hand he sends Hagar and Ishmael away, but he also raises his left hand to bless them.

Sarah, the woman responsible for this tragedy, looks away but listens to every word that is said. Significantly, Ishmael, whom Sarah considers a threat to her son Isaac, stands furthest away from her.

Gerbrand van den Eeckhout, 1621–1674
The Banishment of Hagar, 1666

Canvas, 54.5 x 68.5 cm
North Carolina Museum of Art, Raleigh

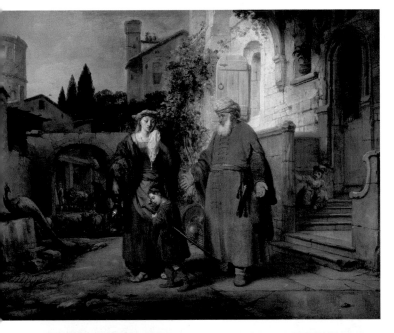

Like many of his fellow painters, Gerbrand van den Eeckhout concentrated on the sorrow of parting. All who play a role in the episode are present. The scene is set in a typically southern European landscape. Abraham's gestures express his helplessness, and Hagar, carrying a water jar, weeps as she turns to leave. Sarah watches them from the doorway. This poignant tale of love, jealousy, uncertainty and fear was widely known in the 17th century.

Ishmael is heartbroken and turns to his mother for comfort. According to the Bible, he would have been at least thirteen years old.

Isaac, no more than an anecdotal detail, looks on curiously from the steps of the house. He has just been weaned. It was because of him that Sarah persuaded Abraham to banish Hagar and Ishmael.

The scene is rendered on a horizontal canvas, with the figures in close-up in the foreground. The angel is often shown making a spectacular descent from the sky, but Caravaggio represented him as a human being. Only on closer examination do we see the base of his wings.

The ram's head is close to Isaac's. The angel draws Abraham's attention to the animal, which is to be sacrificed instead of his son.

ABRAHAM

Caravaggio, 1573–1610
The Sacrifice of Abraham, 1603
Canvas, 104 x 135 cm
Galleria degli Uffizi, Florence

Now it came to pass after these things that God tested Abraham, and said to him, 'Abraham!' And he said, 'Here I am.' Then He said, 'Take now your son, your only son Isaac, whom you love, and go to the land of Moriah, and offer him there as a burnt offering on one of the mountains of which I shall tell you.' So Abraham rose early in the morning and saddled his donkey, and took two of his young men with him, and Isaac his son; and he split the wood for the burnt offering, and arose and went to the place of which God had told him. Then on the third day Abraham lifted his eyes and saw the place afar off. And Abraham said to his young men, 'Stay here with the donkey; the lad and I will go yonder and worship, and we will come back to you.' So Abraham took the wood of the burnt offering and laid it on Isaac his son; and he took the fire in his hand, and a knife, and the two of them went together. But Isaac spoke to Abraham his father and said, 'My father!' And he said, 'Here I am, my son.' Then he said, 'Look, the fire and the wood, but where is the lamb for a burnt offering?' And Abraham said, 'My son, God will provide for Himself the lamb for a burnt offering.' So the two of them went together. Then they came to the place of which God had told him. And Abraham built an altar there and placed the wood in order; and he bound Isaac his son and laid him on the altar, upon the wood. And Abraham stretched out his hand and took the knife to slay his son. But the Angel of the Lord called to him from heaven and said, 'Abraham, Abraham!' So he said, 'Here I am.' And He said, 'Do not lay your hand on the lad, or do anything to him; for now I know that you fear God, since you have not withheld your son, your only son, from Me.' Then Abraham lifted his eyes and looked, and there behind him was a ram caught in a thicket by its horns. So Abraham went and took the ram, and offered it up for a burnt offering instead of his son. / GENESIS 22:1–13
God rewarded Abraham's obedience by granting him a long line of heirs.

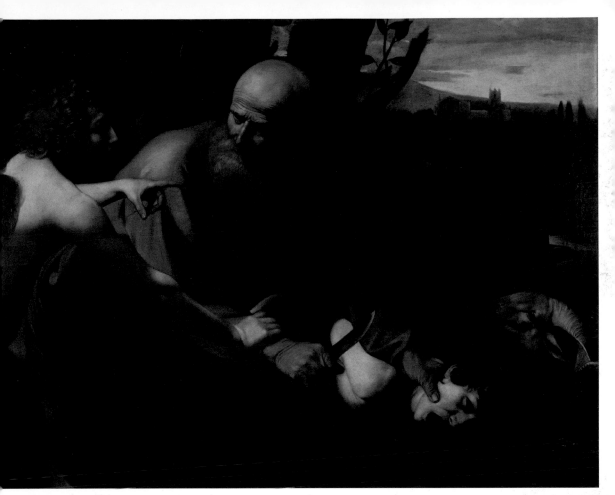

This painting shows the climax of the story. Contrary to the account in the Bible, Caravaggio, and indeed many other artists, depicted the angel restraining Abraham by seizing his wrist to stop him from slaying his son. Isaac fixes his eyes on the observer and screams in terror, not yet aware that his life has been spared. The story of Abraham appealed to artists for both its religious and dramatic content. No matter what God demanded of him or how terrible his ordeal, Abraham's faith was absolute. Isaac was seen as a prefiguration of Christ.

This is one of Caravaggio's few paintings with a landscape background. The hilly terrain recalls the countryside around Rome, and to judge by the light, it must be either dawn or dusk. The Bible does not say when the incident took place.

Some of the young women are preoccupied with the jewellery scattered on the ground and are oblivious to the dramatic turn of events.

SOURCES

Ovid's Metamorphoses *alludes only in passing to this episode of Achilles wearing women's clothing. It mentions the trick played by Odysseus, but says nothing about Lycomedes or his daughters. The full story is told in commentaries on Ovid's work.*

ACHILLES

Anthony van Dyck, 1599–1641
Achilles and the Daughters of Lycomedes, 1631–32
Canvas, 123 x 137.5 cm
Collection of Graf von Schönborn, Pommersfelden

Achilles' mother knows that her son is destined to die if he goes to fight in the Trojan war, the famous war between Greeks and Trojans (see pp. 326–333).

Once Thetis learned that the son she had borne to Peleus would die if he took part in the siege of Troy, she sent him to Lycomedes on the island of Skyros. There he was brought up among the king's daughters, disguised in women's attire, his identity concealed by a false name. The girls called him Pyrrha for his coppery hair, *pyrrhos* being the Greek word for red. But the Greeks discovered where he had found refuge and dispatched envoys to Lycomedes to secure the surrender of Achilles. The king denied that his protégé was there, and invited the envoys to search the palace. Having failed to recognize Achilles among the women, Odysseus scattered feminine trinkets in the palace hall, and placed among them a shield and a spear. Then, at a sign from him, the startling blare of a trumpet and the clamour of arms and battle-cries filled the air. Fearing that the enemy had launched an attack, Achilles at once cast off his woman's attire and reached for the spear and shield. So he betrayed his true identity and now pledged his allegiance and armies to the service of the Greeks. / HYGINUS, *Myths*, no. 96

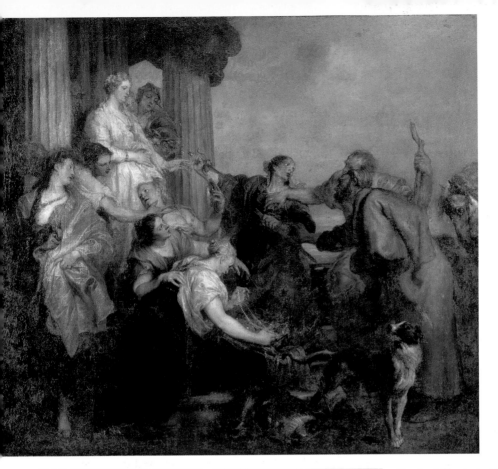

Van Dyck illustrated the moment when Achilles, still in woman's attire, draws the sword from its sheath, and so betrays his true identity. Two men – one of the two on the right is the cunning Odysseus – seize him by the arm. This humiliating episode in the life of the Greek hero Achilles, whose adventures nevertheless continued to inspire painters, was often represented in Renaissance and Baroque art. Artists sometimes based their work on a surviving description of an ancient painting of the same subject.

Achilles has already lost interest in the female companions with whom he has been living for some time. He will sail to Troy where, as prophesied, an untimely death awaits him. In Van Dyck's day, Achilles' return to Troy was understood as a metaphor for a man being true to his own nature.

The striking young woman standing on the stairs is the king's daughter Deidamia. Her left hand almost touches Achilles; her right hand rests on her lap. In some versions of the story she conceived Achilles' child during his stay at the palace. In this scene the two are forced to part.

ADAM AND EVE

Michelangelo, 1475–1564
The Creation of Eve, 1510
Fresco, 170 x 260 cm
Sistine Chapel, Vatican, Rome

Eve is not created from Adam's rib but, at a sign from God, she emerges from behind the sleeping Adam as a perfectly formed woman with long golden hair. Her step is still uncertain and she opens her mouth in surprise. She greets her Maker and gives thanks.

And the Lord God said, 'It is not good that man should be alone; I will make him a helper comparable to him.' Out of the ground the Lord God formed every beast of the field and every bird of the air, and brought them to Adam to see what he would call them. And whatever Adam called each living creature, that was its name. So Adam gave names to all cattle, to the birds of the air, and to every beast of the field. But for Adam there was not found a helper comparable to him. And the Lord God caused a deep sleep to fall on Adam, and he slept; and He took one of his ribs, and closed up the flesh in its place. Then the rib which the Lord God had taken from man He made into a woman, and He brought her to the man.
And Adam said:

'This is now bone of my bones
And flesh of my flesh;
She shall be called Woman,
Because she was taken out of Man.'

Therefore a man shall leave his father and mother and be joined to his wife, and they shall become one flesh. And they were both naked, the man and his wife, and were not ashamed. / GENESIS 2:18-25

THE SECOND EVE
The Sistine Chapel is dedicated to the Virgin Mary. The mother of Christ was regarded as the 'second Eve', whose advent absolved the world of original sin, the legacy of the Old Testament Eve. For that reason the scene is in the centre of the nine episodes painted on the chapel ceiling.

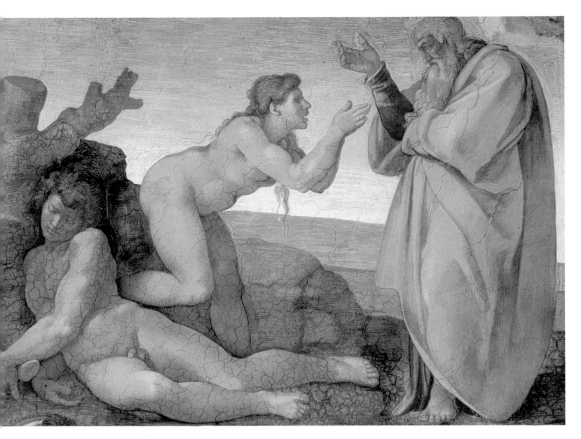

Michelangelo – like many other artists – depicted God as a venerable old man with a flowing beard. He wears a purple robe and appears to be encouraging Eve to rise. This was Michelangelo's first representation of the Creator.

Michelangelo included non-biblical imagery in his iconic *Creation of Adam*, where he shows God's hand reaching out to touch the reclining Adam as a sign of his creation. *The Creation of Eve*, which was painted before its counterpart, is more faithful to the biblical text. The fresco in the Sistine Chapel incorporates images from woodcuts published in a popular Italian Bible translation of 1493, which would have made the scene more easily recognizable to the public. The barren landscape in the background was supposed to represent the lush Garden of Eden. A consummate master of the human form, Michelangelo looked down on landscape painting, which he considered artistically and intellectually irrelevant and the province of Northern artists.

Eve, with hair down to her ankles, has already tasted the first apple she picked. The Bible mentions a fruit, but not specifically an apple. The iris is a symbol of purity.

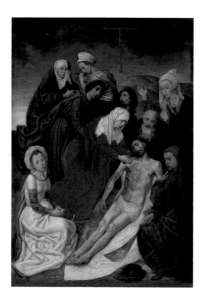

This is the right wing of the diptych of which *The Fall of Man* forms the left wing. Christ has been brought down from the cross and is surrounded by mourners. The Fall was the *raison d'être* of Christianity: Christ came to earth as the son of God and sacrificed his life to redeem humankind from the burden of original sin inherited from Adam and Eve. He brought salvation and the promise of a return to Paradise with eternal life after death.

ADAM AND EVE

Hugo van der Goes, c. 1440–1482
The Fall of Man, 1470s
Left wing of a diptych, 32.5 x 22 cm
Kunsthistorisches Museum, Vienna

Adam and Eve, the forebears of the human race, lived in the Garden of Eden, which had four rivers and luscious fruit trees of every kind. In the middle of the garden stood the Tree of Life and the Tree of Knowledge of Good and Evil.

Then the Lord God took the man and put him in the Garden of Eden to tend and keep it. And the Lord God commanded the man, saying, 'Of every tree of the garden you may freely eat; but of the tree of the knowledge of good and evil you shall not eat, for in the day that you eat of it you shall surely die.'

God created man and then woman (see p. 24).

Now the serpent was more cunning than any beast of the field which the Lord God had made. And he said to the woman, 'Has God indeed said, "You shall not eat of every tree of the garden"?' And the woman said to the serpent, 'We may eat the fruit of the trees of the garden; but of the fruit of the tree which is in the midst of the garden, God has said, "You shall not eat it, nor shall you touch it, lest you die."' 'Then the serpent said to the woman, 'You will not surely die. For God knows that in the day you eat of it your eyes will be opened, and you will be like God, knowing good and evil.' So when the woman saw that the tree was good for food, that it was pleasant to the eyes, and a tree desirable to make one wise, she took of its fruit and ate. She also gave to her husband with her, and he ate. Then the eyes of both of them were opened, and they knew that they were naked; and they sewed fig leaves together and made themselves coverings. / GENESIS 2:15–17, 3:1–7

Thus mankind acquired knowledge of good and evil. But God banished Adam and Eve from the Garden of Eden (see p. 32), and sent them out to work the soil to ensure that they would not taste the fruit of the Tree of Life and so attain immortality.

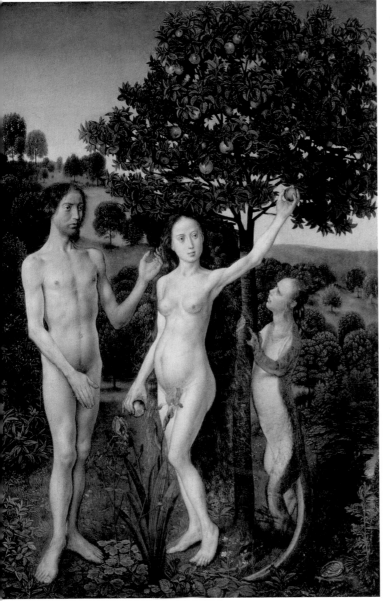

Surrounded by the trees and flowers of a paradise on earth, Eve holds an apple from the Tree of Knowledge. She picks a second apple and Adam reaches out to take one from her. The creature that has tempted Eve resembles a salamander with a woman's head. The Fall of Man has been widely represented in art since the Middle Ages. It is one of the few scenes from the Old Testament in which a man and woman appear together naked. Adam and Eve are often depicted on either side of the tree, with Adam on the right, or 'good' side (left for the observer; cf. p. 131).

The creature that tempted Eve was female, reflecting the prevailing view of woman as the sensual seductress of rational man. The 'serpent' also stands erect. After this incident God condemned the serpent to crawl on its belly.

ADAM AND EVE

Hieronymus Bosch or workshop, c. 1450–1516
Paradise, 1510–16
Left wing of the *Haywain* triptych, 135 x 50 cm
Museo Nacional del Prado, Madrid

The panel illustrates three scenes from the Creation. Starting at the
back: the creation of Eve (see p. 24), the Fall, and the angel expelling
Adam and Eve from the Garden of Eden (cf. pp. 32–33). Much of Bosch's
idiosyncratic oeuvre relates to the evil inherent in man – originating
from the sin of Adam and Eve – of which he is unaware but which
ultimately leads to hell and damnation. Bosch invented his own imagery
to breathe new life into the theme.

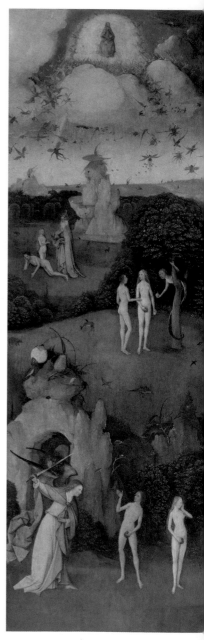

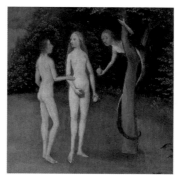

The contest between good and evil
is fought in heaven as well. The
rebellious Lucifer and his angels
are banished from heaven, just
as the sinful Adam and Eve are
expelled from Paradise.

Like Van der Goes, Bosch gave
the serpent-like creature a female
head. And here, again, Adam
appears to be asking Eve for
the forbidden fruit, thereby taking
equal responsibility for their fall.

Titian, c. 1487–1576

Adam and Eve, 1550

Panel, 240 x 186 cm
Museo Nacional del Prado, Madrid

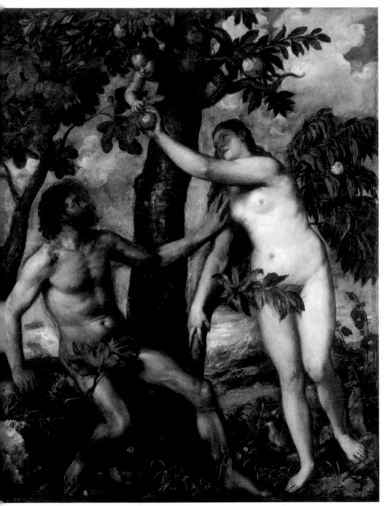

Titian's 'serpent' has the face
and torso of a human child.

Titian's symmetrical composition, with Adam and Eve
depicted on either side of a tree, had precedents in the
work of Dürer and Raphael. The serpent, with a human
face, offers an apple to the standing Eve. Adam, who
is seated, tries to stop her from taking it. His body
is tense with anxiety. The work attests to Titian's
psychological insight but it also reflects the perception
of and attitudes towards women in his day.

A fox, symbolizing evil and
sensuality, lies on Eve's side
of the tree.

ADAM AND EVE

Tintoretto, 1518–1594
The Fall of Man, c. 1550
Canvas, 150 x 220 cm
Galleria dell'Accademia, Venice

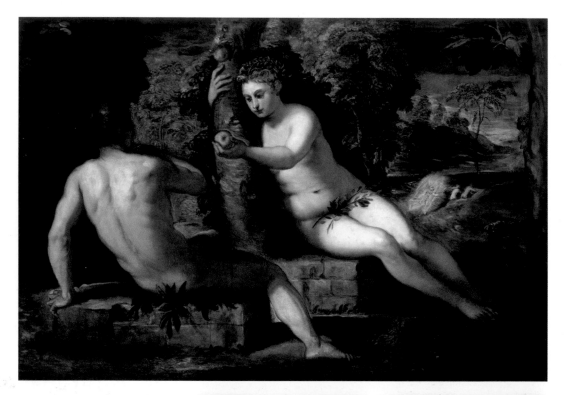

Eve embraces the Tree of
Knowledge and looks intently
at the apple she hands to Adam,
but he appears to be drawing back
from her. This view of Adam and
Eve seated, with Adam shown
from the back, is unusual in art.

The immediate result of Adam
and Eve's disobedience is shown
in the background: at God's
command, an angel with a flaming
sword drives the couple out of
Paradise.

Tintoretto's serpent has the head
of a mammal. It already holds
a second apple in its mouth.

Jan Brueghel and Peter Paul Rubens, 1568–1625 and 1577–1640
Paradise and the Fall of Man, c. 1617
Panel, 74.5 x 114.5 cm
Koninklijk Kabinet van Schilderijen Mauritshuis, The Hague

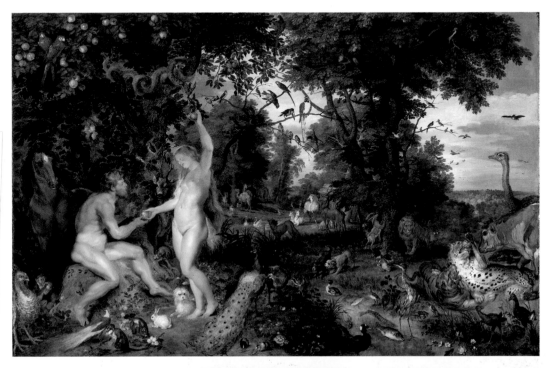

This is a true paradise on earth. Adam and Eve are in a wooded landscape with lush vegetation and a variety of exotic and European animals (realistically painted by the specialist Jan Brueghel). This colourful painting is a tribute to the splendour of God's creation.

The serpent here is a real serpent. Eve stands with an apple in her left hand and offers it to the seated Adam. The tree bears not only apples but other fruits as well. At this point, all is peace and harmony; predators like the lion, the tiger and the leopard are docile, but in a few moments all that will change.

The grapes above Adam's head allude to the wine which, according to Roman Catholic doctrine, turns into the blood of Christ in the Eucharist. Christ redeemed humankind from the burden of original sin resulting from Adam and Eve's transgression.

A monkey behind Adam bites into an apple. Monkeys are known for imitating human behaviour, but they also symbolize sin. This is the first painted representation of a bird of paradise which includes the animal's feet. The species was unknown in Europe before travellers arrived with a mounted bird of paradise at the beginning of the 16th century. As that specimen had no legs it was assumed that the bird was perpetually in flight, as if it were in Paradise.

Adam and Eve are sexless in the preceding panels, but after the Fall they cover their loins with fig leaves, as the Bible says.

ADAM AND EVE

Bertram von Minden, c. 1340–1414
The Expulsion from Paradise, c. 1380
Panel, 84 x 56 cm each
Hamburger Kunsthalle, Hamburg

After tasting the forbidden apple, Adam and Eve covered their loins with fig leaves.

And they heard the sound of the Lord God walking in the garden in the cool of the day, and Adam and his wife hid themselves from the presence of the Lord God among the trees of the garden. Then the Lord God called to Adam and said to him, 'Where are you?' So he said, 'I heard Your voice in the garden, and I was afraid because I was naked; and I hid myself.' And He said, 'Who told you that you were naked? Have you eaten from the tree of which I commanded you that you should not eat?' Then the man said, 'The woman whom You gave to be with me, she gave me of the tree, and I ate.' And the Lord God said to the woman, 'What is this you have done?' The woman said, 'The serpent deceived me, and I ate.'

God cursed the serpent, condemning it forever to creep on its belly and be shunned. The fate of Eve and her seed was to conceive children in sorrow and live to serve their men, who would henceforth toil for their bread.

And Adam called his wife's name Eve, because she was the mother of all living. Also for Adam and his wife the Lord God made tunics of skin, and clothed them. Then the Lord God said, 'Behold, the man has become like one of Us, to know good and evil. And now, lest he put out his hand and take also of the tree of life, and eat, and live forever' – therefore the Lord God sent him out of the Garden of Eden to till the ground from which he was taken. So He drove out the man; and He placed cherubim at the east of the garden of Eden, and a flaming sword which turned every way, to guard the way to the tree of life. / GENESIS 3:8-13, 20-24

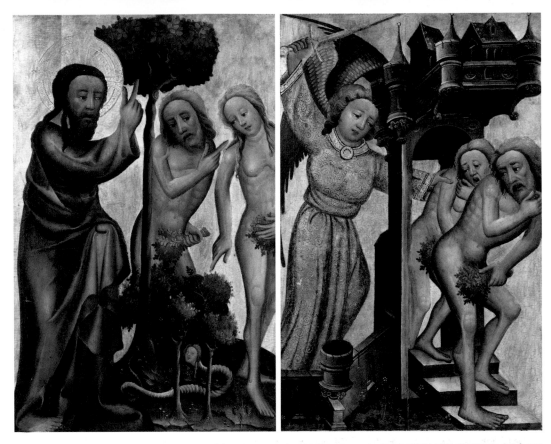

The first panel represents the exchange between God and Adam and Eve. God points at the forbidden tree, Adam points at Eve, and Eve puts the blame on the serpent. The following scene shows Adam and Eve cowering in fear as an angel brandishing a sword expels them from the Garden of Eden. In art this scene usually included a walled city, a detail not mentioned in the Bible.

The two panels form part of the Grabow Altarpiece, which consists of twenty-four scenes in all. Half represent the creation of the world and the lives of the first couple. The altarpiece is an early example of Northern European panel painting.

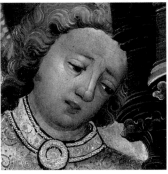

Although Adam and Eve are visibly afraid, the angel pitilessly continues to drive them out of Paradise.

God has apparently already condemned the serpent to crawl on its belly. It is often depicted with a woman's head.

The unspecified 'gate' mentioned in the apocryphal gospel was later identified as the Golden Gate, one of the entrances to Jerusalem. Before they were reunited, both Joachim and Anna were visited by angels bearing the good tidings. In the painting Anna is accompanied by a servant and Joachim by a herdsman.

THE HOLY KINSHIP

The Old Testament also contains stories of elderly barren women who miraculously conceived and bore children (see pp. 14 and 16). In biblical times infertility was believed to be a punishment from God while, conversely, a woman who conceived at an advanced age was deemed to have been chosen by God. The genealogy at the beginning of the Book of Matthew identifies Christ as a descendant of King David. Moreover, according to a medieval legend, Anna remarried twice after Joachim's death and bore two more daughters, who were also called Mary. The 'Holy Kinship' (or extended Holy Family) derived from this and other apocryphal sources was used to demonstrate that all who played a role in Christ's life were in some way related to one another.

ANNA AND JOACHIM

Giotto, c. 1267–1337
The Meeting at the Golden Gate, 1303–05
Fresco, 200 x 185 cm
Scrovegni Chapel, Padua

Joachim and Anna were childless, and for that reason Joachim was cast out of the temple in Jerusalem where he had come to offer a sacrifice. Shamed and humiliated he went to join his herdsmen in the wilderness and there spent forty days fasting. Meanwhile, the elderly Anna lamented her fate.

And lo, an angel of the Lord stood before her and said, 'Anna, Anna, the Lord has heard your prayer. You will conceive and give birth and people will speak of your child the world over.' And Anna said, 'As the Lord God lives, the child that I beget, whether it be a male or a female child, I will bring it as an offering to the Lord my God and it will be a servant to him all the days of its life.' And lo, two angels came, saying to her, 'Behold, your husband Joachim is coming with his flocks.' For an angel of the Lord had descended to Joachim, saying, 'Joachim, Joachim, the Lord God has heard your prayer. Go from here, for your wife Anna shall conceive a child.' And immediately, Joachim went from the wilderness and called his shepherds, saying to them, 'Bring to me here ten lambs without flaw or fault, and they shall be for the Lord my God. And bring me also twelve tender calves, and they shall be for the priests and the elders; and bring one hundred male goats for all the people.' And lo, Joachim came with his flocks. Anna was standing at the gate and when she saw Joachim coming, she ran to him and embraced him, saying, 'Now I know that the Lord has blessed me greatly. Behold, the widow is no longer a widow and I, who had no child, have conceived a child.' ... Her months passed and in the ninth month Anna gave birth and she said to the midwife, 'What is it?' And the midwife said, 'A girl.' Then Anna said, 'My soul exalts this day.' And she laid the infant to rest. And when the time came, Anna cleansed herself and gave her breast to the child and gave her the name Mary. / INFANCY GOSPEL OF JAMES 4–5

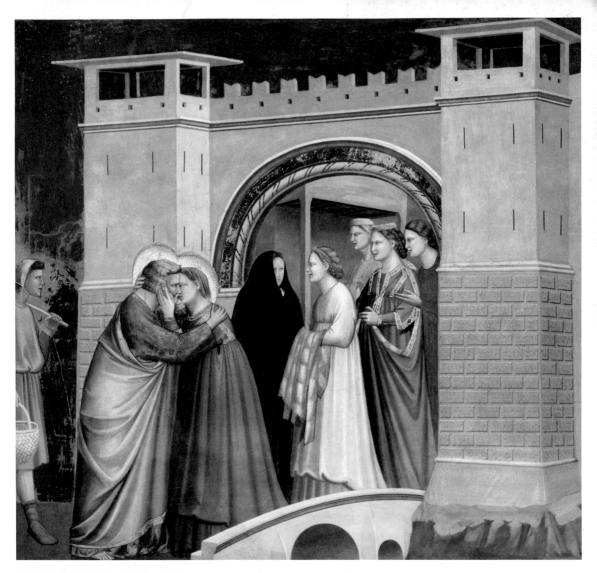

Giotto's celebrated cycle of frescos in the Scrovegni Chapel in Padua illustrates scenes from the lives of Mary and her parents. Anecdotes about them were disseminated mainly through the 13th-century *Golden Legend* by Jacobus de Voragine, though some were based on the 2nd-century apocryphal texts quoted here. Mary's parents are not mentioned in the four canonical gospels, while the first reference to Mary occurs only when an angel reveals that she is to be the mother of Christ. In the 16th century, the Church tried to eliminate apocryphal accounts of this kind from art, but the story of Mary's birth was one of several that proved impossible to eradicate; it remained as popular as the figure of Mary herself.

In some interpretations of the story, Mary was conceived when Joachim and Anna embraced and kissed. In other words, Mary's conception was immaculate in the sense that it was untainted by original sin (see p. 246), which was one of the conditions for her to become the mother of Christ.

The swarthy, unsavoury-looking Jupiter is shown with a goat's horns sprouting from his head. The goat-like satyrs of classical mythology were notorious libertines and philanderers. In the 17th century they personified primeval strength and fertility.

The painting depicts the climactic moment when Jupiter is poised to lift the last fragment of cloth covering the unsuspecting Antiope. Van Dyck was an outstanding painter of textiles, and the beautifully rendered velvet shows him at his best. Neither the painting nor the original texts contain much in the way of narrative detail.

ANTIOPE

Anthony van Dyck, 1599–1641
Jupiter and Antiope, c. 1620
Canvas, 112.5 x 151 cm
Wallraf-Richartz-Museum & Fondation Corboud, Cologne

Ovid describes the cloth that Arachne wove when challenged to a contest by the goddess Minerva (see p. 44). It depicts some of Jupiter's amorous escapades, one being his seduction of Antiope:

She showed, too, how Jupiter, in a satyr's guise, had fathered the twins of Nykteus' beautiful daughter Antiope.

*Ovid says nothing further about Antiope's fate.
The mythographer Apollodorus continues:*

When her father Nykteus learned that she had conceived a child and tormented her, she fled and sought refuge with Epopeus in Sikyon, and there became his wife. In despair, her grieving father took his own life, but not before soliciting his brother Lykos to kill Epopeus and Antiope. Lykos departed for Sikyon, where he slew Epopeus and carried off Antiope. On the return journey Antiope gave birth to twin sons. The infants were abandoned and left to fend for themselves in the wilds, but a herdsman chanced upon them and brought them up as his own, naming them Zethos and Amphion. In later life Zethos became a herdsman, and Amphion a poet who sang to the accompaniment of his lyre. Lykos and his consort Dirke held Antiope in captivity and treated her cruelly, until one day, unbeknown to her captors, the shackles that bound her came loose. Antiope fled and managed to reach the home of her sons, and there sought refuge. The sons recognized their mother, killed Lykos and bound Dirke to a bull to be torn apart. After her death they flung her body into a pool of water, which has ever since borne her name. / OVID, *Metamorphoses*, 6, 110–111; APOLLODORUS, *Mythology*, 3, 5, 5

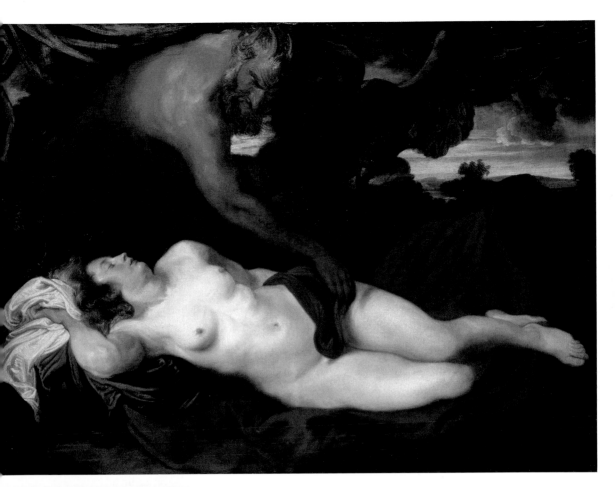

What is about to happen is abundantly clear. Van Dyck's explicitly erotic scene represents an incident that Ovid mentions only in passing, and though in Ovid's version Antiope is not asleep, she is often shown in this state in art. Many of the great masters illustrated the scene of Antiope and the lustful satyr-god. This is one of Van Dyck's few paintings of a mythological subject. It was evidently successful, and he painted several versions. The one in Cologne is considered the best.

To distinguish the scene from the many representations of satyrs seducing nymphs, Van Dyck depicted Jupiter with his constant companion, the eagle, holding Jupiter's bolts of lightning, in its beak.

APOLLO

The instruments that Apollo and the satyr Marsyas used in the contest lie on the ground, but Ribera replaced them with contemporary instruments.

Jusepe de Ribera, 1591–1652
Apollo Flaying Marsyas, 1637
Canvas, 202 x 255 cm
Koninklijke Musea voor Schone Kunsten van België/Musées Royaux des Beaux-Arts de Belgique, Brussels

The god Apollo murdered Marsyas, and this is how it came to pass. Marsyas found the musical pipe that Athena had discarded because playing upon it distorted her face. Now, with the instrument in his possession, Marsyas challenged Apollo to a contest. They agreed that the winner might decide the fate of the loser. While they competed Apollo played his lyre upside-down and defied Marsyas to follow his example. Marsyas was, of course, unable to do so and Apollo was declared the winner. He hanged Marsyas from the branch of a tall pine tree and flayed him to death.
/ APOLLODORUS, *Mythology*, 1, 4, 2

Ovid describes Marsyas' punishment in gory detail:
The satyr Marsyas lost the contest to Apollo when he played the pipe he had taken from Minerva [Athena] and for this received his retribution. 'Ah,' he roared in agony, 'what fate is this? My body is torn to shreds! I repent,' he cried, 'a pipe's not worth the price.' But howl and bellow as he might, he was flayed pitilessly from head to foot. All that remained was a single, large wound, with blood flowing freely, sinews bared, veins, stripped of skin, trembling and pulsating. One could see his convulsing organs, count the transparent tissues in his breast. All his brother satyrs and the fauns of fields and woods, his faithful friend Olympus, the nymphs, and all who grazed their flocks and long-horned cattle on those mountainsides, wept bitterly for Marsyas. The fertile soil grew moist, drenched with the tears that gathered deep in the earth and there formed a river. The waters rose to the surface and flowed between sloping banks to the raging sea. They formed the river Marsyas, the clearest stream of Phrygia. / OVID, *Metamorphoses*, 6, 384–400

Artists were inspired not only by written accounts of the story of Marsyas but also by the many ancient sculptures, reliefs and paintings which showed him bound to a tree or hanging from a branch, with Apollo looking on and either instructing an executioner to flay him or administering the gruesome penalty himself. Those were the most common images in the 16th century, but some artists, Titian among them, painted Marsyas suspended by the feet.

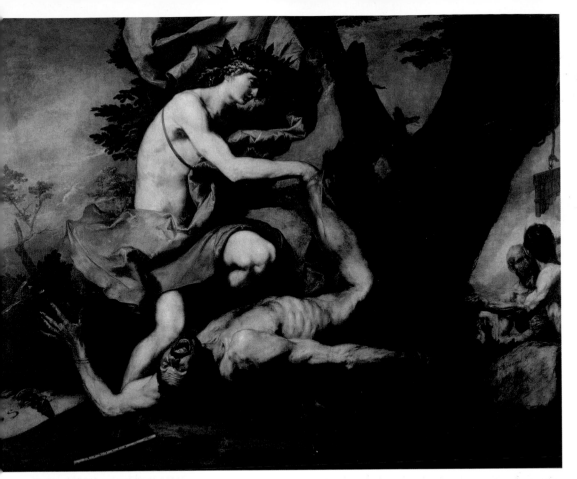

Ribera's Marsyas lies on the ground – his agonized face extends into our space, confronting us with the utter brutality of the scene – while Apollo, god and executioner, has started to administer the cruel punishment and flays the satyr's hoofed feet. All our attention is drawn to this central image. The two main characters are complete opposites. Apollo is a young, idealized figure and every inch a god, whereas Marsyas could have been modelled on the kind of hoodlum that Ribera might have encountered in the back alleys of his adoptive city, Naples. One of the main themes of this story, which Ribera illustrated several times, is the contrast between the godly and the worldly. But the original myth would also have conveyed the ideas that pride comes before a fall, and that civilization prevails over barbarism.

In the background are the satyrs of the forest from Ovid's story, distraught at the sight of Marsyas' suffering. A pan-pipe hangs overhead. Pan, too, had once challenged Apollo to a contest and lost – he stood little chance against the god of music – but in his case the consequences were not so dire (cf. p. 254). The stories of these two music contests were occasionally intertwined.

Apollo is still running when he reaches Daphne and clasps her around the waist. He is dressed in the manner of a wealthy young Florentine of Pollaiuolo's day.

APOLLO

Antonio del Pollaiuolo, c. 1432–1498
Apollo and Daphne, 1470s?
Panel, 29.5 x 20 cm
The National Gallery, London

Daphne, the daughter of a river god, was Apollo's first love, but the romance was ill-fated from the start. Cupid had pierced her with a leaden arrow and Apollo with an arrow of gold. As a result, Apollo fell in love, but Daphne, unmoved, took a vow of chastity.

Apollo saw the hair tumbling loose about her neck, and wondered aloud what it would look like drawn back. He saw the fire of stars sparkling in her eyes, and yearned for more than merely to gaze upon her lips. He loved her fingers, her hands, her arms, bare almost to the shoulder, and all that was hidden from sight he fancied even more lovely. But swift as the wind she fled, nor stopped when he called her to stay.

Apollo entreated Daphne not to run from him, and revealed that he was a god.

In fear Daphne fled on, eluding him and leaving him with his words unspoken. Still her beauty moved him. Zephyrs lifted her garments, laying bare her limbs, and a gentle breeze ruffled her flowing hair. She grew larger in flight. His endearments spurned, the young god fell silent and quickened his steps, urged on by his burning desire. The one was borne on wings of love, the other was driven by fear. Apollo gained upon the girl, almost treading her heels, until his breath caressed her hair. Her strength spent, her face deathly pale, she turned to her father, the waters of the river Peneius, and murmured, 'Help, father, help, if a river god possess the powers to do so. Deliver me from this body that has pleased too well.' Her words not yet spoken, a languor spread through her limbs, a fine bark began to cover her soft breasts, her hair turned into leaves and her arms into branches. Her feet, then so swift, were now rooted fast to the ground, her face framed by a crown of foliage. All that was left of Daphne was her radiant beauty, and Apollo loved her yet. He placed his right hand on the bark and felt her heart still beating beneath it. He embraced the trunk and pressed his lips to the wood that even now shrank from his kiss. / OVID, *Metamorphoses*, 1, 497–556

Daphne was turned into a laurel, which has been associated with Apollo ever since.

The problem for artists was how to incorporate the main components of Ovid's tale in a single image: the thrill of the chase and the terror of flight, Apollo's desire and Daphne's metamorphosis. Pollaiuolo was probably the first painter to tackle the theme. But for her arms, Daphne is still a mortal, shown here in the semblance of a graceful dance. It is often unclear whether a painting was intended to convey a particular message. In this case, in the literature and in moralistic Christian editions of Ovid, the lesson was that chastity ultimately prevails over lust. Pollaiuolo's panel was probably made for a *cassone*, or bridal chest (see also p. 57). In any event, this love story would have been a suitable decoration for an object of that kind.

The wind blows through Daphne's blonde hair, just as Ovid writes. She smiles sweetly at Apollo, and no longer resists his advances. The branches that replaced her arms in the tale look more like trees in the painting.

Pollaiuolo portrayed only the two main characters. Later artists included other figures from the myth, like Daphne's father, the river god, who, by Ovid's account, answered his daughter's prayer by turning her into a tree. The river flowing through this typically Tuscan landscape is the Arno.

The voluptuous deity Pan – Apollo's raised hand conceals his loins – casts a mischievous, sidelong glance at the beautiful Hyacinthus. The impish sculpture seems almost alive.

APOLLO
·····································

Giovanni Battista Tiepolo, 1696–1770
The Death of Hyacinthus, c. 1752–53
Canvas, 287 x 232 cm
Museo Thyssen-Bornemisza, Madrid

Apollo would have taken Hyacinthus, the son of Amyclas, up to heaven, had unhappy fate but given him the chance. Yet in a sense Hyacinthus remains immortal. Year after year, when spring dispels winter and Aries follows on the heels of watery Pisces, he flowers again in the fresh new grass. Apollo loved him above all other and left his Delphi, centre of the earth, to pass his days in unwalled Sparta, the place where Hyacinthus dwelt. His lyre and his bow lay idle; he spared no thought for himself, but was content to bear Hyacinthus' nets for the hunt, or rein in the hounds and wander over lonely mountain slopes, steadfastly nurturing his passion. One day at noon, when the sun was at its zenith, as far from the night past as the night to come, the two disrobed, smoothed their limbs with lustrous olive oil, and tested their skills with the discus. Apollo, first, balanced the disc in his hand and hurled it through the air. It soared skyward, ever higher, cleaving a path through the clouds before swooping down at last to fall on solid ground, attesting to his strength and skill.

Hyacinthus, careless and intent on the game, leapt forward to retrieve the disc. But it rebounded from the hard surface and struck him full in the face. Apollo turned pale, as pale as the boy who had fallen to the ground. He lifted the crumpled body and tried to revive him, with herbs tried to staunch the blood flowing from the tragic wound, and stop the soul slipping from his friend. But his endeavours were fruitless, the wound was fatal. Hyacinthus' head, grown too heavy as all strength ebbed from his neck, sank upon his shoulder.

Hyacinthus died and the inconsolable Apollo was filled with remorse. From the lifeless body of his beloved friend he created a flower.

The blood that spilled on the ground and stained the grass was no longer blood, and there grew a flower brighter than purple dye from Tyre. It resembled a lily, but lilies are silver and the colour of this flower was purple. / OVID, *Metamorphoses*, 10, 162–213

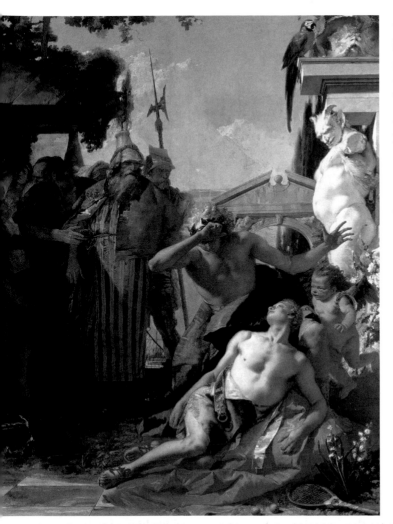

Tiepolo made an unusually large painting of this poignant tale. The lovers are shown with others looking on. The man who stands rigid with grief in the midst of his entourage is presumably Hyacinthus' father. The architecture and some of the costumes place the scene in Tiepolo's 18th century. We recognize the god Apollo by his blond curls and crown of laurel. He bends over his dying friend in a melodramatic display of anguish, while Hyacinthus seems to be mustering the last of his strength to look once more at his friend. Cupid, the god of love, hovers beside them.

Apollo created a flower from Hyacinthus' blood, which Tiepolo discreetly replaced with a crimson cloth. In Ovid, however, the blood flowing from Hyacinthus' body was purple.

The potentially deadly discus has been replaced by a *jeu de paume* racket and balls, which can be seen in the lower right corner. The substitution is implausible, but from it we can deduce that Tiepolo based his painting on a 16th-century translation of Ovid's Latin text, which includes the same detail. *Jeu de paume*, the game known today as tennis, was introduced in the Renaissance and soon gained popularity among young aristocrats.

According to Ovid, Pallas came to the lowborn Arachne in the guise of an old woman to urge her to be more modest. Few of Velázquez' contemporaries in Spain depicted mythological subjects. This highly individual interpretation flawlessly weaves the ancient myth into the tapestry of everyday life in Velázquez' day.

This girl, whose face we cannot see, could be Arachne weaving in the contest, with the old woman representing Pallas. According to Ovid, Pallas took part in the contest without a disguise.

ARACHNE

Diego Velázquez, 1599–1660
The Fable of Arachne (The Weavers), c. 1656–58
Canvas, 220 x 289 cm
Museo Nacional del Prado, Madrid

In Lydia there once lived an industrious weaver called Arachne. Gods and mortals came from the heavens and all the earth to admire her work. Emboldened, Arachne challenged Pallas to a contest. In response, Pallas appeared to Arachne in the guise of an old woman and urged her to repent for her audacity. When the girl remained adamant, Pallas revealed her true identity, and the contest began. The goddess wove a cloth depicting fools who had been punished for their boldness. Arachne wove scenes that revealed the debauchery of the gods and the exploits of the philandering Jupiter.

Arachne wove the story of Europa deceived by a bull, her art so true that the bull might be mistaken for a real bull and the waves for real waves. Europa gazed back at the land she had left; she called to her companions and, afraid of the advancing swell, timidly drew up her feet.

Envious of Arachne's superior skill, Pallas decided to punish the girl.

In fury, the formidable, golden-haired Pallas tore to shreds her [Arachne's] colourful cloth depicting the shameful conduct of the gods, and with her boxwood shuttle in her hand, struck the girl's forehead thrice and perhaps even once more. Defeated by her taunts, the hapless Arachne tied a loop around her neck and was already suspended in the air when Pallas, moved to pity, lifted her up and said: 'You shall live, you wretch, yet your fate shall be to dangle forever more.' And as she retreated, she sprinkled Arachne with the liquor of magic herbs. No sooner had those cruel drops touched her skin than Arachne's hair fell out, her nose and her ears disappeared, and her head and body shrank to little more than a speck. Slender strands projected ·from her sides, replacing her legs, and all the rest was abdomen from which fine threads emerged. Reduced to a spider, Arachne continues to weave her web of old. / OVID, *Metamorphoses*, 6, 103–137

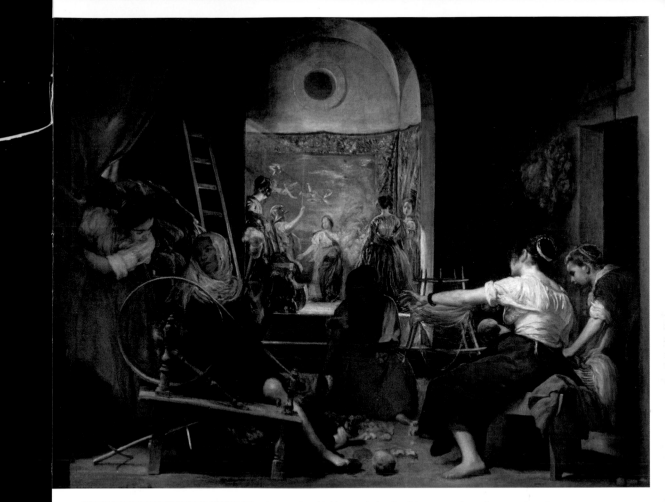

Long after Velázquez' death, this unusual work was taken for a genre painting depicting a tapestry workshop, with women spinning and weaving in the foreground and others examining a completed work in the background. But in 1948 it was discovered that the tapestry in the background represented Titian's painting of the *Rape of Europa* (see pp. 184–185), which, according to Ovid, was the first scene that Arachne depicted in her cloth. This revelation cast an entirely new light on the Velázquez, which, it now transpired, was a rare illustration of the story of Arachne. Hence, the two women standing in front of the brightly lit tapestry are Arachne and Pallas deciding the winner of the contest. Badly damaged by fire in the 18th century, Velázquez' painting was subsequently enlarged along the top and completely restored.

The woman wearing a helmet is Pallas, the goddess of war, knowledge and art. She is about to punish Arachne for her pride and appears to be brandishing a spindle. A Spanish translator of Ovid suggested that the tale might be a metaphor of the fate that may befall an artist who is unfairly criticized. Could that have been Velázquez' reason for painting the subject?

BABEL

Pieter Bruegel the Elder, c.1525–1569
The Tower of Babel, 1563
Panel, 114 x 155 cm
Kunsthistorisches Museum, Vienna

'All who were engaged to build the tower toiled with unflagging energy and devoted themselves tirelessly to their labours. A multitude were employed in the enterprise, and the tower rose faster and higher than anyone had anticipated' (Flavius Josephus, *Antiquities of the Jews*, 1, 115–116). The diminutive figures of the workmen can be seen on the site. The houses in the city are also tiny. The soaring tower dwarfs everything in sight.

Nimrod, a great-grandson of Noah, accompanied by his guards, surveys the construction site where labourers are hard at work. According to non-biblical Judaeo-Christian writings, King Nimrod, who incited his people to disobey God, ordered the building of the tower as a stronghold in which he would survive a second Flood and so avenge the death of his ancestors.

Now the whole earth had one language and one speech. And it came to pass, as they [Noah's descendants] journeyed from the east, that they found a plain in the land of Shinar, and they dwelt there. Then they said to one another, 'Come, let us make bricks and bake them thoroughly.' They had brick for stone, and they had asphalt for mortar. And they said, 'Come, let us build ourselves a city, and a tower whose top is in the heavens; let us make a name for ourselves, lest we be scattered abroad over the face of the whole earth.' But the Lord came down to see the city and the tower which the sons of men had built. And the Lord said, 'Indeed the people are one and they all have one language, and this is what they begin to do; now nothing that they propose to do will be withheld from them. Come, let Us go down and there confuse their language, that they may not understand one another's speech.' So the Lord scattered them abroad from there over the face of all the earth, and they ceased building the city. Therefore its name is called Babel, because there the Lord confused the language of all the earth; and from there the Lord scattered them abroad over the face of all the earth. / GENESIS 11:1–9

The Tower of Babel was the ultimate symbol of what happens when man turns from God. The moral of the story is that God punishes evil and pride; and faith leads to salvation.

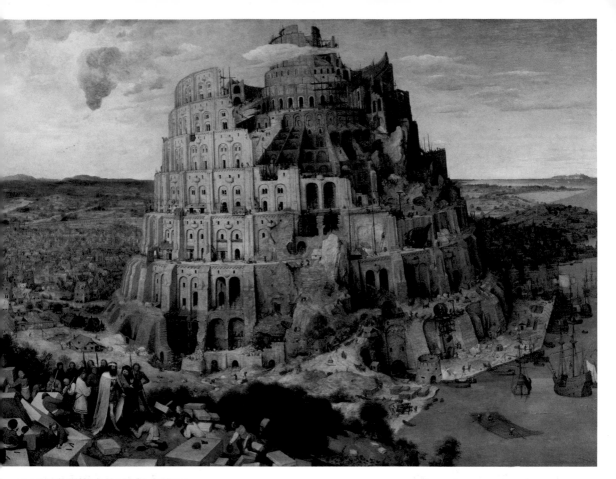

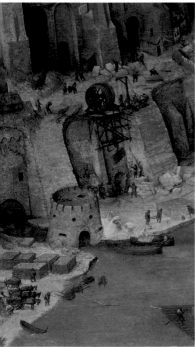

Bruegel's soaring tower, though not yet finished, reaches up to 'the heavens'. In the upper section only the red-brick interior structure has been completed. The impressive architecture was based on the Colosseum, which Bruegel had seen on a visit to Rome. For Christians, the Colosseum, like the Tower of Babel, was a symbol of pride: it was the site where their forebears had died as martyrs.

The real Tower of Babel, which was unknown in Europe in Bruegel's day, was a *ziggurat*, or tiered tower, of approximately 90 metres in height. It formed part of the temple to Marduk, the chief god of the Babylonian pantheon. The biblical story of the Tower of Babel was illustrated predominantly by Netherlandish artists of the 16th and 17th centuries. Bruegel also made a smaller variant of this painting (Museum Boijmans Van Beuningen, Rotterdam), while a third painting of the tower from his hand has been lost.

Bruegel's awesome and meticulously detailed tower is both pointless and physically impossible. The project was apparently badly planned, as parts of the lower section are not yet finished, and the building, with work still in progress, leans to the left.

BACCHUS AND ARIADNE

Titian, c. 1487–1576
Bacchus and Ariadne, 1520–23
Canvas, 172 x 188.5 cm
The National Gallery, London

Titian could have drawn on a variety of classical texts on this subject. The stars are not mentioned in Catullus' account, but in *Metamorphoses* Ovid writes: 'Bacchus comforted Ariadne, and so that she might shine forever as a star he took the crown from her hair and hurled it into the sky. And as it soared through the thin air its jewels turned into sparks of fire. They rose to heaven in the form of a crown and took their place between two other constellations' (Ovid, *Metamorphoses*, 8, 177–182).

BACCHANALES
Titian painted this canvas, along with two others, to decorate a private room in the ducal palace in Ferrara. Bellini's Feast of the Gods *(see pp. 296–297) also formed part of the commission for Duke Alfonso d'Este, one of the highlights of Italian Renaissance art. All these works have erotic overtones and represent bacchanals.*

Thanks to the enamoured Cretan princess Ariadne, the Athenian hero Theseus managed to slay the formidable Minotaur, and together the couple fled from Crete. But Theseus abandoned Ariadne on the island of Naxos, even before they reached Athens ... just as the wine god Bacchus and his entourage came storming in. Sadly she watched as Theseus' ship sailed away, her heart heavy with grief and worry. But from yonder came the dazzling Bacchus with his retinue of satyrs and sileni, in search of Ariadne. Now he stood before her, inflamed with love. The bacchantes were jubilant, whooping hurrah and wagging their heads. Some flourished ivy-covered spears, others tossed chunks of flesh from a bullock, others still coiled writhing serpents around their limbs, or carried in baskets murky mysteries that the uninitiated vainly desired to know, raised their tambourines in the air and beat them like drums, or clashed their copper cymbals. / CATULLUS, *The Marriage of Peleus and Thetis*, 64, 249–264

Two cheetahs have drawn Bacchus' chariot to this point. They alone stand quietly in the midst of this boisterous scene. Ovid wrote in *The Art of Love*: 'Bacchus leapt from his chariot so that Ariadne would not be afraid of the tigers.' Titian's cheetahs, however, seem to give little cause for concern.

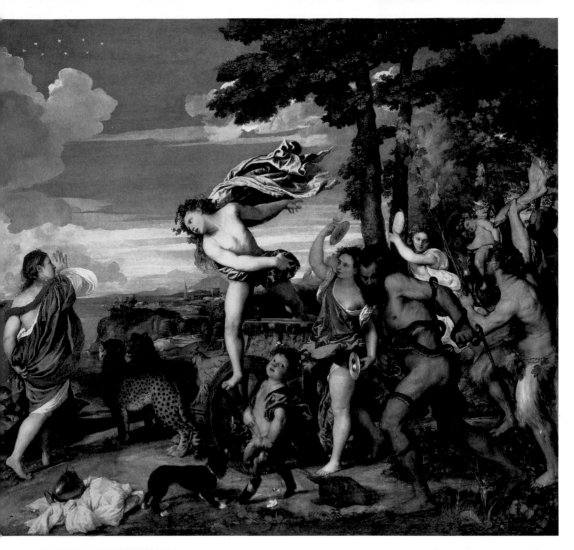

Titian's superb mastery of colour, composition and vitality in this *tour de force* remains unsurpassed. Theseus' ship can just be seen in the distance. Ariadne is grief-stricken, frightened and surprised all at once, and the stunning young Bacchus leaps from his triumphal chariot. Their eyes meet. Bacchus is followed by the riotous company of female bacchantes and male satyrs and sileni that Catullus describes. There are also quieter and more dignified representations of the meeting between Bacchus and – the sometimes slumbering – Ariadne, but Titian opted for a composition that resounds with an inaudible clamour.

Fat old Silenus, lurching drunkenly on his donkey, is not mentioned by Catullus. His presence here suggests that this detail, at least, was derived from Ovid, who described the same bacchanal in *The Art of Love*: 'Silenus was there too, that fat old drunk, slumped on his donkey. He clung to its neck and mane and chased after the women, who fled in all directions. They provoked him; he beat his mule with a stick, and promptly fell on his face. The satyrs cried out, 'Rise, old man, get back on your feet!'

BALAAM

Pieter Lastman, c. 1583–1633
Balaam and his Donkey, 1622
Panel, 40.5 x 60.5 cm
Israel Museum, Jerusalem

Balaam is accompanied by the two servants mentioned in the Bible. They are in the shadows and take no part in the event but, unlike their master, they gaze wide-eyed at the angel. The horseman in the background is a servant of King Balak. According to the Bible, Balaam had sent for him.

On their journey to the Promised Land the Israelites were refused passage through Moab, the territory of King Balak. The king wanted the magician Balaam to curse the Israelites. At first God asked Balaam not to obey, but finally let him go.

Then God's anger was aroused because he went, and the Angel of the Lord took His stand in the way as an adversary against him. And he was riding on his donkey, and his two servants were with him. Now the donkey saw the Angel of the Lord standing in the way with His drawn sword in His hand, and the donkey turned aside out of the way and went into the field. So Balaam struck the donkey to turn her back onto the road. Then the Angel of the Lord stood in a narrow path between the vineyards, with a wall on this side and a wall on that side. And when the donkey saw the Angel of the Lord, she pushed herself against the wall and crushed Balaam's foot against the wall; so he struck her again. Then the Angel of the Lord went further, and stood in a narrow place where there was no way to turn either to the right hand or to the left. And when the donkey saw the Angel of the Lord, she lay down under Balaam; so Balaam's anger was aroused, and he struck the donkey with his staff. Then the Lord opened the mouth of the donkey, and she said to Balaam, 'What have I done to you, that you have struck me these three times?' And Balaam said to the donkey, 'Because you have abused me. I wish there were a sword in my hand, for now I would kill you!' So the donkey said to Balaam, 'Am I not your donkey on which you have ridden, ever since I became yours, to this day? Was I ever disposed to do this to you?' And he said, 'No.' Then the Lord opened Balaam's eyes, and he saw the Angel of the Lord standing in the way with His drawn sword in His hand; and he bowed his head and fell flat on his face. And the Angel of the Lord said to him, 'Why have you struck your donkey these three times? Behold, I have come out to stand against you, because your way is perverse before Me. The donkey saw Me and turned aside from Me these three times. If she had not turned aside from Me, surely I would also have killed you by now, and let her live.' / NUMBERS 22:22–33

Balaam saw the error of his ways and instead of cursing the Israelites he blessed them, to the fury of King Balak.

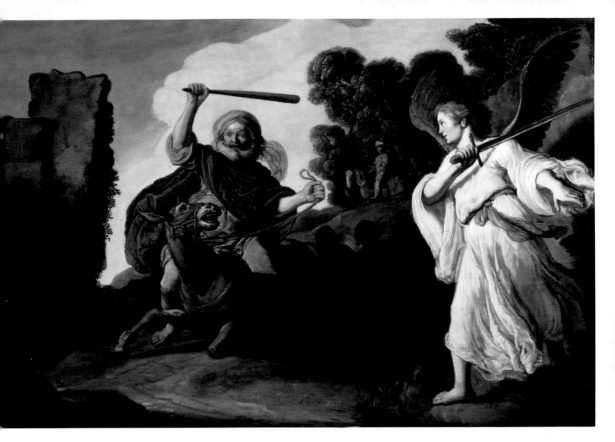

As far as we know, Lastman was the first painter to illustrate this story. He chose the scene just before the end of the narrative, when the angel blocks the donkey's path for the third time, the animal lies down, and Balaam flies into a rage. A few moments later, Balaam saw the vision of the angel and repented. This is one of many Old Testament scenes that were interpreted as prefiguring an event in the New Testament: the angel appearing before Balaam foreshadowed the resurrected Christ appearing before the doubting apostle Thomas (see p. 46). Pieter Lastman was one of Rembrandt's teachers.

This is the moment when God gave the donkey the power of speech. The animal turns to Balaam and reproaches him.

With his hand raised to beat the donkey, Balaam's eyes open wide in amazement when the animal starts to speak. According to the Book of Numbers, this is the moment that Balaam's eyes are 'opened' and he sees the angel 'with his drawn sword in his hand'. The angel shows him the error of his ways.

BELSHAZZAR

Rembrandt, 1606–1669
Belshazzar's Feast,
c. 1635
Canvas, 167 x 209 cm
The National Gallery, London

The woman in the sumptuous velvet dress recoils from the vision and spills wine from the gold beaker onto her red sleeve.

Rembrandt possessed a large collection of art and miscellaneous objects such as helmets, beakers and robes, which he used as props in paintings such as this.

During the exile of the Israelites in Babylon (6th century BC) King Belshazzar made a great feast 'for a thousand of his lords'.

While he tasted the wine, Belshazzar gave the command to bring the gold and silver vessels which his father Nebuchadnezzar had taken from the temple which had been in Jerusalem, so that the king and his lords, his wives, and his concubines might drink from them. Then they brought the gold vessels that had been taken from the temple of the house of God which had been in Jerusalem; and the king and his lords, his wives, and his concubines drank from them. They drank wine, and praised the gods of gold and silver, bronze and iron, wood and stone. In the same hour the fingers of a man's hand appeared and wrote opposite the lampstand on the plaster of the wall of the king's palace; and the king saw the part of the hand that wrote. Then the king's countenance changed, and his thoughts troubled him, so that the joints of his hips were loosened and his knees knocked against each other. The king cried aloud to bring in the astrologers, the Chaldeans and the soothsayers.

To the king's dismay, no one was able to read the writing on the wall. The queen advised him to send for Daniel, an exile from Judaea who lived in Babylon. Daniel said that Belshazzar was guilty of pride and blasphemy for having stolen the drinking vessels from the temple and worshipping idols.

'The God who holds your breath in His hand and owns all your ways, you have not glorified. Then the fingers of the hand were sent from Him, and this writing was written. And this is the inscription that was written: MENE, MENE, TEKEL, UPHARSIN. This is the interpretation of each word. MENE: God has numbered your kingdom, and finished it; TEKEL: You have been weighed in the balances, and found wanting; PERES: Your kingdom has been divided, and given to the Medes and Persians.' / DANIEL 5:1–28

That same night Belshazzar was slain.

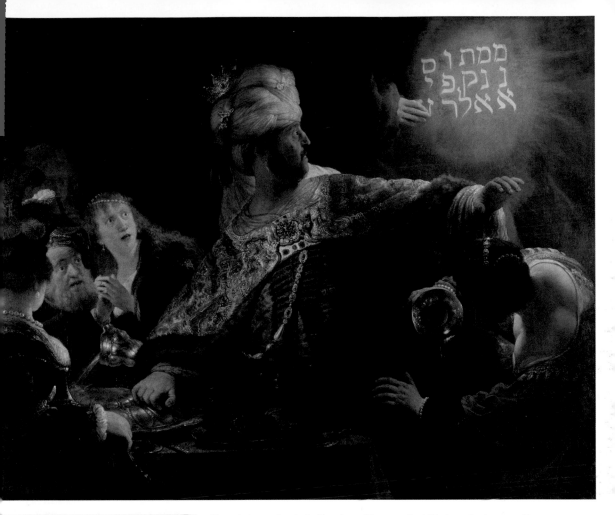

The picture attests to Rembrandt's superb skill at capturing emotion, which artists aimed to achieve in paintings of biblical or mythological scenes. The mysterious hand is clearly visible and has just inscribed the blindingly luminous words. Belshazzar, in some sort of oriental costume, is flustered and upsets a silver wine beaker. His companions are also stricken with fear, as we see from their hands. The story was understood as an admonition against arrogance and overindulgence.

The Hebrew inscription reads from right to left, but the words are inscribed in columns, which is unconventional. Rembrandt must have consulted a rabbi or, even more likely, one of the Hebrew scholars in his circle of Dutch acquaintances (but he nevertheless mistranscribed the word *upharsin*). The strange, ghostly hand is just completing the last character, as if sealing Belshazzar's fate. The words are not inscribed on the wall, but appear in a nimbus of light.

CAMBYSES

Gerard David, c. 1460–1523
The Judgement of Cambyses, 1498
Panel, 182 x 318.5 cm
Groeningemuseum, Bruges

King Cambyses, in a brocade robe trimmed with ermine, enumerates the charges against Sisamnes. He is also present at the execution of the punishment, death by flaying, on the right. In both panels he is accompanied by the impassive and rather static-looking aldermen of Bruges, who are believed to have commissioned the diptych.

Sisamnes stands in a portico and surreptitiously accepts money. This is the act of corruption that Herodotus mentions. Some of the buildings in the background can be identified: the citizens' hall can be seen in the left panel, and one of the side walls of the town hall in the right panel.

Sisamnes was a corrupt judge under King Cambyses of Persia. He accepted a bribe and delivered an unjust verdict, for which the king condemned him to be flayed. His skin was cut into strips and spanned across the seat of the throne on which he had sat in judgement. Sisamnes' son was appointed to succeed his father, with a warning never to forget how his seat was made. / HERODOTUS, *Histories*, 5, 25

This story gained currency predominantly through the later Roman version by Valerius Maximus, whose Facta et dicta memorabilia (Memorable Deeds and Sayings of the Ancient Romans) *brought together a collection of anecdotes which were reworked once again in the Middle Ages.*

Cambyses ruled with an iron fist. At his command a judge was flayed and his skin spanned over the seat of the chair on which his son was to sit in judgement. The king showed no mercy, but introduced this cruel new form of punishment to ensure that no judge would ever again succumb to bribery. / VALERIUS MAXIMUS, *Memorable Deeds and Sayings of the Ancient Romans*, 6, 3

David illustrated the ancient story in a diptych (now two separate panels) set in the Bruges of his day. On the left, Sisamnes is found guilty and arrested by a guard. On the right, four executioners administer the grisly punishment with spine-chilling efficiency. Scenes depicting the dispensation of justice were first produced in the 15th century. They were usually displayed in courtrooms to inspire integrity in judges. David's diptych was probably commissioned by the city of Bruges for the aldermen's chamber, or tribunal, in the town hall of Bruges.

Sisamnes' son has taken his place on the gruesome seat of judgement made with his father's skin. The garlands of flowers, like the loggias and arches, are Renaissance motifs, presaging the dawn of a new culture in the closing years of the 15th century.

CEPHALUS AND PROCRIS

Piero di Cosimo, c. 1462–1515
A Satyr Mourning over a Nymph
(Cephalus and Procris?), c. 1495
Panel, 65.5 x 184 cm
The National Gallery, London

From Ovid's account we would expect to see the Athenian Cephalus, but the figure shown here with horns and hoofs is a satyr. The artist may have seen a similar character in the play *The Story of Cephalus (Fabula di Cefalo)* by Niccolò da Correggio, dating from 1486. It is uncertain whether the painting represents Procris and Cephalus.

Soon after Cephalus married Procris, the goddess Aurora sowed suspicion in his heart. Was Procris faithful to him when he went out to hunt? To put her to the test he assumed a disguise and then tried to seduce her. Procris fell for the ruse when Cephalus promised her mountains of gold. The two parted and Procris joined the nymphs of the goddess Diana. Like her mistress, she shunned men, but after a time she returned to Cephalus with two gifts: a hound and javelin that never missed its mark. The two were happy for a while, but in the end the javelin was their undoing. Cephalus was out hunting one day when a stranger overheard him singing a song to the zephyr, the gentle breeze that brought relief from the heat. Thinking that Cephalus was flirting with a nymph, the stranger told Procris, and now it was she who grew jealous. She secretly followed Cephalus when he went hunting. Cephalus tells the story: 'Come, zephyr,' I called, 'lighten my labours.' Even as I spoke I believed I heard a sigh, yet I called again, 'Oh come, my lovely.' Once more I made out a soft sound like the snap of a twig and, taking it for quarry, I hurled my javelin. It was Procris – wounded and clutching her breast! 'Alas,' she cried. I recognized the voice of my wife and sped to her side, my heart wild with grief. Blood stained her robe as she plucked from her flesh the javelin, her gift to her wretched husband – oh fateful day! Yet still she lived! I embraced her in my arms and lifted her body, dearer to me than my own. Then I tore a strip from her robe to cover the gaping wound and staunch the flow of blood, entreating her all the while not to die and leave me behind, a murderer. But her strength was gone and her life was fading when she spoke these words: 'By the vows of our union, by the gods of the heavens and the underworld, by all that you have cherished in me and by the love I feel for you, even now, though she caused my death, I implore you, do not take Zephyr to our bed as your wife.' At once I understood how she had mistaken my words, and I told her, but to what avail? She sank down as the last of her strength ebbed away. For as long as her eyes could see, she gazed upon my face, turning her pitiful soul to me. I held her last breath on my lips, and she died at peace, the sadness gone from her face. / OVID, *Metamorphoses*, 7

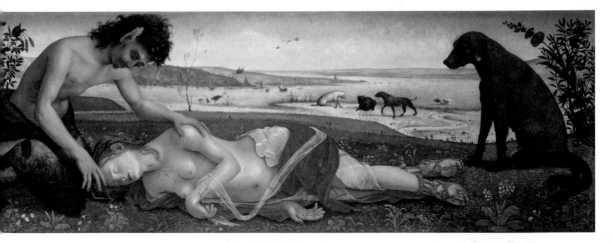

The young woman in this baffling painting appears to be asleep. A charming young man with a goat's hoofs bends over her tenderly, and a dog looks on from the right. The scene takes place in a flower-strewn meadow near a beach, where a pelican and other animals can be seen. Various episodes from the moving and sometimes bizarre story of Cephalus and Procris were depicted in art. The tale warns against the evils of jealousy and marital infidelity, and was often used to decorate *cassone*, or Italian bridal chests. This panel may have been the backrest of a couch or bed.

The beautiful Procris in Piero di Cosimo's painting is wounded in the neck, wrist and hand. In the play by Correggio the goddess Diana brought her back to life.

When Procris returned to Cephalus in an earlier episode of the story, she gave him a dog that could run like the wind. While Cephalus was out hunting, a god turned both the dog and the fox it was pursuing into stone.

CEPHALUS AND PROCRIS

Paolo Veronese, c. 1528–1588
The Death of Procris, before 1582

Canvas, 162 x 190 cm
Musée des Beaux-Arts, Strasbourg

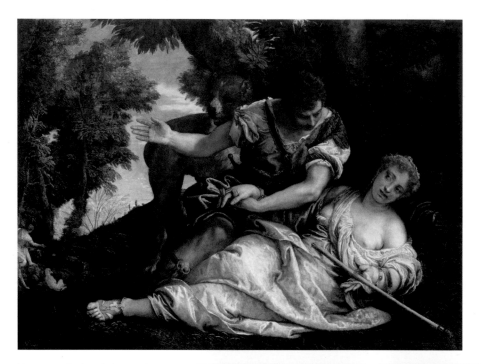

Veronese depicted the tragic moment of separation. Cephalus has just wounded his wife Procris with his javelin and now, to his dismay, discovers his mistake. Procris turns to face him, with her eyes closed and her lips parted. With her hand clasped in his, she breathes her last. The javelin that killed her had been a gift to Cephalus. Veronese also painted *Venus and the Sleeping Adonis*, another love story with a tragic ending. There, however, it is the man, not the woman, who dies.

The dog, like the javelin, was a gift from Procris to her husband Cephalus when she returned to him after their separation.

Cephalus appears to be making a last attempt to explain what happened. The message Ovid conveys is that Procris' jealousy was ultimately her downfall. Love can be fatal.

Claude Lorrain, 1604/05–1682
Landscape with Cephalus and Procris Reunited by Diana, 1645
Canvas, 101 x 133 cm
The National Gallery, London

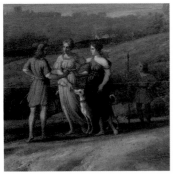

Most of Claude Lorrain's biblical and mythological scenes are set in characteristically timeless landscapes, inspired mainly by the Campagna around Rome. On the right, Diana reunites Procris and Cephalus after their separation. Ovid does not recount this early episode from the story.

The dog and the spear carried by the unknown fourth figure are crucial to our understanding of the painting. According to Ovid, they were gifts Procris gave to Cephalus when the couple were reunited. She had received the dog from Diana.

Ancient buildings or ruins with a bright horizon in the distance are typical of Claude's landscapes. They are invariably bathed in the golden light of the Italian sun.

Elsheimer's composition closely follows Ovid's text. One of the blazing torches mentioned in the story can be seen in the painting. It rests on a cartwheel, which adds a rustic touch to the scene. Its light, augmented by the glow of the old woman's candle, sets the mood of the painting, one of Elsheimer's celebrated night pieces. Ceres is thus illuminated from two sides. Both Rembrandt and Rubens, who knew the melancholic Elsheimer personally, admired his rendering of light and shadow.

CERES

Circle of Adam Elsheimer, 1578–1610
The Mocking of Ceres, c. 1608
Copper, 29.5 x 24 cm
Museo Nacional del Prado, Madrid

Proserpine, the daughter of the goddess Ceres, was abducted by Hades, the god of the underworld. The heartbroken Ceres wandered the earth in search of her daughter, never pausing to rest …

Holding in each hand a blazing torch kindled at Etna's fires, she roamed with foreboding through the dew-laden darkness of night. When clement day had dimmed the stars, she sought her daughter from early dawn to dusk. Weary from her wanderings and yearning to drink, for no spring had quenched her thirst, she chanced to see a thatched cottage, and knocked at its humble door. An old woman emerged. On seeing the goddess and hearing that she wanted some water, she brought her a sweet drink sprinkled with roasted barley. As Ceres drank, a churlish boy appeared at her side and mocked her urgent need. In anger, the goddess flung the remains of her drink, liquid and grains of barley, into the face of her tormentor. At once, bright spots broke out on his face, and legs sprouted where his arms had been; his body changed, a tail began to grow, he shrivelled, and shrank in size. Reduced to a creature no greater than a lizard, he was too small to cause much mischief. The old woman was aghast. Weeping, she stooped to touch the changeling, but it slipped away and vanished in a dark hole. The creature is known today as a spotted newt for the colourful marks on its skin. / OVID, *Metamorphoses*, 5, 441–461

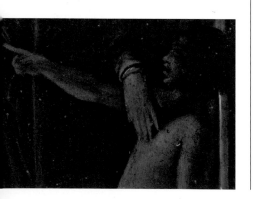

The old woman makes a futile attempt to control the boy, who raises his hand in a gesture of contempt. His pose and nakedness have been interpreted as marking the start of his metamorphosis. Before the subject was identified, the old woman was taken for a witch.

The youthful-looking Ceres clutches her cup in both hands and eagerly
quenches her thirst. There were few precedents for this story in
painting. Elsheimer's representation – he painted it several times –
was copied by many other artists. The original has been lost, and this
painting at the Prado is possibly not by his hand.

JESUS CHRIST

Anonymous
The Nativity, c. 1400
Panel, 38 x 26 cm
Museum Mayer van den Bergh, Antwerp

The bearded Joseph – without a halo – cuts strips from his stocking to use as swaddling cloths for the child. This motif, which characterizes him as a solicitous father, makes it possible to locate the painting to the Meuse-Rhine region: Joseph's stockings were venerated as relics in Aachen Cathedral, and Christmas carols sung in that area refer to them.

The story of Christ's birth and the events that surrounded it are told only by the evangelist Luke.

And it came to pass in those days that a decree went out from Caesar Augustus that all the world should be registered. This census first took place while Quirinius was governing Syria. So all went to be registered, everyone to his own city. Joseph also went up from Galilee, out of the city of Nazareth, into Judaea, to the city of David, which is called Bethlehem, because he was of the house and lineage of David, to be registered with Mary, his betrothed wife, who was with child. So it was, that while they were there, the days were completed for her to be delivered. And she brought forth her firstborn Son, and wrapped Him in swaddling cloths, and laid Him in a manger, because there was no room for them in the inn. Now there were in the same country shepherds living out in the fields, keeping watch over their flock by night. And behold, an angel of the Lord stood before them, and the glory of the Lord shone around them, and they were greatly afraid. Then the angel said to them, 'Do not be afraid, for behold, I bring you good tidings of great joy which will be to all people. For there is born to you this day in the city of David a Saviour, who is Christ the Lord. And this will be the sign to you: You will find a Babe wrapped in swaddling cloths, lying in a manger.' And suddenly there was with the angel a multitude of the heavenly host praising God and saying 'Glory to God in the highest, and on earth peace, goodwill towards men.' So it was, when the angels had gone away from them into heaven, that the shepherds said to one another, 'Let us now go to Bethlehem and see this thing that has come to pass, which the Lord has made known to us.' And they came with haste and found Mary and Joseph, and the Babe lying in a manger. Now when they had seen Him, they made widely known the saying which was told them concerning this Child. And all those who heard it marvelled at those things which were told them by the shepherds. But Mary kept all these things and pondered them in her heart. Then the shepherds returned, glorifying and praising God for all the things that they had heard and seen, as it was told them. / LUKE 2:1–20

Among the most successful apocryphal additions were the ox and the ass. 'On the third day after the birth of Our Lord Jesus Christ, Mary came forth from the cavern and entered into a stable and there laid the child in the manger. An ox and an ass worshipped the child', thus fulfilling the prophecy of Isaiah: 'An ox knows its master, an ass its manger' (Infancy Gospel of Matthew 14). Here, the two animals warm the naked child with their breath.

ANECDOTES

Anecdotal details were added to the apocryphal texts on Christ's birth and childhood and became entrenched in the imagery of scenes of the Nativity and what came to be known as the Adoration of the Shepherds. In the Middle Ages new interpretations were advanced regarding the birth of Christ and the role of Joseph (see pp. 68 and 82).

The head and shoulders of God, surrounded by angels, emerge from an azure sky, beneath which the shivering Mary reclines on a couch of the kind seen in Byzantine art. She looks at Joseph and, in contrast to most other paintings depicting the theme, lies with her back to the child. The event takes place in a mountainous landscape; neither here nor in the gospels is there any reference to a stable or cavern. This beautiful panel formed part of the Quadriptych of Philip the Bold, and may have served as a small portable altarpiece.

Hugo van der Goes, c. 1440–1481

The Nativity or Adoration of the Shepherds, c. 1475–80

Panel, 97 x 246 cm

Staatliche Museen zu Berlin, Gemäldegalerie

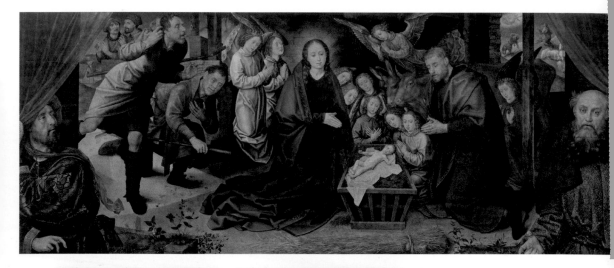

Christ lies in a manger, as the evangelist Luke mentions more than once, but he is not wrapped in swaddling cloths. Hugo's celebrated *Adoration of the Shepherds*, better known as the Portinari Triptych (Uffizi, Florence), shows the child lying on the ground, radiating light. That image derives from a visionary manuscript by Saint Birgitta of Sweden (1302–1373).

Outside, a shining angel announces the birth of the Messiah to two astonished shepherds. Just before his account of the Nativity, the evangelist Luke quotes Zacharias, the father of John the Baptist: 'The Dayspring from on high has visited us; To give light to those who sit in darkness and the shadow of death' (Luke 1:78–79).

'Lifelike' shepherds pitch headlong towards Mary and Joseph, who kneel reverently and worship the child. The painting is unusually long and crowded with angels. At either end, elegantly dressed figures representing the prophets who had announced the coming of Christ draw a curtain aside, as if directing our gaze into a theatre. The scene was indeed often performed on stage. The man on the right appears to be addressing us. The sheaf of wheat in the foreground may allude to the Last Supper, but also to the name Bethlehem, meaning 'house of bread'.

Geertgen tot Sint Jans, c. 1455/65–1485/95
The Nativity, end 15th century
Panel, 34 x 25 cm
The National Gallery, London

Joseph is literally in the background; at this stage the light does not fall on him. He is assigned a secondary role, as in most art from this period.

LIGHT

Light and the symbolism associated with it play an important role in the Nativity and the Christmas liturgy, as we see, for instance, from the following apocryphal account: 'The angel commanded Mary to enter into a cavern beneath the earth where light never shone and all was darkness, as no daylight entered the cavern. And when Mary entered, the cavern began to shine as brightly as if it were noon. God's light shone so intensely in the cavern that, while Mary was there, no light was needed by day nor by night. And there a son was born unto her and angels kept watch all around until the child was born. And as soon as he was born he rose on his feet...' (Infancy Gospel of Matthew 13).

The Nativity is shown here as a nocturnal scene. The bright light emanating from the child in the manger illuminates the face of the worshipping Virgin and the small angels on the left. It also heightens the mystery of the miracle taking place in the stable. The muzzles of the donkey and the ox can be seen near the crib.

In the background an angel appears to the shepherds, bringing the glad tidings of the Messiah's birth. There are three sources of light in the painting: the light emanating from the infant Christ, the radiance of the angel against the night sky, and the glow of the fire at which the shepherds keep themselves warm.

Giorgione, c. 1478–1510
The Adoration of the Shepherds, 1505–10
Panel, 91 x 110 cm
National Gallery of Art, Washington, Samuel H. Kress Collection

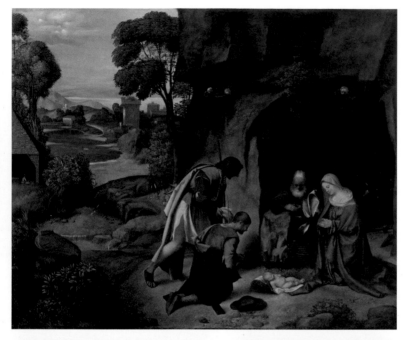

This *Adoration* consists of two distinct parts: the dark cavern suffused with an atmosphere of pious worship, where all eyes are turned on the child, and the landscape at dawn, with a meandering river. Giorgione's tremendous influence on art is out of proportion to the small number of paintings that can be firmly attributed to him. The work discussed here has been variously ascribed to his fellow-student Bellini or his pupil Titian. Another version of this *Adoration* is in Vienna (Kunsthistorisches Museum).

The angels appear as small faces radiating light near the mouth of the cavern. Their physical presence would detract from the pastoral atmosphere.

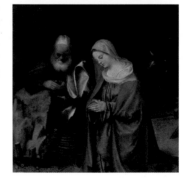

One of the more influential apocryphal texts – the Infancy Gospel of James (see, for example, p. 68) – refers to a cavern in connection with Christ's nativity. The gospels do not specify the exact location, and since medieval times it has often been depicted in western art as taking place in a stable. The ox and the ass are only just visible in Giorgione's cavern.

Georges de La Tour, 1593–1652
The Adoration of the Shepherds, c. 1643

Canvas, 107 x 131 cm
Musée du Louvre, Paris

Illuminated by a candle that
Joseph holds in one hand and
shields with the other, five people
gather in a semicircle around the
sleeping child. From left to right
they are the Virgin, two shepherds
– one of whom respectfully
removes his hat, a serving maid
with a bowl of water in her hands,
and Joseph. The background to
this intimate scene is empty.
La Tour was clearly influenced
by Caravaggio and is known for
his nocturnal scenes by
candlelight, which focus entirely
on the figures. This canvas was
originally larger and showed
the figures full length.

The Virgin is the only person who
prays. She appears to be lost in
contemplation: 'Mary kept all
these things and pondered them
in her heart', Luke writes.

A sheep brought by one of the
shepherds nibbles at the straw.
The all but obligatory extras,
the ox and the ass, are nowhere
to be seen.

This woman holds a banderole bearing a Latin inscription that reads: 'A virgin has brought a son into the world'. She is the believing midwife who unquestioningly accepts what Joseph tells her.

Robert Campin, c. 1375–1445

The Nativity or The Incredulous Midwife, c. 1420

Panel, 86 x 72 cm

Musée des Beaux-Arts, Dijon

In the apocryphal manuscript known as the Infancy Gospel of James, Joseph goes in search of a midwife. And behold, a woman descended from the mountain and spoke to me saying, 'Man, where are you going?' And I replied, 'I am seeking a Hebrew midwife.' She asked, 'Are you come from Israel?' And I said, 'Yes.' She asked, 'Who is it that begets a child in the cave?' And I said, 'My betrothed.' She asked, 'Is she not your wife?' And I answered her, 'She is Mary who was brought up in the temple of the Lord and whom I received when the die was cast to be my wife. Yet she is not my wife. She has conceived a child of the Holy Spirit.' Whereupon the midwife said, 'Do you speak the truth?' And Joseph replied, 'Come and bear witness with your own eyes.' And the midwife went forth with him.

A blinding light shone in the cave, too bright to behold, but after a while it was possible to see the child.

And the midwife cried out, 'Great is this day, for my eyes have witnessed a sight never revealed before.' And she departed from the cave and Salome came to her. And she spoke, saying 'Salome, Salome, I must speak to you of a sight never revealed before. A virgin has brought forth a child: it cannot be.' But Salome said, 'Forsooth, as the Lord my God lives, I shall not believe that a virgin may conceive a child until I have placed my own finger in her womb.' And the midwife entered and spoke thus to Mary: 'Be heedful, for your condition is no small matter of dispute.' And Salome placed her finger within her womb to decide her circumstance. She wailed and cried out, 'Woe for my wickedness and want of faith, as I beseech the living God. Behold, my hand is consumed by fire and falls from my body.' / INFANCY GOSPEL OF JAMES 19–20

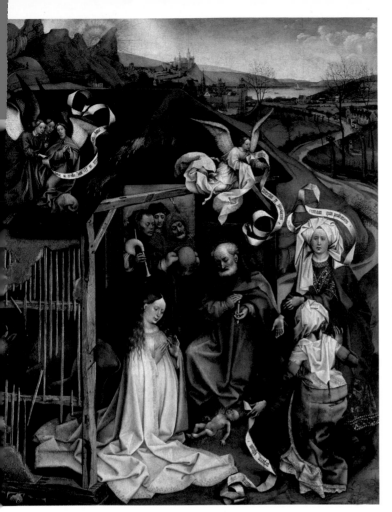

Depicted in front of the beautifully painted winter landscape are the newborn Christ, radiating light; his worshipping parents; the shepherds to whom the hovering angels have brought the glad tidings; the rundown stable; the donkey and the ox. The two women on the right are not mentioned in the four official gospels. The panel combines three distinct subjects: the nativity of Christ, the adoration of the shepherds, and the story of the disbelieving midwife. Salome's test was a prefiguration of the incredulous Thomas' response to Christ's resurrection (see p. 146).

Salome is sceptical, as we see from the words on her banderole: 'I will believe once I have proved it'. Her right hand is limp.

The inscription on the angel's banderole proclaims: 'Touch him and you shall be healed'. The redeeming message is meant for the incredulous Salome.

Gentile da Fabriano, c. 1370–1427
The Adoration of the Magi (Strozzi Altarpiece), 1423

Panel, 303 x 282 cm
Galleria degli Uffizi, Florence

The three kings represent the three ages of man, and so symbolize humankind as a whole. The eldest pays homage to the infant Christ on bended knee, the second king also kneels before him, and the third waits to present his gift. The two women standing behind the Virgin are probably midwives (see p. 68).

FROM ASTRONOMERS TO THREE KINGS

Matthew does not mention how many 'wise men' there were, nor precisely where they came from or what they were called. From references to the gifts they brought – gold, frankincense and myrrh – it was assumed early on that there must have been three; the idea that they were kings derives from the Old Testament: 'Kings [shall come] to the brightness of your rising' (Isaiah 60:3).

The apostle and evangelist Matthew confines his account of the events surrounding the birth of Christ to the story of the Magi – astrologers or astronomers from the East, often also called 'kings' (see below) – who came to Bethlehem where Christ was born. Matthew was the only gospel writer to describe the incident.

Now after Jesus was born in Bethlehem of Judaea in the days of Herod the king, behold, wise men from the East came to Jerusalem, saying, 'Where is He who has been born King of the Jews? For we have seen His star in the East and have come to worship Him.' When Herod the king heard this, he was troubled, and all Jerusalem with him. And when he had gathered all the chief priests and scribes of the people together, he enquired of them where the Christ was to be born. So they said to him, 'In Bethlehem of Judaea, for thus it is written by the prophet.' ... Then Herod, when he had secretly called the wise men, determined from them what time the star appeared. And he sent them to Bethlehem and said, 'Go and search carefully for the young Child, and when you have found Him, bring back word to me, that I may come and worship Him also.' When they heard the king, they departed; and behold, the star which they had seen in the East went before them, till it came and stood over where the young Child was. When they saw the star, they rejoiced with exceedingly great joy. And when they had come into the house, they saw the young Child with Mary His mother, and fell down and worshipped Him. And when they had opened their treasures, they presented gifts to Him: gold, frankincense and myrrh. Then, being divinely warned in a dream that they should not return to Herod, they departed for their own country another way. / MATTHEW 2:1–12

The three 'kings' in this large altarpiece, which was commissioned by the Strozzi banking family, are accompanied by a vast entourage as well as some exotic-looking animals. The work also includes lush scenes of nature. Three rectangular panels in the lower section, forming the predella or base (see also p. 247), show episodes from the first days of Christ's life: on the left we see his birth, in the centre the flight into Egypt, and on the right, the presentation of Christ in the temple (see pp. 78–81 and 74).

The background of this narrative panel shows the colourful company on their journey. Here, they arrive at Herod's palace in Jerusalem, as described in the gospels. The painter paid close attention to naturalistic details.

THE POWER OF IMAGES

As far as paintings of subjects from the gospels are concerned, Gentile and his contemporaries believed that Christ's closest followers had drawn or painted the events they had witnessed. A well-known story, for instance, was that the apostle Luke had painted a portrait of the Virgin. The Magi – three of them – were said to be kings, because they had evidently worn crowns in the earliest paintings of them, which, needless to say, had 'disappeared'. Because of this absolute trust in the authenticity of artistic representations, images of this kind carried the same authority as the actual words of the gospel.

Rogier van der Weyden, c. 1399/1400–1464
The Adoration of the Magi, c. 1455
Centre panel of the 'Columba Triptych', 138 x 153 cm
Alte Pinakothek, Bayerische Staatsgemäldesammlungen, Munich

This work by Rogier van der Weyden had a tremendous influence on Northern European painting. Against the background of a contemporary city, and with the ox and the donkey in a stable-like structure directly behind them, the three beautifully attired 'kings' pay homage to the new King of Heaven. They have removed their headdresses as a mark of respect. The three men, who are all different ages, are accompanied by numerous attendants who wait their turn in a long queue in the background.

We can just see the star that the Magi had seen rise, according to the gospel, and that had shown them the way. Though the three men were believed to be kings even in ancient times, they were in fact astronomers from the Near East.

This anachronistic detail reveals the ultimate purpose of Christ's life on earth: he came to sacrifice his life on the cross to deliver humankind from the sin committed by Adam and Eve in the Garden of Eden, which, according to Christian doctrine, was the origin of the human condition (see p. 26).

Albrecht Dürer, 1471–1528
The Adoration of the Magi, 1504

Panel, 99 x 113.5 cm
Galleria degli Uffizi, Florence

The beautifully dressed and exotic-looking kings represent different ages and come from different continents; one, for instance, is black. The differences between them serve to emphasize that literally the whole world came to worship the newborn king. Early on the kings acquired the names by which they are known: Balthazar (the black king), Gaspar (in the middle) and Melchior (the eldest). Mary's husband Joseph usually appears in a supporting role in scenes of the Adoration, but Dürer has left him out altogether.

The middle-aged king is a self-portrait of the artist, whose signature 'AD 1504' can be seen on the stone.

Ruined buildings in scenes relating to Christ's birth symbolize the Old Testament. Dürer based those in his painting on ruins he had seen in Italy. The stable is supported by such a structure.

The church which is still in the process of being built symbolizes the fact that Christ has only just come to earth. The coming of Christ marked the beginnings of the Church as an institution.

Master of the Prado Adoration of the Magi, 3rd quarter 15th century?
The Presentation in the Temple, 1470s
Panel, 59 x 48 cm
National Gallery of Art, Washington, Samuel H. Kress Collection

Christ's parents took their newborn child to the temple, according to the tradition.

Now when the days of her purification according to the law of Moses were completed, they brought Him to Jerusalem to present Him to the Lord (as it is written in the law of the Lord, 'Every male who opens the womb shall be called holy to the Lord'), and to offer a sacrifice according to what is said in the law of the Lord, 'A pair of turtledoves or two young pigeons.' And behold, there was a man in Jerusalem whose name was Simeon, and this man was just and devout, waiting for the Consolation of Israel, and the Holy Spirit was upon him. And it had been revealed to him by the Holy Spirit that he would not see death before he had seen the Lord's Christ. So he came by the Spirit into the temple. And when the parents brought in the Child Jesus, to do for Him according to the custom of the law, he took Him up in his arms and blessed God and said: 'Lord, now You are letting Your servant depart in peace, according to Your word; For my eyes have seen Your salvation which You have prepared before the face of all peoples, a light to bring revelation to the Gentiles, and the glory of Your people Israel.' And Joseph and His mother marvelled at those things which were spoken of Him. Then Simeon blessed them, and said to Mary His mother, 'Behold, this Child is destined for the fall and rising of many in Israel, and for a sign which will be spoken against (yes, a sword will pierce through your own soul also), that the thoughts of many hearts may be revealed.' Now there was one, Anna, a prophetess, the daughter of Phanuel, of the tribe of Asher. She was of a great age, and had lived with a husband seven years from her virginity; and this woman was a widow of about eighty-four years, who did not depart from the temple, but served God with fastings and prayers night and day. And coming in that instant she gave thanks to the Lord, and spoke of Him to all those who looked for redemption in Jerusalem. So when they had performed all things according to the law of the Lord, they returned to Galilee, to their own city, Nazareth. And the Child grew and became strong in spirit, filled with wisdom; and the grace of God was upon Him.
/ LUKE 2:22–40

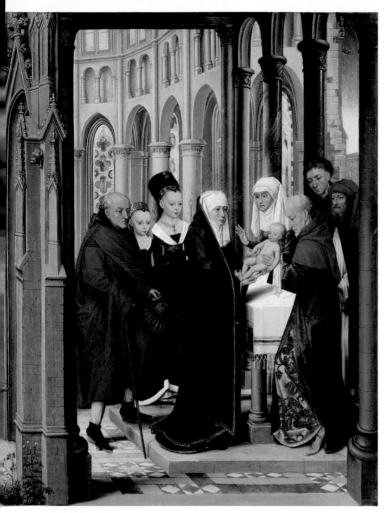

This biblical story is set in a contemporary church interior, like many 15th-century paintings of this kind by Flemish masters. The Virgin passes the naked infant Jesus to the righteous Simeon, over an altar covered with a white cloth. The elderly widow Anna stands on the same side as Simeon. The panel was attributed to Hans Memling until the 1980s, when it was assigned to an unidentified artist subsequently known as the Master of the Prado Adoration of the Magi. The work was strongly influenced by Rogier van der Weyden's version of the same story (Columba Altarpiece, Alte Pinakothek, Munich).

Joseph holds a pair of doves, the traditional sacrifice, as the gospel of Luke notes. The birds are in a wicker basket in the shape of a pitcher.

This unidentified woman – one of four secondary characters – wears contemporary dress. Note also the shoes worn by Joseph and Simeon.

The woman wringing her hands in despair – she is the only one who turns away from the bloodthirsty scene – recalls the Virgin in paintings of the death of her son on the cross. She has also been seen as Rachel of the Old Testament lamenting the death of her children.

Earlier paintings include Herod, the instigator of this cruelty, but after the Renaissance he was no longer depicted in scenes of the subject. Here, his palace in the background invokes his presence.

Guido Reni, 1575–1642
The Massacre of the Innocents, c. 1611–12
Canvas, 268 x 170 cm
Pinacoteca Nazionale, Bologna

Only the evangelist Matthew devotes a few lines to this horrific, but historically undocumented incident, relating it to an Old Testament prophecy. The 'wise men' (see p. 70) broke their promise to King Herod by not returning to report to him on their visit to the newborn Christ …

Then Herod, when he saw that he was deceived by the wise men, was exceedingly angry; and he sent forth and put to death all the male children who were in Bethlehem and in all its districts, from two years old and under, according to the time which he had determined from the wise men. Then was fulfilled what was spoken by Jeremiah the prophet, saying: 'A voice was heard in Ramah, lamentation, weeping, and great mourning, Rachel weeping for her children, refusing to be comforted, because they are no more.' / MATTHEW 2:16–18

In an apocryphal version of this story on which earlier painters based their work, Christ was not in Egypt. That version also features Mary's cousin Elizabeth and her son John (the Baptist).

Herod was angered when he discovered that the wise men had deceived him and sent executioners to destroy all infants who were two years old or younger. Mary heard that the children were being slain and grew afraid. She took the child, swaddled him in cloth and laid him in the ox manger. Elizabeth received word that John, too, was being sought, and fled with him into the mountains. There she sought refuge, but found none. She sighed and wailed, 'Mount of God, take in this mother and child', for she could ascend no further. And at once the mountain sundered and received her, and light shone through the mountain, for there appeared an angel of the Lord to protect them. / INFANCY GOSPEL OF JAMES 22

Herod sent his servants to seek John and kill his father Zacharias.

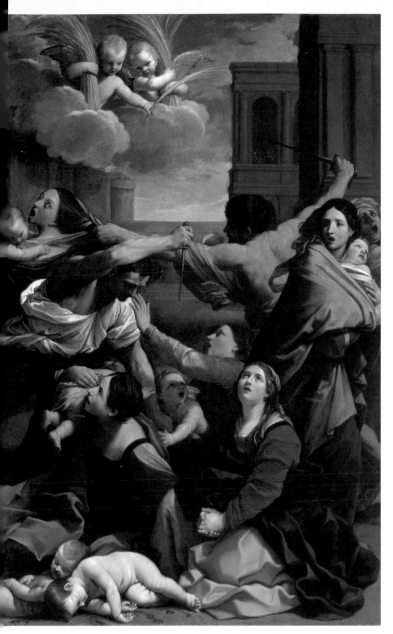

Paintings of this cruel slaughter were in great demand in the 17th century. The story was illustrated in heartrending scenes of young women fleeing or trying to protect their young; ferocious men brandishing daggers; panic-stricken children and murdered infants. In some respects it recalled the mass violence of the Rape of the Sabine Women from the iconography of classical mythology (see p. 308). Some artists used the subject to protest against war and violence. The story of a child's life miraculously spared through divine intervention had a precedent in the Old Testament story of Moses (see p. 256).

The murderers in Reni's painting are ordinary men. In older works they were often portrayed as Jews or, during the wars against Turkey in the 15th century, men from the East.

The angels hold palm branches which they are about to distribute. The palm is a Christian symbol of martyrdom.

The donkey is not mentioned in the apostle Matthew's account of the flight into Egypt. However, the Infancy Gospel of Matthew refers to oxen, donkeys and other beasts of burden, and notes that the Virgin rode one of those animals on her journey. Many paintings show angels accompanying the travellers.

The other anecdote is known as the Miracle of the Corn. Herod's soldiers were pursuing the Holy Family and interrogated whomever they encountered on their way. The Virgin asked a peasant to say that he had seen them pass by when he was sowing his corn. By the time the soldiers arrived, shortly afterwards, the corn had miraculously grown to full height. Hence, they drew the wrong conclusion and turned back.

CHRIST / FLIGHT INTO EGYPT

Joachim Patinir, c. 1474–1524
Landscape with the Flight into Egypt, c. 1515
Panel, 17 x 21 cm
Koninklijk Museum voor Schone Kunsten, Antwerp

The flight into Egypt, which took place shortly after Christ's birth, is mentioned briefly in the canonical gospels. Only Matthew devotes a few lines to the episode. Now when they had departed, behold, an angel of the Lord appeared to Joseph in a dream, saying, 'Arise, take the young Child and His mother, flee to Egypt, and stay there until I bring you word; for Herod will seek the young Child to destroy Him.' When he arose, he took the young Child and His mother by night and departed for Egypt, and was there until the death of Herod, that it might be fulfilled which was spoken by the Lord through the prophet, saying, 'Out of Egypt I called My Son.'
/ MATTHEW 2:13–15
After Herod's death the Holy Family returned from Egypt and settled in the town of Nazareth in Galilee.

The Infancy Gospel of Matthew, a major source for the visual arts, contains a detailed and richly anecdotal account of the episode. One of the apocryphal stories illustrated here took place in the Egyptian town of Sotine. In the temple where Mary and Jesus entered there were three hundred and sixty-five images of idols. Each was worshipped on its own sacred day and holy rituals were performed in its honour. Now it happened that when Mary entered the temple with the Child, the images cast themselves to the ground. All lay on their faces and were broken into pieces. Thus they showed that they were worthless. / INFANCY GOSPEL OF MATTHEW
The governor of the town declared that this could only have been the work of the true God, whereupon the entire population converted to Christianity.

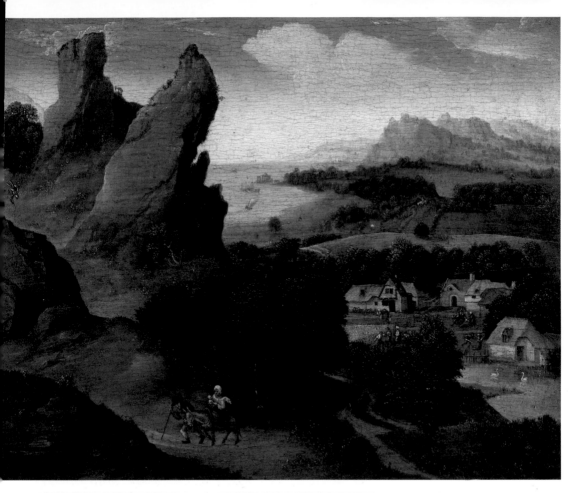

A pagan idol falls from its plinth. This is a free interpretation of one of the anecdotes in the apocryphal story.

This scene represents an episode described in the Book of Matthew, which took place when the Holy Family were in Egypt. In a small country hamlet soldiers are carrying out Herod's orders to kill all male children under the age of two. The incident is known as the Massacre of the Innocents (see p. 76).

Scores of paintings were made of this subject, many of them incorporating anecdotes and details from apocryphal writings which had been absorbed into medieval texts. Joachim Patinir set the story in a schematically layered composition which is characteristic of early landscape painting, with brown in the foreground, green in the middle ground, and blue-grey in the background. The panorama, with three tiny scenes representing two miracles and a massacre, is a composite of diverse elements and bears no resemblance to the countryside between Bethlehem and Egypt.

The Virgin is shown in her customary blue robe and red gown. Christ holds a bunch of grapes in his hand and the Virgin reaches out to take one. Though the motif is unrelated to the story, it has a symbolic meaning. In the gospel Christ refers to himself as 'the true vine', and according to the Roman Catholic and certain other Christian doctrines, wine is transformed into his blood in the Eucharist. A medieval metaphor refers to Christ as 'the divine grape that grew in the holy vineyard', which is to say, the Virgin.

The miracle of the palm tree that bent at Christ's bidding is depicted here as a realistic scene. Joseph beats a tree to bring down the nuts, which were in fact an important component of the staple diet in David's day. In other versions of this theme David shows Joseph asleep in the background.

Gerard David, c. 1460–1523
The Rest on the Flight into Egypt, c. 1510
Panel, 44 x 45 cm
National Gallery of Art, Washington, Andrew W. Mellon Collection

Joseph and the Virgin with their newborn child were fleeing to Egypt to escape from King Herod (see p. 76). On the third day, they continued their journey. The blazing heat of the desert sun tired Mary and when she saw a palm tree she spoke to Joseph, saying, 'I would like to rest in the shade of that tree.' Joseph hastened to bring her to the palm and helped her dismount from her pack animal. As she sat there, Mary lifted her eyes to the leaves of the palm and saw that the tree bore fruit. She turned to Joseph and said, 'I would that we could reach that fruit.' And Joseph answered her saying, 'I wonder that you speak thus, for the tree is tall, as you see. How should we eat of its fruit? I fear more that we shall want for water. Our water vessels are empty and we have nothing for ourselves or our animals.' And little Jesus, resting on his mother's lap with a beatific air, addressed the palm tree with these words, 'Tree, bend your branches and refresh my mother with your fruit.' At his word, the palm bowed down to Mary's feet and she plucked its fruit to refresh herself. And after she had plucked all the fruit, the palm remained bowed, waiting for the command to rise; that command must come from him who had made it to bow. And Jesus spoke to the tree, saying 'Rise, tree, be strong akin to the trees in my Father's paradise. Send forth from your roots water that is hidden in the earth. Send forth water that we may quench our thirst.' At once the tree rose and at its roots there appeared a well with cool, clear, sparkling water. And when they beheld the well, they were overcome with great joy and all were fulfilled, even the cattle and other animals. They lifted their voices and gave thanks to God. / INFANCY GOSPEL OF MATTHEW, 20

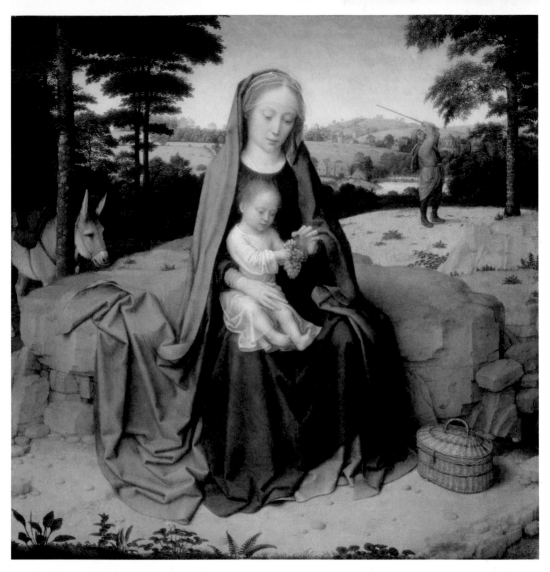

The Rest on the Flight into Egypt is an anecdotal addition to the brief account of the journey in the gospels. The story became known through apocryphal texts and the subject was widely represented in medieval and later art. Gerard David painted several versions of this scene. In most cases, the Virgin sits on a rocky ledge near a forest. As the preferred site for hermits and cloisters, forests were the northern European counterpart of the wilderness in the Bible. Tranquil scenes of the Virgin in a small format such as this were ordered by well-to-do clients. They were used to inspire meditation and prayer.

The travelling basket on the ground dates from David's time.
The flowers and plants in the foreground are symbolic. Among them we can identify plantain, strawberry, mint, ferns and violets, all neatly set out in a row.

CHRIST AND JOSEPH

Georges de La Tour, 1593–1652
Jesus with Joseph in his carpentry workshop,
c. 1640–45
Canvas, 137 x 101 cm
Musée du Louvre, Paris

Jesus – with dirty fingernails –
shields the flame of the candle with
his left hand. His face is bathed in
light. The symbolism is self-evident:
the child brings light into the lives of
others and the candle may therefore
be seen as the main subject.

*The four gospels say almost nothing about Christ's
childhood, apart from Luke's account of the twelve-year-
old boy's astonishing exchange with the 'doctors' in the
temple (p. 84). Luke also writes, 'The Child grew and
became strong in spirit, filled with wisdom; and the grace
of God was upon Him.' Medieval apocryphal literature
propagated stories about Christ's early days, presenting
him as a wonder child or even an* enfant terrible.
*The following is one of those accounts. Though not directly
related to the painting, it conveys the same kind of idea.*

When Jesus was eight years old, a wealthy man asked Joseph to make him a bed, for Joseph was
a carpenter. Joseph went forth into the fields to gather wood, and Jesus went with him at his
side. And when he had hewn two beams of timber, he laid them one beside the other, but when
he measured them, he saw that one was too short. And when he saw that, he sorrowed and went
out to seek another beam. But Jesus spoke to Joseph, saying, 'Lay those two beams one beside
the other and place the ends of the two together.' Joseph wondered at the child's words, but did
as he was bade. Again Jesus spoke to him, 'Hold the short beam firmly in your hands.' And again
Joseph marvelled at his words and understood not, but he held the beam fast. Jesus took the
other end in his hands and drew it out until the two beams were the same in length. And he said
to Joseph, 'Do not sorrow, for now you can work.' Joseph was astonished at what he had wit-
nessed and said to himself, 'Blessed am I that God has given me this son.' And when they went
to the city Joseph told Mary what had passed. When he had told her these things and she beheld
the wondrous miracles her son had wrought, she rejoiced and worshipped him and the Father
and the Holy Ghost, forever and ever. Amen. / INFANCY GOSPEL OF THOMAS 11

Father and son are depicted in a room which can be identified as a carpenter's workshop from the tools on the floor, but which is otherwise empty. Joseph drills a hole in a wooden beam on the floor. A candle is the only source of light in the dark room, where this homely scene takes place. Gerard van Honthorst (see p. 123) painted similar nocturnal scenes reminiscent of the work of Caravaggio (see, for example, pp. 95, 119, 147).

JOSEPH

The way Joseph was portrayed changed over the years: in medieval art he played a secondary role as an old man in the background (see p. 73), but he became increasingly prominent in the 16th and especially the 17th century. He was presented as middle aged and a saint in his own right. His new image was related to a growing trend to project the family as the cornerstone of society.

Scenes of this kind – including those of the Holy Family seated at table – may contain unambiguous references to Christ's death, alluding, for instance, to the Eucharist or the cross. This appears not to be the case here.

Christ's youthful hands and the gnarled hands of the elderly scholars are in the centre of the composition. Christ is presenting an argument: he counts on his fingers as though he were in fact the teacher.

The inscription from the Bible pasted onto this teacher's cap advertises his law-abiding way of life.

CHRIST AND THE DOCTORS

Albrecht Dürer, 1471–1528
Jesus among the Doctors, 1506
Panel, 65 x 80 cm
Museo Thyssen-Bornemisza, Madrid

And the Child grew and became strong in spirit, filled with wisdom; and the grace of God was upon Him. His parents went to Jerusalem every year at the Feast of the Passover. And when He was twelve years old, they went up to Jerusalem according to the custom of the feast. When they had finished the days, as they returned, the Boy Jesus lingered behind in Jerusalem. And Joseph and His mother did not know it; but supposing Him to have been in the company, they went a day's journey, and sought Him among their relatives and acquaintances. So when they did not find Him, they returned to Jerusalem, seeking Him. Now so it was that after three days they found Him in the temple, sitting in the midst of the teachers, both listening to them and asking them questions. And all who heard Him were astonished at His understanding and answers. So when they saw Him, they were amazed; and His mother said to Him, 'Son, why have You done this to us? Look, Your father and I have sought You anxiously.' And He said to them, 'Why did you seek Me? Did you not know that I must be about My Father's business?' But they did not understand the statement which He spoke to them. Then He went down with them and came to Nazareth, and was subject to them, but His mother kept all these things in her heart. And Jesus increased in wisdom and stature, and in favour with God and men. / LUKE 2:40–52

This is the only episode in the Bible concerning Christ's youth, and the story is told only by Luke. It was the first time that Christ referred to his heavenly Father and so to his own divinity.

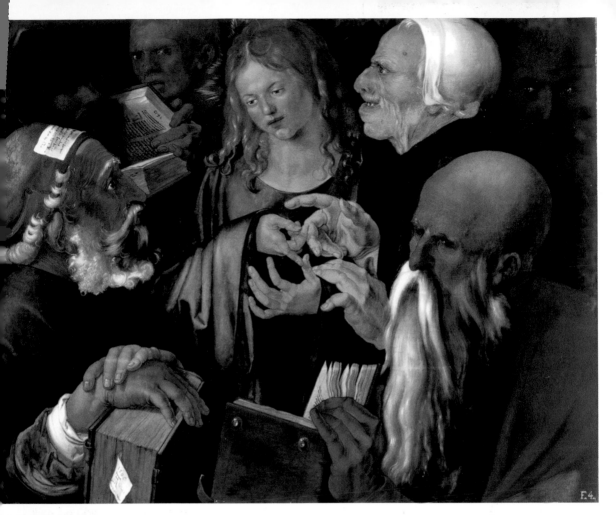

In most paintings the episode takes place in a temple, often with Mary and Joseph hastening to the scene. Dürer, however, gives us an intimate, close-up view of the main protagonists: six elderly men with expressive faces, and the young Christ in the centre. The role of the two men in the background, one on either side, has never been satisfactorily explained.

The teachers that Luke refers to are usually portrayed as elderly, bearded and rather forbidding-looking men. Caricatural representations of that kind recall some of Leonardo's character studies. The teachers are seasoned scholars, but Christ has no need for books. His wisdom comes straight from God.

John, who forms a link between the Old and New Testaments, lived as an ascetic in the wilderness and baptized his followers in the Jordan. He usually looks unkempt and wears a ragged animal hide. Two of his standard attributes are not shown in the painting: a lamb and a cross made from reeds.

CHRIST AND JOHN THE BAPTIST

Piero della Francesca, c. 1420–1492
The Baptism of Christ, 1450s
Panel, 167 x 116 cm
The National Gallery, London

In those days John the Baptist came preaching in the wilderness of Judea, and saying, 'Repent, for the kingdom of heaven is at hand!' ... Now John himself was clothed in camel's hair, with a leather belt around his waist; and his food was locusts and wild honey. Then Jerusalem, all Judea, and all the region around the Jordan went out to him and were baptized by him in the Jordan, confessing their sins.

Many of the Pharisees came, too, but he turned them away.

Then Jesus came from Galilee to John at the Jordan to be baptized by him. And John tried to prevent Him, saying, 'I need to be baptized by You, and are You coming to me?' But Jesus answered and said to him, 'Permit it to be so now, for thus it is fitting for us to fulfil all righteousness.' Then he allowed Him. When He had been baptized, Jesus came up immediately from the water; and behold, the heavens were opened to Him, and He saw the Spirit of God descending like a dove and alighting upon Him. And suddenly a voice came from heaven, saying, 'This is My beloved Son, in whom I am well pleased.' / MATTHEW 3:1–2, 4–6, 13–17

The man undressing is the next to be baptized. He stands for the masses who, according to the gospel, were baptized by John. The robes worn by the supposedly oriental figures – who may represent Pharisees – are reflected in the water.

The figure on the left has wings, from which we know that the three figures standing together are angels attending the baptism. The angels usually hold Christ's clothes.

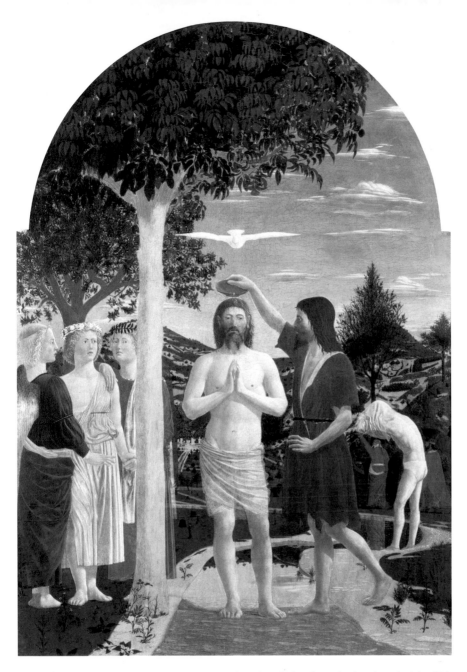

The *Baptism of Christ* was the central panel of a triptych that hung in the chapel of the Abbey of Saint John the Baptist in the vicinity of the artist's birthplace, Borgo Sansepolcro. Piero illustrated the moment when John starts to pour the baptismal water over Christ's head. Christ stands beside him on the bank of the Jordan with his hands clasped in prayer. The Holy Ghost in the form of a dove hovers above him. A roundel showing God the Father, probably also painted by Piero but now lost, was displayed above the present panel. The typically Tuscan landscape – with a town resembling Borgo in the left background – would in any event have looked familiar to Piero's contemporaries and enabled them to relate to the story more easily.

Paolo Veronese, c. 1528–1588
The Marriage at Cana, 1562–63
Canvas, 667 x 994 cm
Musée du Louvre, Paris

Christ, the Virgin and the disciples attending the wedding feast wear simple, classical costumes, whereas everyone else is elegantly dressed in the fashion of the day. The bride and groom are tucked away on the far left of the composition. As in the biblical text, the real protagonists are Christ and his mother.

Only the evangelist John writes about the wedding in Cana in Galilee. It was the first miracle that Christ performed in public, and for his disciples it confirmed that he was the Son of God.

On the third day there was a wedding in Cana of Galilee, and the mother of Jesus was there. Now both Jesus and His disciples were invited to the wedding. And when they ran out of wine, the mother of Jesus said to Him, 'They have no wine.' Jesus said to her, 'Woman, what does your concern have to do with Me? My hour has not yet come.' His mother said to the servants, 'Whatever He says to you, do it.' Now there were set there six waterpots of stone, according to the manner of purification of the Jews, containing twenty or thirty gallons apiece. Jesus said to them, 'Fill the waterpots with water.' And they filled them up to the brim. And He said to them, 'Draw some out now, and take it to the master of the feast.' And they took it. When the master of the feast had tasted the water that was made wine, and did not know where it came from (but the servants who had drawn the water knew), the master of the feast called the bridegroom. And he said to him, 'Every man at the beginning sets out the good wine, and when the guests have well drunk, then the inferior. You have kept the good wine until now!' This beginning of signs Jesus did in Cana of Galilee, and manifested His glory; and His disciples believed in Him.
/ JOHN 2:1–11

In the Eucharist, too, water is transformed into wine. The story of the wedding in Cana was understood as a prefiguration of the Last Supper and the institution of Holy Communion (see p. 112).

The meat for the banquet is being prepared on the gallery above Christ. This motif has been explained as a prefiguration of his sacrifice.

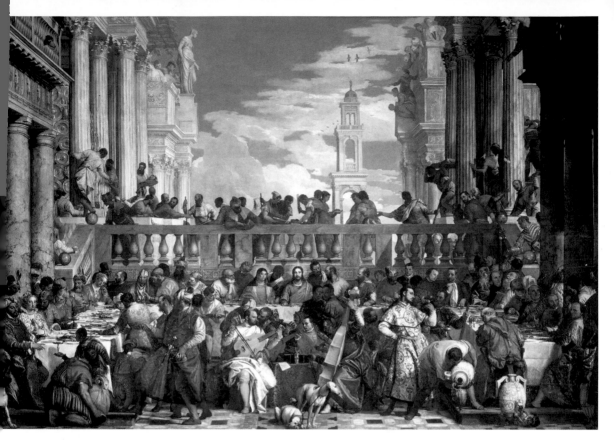

Veronese's brilliant canvas is a scene of great festivity. The religious nature of the story is almost overshadowed by the excitement of the many guests and onlookers, but Christ and the Virgin, recognizable by their haloes, are seated conspicuously in the centre of this compelling painting. The ornate imaginary architecture in the background was inspired by classical and Venetian examples. Like the Last Supper, the Marriage at Cana was considered a suitable subject to grace the walls of refectories or other dining halls. Veronese's work hung in the refectory of the Benedictine monastery of San Giorgio Maggiore in Venice.

An hourglass stands on the table in front of the four musicians. There can be no doubt that it alludes to the words Christ spoke to his mother: 'My hour has not yet come.'

We can see with our own eyes that the water in the jar has turned into red wine. A beautifully dressed man, undoubtedly the master of the feast referred to in the gospel, examines the wine in his glass.

Satan challenges Christ to turn a stone into bread, but, despite his hunger, Christ dismisses the idea with a wave of his hand. A similar stone lies on the ground.

Christ and his rival-contender stand at the edge of a precipice, where Satan promises him all the kingdoms of the world if he agrees to worship him. After the third and last temptation Christ repudiated Satan and angels came to minister to him. This part of the narrative is not shown in the painting.

CHRIST AND SATAN

Juan de Flandes, active 1496–1519
The Temptation of Christ, c. 1500–1504
Panel, 21 x 16 cm
National Gallery of Art, Washington, Ailsa Mellon Bruce Fund

This story from the gospels is essentially about Christ's humanity. Thrice his obedience to God was put to the test and thrice he invoked the laws of Moses ('It is written …') to renounce the devil and eschew his promise of political power and other temptations.

Then Jesus was led up by the Spirit into the wilderness to be tempted by the devil. And when He had fasted forty days and forty nights, afterward He was hungry. Now when the tempter came to Him, he said, 'If You are the Son of God, command that these stones become bread.' But He answered and said, 'It is written, "Man shall not live by bread alone, but by every word that proceeds from the mouth of God."' Then the devil took Him up into the holy city, set Him on the pinnacle of the temple, and said to Him, 'If You are the Son of God, throw Yourself down. For it is written: "He shall give His angels charge over you," and, "In their hands they shall bear you up, Lest you dash your foot against a stone."' Jesus said to him, 'It is written again, "You shall not tempt the Lord your God."' Again, the devil took Him up on an exceedingly high mountain, and showed Him all the kingdoms of the world and their glory. And he said to Him, 'All these things I will give You if You will fall down and worship me.' Then Jesus said to him, 'Away with you, Satan! For it is written, "You shall worship the Lord your God, and Him only you shall serve."' Then the devil left Him, and behold, angels came and ministered to Him. / MATTHEW 4:1–11

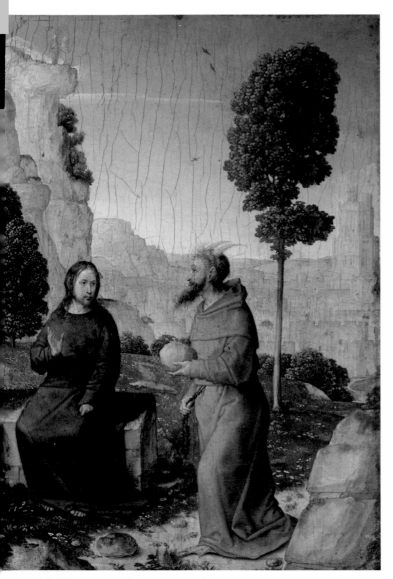

Juan de Flandes represented the three temptations, but without revealing their outcomes. Whereas medieval painters depicted Satan with horns, scales, wings, claws and – often – black skin, here he is cunningly disguised in a monk's habit. All that gives him away are his pointed beard, his horns and his reptilian feet. This small painting was originally part of an unfinished altarpiece depicting more than forty scenes. It was commissioned from the Flemish-born Juan de Flandes, who was court painter to Isabella of Castile (Isabel la Católica), for the queen's private chapel.

Juan de Flandes may have been a pseudonym for Annekin Verhanneman, who is known to have been a pupil of Hans Memling.

Christ and Satan stand on the roof of a structure that was meant to represent the temple in Jerusalem, but sooner recalls a contemporary Gothic church tower in the Low Countries. The composition is structured in the same way as landscape paintings of the period, with a hazy blue horizon in the distance.

The woman is not named in the gospel, but the church father Augustine identified her as Mary Magdalene, who repented for her sins and was later present at Christ's death on the cross. The jar of oil or ointment was her standard attribute in art.

CHRIST AND SIMON THE PHARISEE

Dirk Bouts, c. 1410–1475
Christ in the House of Simon the Pharisee, c. 1445–50
Panel, 40 x 61 cm
Staatliche Museen zu Berlin, Gemäldegalerie

Then one of the Pharisees asked Him to eat with him. And He went to the Pharisee's house, and sat down to eat. And behold, a woman in the city who was a sinner, when she knew that Jesus sat at the table in the Pharisee's house, brought an alabaster flask of fragrant oil, and stood at His feet behind Him weeping; and she began to wash His feet with her tears, and wiped them with the hair of her head; and she kissed His feet and anointed them with the fragrant oil. Now when the Pharisee who had invited Him saw this, he spoke to himself, saying, 'This Man, if He were a prophet, would know who and what manner of woman this is who is touching Him, for she is a sinner.' And Jesus answered and said to him, 'Simon, I have something to say to you.' So he said, 'Teacher, say it.' 'There was a certain creditor who had two debtors. One owed five hundred denarii, and the other fifty. And when they had nothing with which to repay, he freely forgave them both. Tell Me, therefore, which of them will love him more?' Simon answered and said, 'I suppose the one whom he forgave more.' And He said to him, 'You have rightly judged.' Then He turned to the woman and said to Simon, 'Do you see this woman? I entered your house; you gave Me no water for My feet, but she has washed My feet with her tears and wiped them with the hair of her head. You gave Me no kiss, but this woman has not ceased to kiss My feet since the time I came in. You did not anoint My head with oil, but this woman has anointed My feet with fragrant oil. Therefore I say to you, her sins, which are many, are forgiven, for she loved much. But to whom little is forgiven, the same loves little.' Then He said to her, 'Your sins are forgiven.' And those who sat at the table with Him began to say to themselves, 'Who is this who even forgives sins?' Then He said to the woman, 'Your faith has saved you. Go in peace.' / LUKE 7:36–50

Donors of winged altarpieces were often portrayed on the shutters with their patron saints, but in single-panel altarpieces such as the one shown here they were usually depicted as discreet witnesses in the same space as the holy figures.

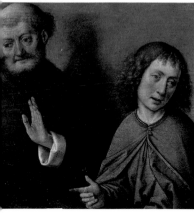

Apart from the person who commissioned the painting, the Carthusian monk kneeling on the right, we see a group of four men seated in a Gothic interior. From left to right, they are Christ, the host Simon the Pharisee, and the apostles Peter and John, neither of whom is mentioned in Luke's account. Each of the four reacts in a different way to the fair-haired woman bending down: Christ blesses her, Simon is intrigued, Peter raises a hand as if to keep her away, and John points at her, expressing approval. The story epitomizes the doctrine of forgiveness that Christ preached, to the indignation of the Pharisees, the orthodox Jews who were strict adherents to the Law of Moses and condemned this as blasphemy. Here, the antagonists confront each other directly, as Christ is the guest of one of them. In the Middle Ages this subject was illustrated predominantly in the Low Countries.

Peter can be recognized by his short beard and balding head, John by his young, soft, beardless face and shoulder-length hair (cf. p. 113).

The painting is not only an illustration of a biblical story, but it also contains a superb, richly detailed still life with cut fish, filled glasses, earthenware jars, sliced bread, and a starched table cloth with folds.

Matthew, a bearded, middle-aged man with a coin in his cap, seems to be wondering whether Christ is addressing him. His companions are dubious-looking characters.

Christ points at Matthew. His hand, bathed in light, alludes to the famous image of God reaching out to Adam in Michelangelo's fresco in the Sistine Chapel. Christ came to redeem sinners like Matthew. Pictures of this kind would have reassured bankers and merchants that they, like Matthew, could still find salvation and 'earn their reward in heaven'.

CHRIST / CALLING OF MATTHEW

Caravaggio, 1573–1610
The Calling of Matthew, 1599–1600
Canvas, 322 x 340 cm
San Luigi dei Francesi, Rome, Contarelli Chapel

In the Roman Empire taxes were often collected by private tax collectors, who were notorious swindlers and cheats. To make matters worse, they associated with foreigners, which put them beyond the pale. They had the same kind of reputation as the moneylenders of the Renaissance, whose dealings were condemned by the Church. The Bible tells how Christ delivered one of his disciples, Levi or Matthew, from that sinful life.

After these things He went out and saw a tax collector named Levi, sitting at the tax office. And He said to him, 'Follow Me.' So he left all, rose up, and followed Him. Then Levi gave Him a great feast in his own house. And there were a great number of tax collectors and others who sat down with them. And their scribes and the Pharisees complained against His disciples, saying, 'Why do You eat and drink with tax collectors and sinners?' Jesus answered and said to them, 'Those who are well have no need of a physician, but those who are sick. I have not come to call the righteous, but sinners, to repentance.'
/ LUKE 5:27–32

The gospels of Matthew (9:9–13), Mark (3:18) and John say little about the calling of Matthew, who obeyed Christ's command without a moment's hesitation. By Matthew's account, he himself was the tax collector, but according to Luke and Mark the man Christ encountered in the tax office was called Levi. Caravaggio's contemporaries debated whether Matthew and others like him were redeemed by their faith, and thus through their own doing, or whether they were chosen by God.

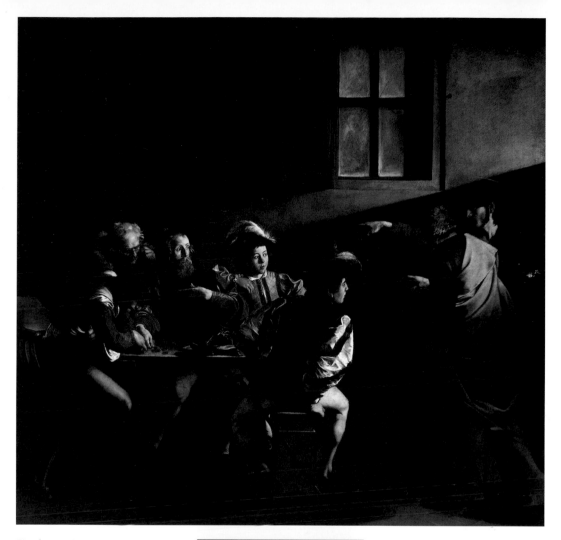

Five 'men of the world' in flashy, contemporary costume are gathered around a table in a dimly lit room evidently discussing money. The Bible, however, says that Christ and his followers were walking through the streets when they came to the tax office. The setting recalls a genre scene with card players. Christ approaches from the right, barefoot and wearing a toga, accompanied by a man who is probably his disciple Peter. Through their gestures Christ and Peter stand out as the principal characters in the scene, into which they bring light.

The old man adjusts his spectacles to examine the 'booty' on the table. Like the man to his right, he is interested only in money and takes no part in what is happening around him. He symbolizes short-sighted greed.

Christ's serenity is in sharp contrast to the agitation of the men around him. Some are arguing, while others try to decipher the words Christ has written on the ground. A medieval legend holds that he enumerated the sins of the scribes.

A few men on either side move away. They have understood Christ's words and will not stone the woman.

CHRIST AND THE WOMAN TAKEN IN ADULTERY

Nicolas Poussin, 1594–1665

Christ and the Woman Taken in Adultery, 1653
Canvas, 121 x 195 cm
Musée du Louvre, Paris

Only John wrote about the scribes putting Jesus to the test, intending to accuse him of violating Mosaic Law.
But Jesus went to the Mount of Olives. Now early in the morning He came again into the temple, and all the people came to Him; and He sat down and taught them. Then the scribes and Pharisees brought to Him a woman caught in adultery. And when they had set her in the midst, they said to Him, 'Teacher, this woman was caught in adultery, in the very act. Now Moses, in the law, commanded us that such should be stoned. But what do You say?' This they said, testing Him, that they might have something of which to accuse Him. But Jesus stooped down and wrote on the ground with His finger, as though He did not hear. So when they continued asking Him, He raised Himself up and said to them, 'He who is without sin among you, let him throw a stone at her first.' And again He stooped down and wrote on the ground. Then those who heard it, being convicted by their conscience, went out one by one, beginning with the oldest even to the last. And Jesus was left alone, and the woman standing in the midst. When Jesus had raised Himself up and saw no one but the woman, He said to her, 'Woman, where are those accusers of yours? Has no one condemned you?' She said, 'No one, Lord.' And Jesus said to her, 'Neither do I condemn you; go and sin no more.' / JOHN 8:1–11

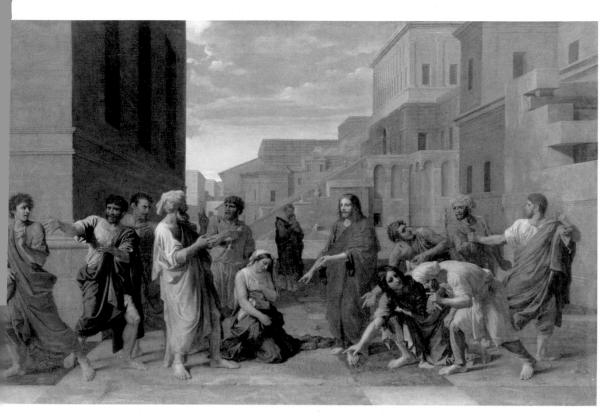

The woman kneeling and holding a hand over her heart expresses humility and repentance. All attention is focused on her.

The woman with a child looking on from the shadows in the background has nothing to do with all the commotion. She is a mother, and stands for the opposite of an adulteress.

Like many of the gospel stories concerning Christ, this too is essentially about forgiveness. But it also attacked the sanctimonious who believed that obedience to the law was the sole measure of moral conduct. The prospect of forgiveness is a fundamental concept in Christianity. As usual, Poussin depicted the scene in a classical-looking setting. According to the gospels, the event took place in the temple complex in Jerusalem.

CHRIST / TRANSFIGURATION

Raphael, 1483–1520
The Transfiguration, 1520
Panel, 405 x 278 cm
Pinacoteca Apostolica Vaticana, Rome

These two figures on the side of the composition have nothing to do with the story. They are thought to be related to the place for which the painting was commissioned: the cathedral of Narbonne in France.

Now it came to pass, about eight days after these sayings, that He took Peter, John and James and went up on the mountain to pray. As He prayed, the appearance of His face was altered, and His robe became white and glistening. And behold, two men talked with Him, who were Moses and Elijah, who appeared in glory and spoke of His decease which He was about to accomplish at Jerusalem. But Peter and those with him were heavy with sleep; and when they were fully awake, they saw His glory and the two men who stood with Him. Then it happened, as they were parting from Him, that Peter said to Jesus, 'Master, it is good for us to be here; and let us make three tabernacles: one for You, one for Moses, and one for Elijah' – not knowing what he said. While he was saying this, a cloud came and overshadowed them; and they were fearful as they entered the cloud. And a voice came out of the cloud, saying, 'This is My beloved Son. Hear Him!' When the voice had ceased, Jesus was found alone. But they kept quiet, and told no one in those days any of the things they had seen. Now it happened on the next day, when they had come down from the mountain, that a great multitude met Him. Suddenly a man from the multitude cried out, saying, 'Teacher, I implore You, look on my son, for he is my only child. And behold, a spirit seizes him, and he suddenly cries out; it convulses him so that he foams at the mouth; and it departs from him with great difficulty, bruising him. So I implored Your disciples to cast it out, but they could not.' Then Jesus answered and said, 'O faithless and perverse generation, how long shall I be with you and bear with you? Bring your son here.' And as he was still coming, the demon threw him down and convulsed him. Then Jesus rebuked the unclean spirit, healed the child, and gave him back to his father. And they were all amazed at the majesty of God. / LUKE 9:28–43

Christ ascended the mountain with his disciples Peter, John and James. The three fell asleep and when they awoke they saw the spectacle before us now: a radiant white Christ in the company of the prophets Elijah and Moses, the latter carrying the stone tablets which identify him as the great Hebrew prophet and leader.

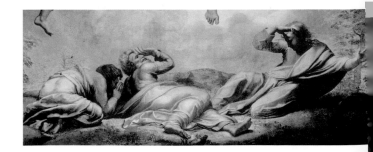

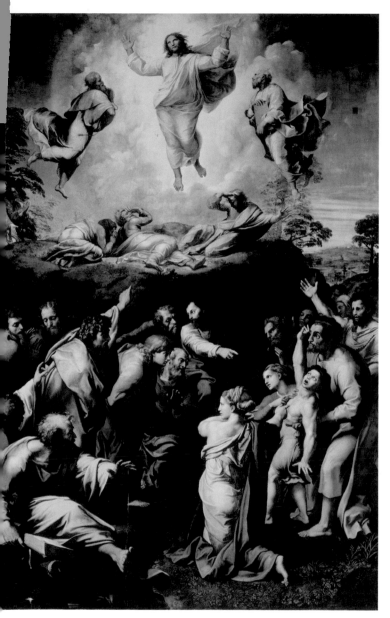

Raphael's majestic altarpiece combines two narratives related successively by the apostles Luke and Mark. In the upper section we see the transfiguration of Christ on Mount Tabor, with Christ floating between the two prophets from the Old Testament. This detail is not in the gospels. The lower section shows a man bringing his epileptic boy to Jesus to have the demons cast out. According to the gospel, the disciples – the nine who were not on the mountain stand in a group on the left – were unable to accomplish this. One of them points insistently at Christ.

The boy is having an epileptic fit. His father holds him and a crowd gathers around them.

CHRIST AND LAZARUS

Giotto, c. 1267–1337
The Raising of Lazarus, 1304–06
Fresco, 185 x 200 cm
Scrovegni Chapel, Padua

This man is literally and figuratively the central character in the fresco. With his hand on his chin, he expresses the scepticism that the bystanders share, but he also points to Christ, the performer of miracles. The onlookers behind him throw their hands up in amazement.

Lazarus and his sisters Mary and Martha were friends of Christ's. Christ was not at Lazarus' sickbed when he died, but went there four days later.

Now Martha, as soon as she heard that Jesus was coming, went and met Him, but Mary was sitting in the house. Now Martha said to Jesus, 'Lord, if You had been here, my brother would not have died. But even now I know that whatever You ask of God, God will give You.' Jesus said to her, 'Your brother will rise again.' Martha said to Him, 'I know that he will rise again in the resurrection at the last day.' Jesus said to her, 'I am the resurrection and the life. He who believes in Me, though he may die, he shall live. And whoever lives and believes in Me shall never die. Do you believe this?' She said to Him, 'Yes, Lord, I believe that You are the Christ, the Son of God, who is to come into the world.'

Mary, too, went to Christ, followed by the Jews who had come to comfort her.

Then, when Mary came where Jesus was, and saw Him, she fell down at His feet, saying to Him, 'Lord, if You had been here, my brother would not have died.' Therefore, when Jesus saw her weeping, and the Jews who came with her weeping, He groaned in the spirit and was troubled. And He said, 'Where have you laid him?' They said to Him, 'Lord, come and see.' Jesus wept. Then the Jews said, 'See how He loved him!' And some of them said, 'Could not this Man, who opened the eyes of the blind, also have kept this man from dying?' Then Jesus, again groaning in Himself, came to the tomb. It was a cave, and a stone lay against it. Jesus said, 'Take away the stone.' Martha, the sister of him who was dead, said to Him, 'Lord, by this time there is a stench, for he has been dead four days.' Jesus said to her, 'Did I not say to you that if you would believe you would see the glory of God?' Then they took away the stone from the place where the dead man was lying. And Jesus lifted up His eyes and said, 'Father, I thank You that You have heard Me. And I know that You always hear Me, but because of the people who are standing by I said this, that they may believe that You sent Me.' Now when He had said these things, He cried with a loud voice, 'Lazarus, come forth!' And he who had died came out bound hand and foot with graveclothes, and his face was wrapped with a cloth. Jesus said to them, 'Loose him, and let him go.' / JOHN 11:20–27, 32–44

The miracle Christ performed persuaded the chief priests of the Jews to intervene.

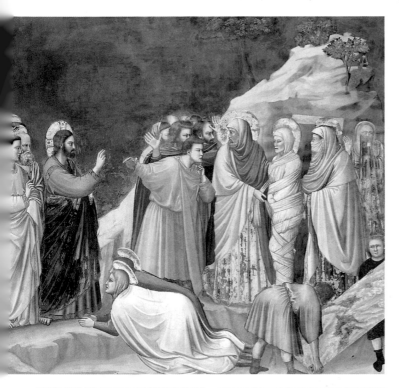

Giotto's painting incorporates different scenes from the story: Christ's hand is still raised in benediction and Lazarus' imploring sisters still lie at his feet when Lazarus emerges from the grave. The raising of Lazarus was understood as foreshadowing Christ's own resurrection and as proof that Christ was the Son of God. This dramatic subject was extremely popular in art.

Heeding Christ's instruction as related in the gospel, two men remove the stone from the tomb. Christ said: 'Take away the stone.'

Lazarus is deathly pale and still wrapped in his shroud. The smell of death that Martha refers to in the gospel can be seen emanating from his body.

Albert van Ouwater, c. 1410/1415–1475
The Raising of Lazarus, c. 1455–60
Panel, 122 x 92 cm
Staatliche Museen zu Berlin, Gemäldegalerie

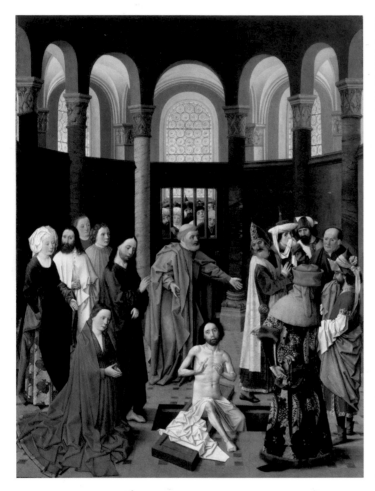

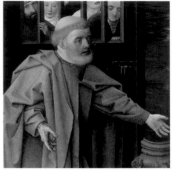

Christ's disciple Peter – who can be recognized by his age, tonsure and short beard (see p. 112) – forms a link between the two groups. He seems to be trying to persuade the Jews to believe what they see.

Ouwater located the scene in the interior of a church, a place where rulers, bishops and other ecclesiastical dignitaries were buried in his time. The virtuous – Christ, his disciples and Lazarus' sisters – stand or kneel reverently on the left. On the right, a group of men representing Jews, dressed in unusual and extravagant garments which are intended to characterize them as alien and sinister, turn their backs on the scene unfolding before them. They appear to be offended by the stench, and some hold cloths over their noses and mouths. Inquisitive onlookers held back by a rood screen peer through the bars in the door of the screen. This is the only work that can be firmly attributed to the Haarlem painter Albert van Ouwater.

Early Netherlandish painters like Ouwater and Van Eyck often incorporated hidden symbols in their work. The capital on the left shows Abraham's sacrifice of Isaac (see p. 20), an Old Testament story which, like the story of Lazarus, teaches that man must trust in God.

Carel Fabritius, 1622–1654
The Raising of Lazarus, c. 1643
Canvas, 210 x 140 cm
Muzeum Narodowe, Warsaw

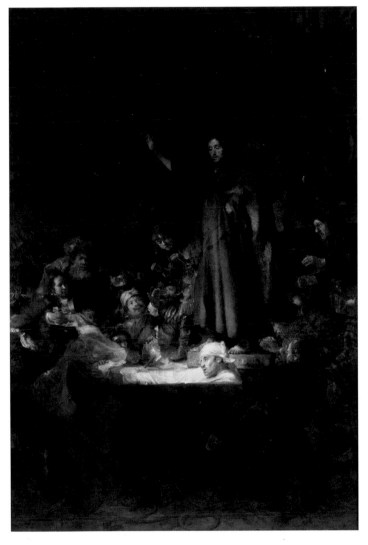

The faces and gestures of the multitude of onlookers – note all the hands – express amazement, fear, disbelief and trust. Some of their faces are partly in shadow. In this version, no one covers their nose (cf. p. 101).

Lazarus' sisters Martha and Mary do not feature prominently in Fabritius' painting. They are somewhere in the crowd and we can only guess who they are.

Carel Fabritius was regarded by many as Rembrandt's most talented pupil. This emotional painting, his earliest known work and probably meant as an altarpiece, is strongly reminiscent of Rembrandt. Rembrandt's influence can be seen, for instance, in the use of light and shadow to heighten the dramatic impact. Once again, we see the deathly pale Lazarus – with his face brightly illuminated – being restored to life. The monumental figure of Christ raising his right arm towers over Lazarus' tomb.

CHRIST / PARABLE OF THE PRODIGAL SON

Bartolomé Esteban Murillo, 1617–1682
The Return of the Prodigal Son, 1667–70
Canvas, 263 x 261 cm
National Gallery of Art, Washington, Gift of the Avalon Foundation

Servants bring lavish and brightly coloured garments and a ring, as the father instructs them to do in the biblical text. The confraternity for which the painting was made, and to which Murillo also belonged, was devoted to acts of charity. One of those acts was to clothe the naked.

*Christ used parables as a method of teaching.
The Prodigal Son, a parable of repentance and
forgiveness, was often represented in painting.*

A certain man had two sons. And the younger of them said to his father, 'Father, give me the portion of goods that falls to me.' So he divided to them his livelihood. And not many days after, the younger son gathered all together, journeyed to a far country, and there wasted his possessions with prodigal living. But when he had spent all, there arose a severe famine in that land, and he began to be in want. Then he went and joined himself to a citizen of that country, and he sent him into his fields to feed swine. And he would gladly have filled his stomach with the pods that the swine ate, and no one gave him anything. But when he came to himself, he said, 'How many of my father's hired servants have bread enough and to spare, and I perish with hunger! I will arise and go to my father, and will say to him, "Father, I have sinned against heaven and before you, and I am no longer worthy to be called your son. Make me like one of your hired servants."' And he arose and came to his father. But when he was still a great way off, his father saw him and had compassion, and ran and fell on his neck and kissed him. And the son said to him, 'Father, I have sinned against heaven and in your sight, and am no longer worthy to be called your son.' But the father said to his servants, 'Bring out the best robe and put it on him, and put a ring on his hand and sandals on his feet. And bring the fatted calf here and kill it, and let us eat and be merry; for this my son was dead and is alive again; he was lost and is found.' And they began to be merry.

*The elder son speaks out in anger when he learns the reason for the celebration. He had always
obeyed his father, but received nothing.*

'But as soon as this son of yours came, who has devoured your livelihood with harlots, you killed the fatted calf for him.' And he said to him, 'Son, you are always with me, and all that I have is yours. It was right that we should make merry and be glad, for your brother was dead and is alive again, and was lost and is found.' / LUKE 15:11–24, 29–32

In this parable Christ shows that repentance is met with forgiveness. Part of the story's appeal lay in the characters' clear-cut roles: the wicked son, the forgiving father and the angry brother. Two moments were especially popular, notably in Northern painting. One was the profligate life of the 'lost son', squandered in taverns and brothels; the other was the moment illustrated here, when he returned destitute and remorseful. The painting demonstrates Murillo's talent for creating realistic drama. In the centre, the elderly father welcomes his ragged son with open arms (note the state of the young man's feet). The work was made for the church of a lodging for the homeless in Seville.

A man accompanied by a smiling child brings the calf that will be slaughtered for the banquet.

The little dog leaping up to greet the prodigal son attests to Murillo's eye for anecdotal detail.

Duccio enlivened the painting with narrative details like the two men climbing trees to break off branches. The trees look more like olive trees than palms, which is in fact consistent with tradition: in Italy, even today, celebrants commemorating Christ's entry into Jerusalem on Palm Sunday carry branches of the *olivo benedetto*. In more northerly regions branches of the box tree (*Buxus*) are used.

UNSEEN STORIES

Duccio's famous Maestà *(see also pp. 128–129) was one of the richest and most complex narrative ensembles ever painted. This is a panel from the back of the altarpiece, which was not normally visible to the public. Eleven scenes on the reverse showed the Passion of Christ. Duccio and any advisers he may have consulted must have possessed a thorough knowledge of the Bible, as some of those scenes had no precedents in art. Duccio may have studied a translation of the* Diatesseron, *a manuscript written to harmonize the four gospels and their many variants into a single narrative.*

CHRIST / ENTRY INTO JERUSALEM

Duccio di Buoninsegna, c. 1255–1319
Christ's Entry into Jerusalem, 1308–11
Panel from the reverse of the *Maestà*, 100 x 57 cm
Museo dell'Opera del Duomo, Siena

According to the four gospels, the last week of Christ's life on earth began eight days before Passover with his triumphal entry into Jerusalem. On this occasion it transpired that Christ had a large following and therefore posed a threat to the Jewish establishment.

Now when they drew near Jerusalem, and came to Bethphage, at the Mount of Olives, then Jesus sent two disciples, saying to them, 'Go into the village opposite you, and immediately you will find a donkey tied, and a colt with her. Loose them and bring them to Me. And if anyone says anything to you, you shall say, "The Lord has need of them," and immediately he will send them.' All this was done that it might be fulfilled which was spoken by the prophet, saying: 'Tell the daughter of Zion, "Behold, your King is coming to you, Lowly, and sitting on a donkey, A colt, the foal of a donkey."' So the disciples went and did as Jesus commanded them. They brought the donkey and the colt, laid their clothes on them, and set Him on them. And a very great multitude spread their clothes on the road; others cut down branches from the trees and spread them on the road. Then the multitudes who went before and those who followed cried out, saying: 'Hosanna to the Son of David! "Blessed is He who comes in the name of the Lord!" Hosanna in the highest!' And when He had come into Jerusalem, all the city was moved, saying, 'Who is this?' So the multitudes said, 'This is Jesus, the prophet from Nazareth of Galilee.'
/ MATTHEW 21:1–11

This event was understood to be the fulfilment of Zechariah's prophecy in the Old Testament. Zechariah had said that the King of Jerusalem would come on a donkey or a colt.

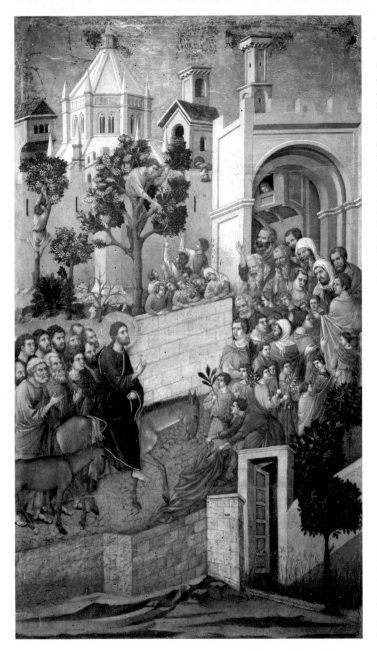

Christ arrives at one of the gates of Jerusalem seated on a donkey and accompanied by his disciples. Some of the towers of the city can be seen in the background. He is welcomed by a multitude of people who honour him, as the Bible says, by spreading their garments before him and strewing his path with palm branches. Matthew speaks of a donkey and her foal, and Duccio follows that description. The other evangelists mention only a foal that has not been ridden before. In medieval times the event was enacted on Palm Sunday.

Duccio made a point of including men as well as women, young people and old in the crowd who have come to welcome Christ. The fact that children, not adults, offer him palm branches is a detail from an apocryphal gospel.

Christ is often shown riding sidesaddle, but Duccio painted him astride the donkey. We see him in profile, raising his hand in benediction. His halo is rendered in gold leaf, like the background of the panel.

The tax collector looks at Peter and points to the city as well as to Christ, as if asking what Christ has decided. The gospel refers to more than one tax collector.

Masaccio, 1401–1428
The Tribute Money, 1426–27
Fresco, 255 x 598 cm
Santa Maria del Carmine, Florence, Brancacci Chapel

This brief fragment is essentially a dialogue between a tax collector who asks whether Christ will pay the tax he owes him, Simon Peter, who hesitantly answers him, and Christ, who replies with an allegory: God is the 'king' whose 'sons', that is, his disciples or those who dwell in the Kingdom of God, are exempt from taxes. He nevertheless agrees to pay.

When they had come to Capernaum, those who received the temple tax came to Peter and said, 'Does your Teacher not pay the temple tax?' He said, 'Yes.' And when he had come into the house, Jesus anticipated him, saying, 'What do you think, Simon? From whom do the kings of the earth take customs or taxes, from their sons or from strangers?' Peter said to Him, 'From strangers.' Jesus said to him, 'Then the sons are free. Nevertheless, lest we offend them, go to the sea, cast in a hook, and take the fish that comes up first. And when you have opened its mouth, you will find a piece of money; take that and give it to them for Me and you.' / MATTHEW 1:24–27

CHURCH OR STATE
The choice of this subject was presumably inspired by the controversy then surrounding the relationship between Church and State: should the Church function independently or should church institutions be subject to State taxation? In the fragment quoted above, Christ says that by divine law the Church should be exempt, but he added that it would pay tax for the sake of peace.

Peter finds money in the fish's mouth and is therefore able to pay the tax collector. This he does on the far right, where Peter is shown standing just outside the town, and the tax collector just within the town's boundaries. These two episodes of the story are depicted on either side of the scene in the centre.

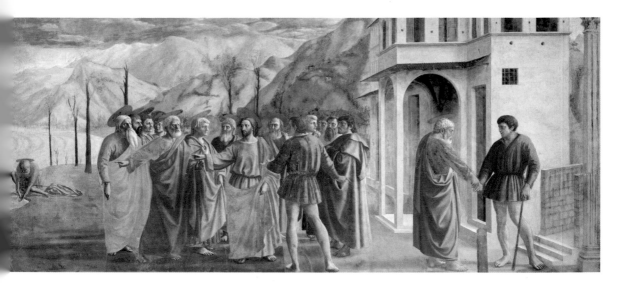

Masaccio was commissioned to paint a series of scenes from the life of Peter in the Brancacci Chapel of Santa Maria del Carmine in Florence. The problem was how to represent the three episodes and the legal issues involved in this brief but complex story. Masaccio's solution is extremely effective. The narrative takes place on the banks of the Sea of Galilee, which is surrounded by barren, snow-covered mountains. Everyone other than the tax collector is depicted in classical costume. Christ is at the centre of the principal scene, but Peter is the main protagonist in the narrative on the left and also in that in front of the city wall on the right. It is possible that the subject had never been illustrated before and that Masaccio worked exclusively from the gospel text.

Peter, the founder of the Church, is obviously angry. The fresco as a whole – and this detail in particular – allude to a new tax proposed on the basis of the ability to pay. In Masaccio's day the Church sought tax exemption, but Masaccio's mural seems to indicate that the Florentine ecclesiastical authorities at least agreed to the principle of being liable to state tax.

Christ, who is really at the centre of this story, is depicted as he makes his decision known: the tax collector, who will receive his money, stands beside him on the same side as the buildings and thus also on the side of the city and the state. Christ shows Peter how to get the money.

Christ kneels on the ground, with a white cloth fastened around his waist. He talks to Peter, who appears to be protesting though he has already dipped his foot in the water.

Tintoretto, 1518–1594
Christ Washing the Feet of his Disciples, 1548–49
Canvas, 210 x 533 cm
Museo Nacional del Prado, Madrid

Only the apostle John tells the story of Christ washing his disciples' feet.

Now before the Feast of the Passover, when Jesus knew that His hour had come that He should depart from this world to the Father, having loved His own who were in the world, He loved them to the end. And supper being ended, the devil having already put it into the heart of Judas Iscariot, Simon's son, to betray Him, Jesus, knowing that the Father had given all things into His hands, and that He had come from God and was going to God, rose from supper and laid aside His garments, took a towel and girded Himself. After that, He poured water into a basin and began to wash the disciples' feet, and to wipe them with the towel with which He was girded. Then He came to Simon Peter. And Peter said to Him, 'Lord, are You washing my feet?' Jesus answered and said to him, 'What I am doing you do not understand now, but you will know after this.' Peter said to Him, 'You shall never wash my feet!' Jesus answered him, 'If I do not wash you, you have no part with Me.' Simon Peter said to Him, 'Lord, not my feet only, but also my hands and my head!' Jesus said to him, 'He who is bathed needs only to wash his feet, but is completely clean; and you are clean, but not all of you.' For He knew who would betray Him; therefore He said, 'You are not all clean.' So when He had washed their feet, taken His garments, and sat down again, He said to them, 'Do you know what I have done to you? You call Me Teacher and Lord, and you say well, for so I am. If I then, your Lord and Teacher, have washed your feet, you also ought to wash one another's feet. For I have given you an example, that you should do as I have done to you. Most assuredly, I say to you, a servant is not greater than his master; nor is he who is sent greater than he who sent him. If you know these things, blessed are you if you do them.' / JOHN 13:1–17

FOOT WASHING IN VENICE
The ritual of foot washing on public occasions was common in Tintoretto's native Venice and also in Rome, and scenes of this kind were often represented in art. Each year, for instance, the doge ceremonially washed the feet of twelve poor citizens. Extant texts describing the event emphasize Christ's exemplary humility.

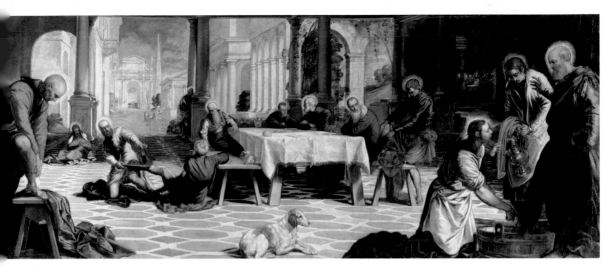

The apostles are dispersed throughout a spacious interior; some are seated, a few recline or kneel as Christ, on the right, prepares to wash Peter's foot. The youthful John stands beside them. Other disciples have had or will have their turn. The 'classical' architectural setting in this large canvas is idealized, whereas the figures and the furnishing – see the washtub at lower right – are lifelike and add a homely and everyday touch. One of the apostles on the left, for instance, helps a companion to remove his footwear. The motif may have been intended to add a humorous note to the scene, but it is in any event true to life. The Last Supper (see p. 112), which took place directly after the washing of the feet, is depicted in the right background.

The man who has separated himself from the group and leans on the base of a pillar is undoubtedly Judas. Of all twelve disciples he is furthest away from Christ.

The perceptively drawn dog also adds a homely touch. It could refer to humility and dedication, two themes closely associated with the washing of the feet.

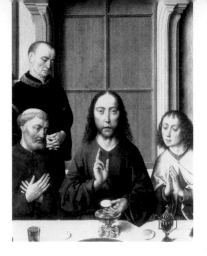

Christ sits in the centre. To his right is Peter, older and silver-haired, portrayed in the customary manner with a cropped beard, and to his left is the young, smooth-faced disciple John, with his hands clasped in prayer. Paintings of the Last Supper often show John laying his head in Christ's lap, or leaning against his shoulder.

Bouts' *Last Supper* is a scene suspended in time. The disciples are impassive and uncommunicative. The painting was made for the church of Saint Peter in Leuven, where it hangs to this day. Bouts was advised on the iconography by two theologians who were members of a local brotherhood committed to promoting the sacrament of the Eucharist.

CHRIST / LAST SUPPER

Dirk Bouts, c. 1410–1475
The Last Supper, 1464–67
Panel, 180 x 150 cm
Sint-Pieterskerk, Leuven

Christ asked his disciples to prepare the Passover meal to commemorate the exodus of Moses and the Israelites from Egypt. The celebration, which is held every year, is marked by the slaughtering of a lamb. Christ had already told his disciples that he would be surrendered to his executioners the following day and that he would subsequently die on the Cross. According to the gospels of Mark and Luke, the meal was held in the large upstairs hall of a house somewhere in Jerusalem.

When evening had come, He sat down with the twelve. Now as they were eating, He said, 'Assuredly, I say to you, one of you will betray Me.' And they were exceedingly sorrowful, and each of them began to say to Him, 'Lord, is it I?' He answered and said, 'He who dipped his hand with Me in the dish will betray Me. The Son of Man indeed goes just as it is written of Him, but woe to that man by whom the Son of Man is betrayed! It would have been good for that man if he had not been born.' Then Judas, who was betraying Him, answered and said, 'Rabbi, is it I?' He said to him, 'You have said it.' And as they were eating, Jesus took bread, blessed and broke it, and gave it to the disciples and said, 'Take, eat; this is My body.' Then He took the cup, and gave thanks, and gave it to them, saying, 'Drink from it, all of you. For this is My blood of the new covenant, which is shed for many for the remission of sins. But I say to you, I will not drink of this fruit of the vine from now on until that day when I drink it new with you in My Father's kingdom.' And when they had sung a hymn, they went out to the Mount of Olives. / MATTHEW 26:20–30

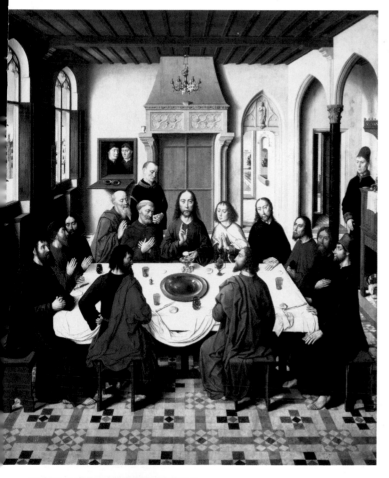

Bouts' altarpiece was innovative in his day, for whereas most artists represented either Christ's prophetic revelation of his betrayal or the scene of Christ giving Communion, Bouts depicted him solemnly blessing the bread and wine. In doing so, Christ instituted the Eucharist, one of the seven sacraments of the Roman Catholic Church. The scene is set in a 15th-century Gothic interior and in the presence of four witnesses serving as table attendants in the costume of Bouts' day. The windows – surprisingly, it is broad daylight – offer a glimpse of the town of Leuven (Louvain) in the Southern Netherlands, where the artist lived and worked.

Judas usually sits or stands alone and is therefore easy to recognize. Bouts, however, shows him in the midst of his companions, though only he has his hand behind his back. In many medieval paintings Judas is depicted with red hair and a yellow robe, both of which were associated with evil. Bouts departed from that convention, but Judas' ruthless expression and harsh features leave no doubt about his identity.

CHRIST / LAST SUPPER

Leonardo da Vinci, 1452–1519
The Last Supper, 1495–98
Fresco, 460 x 856 cm
Santa Maria delle Grazie, Milan

Leonardo da Vinci concentrated on the disciples' reactions to Christ's revelation that one of them would betray him. The impact of this masterpiece lies in its superb composition, and in Leonardo's close attention to detail and astute psychological insight. As the apostle John writes, 'Then the disciples looked at one another, perplexed about whom He spoke.' Luke says, 'Then they began to question among themselves, which of them it was who would do this thing.' That is precisely what the painting shows: a group of distressed and troubled men.

John is seated to the right of Christ, as described in the Book of John: 'Now there was leaning on Jesus' bosom one of His disciples, whom Jesus loved. Simon Peter therefore motioned to him to ask who it was of whom He spoke. Then, leaning back on Jesus' breast, he said to Him, "Lord, who is it?"' In the painting, Peter is agitated and leans over John, who remains calm and composed.

Judas' pose betrays his identity. His face is in shadow. In his hand we can make out the purse containing the thirty pieces of silver that he received in exchange for delivering Christ to his executioners.

Nicolas Poussin, 1594–1665

The Last Supper, 1647
Canvas, 117 x 178 cm
National Gallery of Scotland, Edinburgh

There are two significant moments in the story of the Last Supper. The first was Christ's revelation that one of the disciples would betray him, the other was his blessing of the bread, which he subsequently broke and gave to the disciples, thereby instituting the sacrament of the Eucharist. Poussin is one of the few artists who depicted both scenes in one and the same painting. Sensitive to historical accuracy, he portrayed some of the disciples reclining, as was the custom in the days of the Roman Empire.

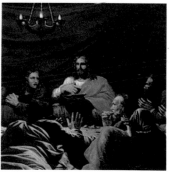

Christ holds a chalice and has raised his right hand in a gesture of blessing. He is seated in the centre. John sits in his usual place beside him. The room is gloomy and the mood oppressive.

The man who is leaving the room is Judas, who betrayed his master for '30 pieces of silver'. The other apostles are still gathered around Christ. It is not clear from the gospels whether or not Judas remained with his companions up to the end of the meal. The theological implication is that if he did stay until after the institution of the Eucharist, he made a sacrilegious communion.

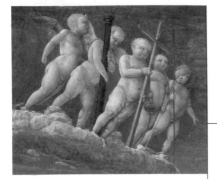

'Then an angel appeared to Him from heaven, strengthening Him', according to the account given in the Book of Luke. Mantegna illustrated this with a group of five cherubs. He thus departed from the medieval tradition, for these are hybrid figures, which are part Christian angels and part classical putti.

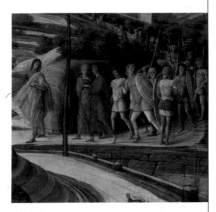

A group of soldiers led by the disciple Judas have come to arrest Christ. Judas had betrayed Christ for 'thirty pieces of silver' (Matthew 26:15).

Andrea Mantegna, c. 1431–1506
The Agony in the Garden, c. 1460
Panel, 63 x 80 cm
The National Gallery, London

These events took place at the foot of the Mount of Olives, after the Passover meal which is now known as the Last Supper.

Then Jesus came with them to a place called Gethsemane, and said to the disciples, 'Sit here while I go and pray over there.' And He took with Him Peter and the two sons of Zebedee, and He began to be sorrowful and deeply distressed. Then He said to them, 'My soul is exceedingly sorrowful, even to death. Stay here and watch with Me.' He went a little farther and fell on His face, and prayed, saying, 'O My Father, if it is possible, let this cup pass from Me; nevertheless, not as I will, but as You will.' Then He came to the disciples and found them sleeping, and said to Peter, 'What! Could you not watch with Me one hour? Watch and pray, lest you enter into temptation. The spirit indeed is willing, but the flesh is weak.' Again, a second time, He went away and prayed, saying, 'O My Father, if this cup cannot pass away from Me unless I drink it, Your will be done.' And He came and found them asleep again, for their eyes were heavy. So He left them, went away again, and prayed the third time, saying the same words. Then He came to His disciples and said to them, 'Are you still sleeping and resting? Behold, the hour is at hand, and the Son of Man is being betrayed into the hands of sinners. Rise, let us be going. See, My betrayer is at hand.' And while He was still speaking, behold, Judas, one of the twelve, with a great multitude with swords and clubs, came from the chief priests and elders of the people.
/ MATTHEW 26:36–47

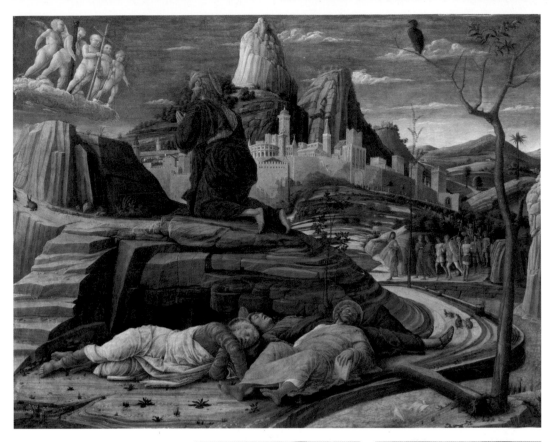

Christ kneels on a rock and prays in a desolate, craggy landscape. The city in the background is meant to be Jerusalem, with walls, as Mantegna imagined it. Angels show Christ the instruments of the Passion, or *arma Christi*, which will be used to torture him in the coming hours. They hold the column where he will be bound and scourged; the cross on which he will be crucified, the sponge dipped in vinegar that will be offered to quench his thirst, and the spear that will pierce his side. The scene illustrated here took place at night and the three disciples have fallen asleep. This episode of the Passion, when Christ, in a moment of human weakness, was torn between fear and resignation, was not widely represented in art before the 15th century.

The dead tree and the vulture are harbingers of death. Pelicans, on the other hand, were believed to nourish their young with their own blood. They symbolized Christ and the ʿnew lifeʾ he brought to humankind.

Mantegna's Jerusalem includes an equestrian statue, a building that resembles the Colosseum, and a triumphal column like the column of the Roman emperor Trajan. All were inspired by monuments that the artist would have seen in Rome.

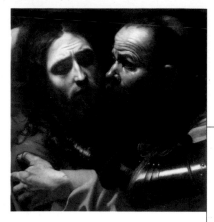

Judas is not actually kissing Christ, though he may yet do so, and Christ seems to be talking to him. It would therefore seem that Caravaggio based his work on Luke's account. Or is this the moment after the kiss when, according to Matthew, Christ spoke to Judas?

CHRIST / BETRAYAL

Caravaggio, 1573–1610
The Betrayal of Christ, 1602
Canvas, 133.5 x 169.5 cm
The National Gallery of Ireland, Dublin

After the Last Supper Christ went to the Mount of Olives, where he was overcome with a mortal fear. He spoke to his disciples briefly, after which they fell asleep. The evangelists give their own accounts of the events that followed.

And while He was still speaking, behold, a multitude; and he who was called Judas, one of the twelve, went before them and drew near to Jesus to kiss Him. But Jesus said to him, 'Judas, are you betraying the Son of Man with a kiss?' When those around Him saw what was going to happen, they said to Him, 'Lord, shall we strike with the sword?' / LUKE 22:47–49

And immediately, while He was still speaking, Judas, one of the twelve, with a great multitude with swords and clubs, came from the chief priests and the scribes and the elders. Now His betrayer had given them a signal, saying, 'Whomever I kiss, He is the One; seize Him and lead Him away safely.' As soon as he had come, immediately he went up to Him and said to Him, 'Rabbi, Rabbi!' and kissed Him. Then they laid their hands on Him and took Him. And one of those who stood by drew his sword and struck the servant of the high priest, and cut off his ear. Then they all forsook Him and fled. Now a certain young man followed Him, having a linen cloth thrown around his naked body. And the young men laid hold of him, and he left the linen cloth and fled from them naked. / MARK 14:43–46, 50–52

And while He was still speaking, behold, Judas, one of the twelve, with a great multitude with swords and clubs, came from the chief priests and elders of the people. Now His betrayer had given them a sign, saying, 'Whomever I kiss, He is the One; seize Him.' Immediately he went up to Jesus and said, 'Greetings, Rabbi!' and kissed Him. But Jesus said to him, 'Friend, why have you come?' Then they came and laid hands on Jesus and took Him. / MATTHEW 26:47–50

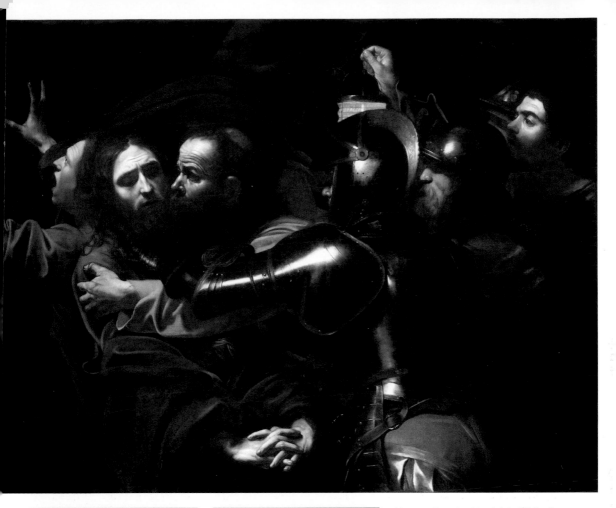

A young man flees in terror, his robe billowing in an arc over the heads of Christ and Judas. Only Mark refers to this character.

Only John refers to a man holding a lantern: 'Then Judas, having received a detachment of troops, and officers from the chief priests and Pharisees, came there with lanterns, torches, and weapons' (John 18:3). John, however, says nothing about the kiss of Judas.

Most artists depicted this biblical scene with numerous figures. Caravaggio shows only six, and even they are not all clearly visible. The absence of any décor, a hallmark of many of his works, makes the composition more forceful. To the left of centre, Judas embraces Christ – for once we are not shown the actual kiss of Judas – while at the same time a soldier wearing a helmet and armour seizes Christ by the throat. Although Caravaggio incorporated components from each of the slightly different versions contained in the four gospels, his work most closely represents the account given by Luke, the most compassionate of the four and a chronicler with a keen eye for detail.

This devastating moment for Peter is apparently of little interest to anyone else. The card players barely look up from their game.

The extinguished candle symbolizes the flame of faith which, at this point, is burning low. Peter repenting his lie was often represented in 17th-century art. It was especially popular among such pioneer orders of the Counter-Reformation as the Jesuits, for whom the prospect of absolution was extremely important.

CHRIST AND PETER

David Teniers the Younger, 1610–1690
The Denial of Peter, 1646
Canvas, 37 x 52 cm
Musée du Louvre, Paris

After the Last Supper Christ had a distressing announcement to make to his disciples.

'All of you will be made to stumble because of Me this night, for it is written: "I will strike the Shepherd, And the sheep of the flock will be scattered." But after I have been raised, I will go before you to Galilee.' Peter answered and said to Him, 'Even if all are made to stumble because of You, I will never be made to stumble.' Jesus said to him, 'Assuredly, I say to you that this night, before the rooster crows, you will deny Me three times.' Peter said to Him, 'Even if I have to die with You, I will not deny You!' And so said all the disciples. Now Peter sat outside in the courtyard. And a servant girl came to him, saying, 'You also were with Jesus of Galilee.' But he denied it before them all, saying, 'I do not know what you are saying.' And when he had gone out to the gateway, another girl saw him and said to those who were there, 'This fellow also was with Jesus of Nazareth.' But again he denied with an oath, 'I do not know the Man!' And a little later those who stood by came up and said to Peter, 'Surely you also are one of them, for your speech betrays you.' Then he began to curse and swear, saying, 'I do not know the Man!' Immediately a rooster crowed. And Peter remembered the word of Jesus who had said to him, 'Before the rooster crows, you will deny Me three times.' So he went out and wept bitterly. / MATTHEW 26:31-35, 69-75

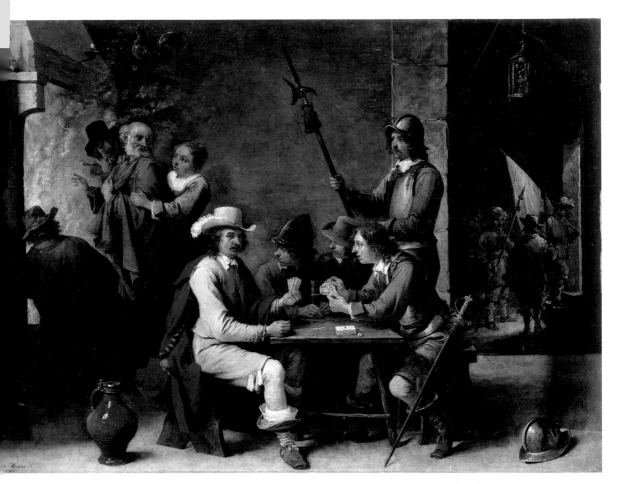

When Peter heard the rooster crow he remembered the prophetic words Christ had spoken a few hours before.

Teniers conceived the story as a genre scene set in an interior where soldiers are playing a game of cards; in the background others leave the room. There are also civilians present. All wear 17th-century costumes and bear arms, except for Peter, who is led away by a man and a woman on the left. Other artists portrayed Peter as a solitary figure weeping in remorse for denying Christ three times. However, Teniers worked the biblical story into a scene that would have been familiar in the Spanish Netherlands in the 17th century: the setting was a guardroom of the Spanish army of occupation, and paintings of this kind were known as *kortegaardjes*, a term derived from the French *corps de garde*.

Christ stands handcuffed, looking down on the high priest seated before him. He waits impassively. According to the gospels, Christ remained silent throughout most of the interrogations; his responses were brief and laconic.

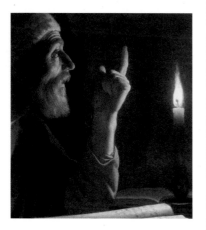

Caiaphas raises an accusing finger at Christ. The book on the table in front of him sets out the laws of Moses on the basis of which Christ will be convicted. Caiaphas is sometimes shown melodramatically tearing his garments when Christ announces that he is the son of God. The gesture is consistent with the account in the gospels and traditionally signifies anger or sorrow.

CHRIST BEFORE THE HIGH PRIEST

Gerard van Honthorst, 1592–1656
Christ before the High Priest, c. 1618
Canvas, 272 x 183 cm
The National Gallery, London

After his arrest, Christ was questioned on several occasions by the Jewish authorities and the Roman governor Pontius Pilate. The first to interrogate him was the high priest Caiaphas, and there his fate was sealed.

And they led Jesus away to the high priest; and with him were assembled all the chief priests, the elders, and the scribes. But Peter followed Him at a distance, right into the courtyard of the high priest. And he sat with the servants and warmed himself at the fire. Now the chief priests and all the council sought testimony against Jesus to put Him to death, but found none. For many bore false witness against Him, but their testimonies did not agree. Then some rose up and bore false witness against Him, saying, 'We heard Him say, "I will destroy this temple made with hands, and within three days I will build another made without hands."' But not even then did their testimony agree. And the high priest stood up in the midst and asked Jesus, saying, 'Do You answer nothing? What is it these men testify against You?' But He kept silent and answered nothing. Again the high priest asked Him, saying to Him, 'Are You the Christ, the Son of the Blessed?' Jesus said, 'I am. And you will see the Son of Man sitting at the right hand of the Power, and coming with the clouds of heaven.' Then the high priest tore his clothes and said, 'What further need do we have of witnesses? You have heard the blasphemy! What do you think?' And they all condemned Him to be deserving of death. / MARK 14:53–64

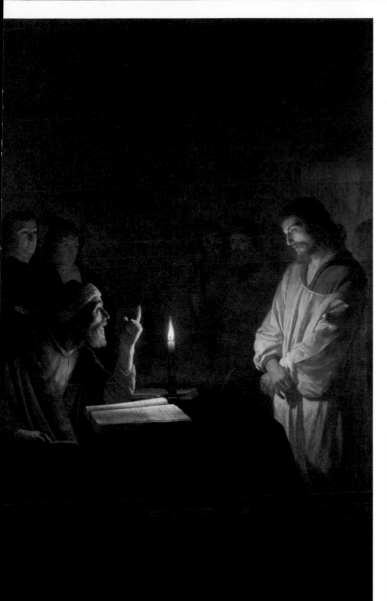

The Dutch artist Gerard van Honthorst lived in Rome for many years, where his reputation as a painter of nocturnal scenes earned him the nickname 'Gherardo della Notte' (Gerard of the Night). These scenes set at night or in darkness are lit by only one or two sources of light – usually candles – which evoke mood and atmosphere. We can deduce from the gospels that Christ's interrogation by Caiaphas took place at night. Caiaphas tried Christ under Jewish law and found him guilty of blasphemy. It was a capital offence, but only the governor Pontius Pilate, representing the authorities of the Roman occupying forces in Palestine, could pronounce and execute the death sentence. The final verdict was given later (see p. 128).

Several onlookers have gathered around Christ and Caiaphas waiting to see what happens. Most are in shadow, which heightens the tension of the scene. Honthorst's painting was highly acclaimed in Rome. It strongly reflects the influence of Caravaggio, whose work is also characterized by an absence of anecdotal detail.

Christ looks straight out at us and by doing so involves us in the event. The scarlet or purple robe he was said to be wearing is pictured here as a green and white cloth. One of Christ's tormentors prods the crown with a stick to drive the thorns deeper into his head.

ANGELS AND DEMONS

The central image is surrounded by angels and demons fighting for the soul of man. It was believed that they fought over the souls of the dead and consigned them either to heaven or to the depths of hell.

MOCKING OF CHRIST

Follower of Hieronymus Bosch, c. 1450–1516
The Mocking of Christ, c. 1530?
Panel, 165 x 195 cm
Monasterio de San Lorenzo de El Escorial, Madrid

The books of Matthew and Mark provide the most detailed accounts of this episode of the Passion, which they say occurred after the Roman prefect Pontius Pilate delivered Christ to the people to be crucified.

Then the soldiers of the governor took Jesus into the Praetorium and gathered the whole garrison around Him. And they stripped Him and put a scarlet robe on Him. When they had twisted a crown of thorns, they put it on His head, and a reed in His right hand. And they bowed the knee before Him and mocked Him, saying, 'Hail, King of the Jews!' Then they spat on Him, and took the reed and struck Him on the head. And when they had mocked Him, they took the robe off Him, put His own clothes on Him, and led Him away to be crucified.
/ MATTHEW 27:27–31

Then the soldiers led Him away into the hall called Praetorium, and they called together the whole garrison. And they clothed Him with purple; and they twisted a crown of thorns, put it on His head, and began to salute Him, 'Hail, King of the Jews!' Then they struck Him on the head with a reed and spat on Him; and bowing the knee, they worshipped Him. And when they had mocked Him, they took the purple off Him, put His own clothes on Him, and led Him out to crucify Him. / MARK 15:16–20

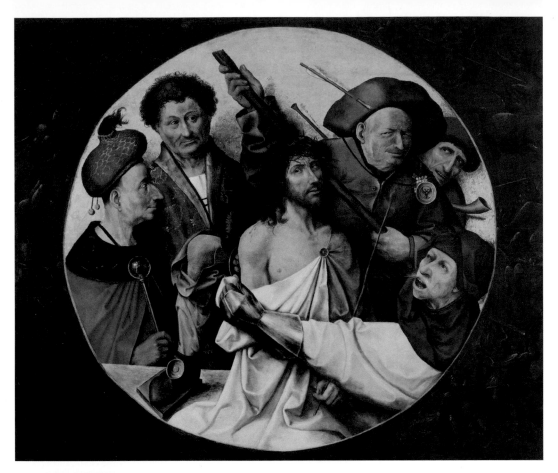

The man in the strange hat represents a Jewish dignitary, as we may deduce from the image of Moses and the tablets of the law on the crystal knob of his staff. According to the gospels, the incident took place at the court of Pontius Pilate, who claimed innocence (see p. 128) and absolved himself of responsibility for the whole affair.

This enigmatic figure raises a number of questions. What does the arrow on his hat signify? Why is the heraldic double eagle of Habsburg displayed on his chest? Why is his leg so long, and why is he shown in such a strange pose?

Wearing the crown of thorns and holding the reed in his right hand, Christ meekly endures the taunts of his ruthless executioners in this stark, compelling scene. The Passion of Christ occupies an important place in Bosch's oeuvre. The underlying message of many of the master's paintings is that Christ suffered to redeem the world. He set an example that Christians should follow, regardless of the evils they may encounter on life's journey. Bosch represented those evils in many of his imaginative and often cryptic works. Here, they are personified by the malevolent villains around Christ.

CHRIST / ECCE HOMO

Hieronymus Bosch, c. 1450–1516
Ecce Homo, 1470–76
Panel, 75 x 61 cm
Städelsches Kunstinstitut und Städtische Galerie, Frankfurt

With his wrists bound, defenceless and bleeding, Christ is brought before the hostile crowd. The soldiers have already placed the crown of thorns on his head and the mantle over his shoulders. This corresponds to the accounts in the gospels of Luke and John, though Matthew and Mark say they did so only after this scene. And only John mentions that the event took place *outdoors*, in front of Pilate's residence.

The chief priests of the Jews demanded that Christ be condemned to death for claiming to be the 'King of the Jews'. He was brought before the Roman prefect Pontius Pilate for questioning.

And when he had said this, he went out again to the Jews, and said to them, 'I find no fault in Him at all. But you have a custom that I should release someone to you at the Passover. Do you therefore want me to release to you the King of the Jews?' Then they all cried again, saying, 'Not this Man, but Barabbas!' Now Barabbas was a robber. So then Pilate took Jesus and scourged Him. And the soldiers twisted a crown of thorns and put it on His head, and they put on Him a purple robe. Then they said, 'Hail, King of the Jews!' And they struck Him with their hands. Pilate then went out again, and said to them, 'Behold, I am bringing Him out to you, that you may know that I find no fault in Him.' Then Jesus came out, wearing the crown of thorns and the purple robe. And Pilate said to them, 'Behold the Man!' Therefore, when the chief priests and officers saw Him, they cried out, saying, 'Crucify Him, crucify Him!' Pilate said to them, 'You take Him and crucify Him, for I find no fault in Him.' The Jews answered him, 'We have a law, and according to our law He ought to die, because He made Himself the Son of God.' Therefore, when Pilate heard that saying, he was the more afraid.

Pilate wanted to release Christ, but the Jews argued that his acquittal would be an affront to the sovereignty of the Roman emperor.

When Pilate therefore heard that saying, he brought Jesus out and sat down in the judgement seat in a place that is called The Pavement, but in Hebrew, Gabbatha. Now it was the Preparation Day of the Passover, and about the sixth hour. And he said to the Jews, 'Behold your King!' But they cried out, 'Away with Him, away with Him! Crucify Him!' Pilate said to them, 'Shall I crucify your King?' The chief priests answered, 'We have no king but Caesar!' Then he delivered Him to them to be crucified. / JOHN 18:38–19:16

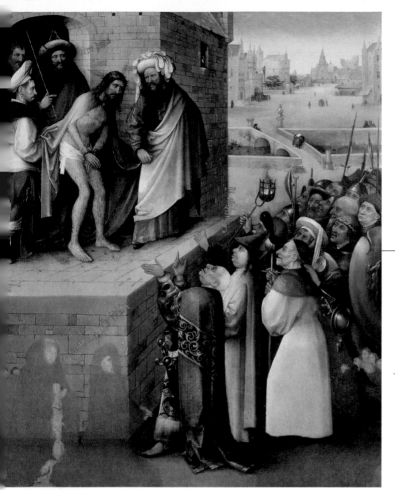

EYEWITNESS REPORT

In Bosch's day there were manuscripts in circulation which described Christ's suffering in the first person. The Dominican Heinrich Suso (14th century), for example, wrote: 'My enemies looked upon me with fearsome eyes and stood before me like menacing warriors. I endured their gaze with a mild heart, my head bowed, like a gentle lamb being led to slaughter.'

In the distance we see a subtly rendered scene from everyday life in a city of Bosch's time. Against this background, Christ, in shackles, is brought before the people. The onlookers are depicted with Bosch's famously caricatural faces. In his day, ugliness was associated with intrinsic evil. Civic dignitaries and religious leaders mingle in the crowd. This is the only known early work by Bosch. The patron who ordered the painting was portrayed with his family in the lower section of the work, but their portraits were later removed and overpainted.

The words that were spoken, according to the inscription, show that this is Pilate. 'Ecce homo', he said in Latin, 'Behold the man'. To which the people replied, 'Crucifige eum' – 'Crucify him'.

CHRIST BEFORE PILATE

Duccio di Buoninsegna, c. 1255–1319
Christ before Pilate, 1308–11
Two panels from the reverse of the *Maestà*,
49 x 57 cm and 51 x 53.5 cm
Museo dell'Opera del Duomo, Siena

Pilate has sentenced Christ to death and will 'wash his hands' of guilt, absolving himself of responsibility for his actions. He yields to the pressure of the crowd before him, though he sees no reason to convict Christ. Duccio's painting highlights that travesty of justice.

When morning came, all the chief priests and elders of the people plotted against Jesus to put Him to death. And when they had bound Him, they led Him away and delivered Him to Pontius Pilate the governor … Now Jesus stood before the governor. And the governor asked Him, saying, 'Are You the King of the Jews?' Jesus said to him, 'It is as you say.' And while He was being accused by the chief priests and elders, He answered nothing. Then Pilate said to Him, 'Do You not hear how many things they testify against You?' But He answered him not one word, so that the governor marvelled greatly.

Now at the feast the governor was accustomed to releasing to the multitude one prisoner whom they wished. And at that time they had a notorious prisoner called Barabbas. Therefore, when they had gathered together, Pilate said to them, 'Whom do you want me to release to you? Barabbas, or Jesus who is called Christ?' For he knew that they had handed Him over because of envy. While he was sitting on the judgement seat, his wife sent to him, saying, 'Have nothing to do with that just Man, for I have suffered many things today in a dream because of Him.' But the chief priests and elders persuaded the multitudes that they should ask for Barabbas and destroy Jesus. The governor answered and said to them, 'Which of the two do you want me to release to you?' They said, 'Barabbas!' Pilate said to them, 'What then shall I do with Jesus who is called Christ?' They all said to him, 'Let Him be crucified!' Then the governor said, 'Why, what evil has He done?' But they cried out all the more, saying, 'Let Him be crucified!' When Pilate saw that he could not prevail at all, but rather that a tumult was rising, he took water and washed his hands before the multitude, saying, 'I am innocent of the blood of this just Person. You see to it.' And all the people answered and said, 'His blood be on us and on our children.' Then he released Barabbas to them; and when he had scourged Jesus, he delivered Him to be crucified. Then the soldiers of the governor took Jesus into the Praetorium and gathered the whole garrison around Him. / MATTHEW 27:1-2, 11-27

Duccio's immense masterwork, the *Maestà*, shows the enthroned Madonna surrounded by saints and angels. On the back are more than forty small scenes depicting the life of Christ, including six representing episodes from his trial. The two panels discussed here are the first and last of those scenes. Duccio's portrayal of Pilate corresponds to the interpretation purveyed by the Church in the Middle Ages: the Roman Pilate wanted to administer justice according to the law, but submitted to the pressure brought to bear by the Jewish 'multitude' and their council. There are subtle differences in the scenography: in the first scene the judge, the soldiers and the crowd form distinctly separate groups; in the last, the crowd – now apparently larger – has taken over Pilate's loggia.

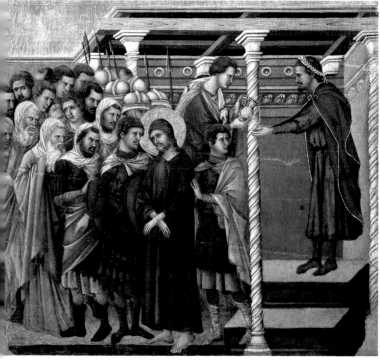

Soldiers guard Christ, who remains silent. They also protect him from the crowd and the gesticulating priests outside, who have already condemned Christ.

The physical threat expressed by the crowd pressing into Pilate's loggia is Duccio's visual translation of the gospel text.

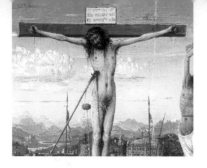

Only the evangelist John mentions the piercing of Christ's side with a spear (19:34). One of the many medieval legends inspired by this incident identifies the perpetrator as a certain Longinus. The sponge soaked in sour wine (or vinegar), which is mentioned in the four gospels, can also be seen in the painting. The soldier who offered it to Christ was said to be called Stephaton.

CRUCIFIXION

The practice of crucifixion was uncommon in Palestine before the period of Roman rule, but from then on it was imposed on convicts who could not prove that they were Roman citizens. (The majority of people who were crucified in Rome were slaves.) The two men who died with Christ on Golgotha were not nailed to the cross but bound with ropes, because their offence, presumably theft, was deemed less serious.

CHRIST / CRUCIFIXION

Jan van Eyck and workshop, c. 1385–1441
The Crucifixion, 1430s
Left wing of a diptych (with *The Last Judgement* on the right)
Canvas (transferred from panel), 56 x 20 cm
The Metropolitan Museum of Art, New York, Fletcher Fund 1933

Christ was delivered by Pilate to be crucified.
Now as they came out, they found a man of Cyrene, Simon by name. Him they compelled to bear His cross. And when they had come to a place called Golgotha, that is to say, Place of a Skull, they gave Him sour wine mingled with gall to drink. But when He had tasted it, He would not drink. Then they crucified Him, and divided His garments, casting lots, that it might be fulfilled which was spoken by the prophet: 'They divided My garments among them, And for My clothing they cast lots.' Sitting down, they kept watch over Him there. And they put up over His head the accusation written against Him: THIS IS JESUS THE KING OF THE JEWS. Then two robbers were crucified with Him, one on the right and another on the left.

Passers-by, high priests, scribes and elders all mocked Christ, the Son of God and the King of Israel, who was now not even able to save himself.

Even the robbers who were crucified with Him reviled Him with the same thing. Now from the sixth hour until the ninth hour there was darkness over all the land. And about the ninth hour Jesus cried out with a loud voice, saying, 'Eli, Eli, lama sabachthani?' that is, 'My God, My God, why have You forsaken Me?' Some of those who stood there, when they heard that, said, 'This Man is calling for Elijah!' Immediately one of them ran and took a sponge, filled it with sour wine and put it on a reed, and offered it to Him to drink. The rest said, 'Let Him alone; let us see if Elijah will come to save Him.' And Jesus cried out again with a loud voice, and yielded up His spirit. Then, behold, the veil of the temple was torn in two from top to bottom; and the earth quaked, and the rocks were split, and the graves were opened; and many bodies of the saints who had fallen asleep were raised; and coming out of the graves after His resurrection, they went into the holy city and appeared to many. So when the centurion and those with him, who were guarding Jesus, saw the earthquake and the things that had happened, they feared greatly, saying, 'Truly this was the Son of God!' And many women who followed Jesus from Galilee, ministering to Him, were there looking on from afar. / MATTHEW 27:32–38, 44–55

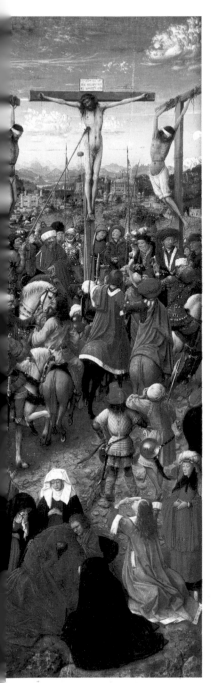

Luke writes about the different responses of the two thieves who were executed with Christ. The man on Christ's left (the viewer's right) taunted Christ, whereas the other expressed remorse. The unrepentant 'bad thief' can be recognized by his tormented pose.

Christ's faithful followers stand at some distance from the cross. John comforts the Virgin, and Mary Magdalene kneels in reverence and awe. Only John mentions the presence of these three at Christ's death. Other sources give conflicting accounts as to which of his followers were present on this occasion.

Christ's death on the cross – the moment he gave his life to save humankind – has been represented, in countless variants, more often than any other scene in Christian art. Van Eyck depicted the moment when a spear is thrust into Christ's side. A large crowd of hostile onlookers with strange faces and headdresses gathers at the foot of the cross. An imaginary view of Jerusalem can be seen in the background. The astounding detail and sense of depth are typical of Van Eyck's work.

CHRIST / CRUCIFIXION

Andrea Mantegna, c. 1431–1506
The Crucifixion, 1457–60
Panel, 67 x 93 cm
Musée du Louvre, Paris

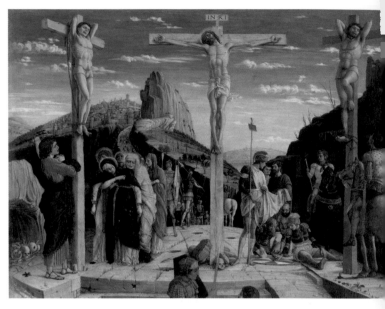

Roman soldiers throw dice for Christ's garments. John writes: 'When the soldiers crucified Jesus, they took his clothes, dividing them into four shares, one for each of them, with the undergarment remaining. This garment was seamless, woven in one piece from top to bottom. "Let's not tear it," they said to one another. "Let's decide by lot who will get it."' (John 19:23–24)

The setting is a barren, rocky and accurately rendered site of execution. Christ is no longer alive: the spear has already been thrust and the onlookers start to disperse. Mantegna visualizes Luke's distinction between the 'good thief' and the 'bad thief' by depicting one in the light and the other in shadow. Mantegna also follows the conventional disposition of the figures, with Christ's loved ones and followers grouped on his 'good' side (the right or, from our point of view, the left), opposite the 'wicked' Romans and Jews.

Christ was crucified on Golgotha, literally 'the Place of Skulls', where, in the Middle Ages, Adam was also said to be buried: hence the heap of skulls and the single skull at the foot of the cross. They imply a direct relationship between original sin and the crucifixion: Christ's death redeemed humankind from the original sin, the result of Adam and Eve's transgression (see p. 26).

Mathias Grünewald, c. 1470–1528
The Crucifixion, c. 1510–15
Panel of the Isenheim Altarpiece, 269 x 307 cm
Musée d'Unterlinden, Colmar

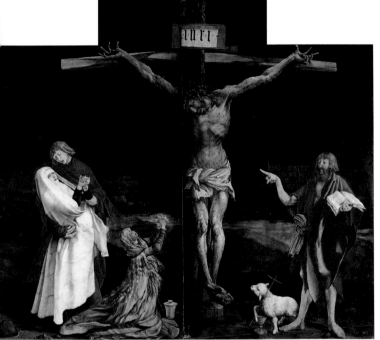

The presence of John the Baptist at the cross is remarkable, for according to the gospel, he had been beheaded long before the crucifixion. The inscription above his extended arm reads: 'He must grow and I diminish.' John's apparent composure in the circumstances underscores his role as a commentator.

This is one of the most moving scenes of Christ's suffering on the cross. It focuses entirely on the blood, pain and the tortured, agonized body. On the left, the young John supports the white-robed Virgin, her face drained of colour; Mary Magdalene kneels at the cross in lament and worship, with her jar of ointment at her side. John the Baptist stands on the right. The panel forms part of the Isenheim Altarpiece that Grünewald painted for the chapel of a hospital for plague victims. Christ's Passion and his resurrection (see pp. 138–139) were meant to sustain those who were dying: their suffering was not in vain.

Christ was the Lamb of God who shed his blood for the salvation of humankind. According to Roman Catholic doctrine, the wine in the chalice is transformed into Christ's blood in the Eucharist (see p. 112).

VARIANTS

The imagery of Christ's crucifixion is varied and rich in detail. Firstly, the four evangelists gave conflicting accounts of the event. Was one of the two thieves indeed 'good' and the other 'bad' (which only Luke reports)? Were the Virgin and John standing at the foot of the cross (according to the evangelist John) or were Christ's faithful, without the Virgin, some distance away (according to the other evangelists)? Was a spear thrust into Christ's side after his death (John)? Did the Virgin swoon (not mentioned in the gospels)? How, precisely, was Christ crucified (not mentioned in the gospels)? Other factors to consider were the influence of medieval legends, the precise moment the artist chose to depict (was Christ dead or not?), various theological interpretations and the wishes of the patron. Clearly, there were numerous options.

CHRIST / CRUCIFIXION

**Anthony van Dyck,
1599–1641**
The Crucifixion, 1630–32
Canvas, 400 x 245 cm
Palais des Beaux-Arts, Lille

'Near the cross of Jesus stood
his mother, his mother's sister,
Mary the wife of Clopas, and Mary
Magdalene. When Jesus saw his
mother there, and the disciple
whom he loved standing nearby,
he said to his mother, "Dear
woman, here is your son,"
and to the disciple, "Here is your
mother." From that time on, this
disciple took her into his home'
(John 19:25–27). Only John writes
that the Virgin, Mary Magdalene
and he himself stood near the
cross. In Van Dyck's painting
'blood and water' flow from the
wound in Christ's side, from which
we know that he is no longer alive.
The sky is ominous.

Many early paintings show the
Virgin in a swoon, but this is less
often the case in work from after
about 1560. At the Council of Trent
(1545–63) the Church explicitly
denounced that motif along with
other apocryphal and medieval
departures from the biblical text.
John, the only evangelist who
refers to the Virgin in this context,
writes that she stood at the cross.

Mary Magdalene, fair-haired and
wearing a sumptuous yellow robe,
clings to the cross and embraces
Christ's feet, the feet she
once anointed (see p. 92).
Thus expressing her faith and
sorrow, the former sinner set an
example for the faithful to follow.

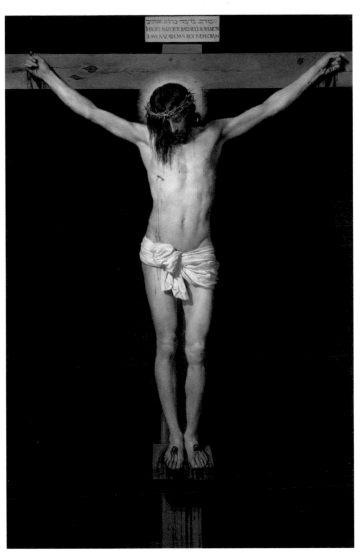

**Diego Velázquez,
1599–1660
The Crucifixion, c. 1631–32**
Canvas, 250 x 170 cm
Museo Nacional del Prado, Madrid

From the 16th century onwards
artists demonstrated their
erudition and knowledge
of philology by reproducing in
Latin, Greek and Aramaic
– the languages mentioned
by the evangelist John – the
inscription *Iesus Nazarenus,
Rex Iudaeorum* [Jesus of Nazareth,
the King of the Jews]. Before that
time, the inscription was usually
abbreviated to *INRI*.

Christ is shown on the cross against a pitch-black background:
'It was now about the sixth hour, and darkness came over the whole
land' (Luke 23:44). The painting shows nothing more. This emotional
image of the solitary Christ, a type that gained currency in the
17th century, was meant to inspire devotion. The emphasis is
on the suffering of the now lifeless Christ – his blood flowing copiously,
the crown of thorns piercing his head, and above all, his infinite
loneliness.

Illustrations of the way Christ
is nailed to the cross may vary.
Velázquez followed the example
of his medieval predecessors by
showing four nails, whereas most
of his contemporaries depicted
one nail driven through both feet.
The foot support can already be
seen in medieval art.

Nicodemus looks out of the painting in the direction of the observer. Like Joseph, he is elegantly dressed in the fashion of the 15th century. This might be a portrait of Cosimo de' Medici, who most probably commissioned the work. In several early Netherlandish paintings Nicodemus is portrayed with the features of one of the artist's contemporaries who was in some way connected with the commission. Van der Weyden made the painting long after his pilgrimage to Italy in the Holy Year 1450.

On the left, two women approach from a distance. In early Netherlandish painting it was not uncommon for artists to incorporate a series of episodes from a story in a single painting, and here it would seem that Van der Weyden depicted two of the three Holy Women making their way to the sepulchre. By the time they arrive – after the Resurrection (see p. 138) – they will find it empty. The Holy Women, also known as the Three Marys, are usually identified as Mary of Cleopas, Mary of Magdala (also, Mary Magdalene) and Mary Salome (see p. 140).

Rogier van der Weyden, c. 1399/1400–1464
The Entombment of Christ, c. 1464
Panel, 111 x 95 cm
Galleria degli Uffizi, Florence

The day after Christ's death on the cross was the Sabbath and something had to be done quickly to ensure that his body was removed.
After this [Christ's death on the cross], Joseph of Arimathea, being a disciple of Jesus, but secretly, for fear of the Jews, asked Pilate that he might take away the body of Jesus; and Pilate gave him permission. So he came and took the body of Jesus. And Nicodemus, who at first came to Jesus by night, also came, bringing a mixture of myrrh and aloes, about a hundred pounds. Then they took the body of Jesus, and bound it in strips of linen with the spices, as the custom of the Jews is to bury. Now in the place where He was crucified there was a garden, and in the garden a new tomb in which no one had yet been laid. So there they laid Jesus, because of the Jews' Preparation Day, for the tomb was nearby. / JOHN 19:38–42

This is the evangelist Mark's account of the event:
Now when evening had come, because it was the Preparation Day, that is, the day before the Sabbath, Joseph of Arimathea, a prominent council member, who was himself waiting for the kingdom of God, coming and taking courage, went in to Pilate and asked for the body of Jesus. Pilate marvelled that He was already dead; and summoning the centurion, he asked him if He had been dead for some time. So when he found out from the centurion, he granted the body to Joseph. Then he bought fine linen, took Him down, and wrapped Him in the linen. And he laid Him in a tomb which had been hewn out of the rock, and rolled a stone against the door of the tomb. And Mary Magdalene and Mary the mother of Joses observed where He was laid. / MARK 15:42–47

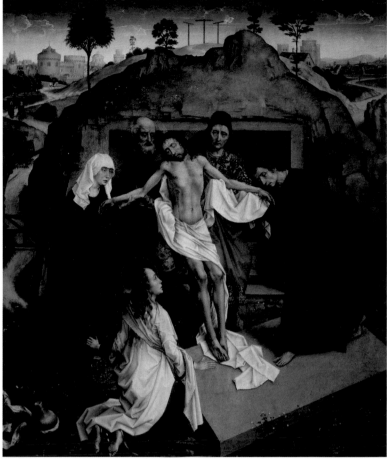

In the background – as evening falls – are the three now idle crosses where Christ and the two thieves died a short time earlier. John recounts that the legs of the two thieves were broken in order to hasten their death, so that they would not remain hanging on the Sabbath, the following day. Christ's legs were not broken, as he had already died. Van der Weyden based his depiction of the city and buildings of Jerusalem on contemporary Flemish architecture.

We see a frontal view of the bloodied body of Christ. It is being swathed in linen and will soon be laid to rest in the sepulchre. Nicodemus and Joseph of Arimathea support the body; according to Matthew, the tomb was intended for Joseph. Standing beside them are the apostle John and the Virgin, who holds her dead son's arm. Mary Magdalene kneels in front of the group and demonstrates what is expected of the observer: the worshipper should be moved to share in the experience and as a result pray more devoutly. The painting combines two episodes from the Passion: the entombment and the mourning of Christ. Both were widely represented in the visual arts, although the latter has no basis in the gospels.

Christ's mortal body appears to be dissolving into the large circle of sun that surrounds him and rises up into the otherwise black night. The stars in the sky are eclipsed by the divine light.

CHRIST / RESURRECTION

Mathias Grünewald, c. 1470–1528
The Resurrection of Christ, c. 1510–15
Panel of the Isenheim Altarpiece, 269 x 141 cm
Musée d'Unterlinden, Colmar

THE RESURRECTION

Although Christ's resurrection, a central doctrine of Christianity, was not represented in early Christian art, the subject gained popularity in the 11th and 12th centuries. It was even more widely disseminated through later art, notably in altarpieces. Representations of the event vary substantially, but two main types can be distinguished: Christ either hovers above the tomb or emerges from a sarcophagus. In the former type more than the latter, Christ is depicted with divine features and attributes.

The moment of Christ's resurrection is not described in the gospels: the event was a mystery and not manifest to human eyes. But various manuscripts were in circulation which described how Christ had risen. One was the apocryphal Gospel of Peter.

In the night whereon the Lord's day dawned, as the soldiers kept watch two by two, a great tumult sounded from heaven, and they saw that the heavens were opened; and two men descended in a radiance of light and drew near to the tomb. And the stone which had been set at the entrance began to roll away from its place and when the tomb was opened, the two young men entered into the tomb. When the soldiers beheld the sight, they awakened the centurion and the elders, for they too were present at the watch. And while they were yet telling them the things they had seen, they beheld three men come out from the tomb, two supporting the third, and a cross followed behind them. And the heads of the two men reached unto heaven, but the head of him whose hand they held reached above the heavens. And a voice came from the heavens saying, 'Have you preached to those who sleep?' And from the cross came the answer, 'Yes'. The men took counsel together to make these things known to Pilate. And as they still spoke, the heavens opened once more and a person descended and entered into the tomb. / GOSPEL OF PETER, 35–42

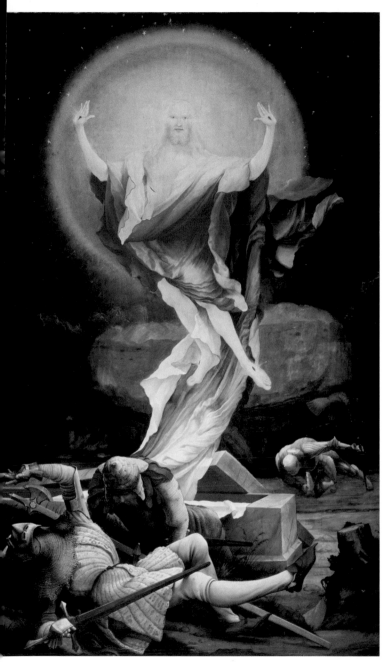

The risen Christ in Grünewald's remarkably dynamic work is depicted from the front in the conventional manner. The trailing drapery from the casket connects him to the tomb, and he wears a scarlet robe, alluding to his suffering and incarnation. (He may also be shown in pure white to symbolize his divinity.) This triumphant figure is like a cosmic apparition, a kind of radiant sun god, who has himself removed the heavy gravestone and now, defying gravity, soars heavenward. He shows us his wounds, the emblems of his triumph over death. *The Resurrection* forms part of Grünewald's celebrated Isenheim Altarpiece (see also p. 133).

The soldiers look like flimsy marionettes that have been tossed aside by an earthquake. 'And behold, there was a great earthquake; for an angel of the Lord descended from heaven' (Matthew 28:2). None of them sees what is happening, which accords with the fact that no one witnessed Christ's resurrection.

The angel – there were two, according to the evangelists Luke and John – is seated on the stone that was said to cover the tomb but now lies across it. He is dressed in white and speaks to the women.

NO WITNESSES

From the 12th century onwards, the scene of Christ rising triumphantly from his tomb was widely represented in art. The miraculous event is not described in the gospels: there were no witnesses to Christ's resurrection.

CHRIST / THREE MARYS

Jan and Hubert van Eyck, c. 1385–1441 and 1366/70–1426
The Three Marys at the Tomb, c. 1425–35
Panel, 71.5 x 90 cm
Museum Boijmans Van Beuningen, Rotterdam

Now when the Sabbath was past, Mary Magdalene, Mary the mother of James, and Salome bought spices, that they might come and anoint Him. Very early in the morning, on the first day of the week, they came to the tomb when the sun had risen. And they said among themselves, 'Who will roll away the stone from the door of the tomb for us?' But when they looked up, they saw that the stone had been rolled away – for it was very large. And entering the tomb, they saw a young man clothed in a long white robe sitting on the right side; and they were alarmed. But he said to them, 'Do not be alarmed. You seek Jesus of Nazareth, who was crucified. He is risen! He is not here. See the place where they laid Him. But go, tell His disciples – and Peter – that He is going before you into Galilee; there you will see Him, as He said to you.' So they went out quickly and fled from the tomb, for they trembled and were amazed. And they said nothing to anyone, for they were afraid. / MARK 16:1–8

This sleeping soldier wears a medieval cuirass and chain mail, and is armed with a halberd. His companions are depicted in costumes with peaked caps. Matthew is the only one of the evangelists who refers to the guards. He says there was an earthquake when 'an angel of the Lord descended from heaven, and came and rolled back the stone from the door, and sat on it ... And the guards shook for fear of him, and became like dead men.'

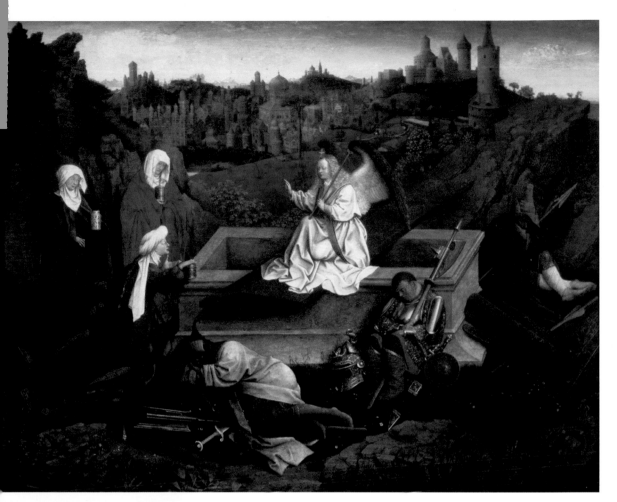

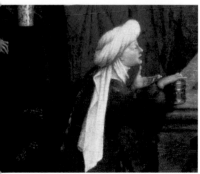

In a rocky landscape with the city of Jerusalem in the distance, three women visit Christ's empty tomb. The tomb is a sarcophagus rather than the burial chamber that the evangelists describe. John notes that it was located in an olive grove. Each of the three women carries an ointment jar and the three guards have fallen asleep.

The kneeling woman in the red robe is Mary of Magdala, or Mary Magdalene, who had once been a prostitute. She is usually portrayed with an ointment jar, alluding to the meal at the home of Simon the Pharisee, where she anointed Christ's feet with balsam (Luke 7:36–50; and see p. 92). According to John, she was alone at the tomb; in Matthew's version two women were present, while Mark mentions three women at the sepulchre. The identity of the other two women depends on the source of the account. The Salome referred to by Mark is usually held to be Mary of Cleopas – hence: the three Marys.

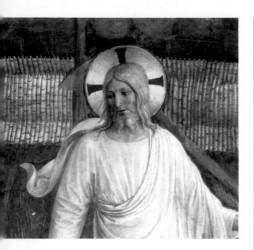

Christ holds a spade to explain Mary Magdalene's initial assumption that he was a gardener. Though he moves away, he turns to face her. The cruciform halo is specific to Christ, but is sometimes also used for the Holy Trinity.

THE SETTING

Fra (Brother) Angelico, a Dominican, was an erudite man. According to the medieval scholar Albertus Magnus, whose writings he would surely have read, a setting is always more than simply a backdrop. A setting and the figures in it impact on one another. This can be seen here in the red spots, which represent, but do not resemble, flowers. They are painted in exactly the same way as Christ's stigmata. It is as if the resurrected Christ were spreading his stigmata over the earth.

CHRIST AND MARY MAGDALENE

Fra Angelico (and Benozzo Gozzoli?), c. 1399–1455
Noli me tangere, c. 1440
Fresco, 180 x 146 cm
Convent of San Marco, Florence

According to the Book of John, Mary of Magdala (Mary Magdalene) was among those who visited Christ's tomb on Easter morning, the day of his resurrection. Mary stood outside by the tomb weeping, and as she wept she stooped down and looked into the tomb. And she saw two angels in white sitting, one at the head and the other at the feet, where the body of Jesus had lain. Then they said to her, 'Woman, why are you weeping?' She said to them, 'Because they have taken away my Lord, and I do not know where they have laid Him.' Now when she had said this, she turned around and saw Jesus standing there, and did not know that it was Jesus. Jesus said to her, 'Woman, why are you weeping? Whom are you seeking?' She, supposing Him to be the gardener, said to Him, 'Sir, if You have carried Him away, tell me where You have laid Him, and I will take Him away.' Jesus said to her, 'Mary!' She turned and said to Him, 'Rabboni!' (which is to say, Teacher). Jesus said to her, 'Do not cling to Me, for I have not yet ascended to My Father; but go to My brethren and say to them, "I am ascending to My Father and your Father, and to My God and your God."' Mary Magdalene came and told the disciples that she had seen the Lord, and that He had spoken these things to her. / JOHN 20:11–18

Mary Magdalene was the first person to encounter the risen Christ. She had also stood beside the cross (see pp. 131–134) and shown remorse for her sins while Christ was still alive (see p.92). Mary Magdalene was Christ's most important female follower.

Mary Magdalene, wearing a red robe, kneels and reaches out to touch Christ, but Christ gently waves her away and steps aside. This is the classic iconography of the scene.

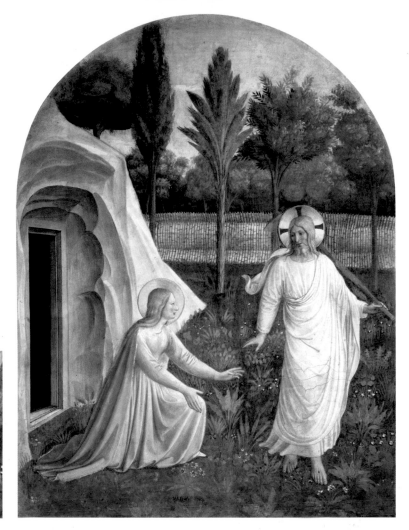

Two of the wounds that Christ sustained during the Passion – the stigmata – can be seen on his feet. Placing his right foot in front of his left, he steps away from Mary Magdalene.

Initially unaware of who is standing before her, Mary Magdalene encounters the newly risen Christ in a radiant white robe beside the open tomb in the rock. The two angels mentioned in the gospel are rarely shown in paintings of this subject, nor, indeed, are they present here. Mary Magdalene recognizes Christ and reaches out to touch him but he gently holds her back with the words 'Noli me tangere' – Latin for 'do not touch me' or 'let me go'. What Christ meant was that his physical being was no longer relevant. According to the New Testament, he ascended to heaven forty days later (see p. 148).

CHRIST / SUPPER AT EMMAUS

Caravaggio, 1573–1610
The Supper at Emmaus, 1601
Canvas, 141 x 196 cm
The National Gallery, London

The innkeeper, who is not mentioned in the Bible, stares uncomprehendingly at Christ. From his whole attitude – he does not remove his cap, for instance – it is clear that he is ignorant of the identity of his distinguished guest, whom the two disciples have only just recognized. His impassiveness is a foil to the disciples' bewilderment.

On the day of the Resurrection two of Christ's disciples were making their way to the village of Emmaus.
So it was, while they conversed and reasoned, that Jesus Himself drew near and went with them. But their eyes were restrained, so that they did not know Him. And He said to them, 'What kind of conversation is this that you have with one another as you walk and are sad?' Then the one whose name was Cleopas answered and said to Him, 'Are You the only stranger in Jerusalem, and have You not known the things which happened there in these days?' And He said to them, 'What things?' So they said to Him, 'The things concerning Jesus of Nazareth, who was a Prophet mighty in deed and word before God and all the people, and how the chief priests and our rulers delivered Him to be condemned to death, and crucified Him. But we were hoping that it was He who was going to redeem Israel. Indeed, besides all this, today is the third day since these things happened. Yes, and certain women of our company, who arrived at the tomb early, astonished us. When they did not find His body, they came saying that they had also seen a vision of angels who said He was alive. And certain of those who were with us went to the tomb and found it just as the women had said; but Him they did not see.'

The 'stranger' was surprised at his companions' failure to understand, and explained that Christ's suffering had been prophesied in the Old Testament. Still they failed to recognize him.
Then they drew near to the village where they were going, and He indicated that He would have gone farther. But they constrained Him, saying, 'Abide with us, for it is toward evening, and the day is far spent.' And He went in to stay with them. Now it came to pass, as He sat at the table with them, that He took bread, blessed and broke it, and gave it to them. Then their eyes were opened and they knew Him; and He vanished from their sight. / LUKE 24:15–24, 28–31

The fruit in the basket, which forms a still life in itself, includes grapes, pomegranates and figs. Critics have pointed out that these are summer fruits and are out of place in a scene that took place around Easter. But the overripe apples and decaying figs stand for original sin, while the pomegranate and the grapes (alluding to wine) are conventional symbols of Christ's Resurrection.

This disciple raises his arms in a gesture that recalls the figure of Christ on the Cross. His left hand extends into the observer's space as if to draw us into the scene. The scallop pinned to his chest – a pilgrim's emblem associated with Santiago de Compostela – is named after Saint James (Santiago) in several languages.

Caravaggio illustrated the moment at the end of the story when the young, beardless 'stranger' raised his right hand in benediction – he did not break the bread – and the astonished disciples, recalling Christ's blessing of the bread at the Last Supper, finally realized who he was (see p. 112). The innkeeper stands beside them. Here, and in many other of his works, Caravaggio represented a biblical scene in a contemporary everyday setting, thus departing from the artistic tradition. The disciples, for instance, look like country bumpkins on a pilgrimage. The background is dark and the lighting dramatic, so that all attention is focused on the characters.

Christ pulls back his clothes and guides Thomas' calloused index finger towards the spear wound inflicted in his right side during his Passion on the cross (see p. 130). Thomas' dirty fingernails heighten the harsh naturalism of the scene. The wound on Christ's hand – small and barely visible in Caravaggio's painting – is another of the stigmata that Thomas demanded to see.

THE LEGENDARY THOMAS

Thomas was the subject of many apocryphal stories and medieval legends. According to one of them, he expressed doubts about Mary's Assumption, as he had not witnessed the event with his own eyes. Another legend introduces him as the twin brother of Jesus – he was known as 'the Twin' – and for that reason he was portrayed as a relatively young man. Thomas was often shown with an attribute that identified him as an architect. According to the apocryphal Acts of Thomas (4th century), he went to preach the gospel in India, where a heathen king commissioned him to build his palace.

CHRIST AND THOMAS

Caravaggio, 1573–1610
The Incredulity of Thomas, 1603
Canvas, 107 x 146 cm
Neues Palais, Potsdam

This event took place shortly after Christ's death and resurrection. Thomas, one of the disciples, doubted what he had heard about but not seen with his own eyes: that Christ was risen from the dead.

Then, the same day at evening, being the first day of the week, when the doors were shut where the disciples were assembled, for fear of the Jews, Jesus came and stood in the midst, and said to them, 'Peace be with you.' When He had said this, He showed them His hands and His side. Then the disciples were glad when they saw the Lord. So Jesus said to them again, 'Peace to you! As the Father has sent Me, I also send you.' And when He had said this, He breathed on them, and said to them, 'Receive the Holy Spirit. If you forgive the sins of any, they are forgiven them; if you retain the sins of any, they are retained.' Now Thomas, called the Twin, one of the twelve, was not with them when Jesus came. The other disciples therefore said to him, 'We have seen the Lord.' So he said to them, 'Unless I see in His hands the print of the nails, and put my finger into the print of the nails, and put my hand into His side, I will not believe.' And after eight days His disciples were again inside, and Thomas with them. Jesus came, the doors being shut, and stood in the midst, and said, 'Peace to you!' Then He said to Thomas, 'Reach your finger here, and look at My hands; and reach your hand here, and put it into My side. Do not be unbelieving, but believing.' And Thomas answered and said to Him, 'My Lord and my God!' Jesus said to him, 'Thomas, because you have seen Me, you have believed. Blessed are those who have not seen and yet have believed.'

/ JOHN 20:19–29

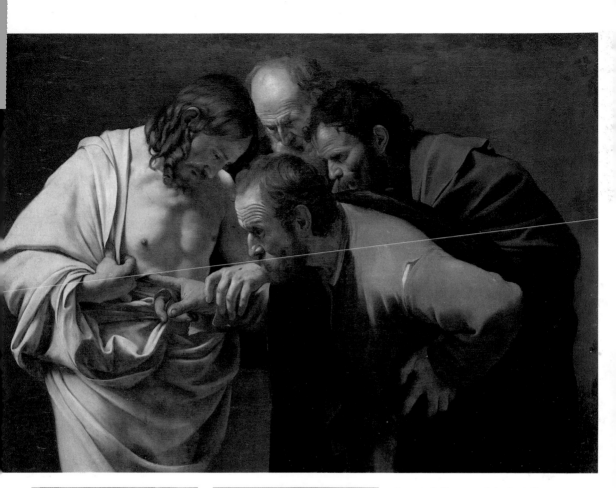

Thomas' eyes widen, he raises his eyebrows and frowns. His taut left hand is another sign of his apprehension.

Most paintings of this subject include two of Christ's disciples. They are identified as Peter and John, although the gospels give no reason to draw this conclusion. They, too, look on with intense concentration.

As usual, Caravaggio's depiction of this episode from the gospel is stunningly realistic and lifelike, with nothing extraneous to distract our attention. The characters are set against a plain, dark background. Thomas' prodding hand graphically expresses the words he speaks in the Book of John: 'Unless I ... put my hand into His side, I will not believe.' For obvious reasons, this is the moment that artists most often represented. It also reflects the humanist and scientific outlook of the time, when empirical knowledge was seen as the only key to truth.

The reported number of witnesses to the Ascension ranges from eleven to fourteen: there were the apostles (without Judas, but in some cases with his successor), and Paul, who, though not one of the disciples, is sometimes present, and so was the Virgin, as she is here. The kneeling apostles are more restrained than in later paintings of the same subject.

The flowing lines of Christ's body and his hands extending beyond the upper edge of the fresco suggest an upward movement. Some paintings include an image of God's hand, or a dove representing the Holy Spirit, and some show only Christ's legs or feet.

Giotto, c. 1267–1337
The Ascension of Christ, 1304–06
Fresco, 185 x 200 cm
Scrovegni Chapel, Padua

Forty days after his resurrection, Christ told the apostles that the Holy Spirit would come upon them and give them the power to bear witness to him all over the world (see p. 150).

Now when He had spoken these things, while they watched, He was taken up, and a cloud received Him out of their sight. And while they looked steadfastly towards heaven as He went up, behold, two men stood by them in white apparel, who also said, 'Men of Galilee, why do you stand gazing up into heaven? This same Jesus, who was taken up from you into heaven, will so come in like manner as you saw Him go into heaven.' / ACTS 1:9–11

The gospel account of Christ's ascension – told by Luke, who may also have been the author of the Book of Acts – is even shorter and less spectacular. It ends as follows:

And He led them out as far as Bethany, and He lifted up His hands and blessed them. Now it came to pass, while He blessed them, that He was parted from them and carried up into heaven. And they worshipped Him, and returned to Jerusalem with great joy, and were continually in the temple praising and blessing God. / LUKE 24:50–52

Mark tells the story in two short sentences.

So then, after the Lord had spoken to them, He was received up into heaven, and sat down at the right hand of God. And they went out and preached everywhere. / MARK 16:19–20

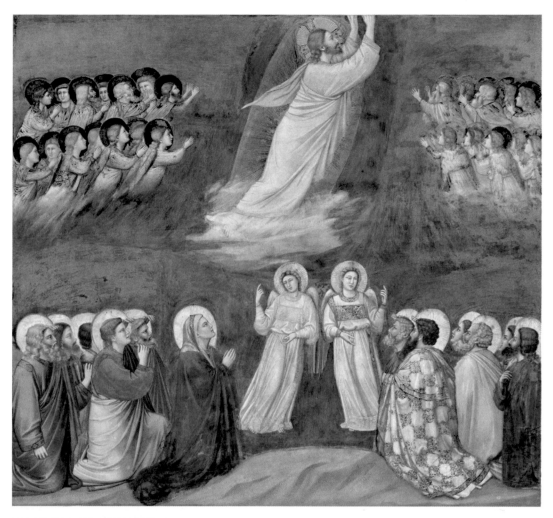

Choirs of angels and all whom
the Old Testament refers to
as 'the just' venerate Christ
as he ascends to heaven.

Brief as it may be, the account in the Book of Acts
includes a number of details that captured the
imagination of Giotto and various painters after him:
the cloud that shrouded Christ, the apostles gazing
up to heaven, and the two men in white robes (with the
wings of angels). From later legends came the notion
that the incident took place on the Mount of Olives,
and that Christ's last footprints could still be seen
there. According to Christian doctrine Christ's
triumphant return to his Father was the ultimate
proof of his divinity.

Peter is in the centre of the group of disciples who, as of this moment, become the apostles, or messengers. He was associated with the foundation of the Church and was assigned that role by Christ. He was the first to speak after this episode. The Virgin, who personified the Church, appears in many scenes of Pentecost, for in an earlier passage in the Book of Acts she was said to have been present with the apostles. However, she is not shown in Giotto's painting.

CHRIST / PENTECOST

Attributed to Giotto, c. 1267–1337
Pentecost, c. 1306–12
Panel, 45 x 44 cm
The National Gallery, London

The disciples gathered together fifty days after Christ's resurrection and ten days after his ascension to heaven. When the Day of Pentecost had fully come, they were all with one accord in one place. And suddenly there came a sound from heaven, as of a rushing mighty wind, and it filled the whole house where they were sitting. Then there appeared to them divided tongues, as of fire, and one sat upon each of them. And they were all filled with the Holy Spirit and began to speak with other tongues, as the Spirit gave them utterance. And there were dwelling in Jerusalem Jews, devout men, from every nation under heaven. And when this sound occurred, the multitude came together, and were confused, because everyone heard them speak in his own language. Then they were all amazed and marvelled, saying to one another, 'Look, are not all these who speak Galileans? And how is it that we hear, each in our own language in which we were born? Parthians and Medes and Elamites, those dwelling in Mesopotamia, Judaea and Cappadocia, Pontus and Asia, Phrygia and Pamphylia, Egypt and the parts of Libya adjoining Cyrene, visitors from Rome, both Jews and proselytes, Cretans and Arabs – we hear them speaking in our own tongues the wonderful works of God.' So they were all amazed and perplexed, saying to one another, 'Whatever could this mean?' Others mocking said, 'They are full of new wine.' / ACTS 2:1–13

Three figures standing outside the house represent the multitude referred to in the Book of Acts. One seems to be contemplating the apostles' words; the other two, who are clearly eavesdropping, express their amazement at the miracle.

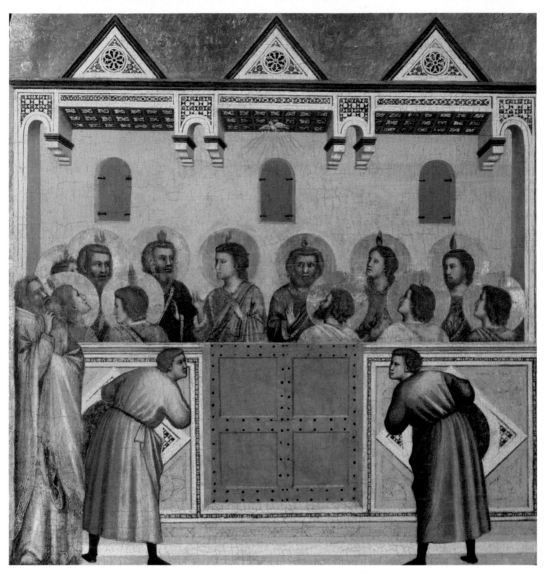

The Holy Spirit is mostly represented in the form of a dove, as is the case here. Rays of light emanate from the bird towards the apostles.

The disciples are gathered indoors, as described in the Bible, and tongues of fire have descended upon each of them. In fact, the entire room is bathed in a fiery glow. Twelve disciples are present: after betraying Christ, Judas was replaced by a new disciple, Matthias. The descent of the Holy Spirit initiated the preaching of Christ's Word and thus the birth of the Church. According to the gospels, these events occurred through divine intervention. Giotto's panel formed part of a long rectangular altarpiece showing scenes from the life of Christ. The other six scenes are dispersed in various museums in the United States and Europe. This is the only one where Christ is not present.

CIMON AND PERO

Peter Paul Rubens, 1577–1640
Caritas Romana (Cimon and Pero), c. 1630
Canvas, 155 x 190 cm
Rijksmuseum, Amsterdam

Rubens painted at least five versions of this subject. In this version he introduced prison guards looking on surreptitiously and so heightened the erotic content, while in another one he included Pero's child to help explain the story (Museum des Siergerlandes, Siegen).

Facta et dicta memorabilia (Memorable Deeds and Sayings of the Ancient Romans), *written by the Roman Valerius Maximus in the 1st century AD, is a comprehensive anthology of anecdotes on a wide range of subjects. The following passage exemplifies filial devotion.*

A magistrate had sentenced a freeborn woman for murder and committed her to the charge of the administrator to be executed in the dungeon. When she arrived there the guard was moved to pity and postponed the hour of her execution by strangulation. He allowed her daughter to visit her, but insisted that she first submit to a thorough search. She was forbidden to bring food, as the guard was counting on the prisoner dying of starvation. Some days passed and he began to wonder why she survived so long. He paid closer attention and saw that the daughter would bare her breast to still her mother's hunger with her milk. He described this extraordinary spectacle to the administrator, who in turn informed the magistrate. The magistrate recounted the tale to the judges, and as a result the prisoner received a remission.

True devotion is boundless and infinitely resourceful. Even in prison it enables us to devise new ways to save the life of the one who gave life to us. What could be more extraordinary, more difficult to conceive, than a mother nurtured at the breast of her daughter? Whoever may deem this unnatural, heed well: filial love is the cardinal law of nature. No less commendable was the devotion of Pero, whose father Cimon suffered a similar fate and was likewise confined in prison. His daughter suckled her aged father and nursed him like an infant. Yet paintings of this subject still cause viewers to flinch. / VALERIUS MAXIMUS, *Memorable Deeds and Sayings of the Ancient Romans*, 5, 4

EMULATION
The above passage quoted from Valerius Maximus is followed by a description of an antique painting of the same subject. Renaissance and Baroque artists studied the classical texts and followed such descriptions to emulate the work of famous painters like Apelles.

The story of the daughter breastfeeding her father was more popular in art than the longer account of the woman nursing her mother. In Rubens' day, this Graeco-Roman paradigm of selflessness and filial devotion came to exemplify Christian charity; hence its title, 'Caritas Romana', or Roman Charity. But that was naturally not the only reason for its popularity.

In spite of its sensual connotations, the theme is consistent with the series of the Seven Works of Mercy, three of which are illustrated here: feeding the hungry, giving drink to the thirsty, and ransoming (or visiting) the captives.

Cimon – who was also called Mykon according to other sources – sits in shackles on a bed of straw. Scattered among the stalks are a few ears of wheat, perhaps alluding to the bread that represents the body of Christ in the Roman Catholic Eucharist.

CONSTANTINE

Piero della Francesca, c. 1420–1492
Constantine's Dream, before 1466
Fresco, 329 x 190 cm
San Francesco, Arezzo

The angel, who is not mentioned in the classical texts, extends his right arm downwards and positions his hand so as not to obscure the light shining from the cross. At the same time, he indicates the person for whom the message is intended: a straight line runs from the cross to Constantine's face.

One of the most famous battles in Roman history was fought in AD 312 between the emperors Constantine and Maxentius. Constantine led his troops to victory on the Milvian Bridge over the Tiber, near Rome, and became the unchallenged ruler of the West Roman Empire. The battle is remembered mainly because Constantine attributed his success to the God of the Christians. After this incident he is said to have converted to Christianity and promoted the faith, marking a turning point in Roman history. Different accounts have been given of the events on the day before the battle. These are the two best-known versions.

As he slept Constantine received a sign that he should inscribe the sacred emblem of God on his soldiers' shields before they went into battle. Thus he did: he turned the letter X a quarter way round, turned back the upper section, and commanded his troops to display the symbol of Christ on their shields. / LACTANTIUS, *The Deaths of the Persecutors*, 44

Around noon, when the day had already begun its retreat, Constantine saw with his own eyes the cross of victory in the sky. It was a luminous apparition imposed over the sun, and with it appeared the words 'Under this sign you will triumph'. He was astonished by that sight, he told me, as were his troops behind him who witnessed the same phenomenon. By his own account, Constantine was marvelling at the event, when night fell. And while he slept Christ appeared before him and told him to inscribe the sacred sign he had seen in the sky to protect him from attacks by the enemy. At daybreak Constantine rose and revealed the vision to his friends. / EUSEBIUS, *The Life of Constantine*, 1

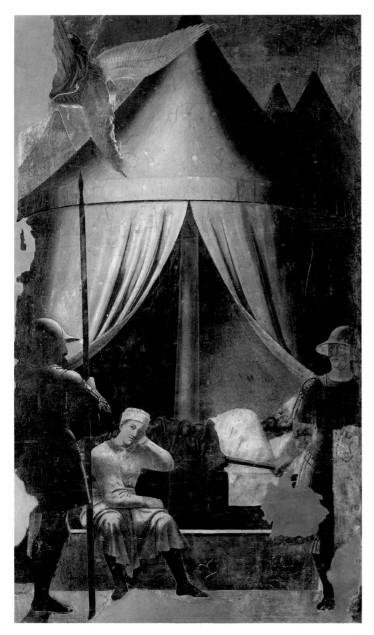

In one of the earliest frescos of a nocturnal scene, Emperor Constantine lies asleep in his tent. The tents of the camp can be seen in the darkness behind. A fore-shortened angel makes a spectacular descent from the sky; he holds a small gold cross that glows with a powerful light. Two fierce-looking sentries with lances guard the tent – one scowls in our direction – and an attendant keeps watch at Constantine's bedside. The fresco belongs to a cycle depicting the 'Legend of the True Cross'. The theme was especially popular with the Franciscans, whose founder Saint Francis had also seen a vision of the cross. Piero's source was the medieval *Golden Legend*, not the classical texts cited above.

A bored attendant keeps watch and rests his elbow on the bed while Constantine dreams his dream. He is oblivious to the vision, which only the emperor can see.

DANAË

Jan Gossaert, 1478–1532
Danaë, 1527
Panel, 114 x 95.5 cm
Alte Pinakothek, Munich

Is this a chaste Danaë like the Virgin Mary? Her conspicuously bared breast and exposed, spread legs could also be considered seductive. Gossaert's beautiful Danaë is bold rather than timid. Be that as it may, this was one of the first of a long series of paintings in which Jupiter comes down as a shower of gold and seduces the naked or semi-naked Danaë, who makes little effort to resist. Gossaert was a key figure of the Northern Renaissance movement and no doubt based his Danaë on classical examples.

The well-known myth of Danaë is mentioned only in passing by illustrious writers like Homer and Ovid, and the tragedies written about her by Sophocles and Euripides have been lost. The most comprehensive version of the story comes from the mythographer Apollodorus (1st or 2nd century AD).

When Acrisius consulted the oracle concerning the birth of male heirs, the god revealed that his daughter would bear a son who was destined to kill him. The frightened Acrisius built a room of brass under the earth [in some versions of the tale, a tower – PDR] and there imprisoned Danaë and kept her under guard. Even so, she was seduced, some say by Acrisius' brother Proetus, while others relate that Zeus turned himself into a shower of gold and streamed through the roof into Danaë's lap.

/ APOLLODORUS, *Mythology*, 2, 4, 1

The story of Danaë was kept alive during the Renaissance mainly through a description of an ancient painting of her, written by Terence, the Roman comic dramatist (2nd century BC). Though the original painting was lost, contemporary artists used Terence's description to illustrate the narrative. In The Eunuch a young man tells of his visit to a brothel, where he found the woman he loved. And there he saw the painting.

She sat in the room and gazed at a painting of Jupiter sending a shower of gold into Danaë's lap. I, too, examined it, and my heart leapt with joy to see that the mighty Jupiter had once played the same game as I had in mind: a god disguised as a mortal had stolen through another man's roof and devised a scheme to seduce his wife. And what a god! A god whose thunder shattered the heavens! Should I, a mere mortal, not do the same? Indeed I did, and with joy!

/ TERENCE, *The Eunuch*, 583–591

The Church Father Saint Augustine denounced the myths of the ancient gods and cited Terence's story as a shocking example. He argued that Jupiter's seduction of Danaë in the guise of a shower of gold implied that women would sell their virtue for money. Boccaccio held the same view.

In medieval times Danaë's congress with a shower of gold, from which she conceived the hero Perseus, was seen as a heathen equivalent of the Immaculate Conception of the Virgin Mary. In the 16th century both humanists and the Church protested against such analogies between Christian and pagan narratives. In more general terms, the story of Danaë was understood as epitomizing virtue or virtue ravaged. Many art historians interpret Gossaert's early Renaissance panel in that light, noting that Danaë, like the Virgin Mary, wears a modest blue robe and sits demurely on the ground.

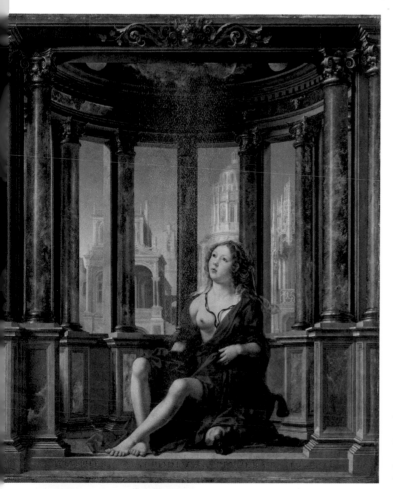

Apollodorus' Danaë was isolated in a dark cell, but Gossaert shows her in a semicircular, Renaissance-style room with windows looking onto different types of building.

The image of Danaë with her breast bared has been likened to that of the Virgin suckling the infant Christ. The difference is that the beautiful Danaë has no child to nurse. Her robe slips from her shoulder, she gazes up in wide-eyed expectation, and with her right hand guides the golden rain into her lap.

DANAË

Titian, c. 1487–1576
Danaë, 1545–46
Canvas, 120 x 172 cm
Museo Nazionale di Capodimonte, Naples

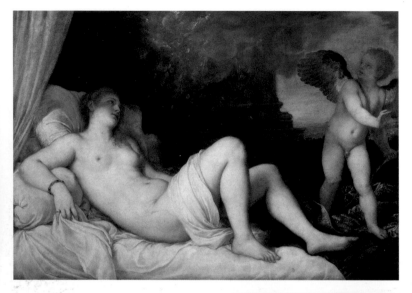

Titian's monumental reclining Danaë is a lifelike nude reminiscent of the love goddess Venus. In the 16th century, the legend of Danaë became the prototype for erotic paintings. Though moralists disapproved, the theme appealed to painters and art collectors. Danaë served as a model for some of the most sensual Old Master paintings. Her story epitomized the power of money and gold, for which women would sacrifice even their honour. This idea is expressed by artists who represented the golden rain as a shower of gold coins.

This painting was commissioned by Cardinal Alessandro Farnese, who had seen Titian's celebrated *Venus of Urbino*. Even while Titian was working on his Danaë, the papal nuncio in Venice wrote to Farnese saying that Danaë would charm even the church censor, and that the Venus of Urbino would look like a nun beside her. It has been suggested that Titian gave her the features of one of the cardinal's mistresses.

Cupid, who is not mentioned in this context in ancient literary sources, turns to leave the room. His work is done and he can now move on to pierce someone else's heart. Like Danaë, he is transfixed by the shower of gold. Titian produced several versions and variants of the subject in which he replaced Cupid with an elderly woman.

Jacopo Tintoretto, 1518–1594
Danaë, c. 1583–85
Canvas, 142 x 182 cm
Musée des Beaux-Arts, Lyon

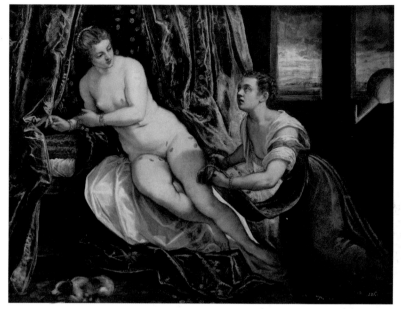

The dog lying on the floor is an ironic motif. A symbol of matrimonial fidelity, it appears here in a scene of the supreme god Jupiter committing adultery with Danaë.

A gentle touch of irony characterizes Tintoretto's treatment of several mythological subjects. His half-reclining Danaë looks faintly amused as she shamelessly counts her coins. A young maidservant stands by to assist her. Like his predecessor Titian, Tintoretto portrayed Danaë as a calculating courtesan. The beautifully rendered fabrics – silk, velvet and wool – convey a sense of wealth and elegance.

The young woman standing beside Danaë holds out her apron to receive the shower of coins. Titian had depicted an elderly woman in her place (in another version than the one reproduced on p. 158) as a foil to the beautiful young Danaë, and many painters followed his example. By introducing a young maidservant into the scene Tintoretto suggests a bond of complicity.

DANAË

Rembrandt, 1606–1669
Danaë, 1636
Canvas, 185 x 203 cm
State Hermitage Museum, St Petersburg

Rembrandt has used every trick in the book to make the scene look as natural as possible and to draw attention to the naked figure of Danaë: his winged Cupid serves merely to decorate the bed, the elderly woman has been relegated to the background, and the shower of golden rain is represented by a warm glow of light that brushes Danaë's hand and caresses her limbs. Rembrandt has transformed the moralistic tale of love for sale into a picture of a joyful woman anticipating the arrival of her beloved. His Danaë is not defenceless, submissive or promiscuous. She is one of the most sensual and lifelike nudes ever portrayed in art.

The elderly woman with Danaë was a conventional type in Rembrandt's time, though she is not mentioned in the classical literature. In art she serves as a foil to the lovely, young Danaë and alludes to the transience of carnal pleasure. In scenes of bordellos or tales of sexual favours for money an elderly woman may represent a procuress or personify greed.

Slippers are often shown in erotic scenes and allude to a woman's sex.

Giovanni Battista Tiepolo, 1696–1770
Danaë, c. 1736

Canvas, 41 x 53 cm
Universitet Konsthistoriska Institutionen, Stockholm

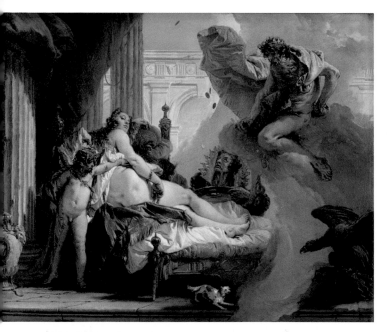

Even in ancient times the sex-for-money story of Danaë was given a burlesque twist. Tiepolo was not the first modern painter to treat the subject in the same light-hearted vein. His Danaë is a jaded, sluggish woman who flaunts her ample posterior. Cupid tries to rouse her and spur her to action. The work is a humorous parody of this once erotically tinged myth.

Danaë's little dog barks at Jupiter's eagle.

Jupiter without a disguise is a departure from the classics. It occurs in translations of Ovid's *Metamorphoses* and in a medieval handbook on mythology. Tiepolo portrays the ruler of the gods as an unattractive, weary, old man.

In an alternative version of this story Daniel was cast into the lions' den for slaying the sacred dragon of Babylon. He remained in the den unharmed for seven days.

DANIEL

Peter Paul Rubens, 1577–1640
Daniel in the Lions' Den, c. 1614–16
Canvas, 224 x 330.5 cm
National Gallery of Art, Washington, Ailsa Mellon Bruce Fund

A law was passed in Persia that any person who worshipped a god or anyone other than the king would be cast into a den of lions. The Hebrew exile Daniel, a trusted friend of the Persian king Darius, continued to worship his God, and the king, against his will, was forced to send him to the lions' den.

So the king gave the command, and they brought Daniel and cast him into the den of lions. But the king spoke, saying to Daniel, 'Your God, whom you serve continually, He will deliver you.' Then a stone was brought and laid on the mouth of the den, and the king sealed it with his own signet ring and with the signets of his lords, that the purpose concerning Daniel might not be changed. Now the king went to his palace and spent the night fasting; and no musicians were brought before him. Also his sleep went from him. Then the king arose very early in the morning and went in haste to the den of lions. And when he came to the den, he cried out with a lamenting voice to Daniel. The king spoke, saying to Daniel, 'Daniel, servant of the living God, has your God, whom you serve continually, been able to deliver you from the lions?' Then Daniel said to the king, 'O king, live forever! My God sent His angel and shut the lions' mouths, so that they have not hurt me, because I was found innocent before Him; and also, O king, I have done no wrong before you.' Now the king was exceedingly glad for him, and commanded that they should take Daniel up out of the den. So Daniel was taken up out of the den, and no injury whatever was found on him, because he believed in his God. And the king gave the command, and they brought those men who had accused Daniel, and they cast them into the den of lions – them, their children, and their wives; and the lions overpowered them, and broke all their bones in pieces before they ever came to the bottom of the den. / DANIEL 6:16–25

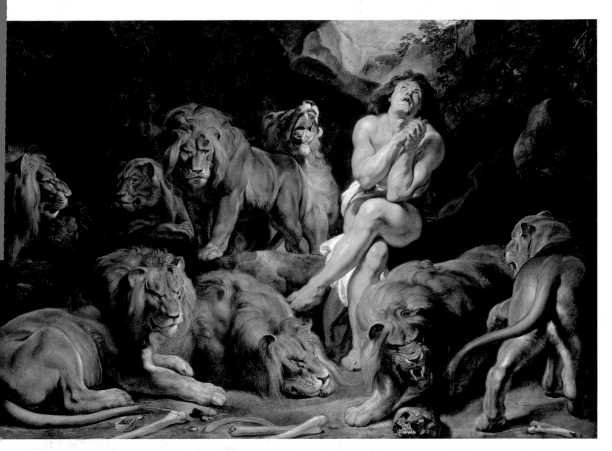

Rubens once wrote a letter saying that he had completed the work himself and that he had painted the lions 'from life'. He had been able to observe real lions in the menagerie of the Archdukes Albert and Isabella in Brussels.

The lion snarls, exposing its savage teeth. This image and the remains of earlier victims emphasize the dangers to which Daniel is exposed.

The young Daniel is seated naked among the lions. He lifts his eyes to heaven and clasps his hands in prayer. Light enters the den, so we may deduce that the stone sealing the entrance has already been removed and Daniel is about to be released by King Darius in person. The story was understood as a prefiguration of Christ's resurrection (see p. 138).

DAVID

Rembrandt, 1606–1669
David Plays the Harp for Saul, 1629–30?
Panel, 62 x 50 cm
Städelsches Kunstinstitut und Städtische Galerie, Frankfurt

Saul looks paranoid and unpredictable. His eyes are fixed on David, but he appears not to see him. This was Rembrandt's inimitable way of depicting someone suffering from a psychological condition.

Saul, the first king of Israel, suffered from bouts of melancholy.

But the Spirit of the Lord departed from Saul, and a distressing spirit from the Lord troubled him. And Saul's servants said to him, 'Surely, a distressing spirit from God is troubling you. Let our master now command your servants, who are before you, to seek out a man who is a skilful player on the harp. And it shall be that he will play it with his hand when the distressing spirit from God is upon you, and you shall be well.' So Saul said to his servants, 'Provide me now a man who can play well, and bring him to me.' Then one of the servants answered and said, 'Look, I have seen a son of Jesse the Bethlehemite, who is skilful in playing, a mighty man of valour, a man of war, prudent in speech, and a handsome person; and the Lord is with him.' Therefore Saul sent messengers to Jesse, and said, 'Send me your son David, who is with the sheep.' And Jesse took a donkey loaded with bread, a skin of wine, and a young goat, and sent them by his son David to Saul. So David came to Saul and stood before him. And he loved him greatly, and he became his armourbearer. Then Saul sent to Jesse, saying, 'Please let David stand before me, for he has found favour in my sight.' And so it was, whenever the spirit from God was upon Saul, that David would take a harp and play it with his hand. Then Saul would become refreshed and well, and the distressing spirit would depart from him.

During the festivities that were held to celebrate David's victory over Goliath (see p. 166), it became clear that David was more popular than Saul – especially with women.

So Saul eyed David from that day forward. And it happened on the next day that the distressing spirit from God came upon Saul, and he prophesied inside the house. So David played music with his hand, as at other times; but there was a spear in Saul's hand. And Saul cast the spear, for he said, 'I will pin David to the wall!' But David escaped his presence twice. Now Saul was afraid of David, because the Lord was with him, but had departed from Saul. / 1 SAMUEL 16:14–23; 18:9–12

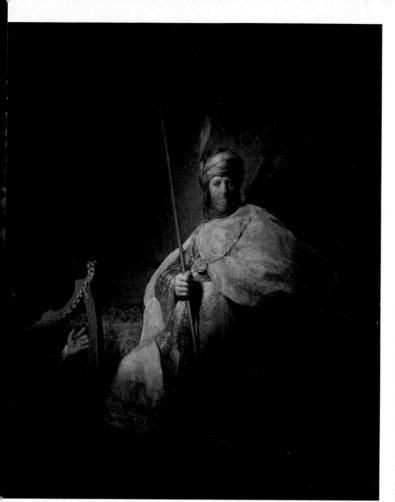

King Saul is seated on a throne, wearing the kind of turban that Rembrandt customarily used to denote a ruler from the East. He faces the viewer but never takes his eyes off David, the young musician. Though he is possessed by the 'distressing spirit', he shows no sign of violence; indeed, quite the contrary. David bows his head and runs his fingers over the strings of the harp. The painting is in poor condition and some sections have been overpainted.

The hand with which Saul clutches his spear is in the very centre of the painting. He is about to hurl it at David. In a later passage of the Bible, after David had married Saul's daughter, Saul made another attempt to 'pin David to the wall'.

Music was thought to relieve depression. The instrument David played was a harp according to the Statenbijbel (the Dutch Authorized Version of the Bible), which is the text that Rembrandt would have used. Later translations refer to either a jew's-harp or lyre. David is hidden in the shadows; only his left hand and part of the harp are illuminated.

DAVID

Caravaggio, 1573–1610
David with the Head of Goliath, c. 1607
Panel, 90.5 x 116.5 cm
Kunsthistorisches Museum, Vienna

David holds Goliath's head by the hair, which signified humiliation. The point at which the head was severed from the neck can be seen quite clearly in the painting. Caravaggio was apparently intrigued by biblical stories of decapitation. He also painted the beheading of John the Baptist at Salome's instigation (see p. 230), and the beheading of Holofernes by Judith (see p. 236).

The Philistines were at war with the Israelites, and their armies were ranked against one another.
And a champion went out from the camp of the Philistines, named Goliath, from Gath, whose height was six cubits and a span. He had a bronze helmet on his head, and he was armed with a coat of mail, and the weight of the coat was five thousand shekels of bronze. And he had bronze armour on his legs and a bronze javelin between his shoulders. Now the staff of his spear was like a weaver's beam, and his iron spearhead weighed six hundred shekels; and a shield-bearer went before him.

Each day for forty days Goliath challenged the Israelites to a duel. The young shepherd David finally agreed to the contest. Placing his faith in God, he went into battle unarmed.

Then he took his staff in his hand; and he chose for himself five smooth stones from the brook, and put them in a shepherd's bag, in a pouch which he had, and his sling was in his hand ... So it was, when the Philistine arose and came and drew near to meet David, that David hurried and ran toward the army to meet the Philistine. Then David put his hand in his bag and took out a stone; and he slung it and struck the Philistine in his forehead, so that the stone sank into his forehead, and he fell on his face to the earth. So David prevailed over the Philistine with a sling and a stone, and struck the Philistine and killed him. But there was no sword in the hand of David. Therefore David ran and stood over the Philistine, took his sword and drew it out of its sheath and killed him, and cut off his head with it. And when the Philistines saw that their champion was dead, they fled. / 1 SAMUEL 17:4–7, 40–51

David took Goliath's head to Jerusalem and placed his opponent's weapons in his tent. After winning several more battles, he was appointed captain of King Saul's army.

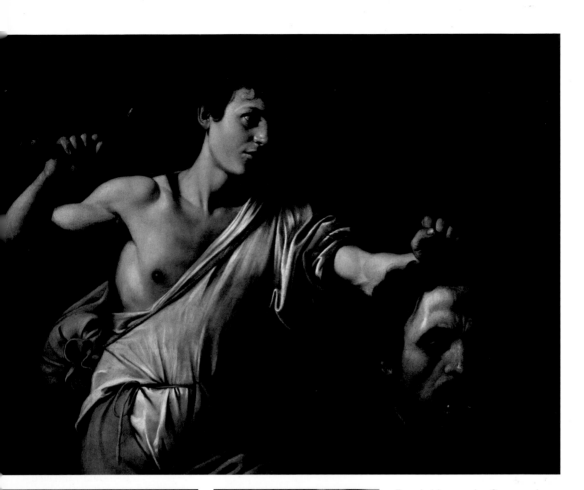

David, who is still very young, concentrates on his task, and though self-assured he is not triumphant. The sword resting on his shoulders is a weapon from Caravaggio's time. It is not the large sword that we normally associate with Goliath, the one with which David beheaded him.

David has a shepherd's bag slung over his shoulder. He wears a herdsman's clothing, while Goliath, according to the Bible, was dressed for combat.

Even in his own day Caravaggio was known for his 'provocative and lively' illustrations of episodes from the Bible. This painting is a good example. As in many of his works, the background is empty, with neither a landscape nor secondary figures. Caravaggio was apparently drawn by the gruesome ending of the contest between the Philistine giant Goliath and David, who at this point was still unknown. He made at least three paintings of this incident. The story served to remind his contemporaries of the power of God's grace. It was also understood as a prefiguration of Christ's victory over Satan.

DAVID

Peter Paul Rubens (studio), 1577–1640
David Meeting Abigail, c. 1620
Canvas, 123 x 228 cm
The J. Paul Getty Museum, Los Angeles

David is in the centre of the composition and appeals for food. The contrite Abigail appears to be offering a humble apology. But at the same time she indicates the provisions she has brought for David's men in order to atone for her husband's misconduct.

Exiled in the wilderness, David and his men appealed to the wealthy, heartless and unscrupulous Nabal for food. Nabal refused and David, who had previously treated him kindly, now sought revenge. But Nabal's beautiful and intelligent wife Abigail learned what had happened.

Then Abigail made haste and took two hundred loaves of bread, two skins of wine, five sheep already dressed, five seahs of roasted grain, one hundred clusters of raisins, and two hundred cakes of figs, and loaded them on donkeys. And she said to her servants, 'Go on before me; see, I am coming after you.' But she did not tell her husband Nabal. So it was, as she rode on the donkey, that she went down under cover of the hill; and there were David and his men, coming down toward her, and she met them. Now David had said, 'Surely in vain I have protected all that this fellow has in the wilderness, so that nothing was missed of all that belongs to him. And he has repaid me evil for good. May God do so, and more also, to the enemies of David, if I leave one male of all who belong to him by morning light.' Now when Abigail saw David, she dismounted quickly from the donkey, fell on her face before David, and bowed down to the ground. So she fell at his feet and said: 'On me, my lord, on me let this iniquity be! And please let your maidservant speak in your ears, and hear the words of your maidservant. Please, let not my lord regard this scoundrel Nabal. For as his name is, so is he: Nabal is his name, and folly is with him! But I, your maidservant, did not see the young men of my lord whom you sent. Now therefore, my lord, as the Lord lives and as your soul lives, since the Lord has held you back from coming to bloodshed and from avenging yourself with your own hand, now then, let your enemies and those who seek harm for my lord be as Nabal. And now this present which your maidservant has brought to my lord, let it be given to the young men who follow my lord.' / 1 SAMUEL 25:18-27

Nabal died a few days later after hearing what Abigail had done. Abigail married David and became one of his wives.

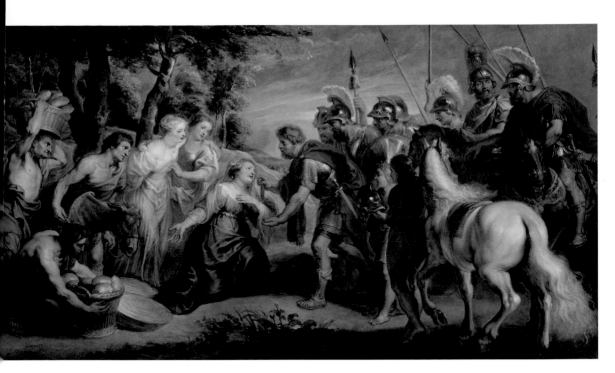

'She fell on her face before David.' Rubens depicted the moment when Abigail has just set eyes on David and starts to plead with him, but through David's response he also hints at how the story will end. David has removed his helmet and leans towards Abigail. The composition – note the barren landscape – is neatly divided in two, with Abigail's attendants on the left and David's soldiers on the right. Rubens planned and laid out the work, which his pupils and assistants subsequently completed. That was the usual practice in his workshop.

Though various provisions are mentioned in the Bible, the most striking are the baskets full of bread.

The painter followed the biblical account and depicted Abigail arriving on a donkey. David, on the other hand – at least according to Rubens – came on a white horse.

Bathsheba's maidservant, who hands her mistress a robe, is also young and beautiful. In paintings by Rembrandt and other 17th-century masters she is often portrayed as an elderly woman. In that guise she is a foil to Bathsheba and also alludes to her adultery: old women often represent matchmakers in art (cf. pp. 236, 312).

This was originally the upper left corner of the painting. Looking out from an upstairs loggia, David watches Bathsheba emerge from her bath; he gives a young servant an engagement ring to take to her. It is this detail that alerts us to the fact that the painting is more than just a picture of a wealthy 15th-century woman taking a bath. The Bible says that David saw Bathsheba when he 'walked on the roof of the king's house'.

DAVID

Hans Memling, c. 1435/40–1494
David and Bathsheba, c. 1485–90
Panel, 191.5 x 84.5 cm; 25.5 x 19.5 cm (David)
Staatsgalerie, Stuttgart

It happened in the spring of the year, at the time when kings go out to battle, that David sent Joab and his servants with him, and all Israel; and they destroyed the people of Ammon and besieged Rabbah. But David remained at Jerusalem. Then it happened one evening that David arose from his bed and walked on the roof of the king's house. And from the roof he saw a woman bathing, and the woman was very beautiful to behold. So David sent and enquired about the woman. And someone said, 'Is this not Bathsheba, the daughter of Eliam, the wife of Uriah the Hittite?' Then David sent messengers, and took her; and she came to him, and he lay with her, for she was cleansed from her impurity; and she returned to her house. And the woman conceived; so she sent and told David, and said, 'I am with child.' Then David sent to Joab, saying, 'Send me Uriah the Hittite.' And Joab sent Uriah to David. When Uriah had come to him, David asked how Joab was doing, and how the people were doing, and how the war prospered. And David said to Uriah, 'Go down to your house and wash your feet.'

David encouraged Uriah to sleep with his wife Bathsheba, hoping to conceal the fact that she was pregnant with his – David's – child. His repeated attempts to send Uriah home failed, because Uriah felt duty-bound to stay at the palace. Finally, David ordered that he be sent into battle to die. And so it was.

When the wife of Uriah heard that Uriah her husband was dead, she mourned for her husband. And when her mourning was over, David sent and brought her to his house, and she became his wife and bore him a son. But the thing that David had done displeased the Lord. / 2 SAMUEL 11:1–8, 26–27

David paid for his wrongdoing with the death of their first child. The couple's second son was Solomon.

The popular story of David and Bathsheba was understood as a warning against the abuse of power, but it also conveyed the message that the sight of a naked woman gave a man impure thoughts. Those were the reasons for illustrating precisely this episode: Bathsheba has just emerged from her bath and David watches her from a distance. In many later paintings of this subject the naked Bathsheba, in the company of her maidservants, either receives or reads a letter from David in her bath. This detail is not in the biblical account. Memling was the first painter to portray her naked and life-sized, stepping out of her bath in a stylish room. This remarkable painting formed part of a triptych. The upper left corner of the panel was removed and replaced with the present substitution (in the 17th century?). The Staatsgalerie Stuttgart later managed also to acquire the original fragment.

Small pools of water can be seen on the wooden planks of the floor, and there are also a few drops on the earthenware jar and dish. Although Memling was born in Germany, his training and work place him among the so-called Flemish Primitives, who even then were known for their attention to detail.

DIANA

Lucas Cranach the Elder, 1472–1553
Diana and Actaeon, c. 1540
Panel, 50 x 73 cm
Wadsworth Atheneum, Museum of Art, Hartford, Connecticut,
The Ella Gallup Summer and Mary Catli Collection Fund

In the background Cranach painted the scene of the hunt, which took place shortly before this episode. Four hounds pursue a herd of stags.

While resting during the hunt, Actaeon left his companions and set off alone into a wooded valley, the domain of Diana, goddess of the chase, who had sworn a vow of chastity. In the farthest reaches he came upon a secluded grotto, an idyllic pool fed by a spring.

Weary from hunting in the woods, the goddess would bathe her chaste limbs in those clear waters. She gave to one of her nymphs her spear and quiver and unstrung bow; another took the robe she cast off and laid it over her arm; two more unfastened her sandals. The most nimble gathered into a knot the locks of hair that strayed around her neck. Others collected water in brimming jars and poured it over her. But look! As Diana bathed in the waters as of old, Actaeon, wandering idly through the unfamiliar wood after the day's hunt, chanced upon that sylvan glade. At the sight of a man entering into the watery grotto, the naked nymphs beat their breasts and filled the grove with their startled shrieks. They hastened to gather around Diana to conceal her body with their own. But the goddess was taller than they, a full head taller. She blushed – she was naked! – and her nymphs pressed closer. Diana turned her eyes from the intruder and glanced over her shoulder. Would that she had an arrow to hand! Instead, she flung water into the young man's face, and as the stream she had hurled in fury soaked his hair, she uttered words that augured the tragedy to come. 'Now tell that you have seen me naked – if you can tell at all.' No further threats she made, but caused antlers to sprout from his drenched head. She made his neck longer, and gave him pointed ears. His hands turned into hoofs, his arms into lanky legs; his body she covered with a dappled hide, and made him as timid as a deer. / OVID, *Metamorphoses*, 3, 163–198

Bereft of speech, Actaeon fled. But his hounds, taking him for prey, fell upon him and tore him limb from limb.

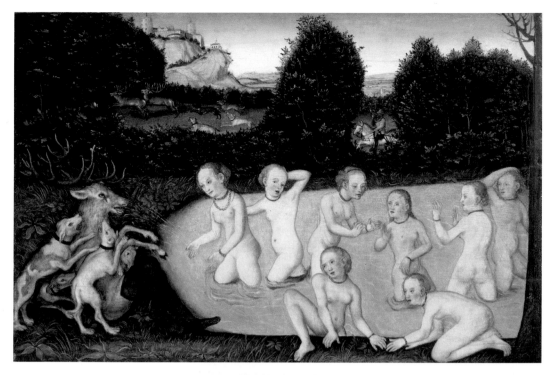

Cranach's painting is a conventional representation of the tale of Diana and Actaeon. Diana and her nymphs are taken by surprise while bathing naked in a pool. The goddess flings water at Actaeon, whose head, torso and arms have already turned into those of a stag. He is attacked by his four hounds. Like the Judgement of Paris (see pp. 281–283), the tale of Diana and Actaeon gave artists a pretext to paint female nudes in different poses and from different angles. The theme is tragic. According to Ovid, Actaeon was innocent – he is sometimes cast as a voyeur – but through Diana he suffered a terrible fate.

Actaeon is rarely shown at such an advanced stage of his metamorphosis. We normally see him with horns just starting to sprout from his head. Notwithstanding his plight, his gaze – like ours – remains fixed on the wondrous vision in the pool.

Diana's hair is bound up and beautifully arranged, but Cranach left out many of the details in Ovid's text so as not to draw attention away from the main subject.

DIANA

Titian, c. 1487–1576
Diana and Actaeon, 1559
Canvas, 188 x 206 cm
National Gallery of Scotland, Edinburgh, on loan from the Collection of the Duke of Sutherland

The stag's head with antlers, directly opposite Actaeon, hints at the terrible fate that awaits him. Titian used this ingenious device to show how the story unfolds. With his gaze fixed on the skull rather than on Diana, Actaeon raises his arm as if to ward off danger.

Titian's unique representation of the tale of Actaeon was never emulated by other artists. It is a dramatic rendering of the moment when Actaeon, accompanied by a hound, first sets eyes on Diana. For once, it is not the scene where Diana punishes him, or where he turns into a stag. Titian focused on a single moment in the narrative, whereas most paintings of the subject depict a sequence of events. The idyllic setting includes both natural scenery and man-made structures.

Diana's attribute is a crescent moon, which can be seen here in her hair. She may also personify the moon. Her nymphs are startled, except for one who is not yet aware of Actaeon's presence. The dog barks at the intruder. Diana's pale skin is offset by the dusky complexion of her black maid.

Rembrandt, 1606–1669

Diana Surprised by Actaeon and the Discovery of Callisto's Shame, 1634

Canvas, 73.5 x 93.5 cm
Museum Wasserburg Anholt, Fürst zu Salm-Salm Collection

There are many parallels between the tales of Actaeon and Callisto (see p. 176). In both cases the goddess Diana punishes what she perceives to be a threat to her chastity. Both are also woodland scenes with nudes bathing. Titian had previously depicted the two scenes in a pair of pendant paintings. Rembrandt went a step further and combined them in this unique iconographic hybrid.

Diana, with a crescent moon in her hair, is about to hurl water at Actaeon. She has no other weapon to hand. Her nymphs scramble ashore in panic. Scenes incorporating numerous small female nudes were popular in Rembrandt's time, but this is his only known work of that genre.

Actaeon is often depicted with horns sprouting from his head. We see him here at the very start of his metamorphosis, raising his arms in dismay. In the 17th century a moral was ascribed to the tale: Actaeon succumbed to lust and so brought about his own downfall. In short, he himself was to blame. Though this is not the sentiment expressed by Ovid, it infiltrated the translations of *Metamorphoses* of Rembrandt's time.

DIANA

Titian, c. 1487–1576
Diana and Callisto, 1556–59
Canvas, 188 x 203 cm
National Gallery of Scotland, Edinburgh

A striking motif in the painting is the fountain in the form of a cupid on a tall pedestal emptying a jar of water. It is mentioned by Ovid, but in a far shorter version of the story of Callisto: 'A tall fountain issuing fresh water stood in the middle of the glade.'

Callisto, an attendant of the chaste Diana, the goddess of hunting, has stopped to rest in a wood. Jupiter is charmed by her.

He caught sight of her, weary and vulnerable. 'This secret dalliance,' he thought, 'my wife will never suspect. And should she discover it, why, the prize is well worth a quarrel.' Not a moment passed but he assumed the guise of Diana, her appearance and even her clothes, and turned to Callisto saying, 'Oh nymph and companion, on what mountain slopes have you pursued your quarry?' Callisto rose from the grass. 'Greetings, Diana,' she said, 'you who are more to me even than Jupiter – and I care not if he hear my words.' Jupiter smiled, for it pleased him to be preferred above himself. And then he kissed her, but he did so with an abandon no nymph would display. And as she began to tell where she had hunted, he stemmed the flow of her words, clasping her to his breast and so betraying his guilty purpose. She resisted, at least, as well as a woman could, and wrestled, but to no avail. No one could triumph over Jupiter, let alone a nymph. Jubilant, he returned to the heavens, while she cursed the forest and woods that had witnessed her shame.

Nine months later …

Nine moons had waxed when Diana, worn out from hunting in the heat of the sun, saw a cool place to rest in the wood. She sat where a murmuring brook rippled over smooth, water-worn pebbles. The place pleased her and she dipped her toes in the stream – how sweet to the touch! 'None can see us,' the goddess said, 'let us bathe here and feel the waters flow over our naked limbs.' Callisto blushed. Her comrades disrobed, while she alone held back, hesitant and filled with misgivings. But nymphs stripped off the robe that covered her, exposing her body and revealing her indiscretion for all to see. Even before the frightened girl could cover her belly with her hands, Diana cried out, 'Be gone! This sacred stream shall not be tainted.' And so saying, she banished Callisto from her companions forever. / OVID, *Metamorphoses*, 2, 422–440, 453–465

After the child's birth, Jupiter's jealous wife Juno turned Callisto into a bear with a woman's heart and mind. Years later, when the boy was about to kill her during a hunt, Jupiter intervened and transformed mother and son into a constellation of stars.

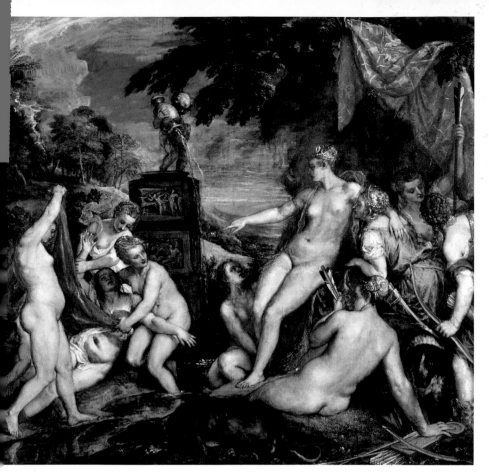

The story of Callisto could be encapsulated in a single scene. Callisto's swollen belly reveals her shame, the nymphs tearing off her clothes express condemnation, and Diana stands ready to punish her.

Is Diana pointing an accusing finger at Callisto? Is she sending her away, as Ovid writes? Or is she ordering her nymphs to undress the girl, which does not occur in Ovid's account? Titian described the painting as 'Callisto, carrying Jupiter's child, being undressed at the fountain on Diana's instructions'. Diana's hand is in the centre of the composition.

Titian illustrated the dramatic moment when the nymphs undress Callisto – here, by force, though other artists focused more on her shame – and Diana realizes that the girl is pregnant. This version of the story, which was disseminated in the form of prints, had a tremendous influence on the scores of painters who depicted the subject after Titian, many of them in Holland. This was the most frequently represented episode. The observer becomes a voyeur. In the literature of the 16th and 17th centuries the punishment imposed on the 'unchaste' Callisto was often deemed to be justified.

DIDO

Simon Vouet, 1590–1649
The Death of Dido, c. 1642
Canvas, 215 x 170 cm
Musée Municipal, Dole

'Dido tried to lift her heavy eyes', and 'Her eyes strayed, seeking the light of the sun in the heavens': Vouet sought to capture these words on canvas. But there is nothing to be seen of Dido's wound or the copious flow of blood that Virgil speaks of. That would have been inconsistent with the decorum of the grand style, of which Vouet, as 'premier peintre du roi', was the leading exponent.

Queen Dido of Carthage was distraught when her beloved Aeneas left her and her city on the orders of the gods. She asked her sister Anna to have a pyre built in the gardens of the palace, ostensibly to burn everything that belonged to the Trojan who had betrayed her. But in the end it is she who hurls herself on the funeral pyre, brandishing Aeneas' sword and uttering a final curse.

Even as she spoke these words, her comrades saw how she threw herself upon her sword, now frothing with blood which stained her hands. A cry echoed through the lofty halls, and word of the calamity passed from mouth to mouth throughout the stunned city. Every home resounded with lamentations and the wails and sighs of the women; the very air was filled with loud commiseration. Dido's sister Anna heard the mourning and hastened breathlessly to the scene, trembling and fearful. On seeing Dido, she clawed at the skin of her cheeks and beat her breast. Forcing her way through the crowd, she cried out to her sister in the throes of death.

And so Anna understood that the pyre had been built for Dido's body.

'Bring water that I may wash her wounds, that her last breath may cling to my lips.' With those words she mounted the last steps, clasped her dying sister in her warm arms and, as she wept, dabbed the dark blood with her garments. Dido tried to lift her heavy eyes to look upon Anna, but the effort was too great and she closed them with a whimper; the wound ached in her breast. Twice, and yet again, she managed to raise her body, supporting her weight on her elbow, and thrice fell back on her bed. Her eyes strayed, seeking the light of the sun in the heavens, and when she saw it she uttered a sigh.

The goddess Juno took pity and decided to release Dido from her agony. To do so, a lock of hair had to be cut from Dido's head.

On wings of saffron Iris descended from the heavens, laden with dew that left a trail of a thousand colours in her wake, reflecting the radiance of the sun. She sat close to Dido and spoke to her, saying: 'I am sent to take a lock of your hair for Hades, the god of the underworld, and so deliver you from your body.' With her right hand she took a curl and cut it from Dido. As she did so, the last whisper of warmth fled from Dido's body and her life wafted away on the wind.
/ VIRGIL, *The Aeneid*, 4, 663–705

The melodramatic story of Dido's suicide was an ideal subject for a baroque painting, where the primary aim was to depict powerful emotions. For that reason, the subject was often represented in the 17th century. In Vouet's painting, the drama is played out by four characters under an oppressive canopy of black cloth. From left to right, they are the divine messenger Iris, the dying Dido supported by her old nurse, and her distraught sister Anna. A few scattered twigs suggest the funeral pyre.

Iris, the messenger of the gods who has just descended to earth, looks like an angel of death. She appears to be preparing to cut a lock of Dido's hair: this was an ancient symbol of death. Dido will die in a matter of seconds.

In Virgil's account, Dido had said that the pyre was intended to burn Aeneas' weapons and everything that reminded her of him. In the painting, Iris appears to be trampling his shield underfoot.

In the distance we see Aeneas setting sail from Carthage on his way to Italy, where the gods have ordered him to found a new empire. For him, duty came before love.

Most paintings show the child with a serpent's body from the waist down, like the illustrations in many editions of *Metamorphoses*. Jordaens leaves the question open.

ERICHTHONIUS

Jacob Jordaens, 1593–1678
The Daughters of Cecrops Discovering Erichthonius, 1617
Canvas, 172 x 283 cm
Koninklijk Museum voor Schone Kunsten, Antwerp

The god Hephaistos ravished the goddess Athena but his seed spilled to the ground, and from that strange union was born the child Erichthonius. Apollodorus and Ovid give different accounts of what happened next.

Athena nursed the child without the knowledge of the other gods and desired him to be immortal. She placed him in a basket and entrusted him to Pandrosos, the daughter of Cecrops, whom she forbade to open the basket. But Pandrosos' sisters, overcome with curiosity, peeped into the basket and beheld a serpent coiled beside the infant. Some say they were killed by the serpent, others that Athena's rage drove them to madness and that once they were no longer in possession of their wits, they threw themselves to their death from the Acropolis. / APOLLODORUS, *Mythology*, 3, 14, 6

Erichthonius, the infant who never knew a mother's womb, was taken by Athena. She placed him in a wicker basket and entrusted him to the three daughters of Cecrops, a creature half mortal, half snake. Athena forbade the daughters to set eyes on the basket's secret charge. Two of the daughters, Herse and Pandrosos, heeded her command, but the third, Aglauros, taunted her sisters and called them faint-hearted. Once she had unfastened the knots, the sisters looked into the basket and there saw an infant and, beside him, a monstrous serpent. / OVID, *Metamorphoses*, 2, 552–561

According to Ovid, Athena heard from a crow that the sisters had disobeyed her. Herse was later to be loved by the god Mercury, while her sister Aglauros, as a punishment from Athena, pined away from jealousy and finally turned into stone.

Erichthonius became the king of Athens. Cecrops was the mythical founder of the city. Both were born of the soil of Athens. The lower half of Cecrops' body resembled that of a snake, and in some versions of the myth, including several translations of Ovid, the same was true of Erichthonius.

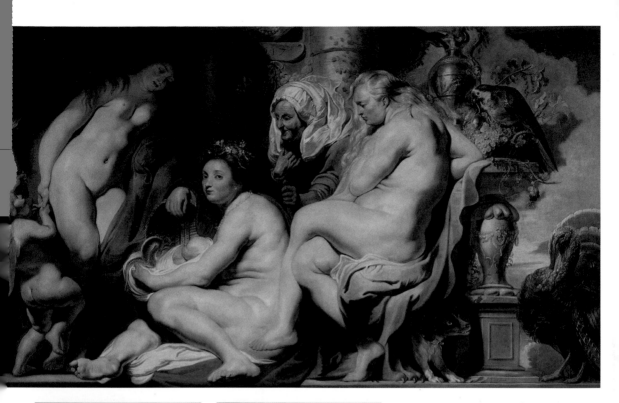

The scarlet drapery and the motif of Cupid holding his burning torch allude to the following episode in Ovid's tale, in which Herse falls in love with the god Mercury.

Part of the appeal of this story was that it gave artists an opportunity to paint the voluptuous nude figures that epitomized the prevailing ideal of beauty. The elderly woman was an addition by Rubens, which Jordaens subsequently copied. Artists relished the challenge of representing the contrast between youth and old age.

Paintings exist of both versions of the story. In one variant, the sight of the snake fills the sisters with horror and dismay. In the other, which corresponds to Ovid's text, they respond with a mischievous smile. This is the version that Rubens represented, and the younger Jordaens followed his outstanding example.

ESTHER

Jan Lievens, 1607–1674
The Feast of Esther,
1625–26
Canvas, 134.5 x 165 cm
North Carolina Museum of Art, Raleigh

Ahasuerus' turban and extravagant robes identify him as ruler from 'the East', at least in the minds of Rembrandt and his contemporaries. The king glares at Haman in fury.

King Ahasuerus, who ruled over Babylon when the Israelites lived there in exile (5th century BC), married the Jewish Esther. His minister Haman conspired to annihilate the Israelites and issued a decree to that effect in Ahasuerus' name. Esther heard about the plot from her cousin Mordecai and twice she invited Ahasuerus and Haman to a banquet of wine.

So the king and Haman went to dine with Queen Esther. And on the second day, at the banquet of wine, the king again said to Esther, 'What is your petition, Queen Esther? It shall be granted you. And what is your request, up to half the kingdom? It shall be done!' Then Queen Esther answered and said, 'If I have found favour in your sight, O king, and if it pleases the king, let my life be given me at my petition, and my people at my request. For we have been sold, my people and I, to be destroyed, to be killed, and to be annihilated. Had we been sold as male and female slaves, I would have held my tongue, although the enemy could never compensate for the king's loss.' So King Ahasuerus answered and said to Queen Esther, 'Who is he, and where is he, who would dare presume in his heart to do such a thing?' And Esther said, 'The adversary and enemy is this wicked Haman!' So Haman was terrified before the king and queen. Then the king arose in his wrath from the banquet of wine and went into the palace garden; but Haman stood before Queen Esther, pleading for his life, for he saw that evil was determined against him by the king. When the king returned from the palace garden to the place of the banquet of wine, Haman had fallen across the couch where Esther was. Then the king said, 'Will he also assault the queen while I am in the house?' As the word left the king's mouth, they covered Haman's face. Now Harbonah, one of the eunuchs, said to the king, 'Look! The gallows, fifty cubits high, which Haman made for Mordecai, who spoke good on the king's behalf, is standing at the house of Haman.' Then the king said, 'Hang him on it!' So they hanged Haman on the gallows that he had prepared for Mordecai. Then the king's wrath subsided. / ESTHER 7:1-10

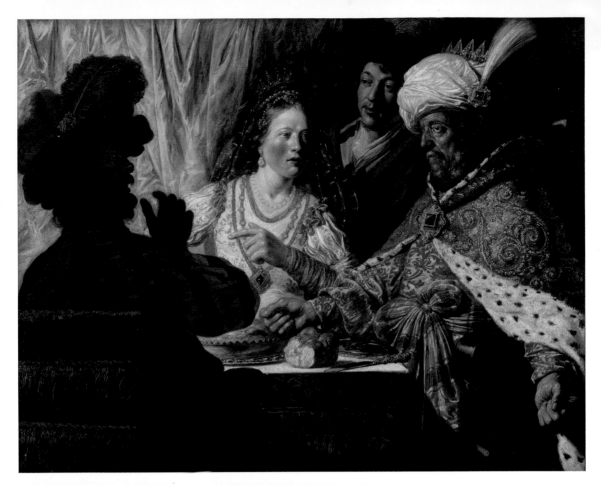

This is the eunuch Harbonah from the Bible, who proposed that the king should hang Haman from the gallows that he himself had erected for the Israelite Mordecai.

Haman – viewed from the back and in shadow – suddenly grasps the full implications of his predicament and draws back in fear. His exotic, flamboyantly plumed hat marks him as a man not to be trusted.

The banquet takes place in an opulent setting. Lievens shows the dramatic moment when Esther, bathed in light, points an accusing finger at Haman, the man who was planning to destroy her nation. King Ahasuerus clenches his fists in rage. The story was extremely popular in the Dutch Golden Age. It struck a chord with Protestants in the Northern Netherlands who had been struggling under the yoke of Catholic Spain. They could identify with the people of Israel and relate to this tale of liberation. Like Rembrandt, to whom this painting was formerly attributed, the talented young Jan Lievens lived in Leiden, and the two artists sometimes worked together.

EUROPA

Titian, c. 1487–1576
The Rape of Europa, 1562
Canvas, 185 x 205 cm
Isabella Stewart Gardner Museum,
Boston

'Dolphins gambolled and cupids romped all about the beast.'
These words are not from Ovid's text, but from a detailed account of a classical painting of the abduction of Europa, by the Greek novelist Achilles Tatius (2nd century AD). Titian may have used an Italian version of that work, translated by his friend Lodovico Dolce, as his main or perhaps secondary source. There, he could have read, for instance, 'Her tunic was white, her robe deep red.' The putto on the back of a dolphin echoes the figure of Europa on the bull and is also an erotic symbol.

Jupiter was infatuated with Europa.
Jupiter called his son Mercury aside, but the words he spoke betrayed no hint of his amorous thoughts. 'My son,' he said, 'faithful agent of my will, take wing and descend to the land known to its people as Sidon. There, you will see from afar the king's herds grazing in the mountain meadows. Drive them to the seashore.' No sooner had he spoken than the bulls, heeding his words, started to amble down the slopes to the strand, where the king's daughter was wont to play with her companions from Phoenicia. But love and awe are ill matched, and so the father and lord of the gods set his weighty sceptre aside and assumed the guise of a strapping bull. Lowing, he merged and mingled with the herd, beside them treading the soft grass. His hide was the colour of pristine snow, his neck powerful, and dewlaps hung from his shoulders. His horns, not large, could have been crafted by hand, so pure and more lustrous than gemstones. No threat from his brow nor rage in his eyes, his head proclaimed the mildness of his nature. Europa was dazzled by his beauty and gentle disposition. Yet, docile as he was, she dared not touch him at first. Soon she grew bolder and drew closer, holding flowers to his white lips. His heart leapt with joy and love – the one he yearned for was approaching! He kissed her hands and could barely restrain his desire. He capered about her, gambolled in the grass, and nestled his snow-white body in the golden sand. Her fear left her. He offered his body for her to caress – oh, the touch of her maiden's hands – and his horns for her to garland with flowers. Bolder still, but yet unaware of who he was, the princess mounted the bull's back. Stealthily, the god rose, left behind the land and the dry shore, and planted his faithless hoofs in the shallow waves. Further he went, and further still, carrying his prize into the open sea. Fear filled Europa's heart as she gazed behind her and saw the shore receding in the distance. Her right hand clutched his horn, her left rested upon his back. Her robe fluttered in the breeze. / OVID, *Metamorphoses*, 2, 836–875
The journey ended in Crete, where Jupiter assumed his true identity and ravished Europa.

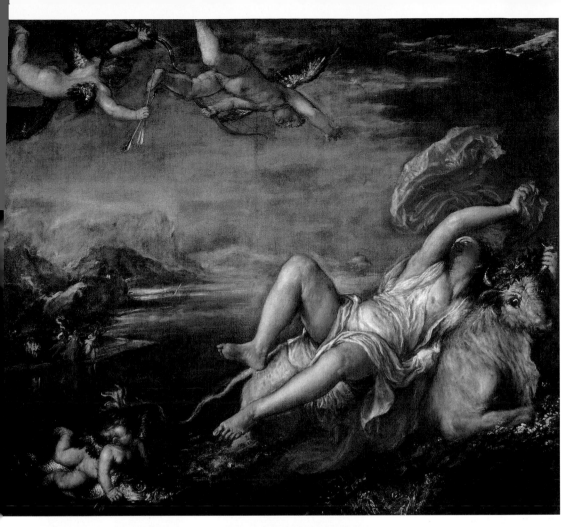

Europa's companions on the beach throw their arms up in astonishment.

Europa looks frightened, but at the same time enraptured. She gazes at the 'armed' cupids flying behind the strange couple. They lighten the tone of an otherwise sombre story.

The abduction of Europa by the 'bull' Jupiter was a popular subject in art. Titian's unrivalled work was painted for Philip II of Spain. It was original and influential, and several artists, including Rubens, copied the composition. Europa is mounted precariously on the bull's back. She usually sits with her legs to one side, like an Amazon.

EUROPA

Paolo Veronese, c. 1528–1588
The Rape of Europa, c. 1580
Canvas, 240 x 307 cm
Palazzo Ducale, Venice

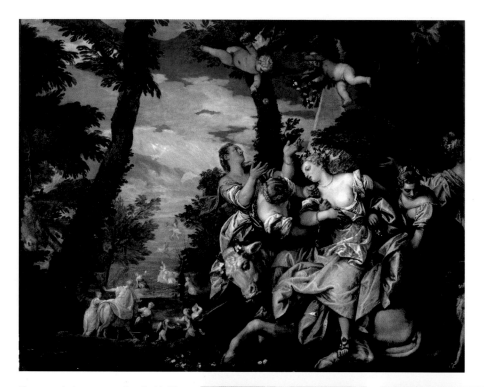

Veronese's interpretation is idyllic compared to Titian's violent scene (p. 185). In the foreground of his narrative painting we see a dazed-looking Europa being helped on to the bull's back. In the middle ground, the bizarre couple head for the sea; further in the distance they disappear into the ocean. The scene is set on a wooded hillside. The work owes its vibrancy to the hovering putti and Europa's sumptuously dressed companions, each in a different pose. This is one of Veronese's most celebrated paintings. The composition was often copied even in the 16th century.

The bull licks – or kisses – Europa's left foot, adding an erotic note to the scene. He has wreaths of flowers around his horns, as Ovid writes.

Europa, now in the water and struggling fiercely, looks back to the shore, as Ovid describes. She has apparently just realized what is happening to her.

Jacob Jordaens, 1593–1678
The Rape of Europa, 1643
Canvas, 172 x 190 cm
Palais des Beaux-Arts, Lille

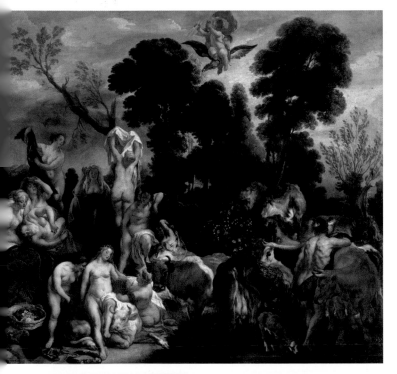

Jordaens chose a quiet moment from the story of Europa: with the help of her voluptuous companions, Europa mounts the back of the docile bull. The right half of the canvas is devoted to the herd belonging to Europa's father. According to Ovid, the animals left the mountain slopes and came down to the coast. The story could be rendered as a secular scene full of nudes, but it could also be interpreted in Christian terms: God (the 'bull' Jupiter) transports the human soul (Europa) to a new world. Jordaens painted several versions of the subject.

Jupiter has sent Mercury to drive the herd to the coast. Though we see him from the back, he can be recognized by his winged cap and caduceus (see also pp. 253, 282).

Cupid hovers over the events unfolding on earth. He sits on an eagle and holds a bolt of lightning, which are normally the attributes of Jupiter, the father of the gods. But at the moment Jupiter, disguised as a bull, has other things on his mind.

GANYMEDE

The eagle strokes Ganymede's arm with his beak to allay his fears. The boy looks as light as a feather in the bird's grasp. The challenge facing artists was to produce a convincing representation of this extraordinary tale of a bird abducting a boy or young man.

Ganymede clings to the bird with both hands, and turns to face the viewer. The bird and the boy are as one, with the dark eagle offsetting the boy's alabaster complexion. The faces of both Ganymede and Io appear to have been based on the same model (see pp. 214–215).

Correggio, c. 1490–1534
The Abduction of Ganymede, c. 1530
Canvas, 163.5 x 74 cm
Kunsthistorisches Museum, Vienna

It happened that Jupiter, the father of the gods, was consumed with love for the Phrygian Ganymede. He contrived to appear not as himself, but in a guise that he preferred to his own. No mere bird would he deign to be save for the one mighty enough to bear his bolts of lightning. Losing no time, he soared through the heavens, his feigned wings cleaving the air, and swept up the Trojan. To this day Ganymede blends the liquor in Jupiter's cup and pours him nectar, under Juno's reproachful eye. / OVID, *Metamorphoses*, 10, 155–161

Ganymede features in several of Lucian's Dialogues of the Gods *(2nd century AD). This light-hearted series of satirical exchanges often targets the classical myths. The following passage is the opening of a conversation between Zeus and Ganymede.*

Zeus: Come, Ganymede, we have reached our journey's end. Now, at last, will you kiss me? For then you shall see that I no longer have a hooked beak, or sharp claws, or wings, as when I came to you in the guise of a bird.
Ganymede: But ... were you not a moment ago an eagle that swooped down and stole me from my herd? How can it be? Your wings have vanished into thin air and your appearance is entirely changed.
Zeus: Dear boy, you see before you neither mortal nor eagle. Before you stands the king of the gods. I appeared this once in disguise. / LUCIAN, *Dialogues of the Gods*, 4

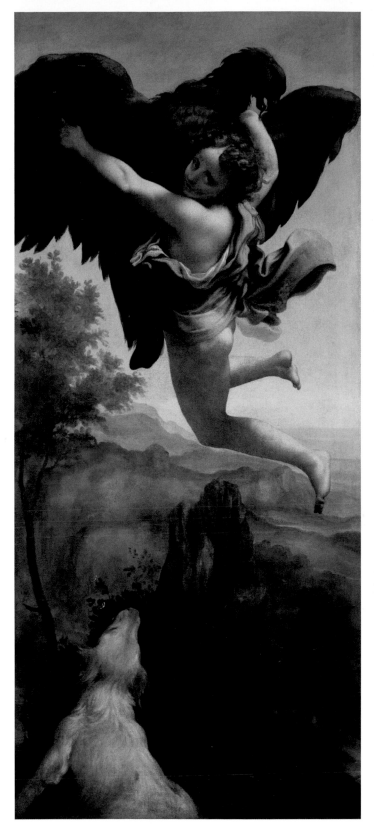

The myth of Ganymede's abduction to Olympus, where he was made to serve as cupbearer to the gods, was understood in different ways: as a tale of men's love for boys in ancient Greece and Rome, but also, in a Christian context, as the pure soul aspiring to God and immortality. Correggio's painting of *Ganymede* and its pendant *Jupiter and Io* (see p. 215) belonged to a series of four erotic mythological scenes commissioned by Duke Federigo II Gonzaga of Mantua as a gift for Emperor Charles V. All four feature Jupiter in some form of disguise. The other two, *Leda* (Gemäldegalerie, Berlin) and *Danaë* (Galleria Borghese, Rome), are in horizontal format. Knowing that Correggio's patron was an admirer of mythological eroticism, we should perhaps not look for a deeper symbolic meaning. The Duke of Mantua presented the series to Charles V in 1532.

The Trojan prince Ganymede was a handsome young shepherd who, accompanied by his dogs, tended his father's flocks in the mountains of Phrygia. Or does the dog shown here symbolize the carnal desires which are the actual subject of the myth?

GYGES AND CANDAULES

Eglon Hendrik van der Neer, 1634–1703
Gyges and the Wife of King Candaules,
c. 1675–80
Canvas, 85 x 99 cm
Museum Kunst Palast, Gemäldegalerie, Düsseldorf

Van der Neer depicted the series of events in the chronological order that Herodotus described. Candaules is in bed, and his wife lays each item of clothing on a chair. Her garments are made of lustrous satin, while the drapes over the four-poster bed are velvet.

Candaules, the king of Lydia, was in love with his wife, whose beauty, he believed, was unsurpassed. His brooding mind was constantly preoccupied with this single thought. As it happened, among his guards was a man called Gyges, whom the king favoured and in whom he confided not only the highest affairs of state, but also his sentiments for his fair wife. He sang her praises from dawn to dusk, and ultimately brought upon himself a tragic fate. One day he said to his guard: 'Gyges, I fear you cannot grasp the full measure of my wife's beauty from my words alone. Men are more inclined to believe what they see rather than what they hear. I want you to contrive some means to see her naked.' But Gyges protested: 'Majesty,' he said, 'what ill-conceived intrigue is this? Would you have me look upon my mistress naked? A woman who sheds her garments sheds also her shame. Let each behold his own, as men have known of old, and indeed to their betterment. I believe full well that your wife is the fairest of all. I pray, ask me not to commit any wrongdoing.' With these words Gyges sought to counter Candaules' inauspicious scheme. But Candaules replied: 'Be assured, Gyges, I do not mean to put you to the test, nor need you fear my wife. She will be unaware of your eyes upon her. You shall wait behind our bedroom door, which will be open. I shall enter first, and she will follow me directly to retire. Close to where you enter is a chair and upon it she will lay her garments one by one. You may gaze upon her undisturbed. Then, when her back is turned and she steps towards the bed, you shall slip away unnoticed.'

Having no means of escape, Gyges prepared to do as he was bade. When the hour came, Candaules led him to the bedroom and, moments later, his wife entered too. Gyges looked on as she disrobed. Once she turned from him and stepped towards the bed, he quietly stole away. But the woman caught sight of him as he retreated. Her suspicions fell on her husband, but she gave no sign and feigned ignorance. Deeply hurt, she began to plan her revenge. / HERODOTUS, *Histories*, 1, 8–10

The woman ordered Gyges to kill her husband or otherwise die by his own hand. Just as her husband had done, she hid him in the bedroom and Gyges murdered the king in his bed.

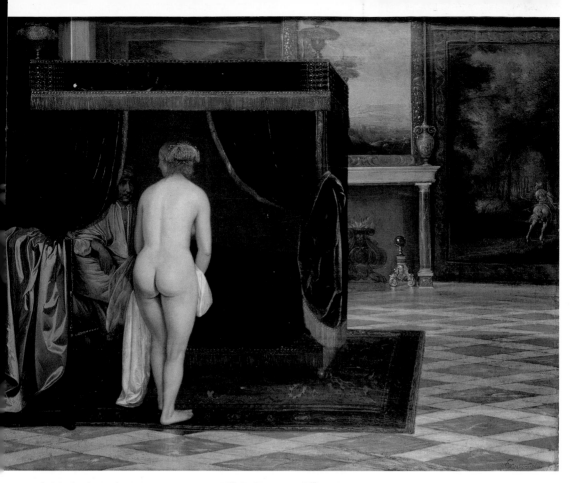

The woman stands with her back to us but the two men see her from the front. She inclines her head and catches sight of Gyges spying on her. In Herodotus she pretends not to see him.

Gyges' head is just visible on the far left of the painting. This is the man King Candaules prevailed upon to watch his wife as she undressed.

At first sight, this scene set in a comfortable 17th-century interior recalls the many works of this kind dating from the Golden Age of Dutch painting. What distinguishes it, however, is the presence of a naked woman, which is out of place in a genre scene. From her fashionable hairstyle the work can be dated fairly accurately. The story it illustrates was quite well known at the time, partly through the writings of the popular Dutch author of emblem books and didactic verse Jacob Cats (1577–1660). However, in Cats' version, and also in art, it conveyed a moral lesson: a marriage should not be dishonoured through idle talk about something as transient as beauty.

HANNIBAL

Joseph Mallord William Turner, 1775–1851
Snow Storm: Hannibal and his Army Crossing
the Alps, 1812
Canvas, 145 x 237 cm
Tate, London

Hannibal took his famous elephants
on the expedition to instil fear in his
enemies. Here, they are no larger
than insects. Hannibal himself on
an elephant would thus look like a
travesty of the conventional august
equestrian portraits of prominent
men and women. Ever since it was
made, the work has been understood
as an allusion to Napoleon's
megalomanic aspirations.

NEW

*Turner's epic canvas is the antithesis
of an 'academic' work with a clearly
legible story. Here, nature tells the
tale. After Goya's Saturn (pp. 314–
315) Turner's painting is the most
recent work in this book. It marked
the beginning of a new way of
representing the age-old stories which
continue to inspire painters to this day.*

*Hannibal, the commander of the Carthaginian army
and a sworn enemy of Rome, arrived at the foot of
the Alps with his troops, elephants and pack animals.*
The soldiers had heard tales of the mountains, embel-
lished with imaginary fears of the unknown. Now they
saw everything close by: the towering peaks, the snow-
covered slopes rising up to the sky, the simple huts perched
on precipices, herds and pack animals rigid in the icy chill,
men unwashed and unshaved, all living and lifeless things
frozen solid; this and far worse, for it was more terrible
to behold than words could tell. Fear gripped their
hearts.

*Hannibal had not only the Romans to contend with,
but also the mountain dwellers and the terrain. His troops
were attacked, the animals took fright, and to add to their
misery, snow began to fall. Provisions were lacking and
his men were exhausted and demoralized. The expedition
came to an impasse. Forced to make a detour, they
embarked on an uncharted course.*
That route was truly treacherous. The fine layer of fresh
snow covering the old offered man and beast a foothold,
but once it had melted under the weight of so many feet, those bringing up the rear slipped over
uncovered ice and stumbled through the mire of melting snow. Their struggle was too dreadful
for words. Feet found no purchase on the slippery ice and on the steep incline slid only faster.
Those who laboured to rise on hands and knees fell back to the ground. No roots or trunks of
trees for hands or feet to grip, they slid ever further over the perilous ice and through the muddy
snow. Some of the animals sank through to the lower layer of old snow and, once down, lash-
ing out savagely in their struggle to rise, they fell to the bottom. Many were left behind, trapped
in the solid ice. / LIVY, *From the Founding of the City*, 21

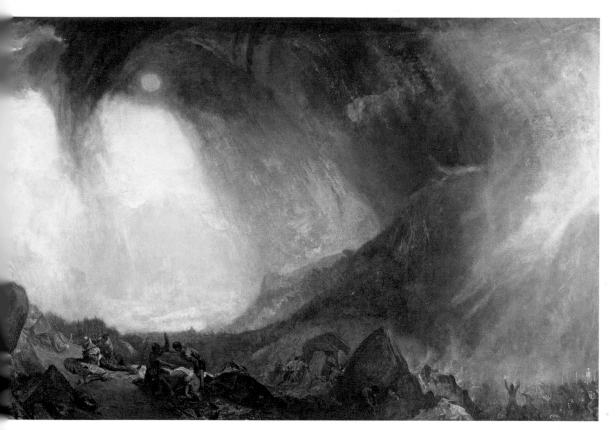

Normally a rousing symbol for a warring army, the minuscule standard is tucked away in a corner of the painting. A soldier appears to be cheering. Or is he in panic? Most artists before Turner depicted a triumphant Hannibal. Here, the outcome of his mission is uncertain.

The Italian sun, like an eye, shines through the clouds: 'Still the chief advanc'd/ Look'd on the sun with hope', Turner wrote about Hannibal in his poem 'Fallacies of Hope', which accompanied the painting. He also mentions the mountain dwellers who attacked Hannibal's troops.

The painting is intrinsically about the insignificance of man and beast in the face of the elements. The Carthaginian troops struggle to cross the Alps in a raging storm. Chaos reigns beneath the tempestuous sky; there is no point of focus and no principal character. Turner drew inspiration from literature, his own travels, and his observations of a storm in Yorkshire. He indicated that the painting should be hung lower than was customary in his time in order to achieve the effect he envisaged.

HERCULES

Tintoretto, 1518–1594
The Origin of the Milky Way, 1577–79

Canvas, 148 x 165 cm
The National Gallery, London

A stream of milk gushes heavenward from Juno's left breast and forms a trail of shimmering stars. The milk from her right breast flows to earth. The goddess' arms follow the lines of the two streams. The lower part of the canvas has been lost, but we know from drawings and an old copy of the original that it depicted the personification of Earth surrounded by lilies.

Tintoretto based his painting on later versions of this originally Graeco-Roman myth. What we know from antiquity about the event he illustrated comes from manuscripts on astronomy that aimed to link myths to astrological constellations and the Milky Way. We should also remember that Hercules was born of the union between the supreme god Jupiter and the mortal Alcmene, to the anger of Jupiter's wife Juno. Jupiter had deceived the unsuspecting Alcmene by assuming the guise of her husband. Juno resented Hercules from the day he was born.

The Milky Way is one of the celestial bodies. Zeus' [*Lat.* Jupiter's] sons were not admitted to heaven unless they had drunk as infants from Hera's [Juno's] milk. It is said, therefore, that Hermes [Mercury] brought the suckling Heracles [Hercules] and laid him at Hera's breast. But on discovering the deceit, Hera rejected the child and thrust him away. The milk that remained in her breasts was spilt and formed the Milky Way. / After *Constellations* by ERATOSTHENES OF ALEXANDRIA, 3rd century BC

Among the stars there is a white circle that some call the Milky Way. Eratosthenes writes that Juno once unwittingly suckled Mercury, but on discovering that he was Maia's son, she flung him from her, and her sparkling milk was splashed among the stars. Others say that Hercules was laid at Juno's breast as she slept, and once she awoke those same events occurred. Others yet recount that the insatiable Hercules took more milk than his little mouth could hold, and the drops he spilt formed the Milky Way. / HYGINUS, *Astronomy*, 1st century BC

The net is a symbol of deceit and alludes to the trick Jupiter played on his wife by giving her his illegitimate child to nurse.
The arrows, the bow and the torch carried by the putti are erotic emblems.

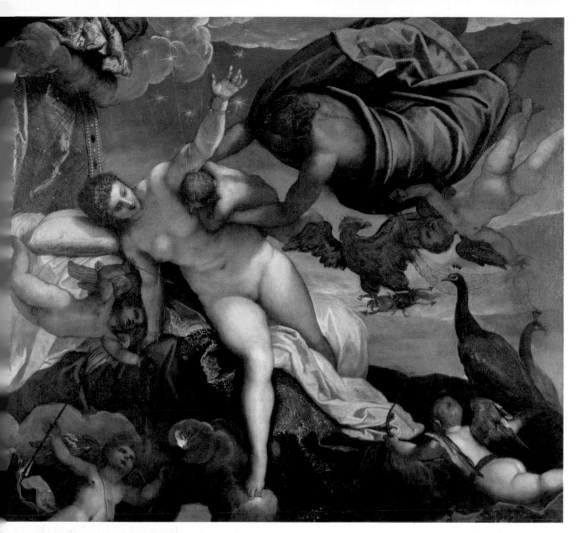

The peacock is Juno's attribute, a counterpart to her husband Jupiter's eagle. The strange object in the eagle's claws – which is hard to imagine and surely harder to depict – is a cluster of bolts of lightning, another of Jupiter's attributes.

Tintoretto made four paintings for the castle of Emperor Rudolph II of Habsburg in Prague: one depicting the Muses and three with episodes from the life of Hercules. This beautiful and colourful painting is one of them. The Habsburg dynasty claimed Hercules as one of their mythical ancestors. Here, Jupiter swoops down with the infant Hercules in his arms. The child drinks from Juno's breast. The scene takes place in the clouds, with tumbling cupids looking on. Tintoretto probably based his iconography on a 10th-century Byzantine treatise on agriculture and other depictions of the subject, rather than a classical text. The treatise was published in Italian in 1539 and included a chapter on the history of the lily.

HERCULES

**Dosso and Battista Dossi,
c. 1490–1542**
Hercules and the
Pygmies, 1535

Canvas, 114 x 146 cm
Alte Galerie des Steiermärkischen
Landesmuseums Joanneum, Graz

The face of the hero crowned with
vine leaves is an idealized portrait
of the new duke, Ercole II, as we may
assume from its similarity to a
marble bust of him. Several
Renaissance rulers commissioned
portraits of themselves as nude
mythological heroes. In the
17th century in particular the *portrait
historié* was favoured as a way of
imbuing the portrait genre with the
grandeur of history painting. Rubens,
for instance, used his beautiful young
wife as a model for nubile goddesses
from ancient Greek and Roman
mythology (see p. 282).

*The Greek writer Philostratus (3rd century AD) described
paintings from antiquity, which no longer exist, in his
book* Imagines [Images]. *This is one of those works.*

In this painting Heracles [*Lat.* Hercules] is in Libya and
lies asleep after defeating Antaeus, when the Pygmies fall
upon him with the intention of avenging their brother.
Courageous they were, but not athletes, nor indeed his
match. Pygmies live in the earth, like ants, and store there
the provisions they collect and make themselves; nothing
is obtained from others. They sow and reap and work the
land with tiny ploughs. They say they use axes to fell ears
of wheat, each stalk as formidable to them as a tree. But
their boldness now is astounding! They advance against
Heracles to kill him as he sleeps, nor would they cower
were he awake.

Now, Heracles, worn out from his contest with
Antaeus, slumbers in the white sand, with open mouth
breathing in deep draughts of sleep. Sleep itself stands
beside Heracles and brags, it would seem, for having man-
aged to overcome him. Antaeus lies there, too, but the art-
ist painted Heracles quick and warm, whereas Antaeus,
lifeless and ashen, has been committed to Earth.

Pygmy warriors have surrounded Heracles. One regi-
ment fires at his left hand while two do battle with his
more powerful right hand. Archers beleaguer his two feet,
their cohorts firing catapults and trembling at the sight
of his mighty limb. Those assigned to assault Heracles'
head – their king among their ranks, for this they believe
to be the strongest of all the components – bring the
machinery of war to bear as if they were attacking a fort-
ress – and fire at his hair and aim a double-pickaxe at his
eyes. Others heave door leaves to cover his mouth and
nose, presumably to stop Heracles from drawing breath,
for once the head has been taken the battle is won. And
Heracles sleeps soundly all the while. But look! Suddenly
he rises and, smiling at the danger, brushes his adversaries
into a little heap and deposits them in his lion's skin.

/ PHILOSTRATUS, *Images*, 2, 22

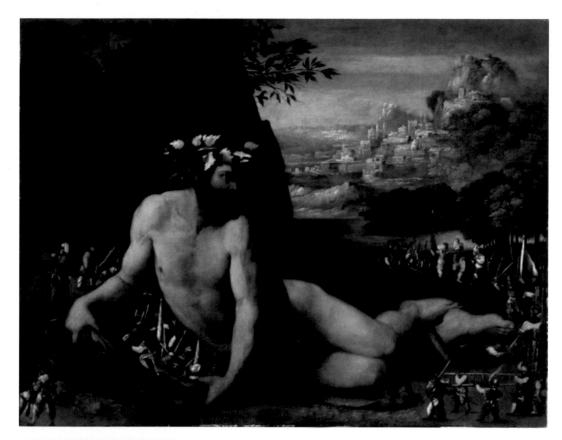

Now awake, Hercules gently gathers up the Pygmies and deposits them in his lion's skin, taking care not to harm them. Other Lilliputians – the parallels between *Gulliver's Travels* by Jonathan Swift (1725) and the painting described here by Philostratus are obvious – are still assaulting the giant. The figure of Hercules featured prominently in the art collection at the court of the d'Este dynasty in Ferrara, where the Dossi brothers worked for some time. This light-hearted painting was made the year after Ercole II d'Este came to power (note that his name is the Italian for Hercules). It may have been an allegory alluding to the duke's certainty of an easy victory over his opponents. A woodcut of the same subject, dating from 1534, bears an inscription to that effect.

The Pygmies wear the uniforms of German infantrymen of Dossi's time. The contrast between them and the naked Hercules is irresistibly comical. Here, we see the standard-bearer, a drummer and a piper. The painting is not a literal representation of the written source: the dead giant Antaeus may have been thought inappropriate in the Ferrara allegory.

REPLICATING UNSEEN PAINTINGS

Descriptions of paintings from ancient Greece and Rome, like the one reproduced here, constituted a unique category of 'stories'. The actual paintings no longer existed, but stories about them fired the imagination of artists and many tried to reconstruct them from those descriptions. In a sense, they were competing with their Greek and Roman predecessors (see also pp. 152, 334).

HERCULES

Francisco de Zurbarán, 1598–1664
Hercules Wrestling with the Hydra of Lerna, 1634
Canvas, 133 x 167 cm
Museo Nacional del Prado, Madrid

Hercules' nephew Iolaus holds the burning torch that he used to cauterize the wounds on the Hydra's body after its heads had been severed. Here, too, Zurbarán followed the classical text.

After killing his wife and three sons in a fit of madness, Hercules recovered his composure. Filled with remorse, he consulted the oracle of Delphi and was told how to atone and absolve himself. As a punishment he was to perform twelve great labours for King Eurystheus, whom he despised. Most of those labours involved contests with monstrous beasts like the serpentine Hydra of Lerna.
The miscreant, bred in the swamps of Lerna, would invade the plain, where it killed the cattle and ravaged the fields. On its huge body were nine heads, of which that in the centre was immortal. Hercules mounted the chariot with his nephew Iolaus holding the reins, journeyed to Lerna, and there drew in his horses. On a hill near the springs of the river Amymone he caught sight of the Hydra lurking in its lair, and loosed flaming arrows and drove the creature into the open. No sooner had it emerged from its den than he seized it and held it firmly in his grip. But the writhing Hydra coiled itself around his legs and clamped itself to him and clung to him. Wielding his club, Hercules delivered blow after blow, shattering its heads, but to no avail, for in the place of each there sprang two more. A monstrous crab reinforced the Hydra's assault and sank its pincers into Hercules' foot. He managed to kill it and summoned the aid of Iolaus, who set alight the surrounding woodlands. With fiery torches he seared the base of the Hydra's heads to hinder new heads from emerging. That hurdle overcome, Hercules severed the immortal head and buried it in the earth beside the road from Lerna to Elaeus, and sealed the spot with a heavy rock. He cut open the Hydra's body, and dipped his arrows in its venom. Then Eurystheus spoke. The labour could not be counted as one of the twelve, he said, as the Hydra had been defeated with the help of Iolaus and not by Hercules alone. / APOLLODORUS, *Mythology*, 2, 5, 2

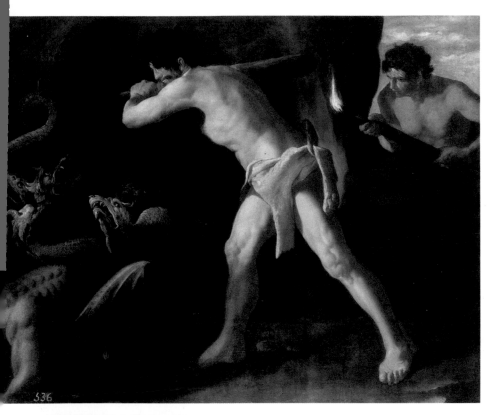

Francisco de Zurbarán painted a cycle of ten compelling scenes of the labours of Hercules for a salon in Buen Retiro Palace in Madrid. As some of the twelve labours were said to have been performed in Spain, Hercules was something of a national hero and a popular figure in Spanish art. An indomitable victor, he personified the power with which leaders sought to associate themselves.

Unlike most other painters, Zurbarán faithfully rendered the classical version of the story, showing also the crab that attacked Hercules during his struggle with the Hydra.

Hercules' encounter with the Hydra was the second of his twelve labours. The first was his slaying of the Nemean lion. He wore the lion's skin for protection when he performed his subsequent labours.

HERCULES

Lucas Cranach the Elder, 1472–1553
Hercules and Omphale, 1537
Panel, 82 x 119 cm
Herzog Anton Ulrich-Museum,
Braunschweig

Hands feature prominently in the painting, as in Ovid's text. Hercules' clumsy masculine hands are engaged in a task better suited to the dainty hands of a woman.

HERCVLEIS MANIBVS DANT LYDÆ PENSA PVELLA
IMPERIVM DOMINÆ FERT DEVS ILLE SVÆ ·
SIC CAPIT INGENTIS ANIMOS DAMNOSA VOLVPTAS
FORTIAQVE ENERVAT PECTORA MOLLIS AMOR ·
1 5 3 7

The influence of humanism is evident from the mythological nature of the subject and the inscription in Latin, which may be loosely translated as follows: 'The Lydian maidens give Hercules his portion of wool for the day; the god-like man defers to the will of his mistress. So ruinous lust may conquer a great mind, and frail love rob a man of his strength.'

Hercules' wife Deianira learned that her husband was in a distant land, dancing to Omphale's tune. He had evidently lost his heart – and his head. Deianira wrote him a furious letter:

Were you not ashamed to festoon your strong body with gems and your muscular arms with gold clasps, those arms that wrung the last breath from the wretched Nemean lion, whose skin you now drape over your left shoulder? And a scarf to cover your bristly head! For shame! How ignoble to wear a girdle, like a wanton girl! They say that you sit among the maidens holding a basket of yarn, and shrink at a cross word from your mistress; that you dip those hands that once accomplished impossible tasks into brightly polished baskets of wool, and wind threads of coarse yarn around your formidable thumb; that you measure out wool to pass to your comely mistress. Does your grip, strong as a bear's, not crush the spool as you spin? And attired in oriental robes, do you speak to her of your heroic deeds? Should such vestments not silence your tongue? As for Omphale, it is she who brandishes the weapons and fabled trophies of the man she holds in her thrall. O shame, that your lion's hide now covers the soft body of a woman, and that she who can all but turn a distaff bears the arrows dipped in the black venom of the Hydra of Lerna. She flaunts, too, the club you wielded to conquer wild beasts. When she looks in the mirror, it is *your* armour she sees! / OVID, *Epistles of the Heroines*, 9, 59–118

HERCVLEIS MANIBVS DANT LYDÆ PENSA PVELLÆ
IMPERIVM DOMINA FERT DEVS ILLE SVÆ·
SIC CAPIT INGENTIS ANIMOS DAMNOSA VOLVPTAS
FORTIAQ̄E ENERVAT PECTORA MOLLIS AMOR·
1 5 3 7

In some paintings of the subject Omphale wears Hercules' lion's skin and carries his club, in line with Ovid's description. On this point, however, Cranach departed from the text, focusing instead on the women spinning and cosseting Hercules.

Hercules winds thread on a distaff while two women who look like ladies-in-waiting adjust his bizarre headdress. He simpers at the woman on the far right, who holds a full spool. The pair of partridges at upper left may allude to sensuality. The Latin inscription at the top explains the picture and the moral it conveys. Cranach painted several versions of this story about a man who loses his heart and allows himself to be dominated by a woman. The theme was often illustrated in 16th-century art.

HERCULES

Abraham Janssen, 1575–1632
Hercules, Pan and Omphale, 1607
Canvas, 149 x 189 cm
Statens Museum for Kunst, Copenhagen

Omphale's hand rests on Hercules'
club. Beneath her we see a corner
of the lion's skin that Hercules wore
when performing his heroic labours
(see p. 199).

After committing a murder in a fit of rage and madness, Hercules became a servant to Queen Omphale of Lydia. The couple had an extraordinary relationship.

Faunus, the god of forests, plains and fields, cares nothing for clothing. The reason lies in a ridiculous incident that occurred many years past. It chanced that young Hercules was strolling with his mistress Omphale, when Faunus spotted the pair from a tall crag. At once inflamed with passion, he cried, 'Nymphs of the mountains, be gone! It is she who stirs my desire.' Omphale's fragrant hair flowed over her shoulders as she moved; her breast glittered with gold. A gold parasol protected her from the burning rays of the sun … but it was Hercules who held it.

When evening fell, the two stopped to eat in a romantic cavern. Hercules changed into Omphales' clothes and she into his.

And so they enjoyed their meal and retired for the night. Their beds stood side by side. Midnight came. Love knows no fear, and the feverish Faunus stole into the cavern under the cover of darkness. He saw the servants overcome by sleep and wine, and believing their masters also to be slumbering, stealthily made his way to the bed on which he had pinned his hopes. But at the touch of the bristly lion's skin he was overcome by fear, drew back his hand and recoiled in terror. In the bed beside it, his fingers encountered garments of a softer cloth, and so he was deceived. He crept into bed and lay down, his swollen member harder than horn. Faunus lifted his tunic – his rough legs were covered with coarse fur – but before he could proceed, Hercules thrust him aside and Faunus tumbled to the ground. Pandemonium broke loose! Omphale called her servants to make light, and in the glow of the fire all was revealed. Faunus lay groaning in pain, barely able to rise from the hard ground. Hercules bellowed with mirth, and all who saw Faunus shared in Hercules' merriment. Omphale, too, was amused. Ever since, Faunus has spurned clothes – they once turned him into a laughing-stock – and whoever attends his revelries must come naked. / OVID, *The Roman Calendar*, 2

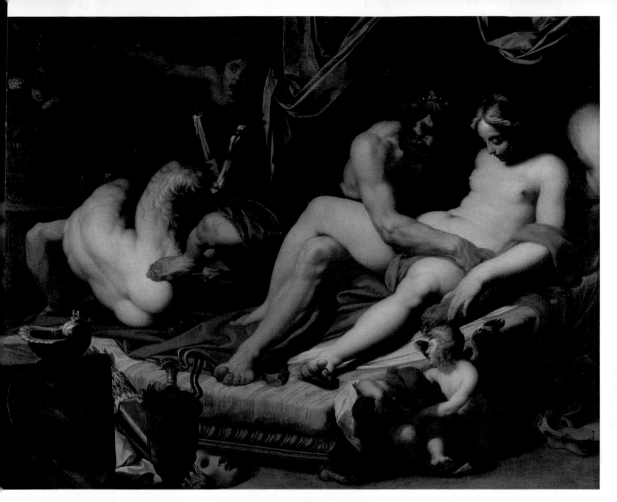

Ovid writes that Hercules and Omphale had been drinking wine. The pitcher alludes to this. Omphale's drowsiness and limp body suggest that she was intoxicated. The mask lying beside the pitcher symbolizes deceit and refers to the couple who misled Faunus by assuming different identities.

The servant's candle – which in Ovid's account exposed the whole affair – has been extinguished. Even so, its light illuminates the main characters A flaming torch normally alludes to love, but that is not the case for Faunus.

Abraham Janssen depicted the moment when Hercules, his limbs partly covered by Omphale's beautiful blue robe, throws Faunus off the bed. A servant is already coming to his assistance. The scene is far more erotic than in Ovid's account, where Hercules and Omphale sleep in separate beds in a cave. Cross-dressing travesties of this kind were often didactic: they warned against the ruses, amatory or otherwise, that women use to gain power over men.

HERCULES

Deianira clings to the back of the fleeing centaur and looks behind her in terror. Hercules will fire an arrow into her abductor's back. In the days of antiquity centaurs were known for their ill-tempered nature. Needless to say, this tale about two 'men' and one woman has erotic connotations.

Paolo Veronese, ca. 1528–1588
Hercules, Deianira and the Centaur Nessus, c. 1586
Canvas, 68 x 53 cm
Kunsthistorisches Museum, Vienna

Hercules, the son of Jupiter, the father of the gods, has just won his wife Deianira in a contest with the river god Achelous.

Jupiter's son Hercules took his young bride and was returning to his native city when he came to the tempestuous waters of the Euenus. The river was swollen with the rains of winter, and hazardous whirlpools made it impassable. Hercules stood contemplating the danger, fearless for himself but anxious for the safety of his wife, when he was approached by the powerful centaur Nessus. 'Hercules,' Nessus said, for he knew the shallow fords, 'I will bring Deianira safely to the shore so that you can use your strength to swim across.' And so the hero gave into Nessus' care the trembling girl, who was pale from fear of the river and, no less, the centaur. Hercules hurled his club and curved bow to the far bank and, with his lion's skin about his loins and his quiver in his hand, he ventured into the water, calling out, 'I have set off and I shall conquer this river.' He neither paused nor sought the gentlest current nor allowed the flow of the water to carry him ashore. Swiftly he reached the bank and was recovering his bow, when suddenly he heard his wife's cries. Nessus was planning to ravish the charge entrusted to his protection. 'You villain,' Hercules roared, 'though fleet of foot, have you such faith in yourself? Where do you propose to go? Heed my words, Nessus, you four-footed fiend, stay away from what is mine. Have you no fear of me, then be chastened by the fate that befell your father, doomed forever to turn on a wheel for the sake of a forbidden love. You shall never escape from me, however firm your trust in your equine strength. Not my feet, but my arrows will conquer you.' True to his word, Hercules dispatched an arrow into the fleeing centaur's back; the barbed arrowhead pierced his heart and emerged from his breast. As Nessus wrenched the shaft loose, blood spurted from the two wounds. / OVID, *Metamorphoses*, 9, 103–129

Hercules' arrows were poisoned. The dying Nessus gave Deianira a cloth soaked with his tainted blood as a talisman to kindle love. Later, Deianira used it and unwittingly caused Hercules' death.

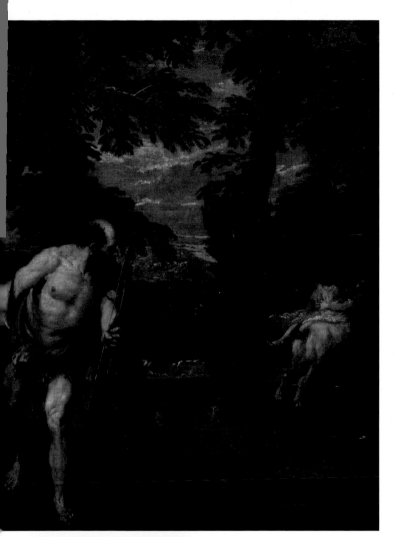

Veronese illustrated the moment when Hercules realizes that something is amiss; Ovid writes that he heard his wife call. The centaur carrying Deianira on his back flees in the opposite direction. Veronese also painted the story of Venus and Adonis (for Titian's version, see pp. 338–339). Both are love stories that end in tragedy, in both cases with the death of the man. The incident depicted here ultimately leads to Hercules' demise.

Veronese's Hercules is an elderly, balding man with a beard, and not the stuff that heroes are made of. He stands on the riverbank with his bow in one hand and an arrow in the other, just before firing the fatal shot.

A poet crowned with laurel is seated at Virtue's feet. He is mentioned only indirectly in the classical texts. Xenophon wrote that the virtuous 'live on in memory, in myriad songs of praise'. And those songs of praise are of course written by poets.

The personification of Vice is depicted with musical instruments, playing cards and masks, symbolizing idleness, frivolity and self-indulgence. She is blonde and draped in yellow, the colour worn by prostitutes in Carracci's day. Yellow had also been associated with hatred, envy and the devil since medieval times. Behind the woman is a dense thicket: the principles she lives by lead nowhere.

HERCULES

Annibale Carracci, 1560–1609
Hercules at the Crossroads, 1596
Canvas, 167 x 237 cm
Museo Nazionale di Capodimonte, Naples

The young Hercules, a child no longer nor yet a man, gaining independence had reached that stage where the young reveal whether they will pursue life's journey on the path of good or evil. One day, he sought a secluded place, there to ponder which of life's paths he should take. Two maidens appeared and approached him where he sat. One, in a robe of white, was graceful and dignified, her skin fair, her manner reserved and modest. Her companion was soft, plump and voluptuous. She had enhanced her complexion with colour to appear fairer and rosier than nature had intended, and stood tall, indeed taller, it seemed, than was normally her way. With wide eyes she gazed upon him, her robe revealing the fullness of her curves. And all the while she examined herself, casting about to know whether other eyes were contemplating her, and with every step she glanced back at her shadow. / XENOPHON, *Memorabilia of Socrates*, 2, 1, 21–34

The two maidens tried to persuade Hercules to choose the paths they represented. One, who was called Happiness, but also Vice, represented a life of pleasure, indulgence and idleness. The other, whose name was Virtue, symbolized the pursuit of good. The first path was quick and easy, the other, long and arduous, led to goodness and joy. The rewards of Virtue were fulfilment, honour and divine approbation.

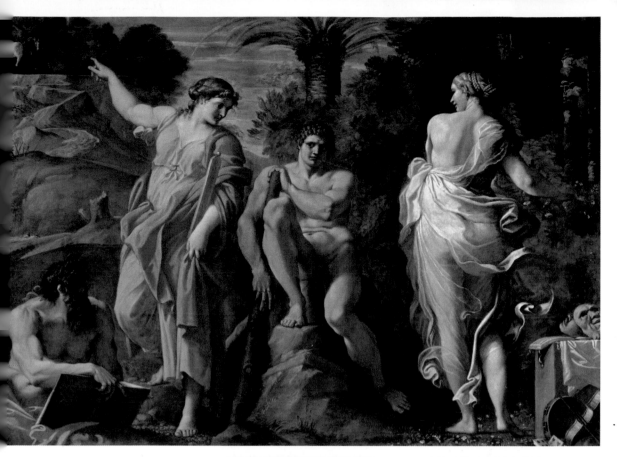

The young, still smooth-cheeked Hercules, identified by his club, sits on a rock before a palm tree, when two women approach him. The one on his right, the personification of Virtue, directs his attention to the steep, winding path leading to the top of the mountain. Her scantily clad companion, representing Indulgence, stands on Hercules' left, some distance away.

The painting hung in the *camerino*, or study, of Cardinal Odoardo Farnese in the *palazzo* of the Farnese family in Rome. Hercules' dilemma was often held up as example to both spiritual and political leaders. It was perfectly consistent with Christian ideology in which the 'path of virtue', which led to heaven, was narrow and strewn with thorns.

The winged horse Pegasus stands at the end of the steep, winding road, ready to convey Hercules the rest of the way to heaven.

The palm symbolizes victory and triumph. The difficult choice will bring Hercules glory, the easy choice, gratification.

HERMAPHRODITUS

Bartholomeus Spranger, 1546–1611
Hermaphroditus and Salmacis, c. 1585
Canvas, 110 x 81 cm
Kunsthistorisches Museum, Vienna

Salmacis' scarlet robe – the colour of passion – has slipped to the ground, and with graceful fingers she unfastens her shoe. Hermaphroditus, too, has one hand on his foot.

Hermaphroditus was the son of Hermes and the love goddess Aphrodite. His name is a combination of theirs. In his sixteenth year he set off on a journey and eventually came to a pool of crystal water.

A nymph dwelt there, a sprite unsuited to the hunt, unwont to bend the bow or run to win the contest. Of all the nymphs, she alone was unknown to the fleet-footed Diana, the goddess of the hunt. No spear or colourful quiver she took, preferring leisure to the rigours of the chase. But in her pool she loved to bathe her comely limbs, or run a boxwood comb through her hair, or gaze at her reflection in the water to see what style suited her best. Arrayed in gossamer she would lie on soft grass or tender leaves, gathering flowers. Now, so preoccupied, she chanced to see the youth and in him saw her heart's desire. Though she yearned to hasten to his side, she stopped first to tend her beauty, smooth her garments and put on her sweetest face, so that she might deservingly be called fair.

Salmacis spoke to Hermaphroditus and extolled his god-like beauty. The timid youth made no response, but threatened to leave when she asked to embrace him. The very thought struck fear in her heart.

She turned as if to retrace her steps, but constantly glanced over her shoulder, and then hid in the leafy shrubs, crouching on her knees. The boy, believing himself alone and unobserved, wandered idly in the grass, then dipped first his toes and soon his foot, ankle-deep, in the rippling water. Delighted by its balmy warmth, he lingered not but removed the fine garments covering his delicate frame. Salmacis gazed enraptured, her passion inflamed, her eyes glowing. She craved his naked beauty! To wait, to defer her joy was unendurable. She yearned to embrace him and was unable to still her frantic desire. / OVID, *Metamorphoses*, 4, 302–352

Salmacis flung aside her garments and followed Hermaphroditus into the water, but he spurned her advances. She prayed to the gods, who granted her wish and united them. Together they formed a single being, both masculine and feminine, and for ever after, any man who bathed in the pool emerged half man, half woman.

Spranger depicted Salmacis
secretly observing Hermaph-
roditus from a distance. The
youth, all but naked, sits on a
rock, with one foot in the water.
In a few moments he will dive into
the pool, followed by Salmacis.
Although other artists depicted
different moments from the tale,
the inherent problem was how
to represent the merging of two
individuals into one. Spranger's
painting belonged to a series of
scenes from *Metamorphoses*.
They were made for the Prague
apartment of Rudolph II,
a connoisseur of erotic art.

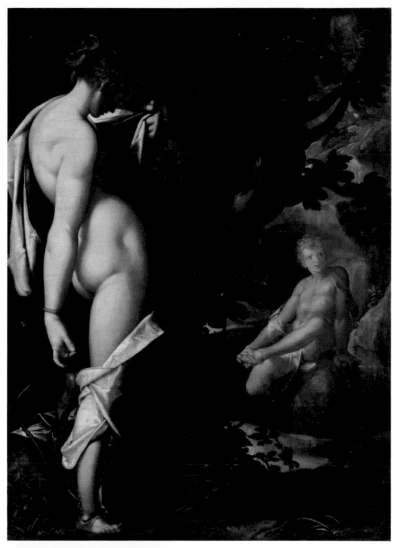

Salmacis, with her hair neatly
bound in a knot, removes her
garments. According to Ovid,
however, she disrobed while she
was crouching among the shrubs.
Spranger depicted the full length
of her body and shows her almost,
but not entirely, naked. The image
is even more erotic as a result.

The beautiful Hermaphroditus
gazes into the distance, unaware
that Salmacis is spying on him.

HORATII

Jacques-Louis David, 1748–1825
The Oath of the Horatii, 1784
Canvas, 330 x 425 cm
Musée du Louvre, Paris

The father of the Horatius brothers holds the lethal swords firmly in his grip. He stands midway between his three patriotic sons, who clasp one another and raise their arms to take an oath on the swords, and the group of sorrowing women on the right. The stark, classical architecture reflects the harshness of ancient Rome. The story was a glorification of heroism, patriotism and self-sacrifice, and a tribute to *raison d'état* and ruthless justice. David's best works are characterized by contrasting images of uncompromising stoicism and infinite sorrow.

In the early days of its history, Rome was at war with Alba. To spare both cities further bloodshed the Albans proposed that each side should designate three warriors to take up swords to determine supremacy. The Romans, represented by three brothers who are believed to have been members of the Horatius family, were ranked against the Curiatius brothers of Alba.

A treaty was signed and the warriors took up arms as agreed. Their countrymen hailed them and stirred them to action, proclaiming that the gods of their ancestors, their fatherland, their fathers and their fellow citizens, fighting men and family, would bear witness to their military prowess. The men were spurred on by the resounding battle-cries of the soldiers, and took their positions between the two fronts, warriors by nature and temperament.

Two of the Romans were slain and all three Albans were wounded in the battle. The surviving Roman put the Albans to flight, and when they fell, exhausted, he killed them one by one. The dead were buried and the armies marched home.

Horatius returned in triumph bearing his threefold spoils. His sister, the promised wife of one of the Albans, met her brother at the Capene Gate and saw, draped over his shoulders, the blood-ied mantle of her betrothed, the mantle she had woven with her own hands. She tore her hair in anguish and cried the name of the man she was to wed. Enraged by his sister's grief in his moment of glory and jubilation, Horatius, quick to anger, drew his sword and ran it through her body, chiding her in his fury, 'Take your wretched love and join your betrothed. You spare no thought for your fallen brethren, nor I, yet alive, nor a thought for your fatherland. Let this be the fate of any Roman woman who weeps for the foe.' / LIVY, *History of Rome*, 1, 25–26

Horatius was tried by the people and acquitted. His father pleaded on his behalf.

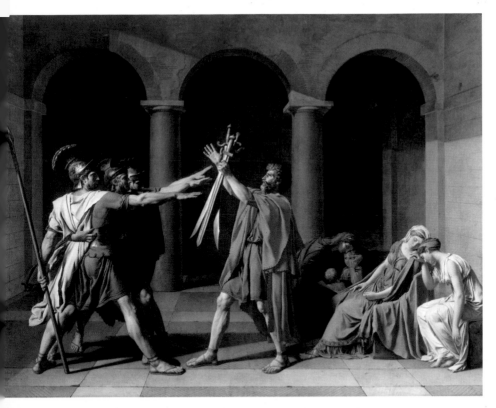

In Corneille's version of the story, Sabina, the sister of the three slain Albans, was married to the surviving Horatius, and, in both Corneille's and Livy's versions, Horatius' sister Camilla had been betrothed to one of the Curiatius brothers. The women who united the two families avert their eyes from the display of heroism which placed fatherland above family.

The presence of Sabina's children and the Horatius brother who will triumph in battle makes the scene all the more poignant. The children are accompanied by a nurse. One of the boys gazes at the three brothers in fascination.

From the Renaissance onwards, this popular Roman legend was often adapted for theatre. One of the most influential dramas was Pierre Corneille's reworking of the story (Horace, 1640), recounting the fate of other members of the two families who broke allegiance by consorting with the enemy. David's emotionally charged and instantly successful painting was inspired by Corneille's work and probably also by a scene from a ballet. The compelling moment he chose had no precedent in art, and his work, painted for Louis XVI, was hailed as revolutionary: here, the body itself serves as an instrument of communication.

ICARUS

After Pieter Bruegel the Elder, c. 1525–1569
Landscape with the Fall of Icarus, c. 1600?
Canvas, 73.5 x 112 cm
Koninklijke Musea voor Schone Kunsten van België/Musées Royaux
des Beaux-Arts de Belgique, Brussels

All that can be seen of the fallen aeronaut Icarus is a pair of thrashing legs, a hand, and a few stray feathers in a corner, a *fait divers* which neither the angler fishing nearby nor the crew of the ship have noticed. (Daedalus is not in the picture, but the figure may have been overpainted.)

The ruined citadel on this uninhabited island alludes to the labyrinth in Knossos (Crete) from which Daedalus and Icarus had escaped.

Ovid's Metamorphoses *describes the ingenious plan devised by Daedalus and his son Icarus to escape from captivity in the labyrinth on the island of Crete. In secret, Daedalus fashioned wings from feathers and wax. He warned his son to fly neither too high nor too low. Then they set off.*

Daedalus kissed his son, whom he was never to kiss again, then rose and flew ahead, anxious for his son's safety. He called Icarus to follow, taught him his accursed skill, and moved his wings, looking back to watch his son.

A man fishing with trembling rod, a shepherd leaning on his staff, and a peasant bent over his plough gazed at the two in astonishment, believing them to be gods who could fly through the air. Swooping over islands, Icarus began to enjoy the thrill of flight. Bolder now, he left his guide and soared upwards, drawn to the higher reaches of the sky. But the sun beat down, and softened and melted the sweet-scented wax that bound the feathers together. Icarus waved his bare arms, but without wings they could no longer bear him aloft. His lips, calling to his father as he fell, were engulfed by the blue waters now named after him.

The desperate father – a father no more – called 'Icarus, Icarus, where are you? Where in the world am I to look for you?' And as still he called, he saw the feathers floating on the water. Cursing his invention, he laid his son's lifeless body to rest. The place where he lies is named after him. / OVID, *Metamorphoses*, 8, 211–235

The partridge perched on a dead branch derives from the following episode in Ovid's account: 'As Daedalus was laying to rest the body of his ill-fated son, a chattering partridge sat watching him from an oak. The bird clapped its wings and sang for joy.' The partridge, which in Bruegel's painting seems to be looking on in silent commiseration, was Daedalus' nephew in a previous life. Daedalus was jealous of the boy's talent and, with the help of the goddess Athena, hurled him from the roof of Athena's citadel. As he fell, he turned into a bird.

The *Landscape with the Fall of Icarus* puts an entirely different slant on the original story by Ovid. The peasant working his plough and the daydreaming herdsman, two nondescript figures with their backs turned to Icarus, stand in the centre of the painting. The peasant is the principal subject, but so is the bird's-eye view of the breathtaking landscape, which includes all four elements. Bruegel, who invented this composition (which has come down to us in two very similar copies after the lost original), took an anecdotal detail from Ovid – the astonished onlookers – as the starting point for his compelling and probably unprecedented interpretation of the tale. For whereas Ovid's story conveys the message that pride comes before a fall, Bruegel's painting proclaims that the world moves on and people live their lives indifferent to the suffering of others.

Io enjoys Jupiter's attentions and shares his passion. Few paintings show the actual act of love, but intimacy with a man in disguise gave artists more scope. The tale of Leda and the Swan is another case in point (see p. 240). Renaissance and Baroque artists may have found inspiration from classical examples.

The animal drinking from the stream has been taken for a deer, but it is also said to represent a heifer and thus allude to the metamorphosis that Io will undergo after her amorous escapade.

IO

Correggio, c. 1490–1534
Jupiter and Io, 1530
Canvas, 163.5 x 74 cm
Kunsthistorisches Museum, Vienna

This is one of Jupiter's many amorous escapades.
Io, the daughter of the river god Inachus, was returning from the banks of her father, the river, when Jupiter saw her and called after her: 'Maid, worthy of Jupiter. You shall bring joy to whoever may share your bed. Will you not seek shade in the wood?' He showed her the cool shelter of the trees. 'The day is warm and the sun has reached its zenith. If you fear to venture alone among the wild beasts that lurk there, then go safely with a god to protect you. And not just any god. Oh no! It is I who wield the celestial sceptre and hurl thunderbolts through the heavens. O stay, do not go from me.' But Io had already fled. She had passed Lerna's meadows and Lyrcea's woods when the god shrouded a wide stretch of land in cloud, stayed her flight, and robbed her of her honour.

His consort Juno, meanwhile, looked down to earth from above and wondered how hovering clouds had turned bright day into the darkness of night. They issued not from the river nor rose from the damp earth. She looked about her to know where her consort might be, for she was all too aware of his philandering and had exposed his infidelity many times before. She searched the skies in vain. 'If I am not mistaken, I am being deceived.' She floated down from heaven to earth and the cloud dispersed at her behest. / OVID, *Metamorphoses*, 1, 588–609
Sensing Juno's arrival, Jupiter turned Io into a heifer to prevent his wife from discovering his adultery. But Juno cunningly asked him to give her the heifer as a gift, which of course he could not refuse (see p. 252).

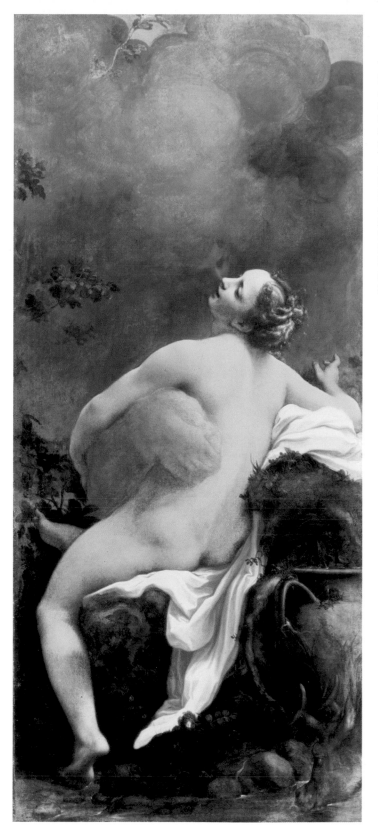

The scene chosen by Correggio has seldom been depicted in art. Jupiter approaches the naked Io and is about to kiss her gently on the lips – a human face can be seen in the clouds – while slipping an etheral arm around her waist. Though Ovid does not say explicitly that Jupiter appeared in the guise of a cloud, that is how his text was generally understood and translated. Or was Jupiter *inside* the cloud, as described in some translations from Correggio's time? For more information about this painting, see Correggio's *Abduction of Ganymede*, p. 189.

JACOB

Govert Flinck, 1615–1660
Isaac Blessing Jacob, 1638
Canvas, 117 x 141 cm
Rijksmuseum, Amsterdam

In the Bible Jacob covered his hands with goatskin – in the painting he wears gloves – to make them feel hairy to his father's touch. For the same reason, he wears a goatskin around his neck. This is how he deceived his father.

Behind Jacob is a dish with the goat that Rebecca prepared for Isaac while her eldest son Esau was out hunting game. In Esau's absence, Isaac unwittingly gave his blessing to Jacob.

Isaac had grown old and blind, and wanted to bless his eldest son Esau before he died. First he sent Esau to slaughter a wild animal so that he could eat and muster some strength. But his wife Rebecca, who favoured her younger son Jacob, overheard the exchange and hatched a devious plan. A father's blessing was important, as the child who received it was entitled to a larger portion of his estate after his death.

'Now therefore, my son, obey my voice according to what I command you. Go now to the flock and bring me from there two choice kids of the goats, and I will make savoury food from them for your father, such as he loves. Then you shall take it to your father, that he may eat it, and that he may bless you before his death.' And Jacob said to Rebecca his mother, 'Look, Esau my brother is a hairy man, and I am a smooth-skinned man. Perhaps my father will feel me, and I shall seem to be a deceiver to him; and I shall bring a curse on myself and not a blessing.' But his mother said to him, 'Let your curse be on me, my son; only obey my voice, and go, get them for me.' And he went and got them and brought them to his mother, and his mother made savoury food, such as his father loved. Then Rebecca took the choice clothes of her elder son Esau, which were with her in the house, and put them on Jacob her younger son. And she put the skins of the kids of the goats on his hands and on the smooth part of his neck. Then she gave the savoury food and the bread, which she had prepared, into the hand of her son Jacob. So he went to his father and said, 'My father.' And he said, 'Here I am. Who are you, my son?' Jacob said to his father, 'I am Esau your firstborn; I have done just as you told me; please arise, sit and eat of my game, that your soul may bless me.' But Isaac said to his son, 'How is it that you have found it so quickly, my son?' And he said, 'Because the Lord your God brought it to me.' Isaac said to Jacob, 'Please come near, that I may feel you, my son, whether you are really my son Esau or not.' So Jacob went near to Isaac his father, and he felt him and said, 'The voice is Jacob's voice, but the hands are the hands of Esau.' And he did not recognize him, because his hands were hairy like his brother Esau's hands; so he blessed him. / GENESIS 27:8–23

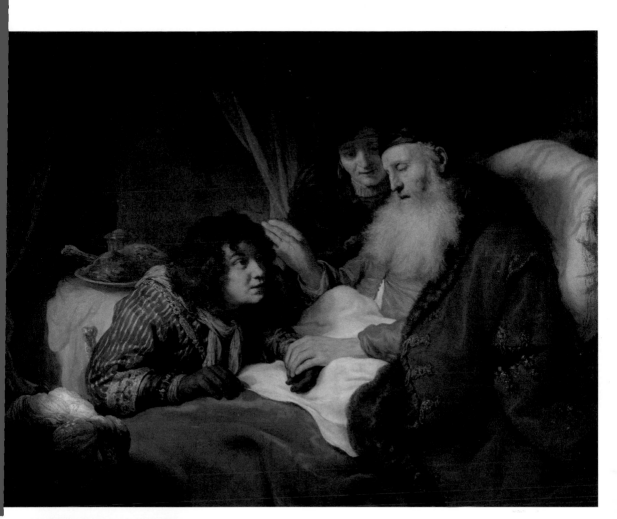

Painters like Rembrandt and Flinck conventionally portrayed characters from the Old Testament in turbans and exotic costumes.

Isaac (see also p. 20), now old and blind, runs his fingers over the head and hands of his youngest son Jacob, and raises a hand to bless him. The moment is filled with suspense, as Isaac has been led to believe that the son he is blessing is Esau. His much younger wife Rebecca, who is responsible for the deception, looks on with satisfaction. As a result, Jacob will become lord and master over his brother Esau. The subject was represented by several of the artists in Rembrandt's circle. Govert Flinck was apprenticed to the master for some time in the 1630s, and Rembrandt's influence on his work is strongly in evidence here.

JACOB

Jusepe de Ribera, 1591–1652
Jacob's Dream, 1639
Canvas, 179 x 233 cm
Museo Nacional del Prado, Madrid

Jacob is a solid figure in contrast to his ethereal dream. The painting follows the description in the Bible: Jacob lies asleep on the ground with his face cupped in his left hand and his head resting on a stone. By showing only the dreamer and not the dream, Ribera transformed this miraculous event into a human, everyday scene. Only Jacob knows what he sees. A shaft of white light brushes over his hair and dissolves in the golden glow of the clouds. The sky occupies more than half of this large composition.

The Jewish patriarch Jacob, who was the grandson of Abraham and the son of Isaac, went in search of a bride. So he came to a certain place and stayed there all night, because the sun had set. And he took one of the stones of that place and put it at his head, and he lay down in that place to sleep. Then he dreamed, and behold, a ladder was set up on the earth, and its top reached to heaven; and there the angels of God were ascending and descending on it. And behold, the Lord stood above it and said: 'I am the Lord God of Abraham your father and the God of Isaac; the land on which you lie I will give to you and your descendants. Also your descendants shall be as the dust of the earth; you shall spread abroad to the west and the east, to the north and the south; and in you and in your seed all the families of the earth shall be blessed. Behold, I am with you and will keep you wherever you go, and will bring you back to this land; for I will not leave you until I have done what I have spoken to you.' Then Jacob awoke from his sleep and said, 'Surely the Lord is in this place, and I did not know it.' And he was afraid and said, 'How awesome is this place! This is none other than the house of God, and this is the gate of heaven!' Then Jacob rose early in the morning, and took the stone that he had put at his head, set it up as a pillar, and poured oil on top of it. / GENESIS 28:11–18

This is one of the few paintings of Jacob's Dream that does not show the ladder on which the angels are said to have mounted and descended from heaven, nor do we see God, who in the dream was standing beside Jacob. Ribera's Jacob, sound asleep, is a man like any other, and even the shaft of light falling from the sky is unremarkable until one knows the story. All attention is focused on the dreamer in this lyrical, evocative scene. The story of Jacob is the first biblical account of a dream, and it was often illustrated in art, albeit with different allegorical interpretations. The ladder, for instance, represents a bridge between heaven and earth, just as Christ, the divine son of man – or his mother the Virgin Mary – formed a link between God and the world.

Jacob lies in a barren wasteland. The tree beside him is withered and dry, but a few green leaves grow on the side exposed to the light from heaven.

Raphael departs from the biblical account by bringing Rachel's sister Leah into the scene, alluding to her role in the intrigue that follows this encounter. It is easy to distinguish between the two sisters, for the Bible describes Rachel as more 'beautiful and well favoured'. Seven years later, the girls' father deceived Jacob by secretly sending Leah, with a bride's veil covering her face, to take Rachel's place on the wedding night. We should remember that Jacob was not always entirely honest either (see p. 216).

JACOB

Raphael, 1483–1520
The Meeting of Jacob, Rachel and Leah, 1514–17
Fresco
Loggia, Palazzi Pontifici, Vatican, Rome

Jacob was fleeing from his vengeful brother Esau. His mother Rebecca and his father Isaac sent him to his uncle Laban in Mesopotamia to marry one of Laban's daughters.

So Jacob went on his journey and came to the land of the people of the East. And he looked, and saw a well in the field; and behold, there were three flocks of sheep lying by it; for out of that well they watered the flocks. A large stone was on the well's mouth. Now all the flocks would be gathered there; and they would roll the stone from the well's mouth, water the sheep, and put the stone back in its place on the well's mouth. And Jacob said to them, 'My brethren, where are you from?' And they said, 'We are from Haran.' Then he said to them, 'Do you know Laban the son of Nahor?' And they said, 'We know him.' So he said to them, 'Is he well?' And they said, 'He is well. And look, his daughter Rachel is coming with the sheep.' Then he said, 'Look, it is still high day; it is not time for the cattle to be gathered together. Water the sheep, and go and feed them.' But they said, 'We cannot until all the flocks are gathered together, and they have rolled the stone from the well's mouth; then we water the sheep.' Now while he was still speaking with them, Rachel came with her father's sheep, for she was a shepherdess. And it came to pass, when Jacob saw Rachel the daughter of Laban his mother's brother, and the sheep of Laban his mother's brother, that Jacob went near and rolled the stone from the well's mouth, and watered the flock of Laban his mother's brother. Then Jacob kissed Rachel, and lifted up his voice and wept. And Jacob told Rachel that he was her father's relative and that he was Rebecca's son. So she ran and told her father. / GENESIS 29:1–12

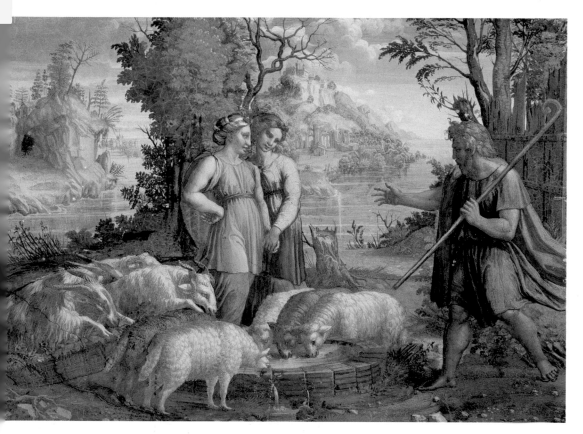

It looks as if Jacob has just arrived on the scene. His garments flutter as he walks, he holds a staff in one hand, and waves to greet the sisters.

At this point in the story the stone has been removed from the mouth of the well – though this is not shown – and the sheep quench their thirst. Jacob must have possessed supernatural powers to have moved the stone.

Several characters in the Bible meet their partners at a well (see pp. 306–307). These episodes gave artists an opportunity to illustrate the story in a pastoral landscape. The incident depicted here clearly takes place in Mesopotamia (literally 'the land between rivers'), with Laban's native city shown in the background. Jacob fell in love with Rachel at first sight, but through the doings of her father Laban, he only married her fourteen years later.

JACOB

Diego Velázquez, 1599–1660
Joseph's Tunic, 1630

Canvas, 223 x 250 cm
Monasterio de San Lorenzo de El Escorial,
Madrid

Jacob gave Joseph a beautiful tunic
made from cloth of many colours.
This was one of the reasons for his
brothers' jealousy. But the Bible also
says quite explicitly that Jacob
favoured Joseph over his other sons.

The brothers react in different ways.
One feigns sorrow, another appears
to be wondering whether Jacob will
be taken in by the deceit, while the
others look embarrassed and
ashamed for lying to their father.
Some of the figures recall the young
blacksmiths in Velázquez' painting
of *Vulcan's Forge*, which dates from
the same period (see p. 343).

*Jacob favoured his youngest son Joseph and made a
beautiful long tunic for him. Joseph's half-brothers were
jealous, and more so when he told them he had dreamed
that he was destined to reign over them. It happened one
day that his brothers were tending their flocks. Reuben
was the eldest. Jacob sent Joseph to them with a message.*

Now when they saw him afar off, even before he came
near them, they conspired against him to kill him. Then
they said to one another, 'Look, this dreamer is coming!
Come therefore, let us now kill him and cast him into
some pit; and we shall say, "Some wild beast has devoured
him." We shall see what will become of his dreams!' But
Reuben heard it, and he delivered him out of their hands,
and said, 'Let us not kill him.' And Reuben said to them,
'Shed no blood, but cast him into this pit which is in the
wilderness, and do not lay a hand on him' – that he might
deliver him out of their hands, and bring him back to his
father. So it came to pass, when Joseph had come to his
brothers, that they stripped Joseph of his tunic, the tunic
of many colours that was on him. Then they took him and
cast him into a pit. And the pit was empty; there was no
water in it. And they sat down to eat a meal.

*The brothers decided to spare Joseph's life, and sold
him to merchants instead.*

[Then] they took Joseph's tunic, killed a kid of the goats,
and dipped the tunic in the blood. Then they sent the
tunic of many colours, and they brought it to their father
and said, 'We have found this. Do you know whether it is
your son's tunic or not?' And he recognized it and said, 'It
is my son's tunic. A wild beast has devoured him. Without
doubt Joseph is torn to pieces.' Then Jacob tore his clothes,
put sackcloth on his waist, and mourned for his son many
days. / GENESIS 37:18–34

*Jacob was later reunited with Joseph, who in
the meantime had become the viceroy of Egypt.*

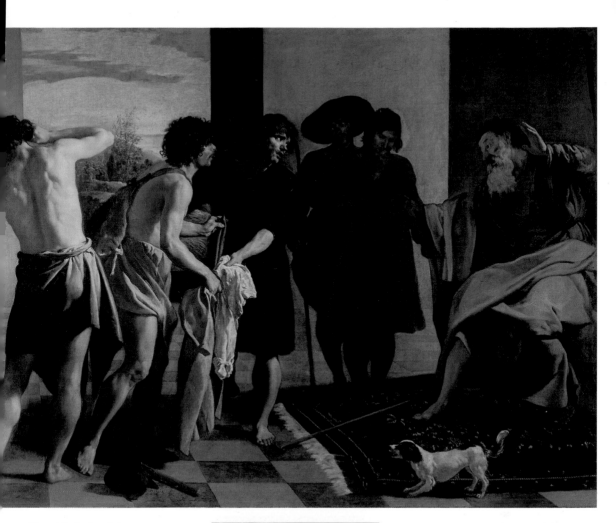

The elderly Jacob is overcome with grief when his sons show him the bloodstained tunic belonging to his favourite son Joseph. In the Bible, however, it is not they who bring it to him. Just as the sons had hoped, Jacob assumes that Joseph was killed by a wild animal. His gesture is a standard means of expressing anguish in art. Three of Joseph's brothers are shown from the back, in profile, and facing the viewer. The two standing nearest to Jacob appear to have been added as an afterthought.

The dog which the painter has introduced into the scene barks wildly at the brothers. It smells the blood of a goat, not that of a man. No one pays it any heed.

JEREMIAH

Rembrandt, 1606–1669
Jeremiah Lamenting the Destruction
of Jerusalem, 1630
Panel, 58 x 46.5 cm
Rijksmuseum, Amsterdam

Jeremiah is depicted outside the city, although the Bible says he was 'shut up in the court of the prison'. The image of Jeremiah grieving – which the Bible does not mention – had precedents in medieval art and alludes to the fact that he was the author of the 'Lamentations'.

On more than one occasion, the prophet Jeremiah (c. 600 BC), speaking in the name of God, foretold the fall and the destruction of Jerusalem at the hands of King Nebuchadnezzar of Babylon (587 BC).

The word which came to Jeremiah from the Lord, when Nebuchadnezzar king of Babylon and all his army, all the kingdoms of the earth under his dominion, and all the people, fought against Jerusalem and all its cities, saying, 'Thus says the Lord, the God of Israel: go and speak to Zedekiah king of Judah and tell him, "Thus says the Lord: Behold, I will give this city into the hand of the king of Babylon, and he shall burn it with fire. And you shall not escape from his hand, but shall surely be taken and delivered into his hand."' / JEREMIAH 34:1–3

This is how the city was captured:

Now it came to pass in the ninth year of his reign, in the tenth month, on the tenth day of the month, that Nebuchadnezzar king of Babylon and all his army came against Jerusalem and encamped against it; and they built a siege wall against it all around. So the city was besieged until the eleventh year of King Zedekiah. By the ninth day of the fourth month the famine had become so severe in the city that there was no food for the people of the land. Then the city wall was broken through, and all the men of war fled at night by way of the gate between two walls, which was by the king's garden, even though the Chaldeans were still encamped all around against the city. And the king went by way of the plain. But the army of the Chaldeans pursued the king, and they overtook him in the plains of Jericho. All his army was scattered from him. So they took the king and brought him up to the king of Babylon at Riblah, and they pronounced judgment on him. Then they killed the sons of Zedekiah before his eyes, put out the eyes of Zedekiah, bound him with bronze fetters, and took him to Babylon. / 2 KINGS 25:1–7

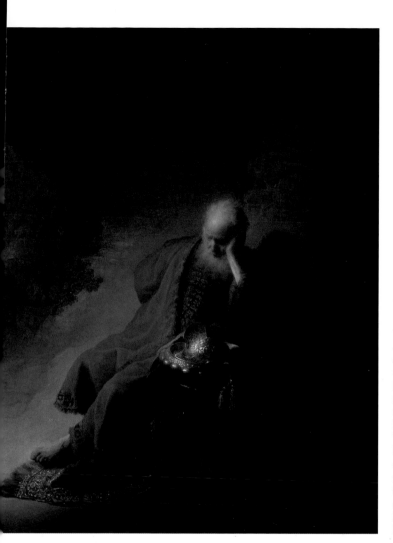

Rembrandt may have derived the precious objects shown with Jeremiah from a different source: according to the *Antiquities of the Jews* by Flavius Josephus (AD 37/38–100), Jeremiah chose not to accompany the Babylonians to Babylon, preferring to remain in the ruins of Jerusalem. The Babylonian governor granted his every wish: 'The prophet desired only to spend the remainder of his days among the ruins and lamentable remains of his fatherland ... and he [the governor] bestowed upon him precious gifts.'

Bathed in light, the old Jeremiah, defeated and disheartened, sits at the base of a large column. He wears a fur-trimmed robe and leans on a heavy tome inscribed, probably by a later hand, with the word 'Bibel'. Beside him are various precious objects, an exquisite burgundy rug, a jug and a bag. A domed church can be seen in the blazing city in the left background. The city is Jerusalem, which has fallen to the Babylonians. Up to the end of the 19th century, the painting was thought to represent, among other things, Lot and the burning of Sodom (see p. 242).

The image of a woman emptying a bucket of water over Job is often understood as an expression of contempt. A similar story was told in classical times, when Xanthippe poured a jar of water over her husband Socrates. In the Bible, Job's wife castigates her husband for his meekness in the face of misfortune. Given that the painting was probably made for a hospital chapel, the motif could also allude to the healing powers of water.

JOB

Albrecht Dürer, 1471–1528
Job and his Wife; Two Musicians, c. 1503–05
Panels of the Jabach Altarpiece, 96 x 51 cm each
Städelsches Kunstinstitut und Städtische Galerie, Frankfurt;
Wallraf-Richartz-Museum & Fondation Corboud, Cologne

There was a man in the land of Uz, whose name was Job; and that man was blameless and upright, and one who feared God and shunned evil. And seven sons and three daughters were born to him. Also, his possessions were seven thousand sheep, three thousand camels, five hundred yoke of oxen, five hundred female donkeys, and a very large household, so that this man was the greatest of all the people of the East.

Satan devised a plan to see whether Job would remain faithful to God even in the face of adversity. As a result – for no reason at all and with God's acquiescence – he was bereft of his cattle, his servants and even his children. Four messengers came, one after another, to tell him of his loss.

Then Job arose, tore his robe, and shaved his head; and he fell to the ground and worshipped. And he said: 'Naked I came from my mother's womb, and naked shall I return there. The Lord gave, and the Lord has taken away; blessed be the name of the Lord.' In all this Job did not sin nor charge God with wrong.

Satan persisted. If he brought illness upon Job, would he still remain faithful to God?

So Satan went out from the presence of the Lord, and struck Job with painful boils from the sole of his foot to the crown of his head. And he took for himself a potsherd with which to scrape himself while he sat in the midst of the ashes. Then his wife said to him, 'Do you still hold fast to your integrity? Curse God and die!' But he said to her, 'You speak as one of the foolish women speaks. Shall we indeed accept good from God, and shall we not accept adversity?' In all this Job did not sin with his lips. / JOB 1:1–3, 20–22 and 2:7–10

The remainder of the Old Testament Book of Job recounts a lengthy debate between Job and his three friends concerning the purpose of suffering. In the end, God gives Job twice as much as he possessed before, and ten children. Job also lived for another one hundred and forty years.

In some translations of the Bible Job sits in ashes, in others in dust and dirt. In the Vulgate, Saint Jerome's Latin translation, he sits on a dungheap.

226

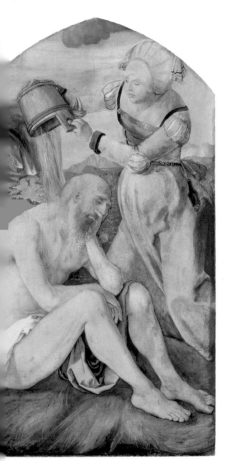

(*Left*) 'The fire of God fell from heaven and burned up the sheep and the servants, and consumed them.' These are the words of the Bible. We see one of the messengers coming to bring Job the bad news.

(*Right*) Another messenger came to Job and said, 'The Chaldeans formed three bands, raided the camels and took them away, yes, and killed the servants with the edge of the sword.'

These panels were originally the wings of a triptych known as the Jabach Altarpiece. The altarpiece may have been made during a plague epidemic, perhaps for a hospital chapel. This is the scene that appeared when the triptych was closed. Job symbolized resignation in the face of suffering. He came to be seen as the protector of plague victims. The picture also recalled Christ's suffering. It brought consolation and served as an example to the sick.

Job sits on the left, his head shaven and his body covered in sores, while his wife, dressed in the fashion of Dürer's time, empties a bucket of water over him. This non-biblical episode was occasionally depicted in art. The drummer and the piper shown on the right-hand wing are not mentioned in the Bible. They might allude to the soothing effect of music. Whatever the case, Job came to be seen as the patron of musicians in the Low Countries and other parts of the world.

Elizabeth passes her newborn child to a midwife. The infant is shown with a halo and is already wrapped in swaddling clothes.

JOHN THE BAPTIST

Jan van Eyck?, c. 1385–1441
The Birth of John the Baptist, 1420s?
Miniature from the Turin–Milan Hours, fol. 93v, 28 x 20 cm
Museo Civico d'Arte Antica, Turin

The priest Zacharias was married to Elizabeth. Both were advanced in years when an angel appeared to Zacharias and announced that his wife would give birth to a son. That son, who was to be called John, would 'make ready a people prepared for the Lord'.

And Zacharias said to the angel, 'How shall I know this? For I am an old man, and my wife is well advanced in years.' And the angel answered and said to him, 'I am Gabriel, who stands in the presence of God, and was sent to speak to you and bring you these glad tidings. But behold, you will be mute and not able to speak until the day these things take place, because you did not believe my words which will be fulfilled in their own time.' Now Elizabeth's full time came for her to be delivered, and she brought forth a son. When her neighbours and relatives heard how the Lord had shown great mercy to her, they rejoiced with her. So it was, on the eighth day, that they came to circumcise the child; and they would have called him by the name of his father, Zacharias. His mother answered and said, 'No; he shall be called John.' But they said to her, 'There is no one among your relatives who is called by this name.' So they made signs to his father – what he would have him called. And he asked for a writing tablet, and wrote, saying, 'His name is John.' So they all marvelled. Immediately his mouth was opened and his tongue loosed, and he spoke, praising God. Then fear came on all who dwelt around them; and all these sayings were discussed throughout all the hill country of Judaea. And all those who heard them kept them in their hearts, saying, 'What kind of child will this be?' And the hand of the Lord was with him. / LUKE 1:18-20, 57-66

Elizabeth and Mary, the mother of Jesus, were cousins and so therefore were their children. Jesus was born a few months after his cousin John.

MARY AND ELIZABETH

According to the evangelist Luke, Mary visited Elizabeth in the sixth month of her cousin's pregnancy. In the late Middle Ages, that event, known as the Visitation, became part of the standard artistic repertoire. However, Mary's presence at the birth of the child is not mentioned in the gospels. Her attendance on that occasion was a non-biblical addition to the story.

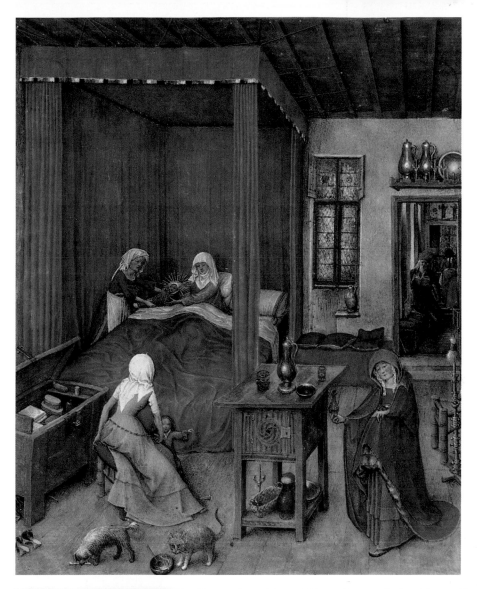

The newborn John and his mother are depicted in an affluent 15th-century interior with a beautiful four-poster bed. The scene is rendered with the detailed realism that characterizes early Netherlandish painting. Luke is the only one of the evangelists to recount this story, which was expanded in the medieval *Legenda aurea* (*Golden Legend*; see also p. 251) and various retellings of the Bible. The miniature comes from a manuscript that was partly destroyed by fire. The full extent of Jan van Eyck's share in that work has yet to be established, but most art historians agree that this and several other illuminated pages are probably from his hand.

An elderly man wearing an unusual cap sits in an anteroom and reads a book. He is the key to our understanding of the scene. The man is Zacharias, who is still mute at this point and who, as a man, is banished from the room where his wife has just given birth.

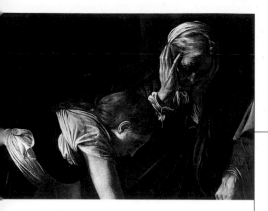

JOHN THE BAPTIST

Caravaggio, 1573–1610
The Beheading of John the Baptist, 1608
Canvas, 361 x 520 cm
Oratory of Saint John's Cathedral, Valletta (Malta)

The older woman holds her head in her hands in a gesture of horror and despair. Salome, however, stares at the platter she holds in her hands.

For Herod himself had sent and laid hold of John, and bound him in prison for the sake of Herodias, his brother Philip's wife; for he had married her. Because John had said to Herod, 'It is not lawful for you to have your brother's wife.' Therefore Herodias held it against him and wanted to kill him, but she could not; for Herod feared John, knowing that he was a just and holy man, and he protected him. And when he heard him, he did many things, and heard him gladly. Then an opportune day came when Herod on his birthday gave a feast for his nobles, the high officers, and the chief men of Galilee. And when Herodias' daughter herself came in and danced, and pleased Herod and those who sat with him, the king said to the girl, 'Ask me whatever you want, and I will give it to you.' He also swore to her, 'Whatever you ask me, I will give you, up to half my kingdom.' So she went out and said to her mother, 'What shall I ask?' And she said, 'The head of John the Baptist!' Immediately she came in with haste to the king and asked, saying, 'I want you to give me at once the head of John the Baptist on a platter.'

And the king was exceedingly sorry; yet, because of the oaths and because of those who sat with him, he did not want to refuse her. Immediately the king sent an executioner and commanded his head to be brought. And he went and beheaded him in prison, brought his head on a platter, and gave it to the girl; and the girl gave it to her mother. When his disciples heard of it, they came and took away his corpse and laid it in a tomb. / MARK 6:17-29

The jailer, with a bunch of keys at his side, looks on dispassionately while he directs the proceedings. Moments later, John's head will be placed on the platter and presented to Herod and Herodias.

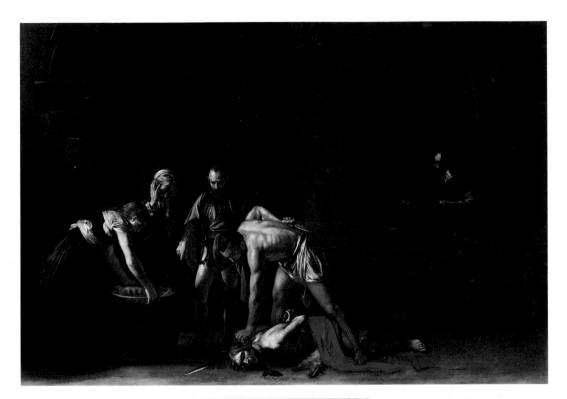

Two men and two women witness the gruesome scene in a gloomy courtyard, where John lies lifeless with his hands tied behind his back. The four observers form a semicircle around him, while two prisoners look on through the bars of their cell as the executioner prepares to sever the head from the body. Caravaggio painted this harrowing altarpiece – his largest work – for the Order of Saint John, or the Knights Hospitaller of Malta. John the Baptist was the patron saint of the Order and Caravaggio was a knight of Saint John. The painting in the chapel served as a reminder of John's death and martyrdom, an event that prefigured Christ's sacrifice on the Cross and the salvation of humankind.

John has just been killed with a sword. Blood pours from his neck as the executioner grasps him by the hair. This is the only signed work by Caravaggio, and his signature appears, somewhat macabrely, right in John's blood. Though the artist was known as Caravaggio after his birthplace near Bergamo, his real name was Michelangelo Merisi. The signature on the painting, 'Fr. Michelangelo', is an abbreviation of the Latin for Brother Michelangelo. Shortly after completing the work, Caravaggio was expelled from the Order of Saint John and sent to prison, evidently following a brawl with a fellow-member. His sentence was handed down in the oratory in which this painting was displayed.

JOSEPH, SON OF JACOB

Rembrandt, 1606–1669
Joseph Accused by Potiphar's Wife, 1655
Canvas, 106 x 98 cm
National Gallery of Art, Washington, Andrew W. Mellon Collection

The despondent Joseph, accused of a wrong he has conscientiously avoided, has the features of Rembrandt's son Titus. The keys to Potiphar's house hang at his side. A few years before making this picture, Rembrandt was himself sued by his mistress for breach of promise. The case dragged on for years.

The Hebrew Joseph was taken to Egypt and sold to a certain Potiphar, an officer of the pharaoh. But God was with Joseph and he prospered and became the head of Potiphar's household.

Now Joseph was handsome in form and appearance. And it came to pass after these things that his master's wife cast longing eyes on Joseph, and she said, 'Lie with me.' But he refused and said to his master's wife, 'Look, my master does not know what is with me in the house, and he has committed all that he has to my hand. There is no one greater in this house than I, nor has he kept back anything from me but you, because you are his wife. How then can I do this great wickedness, and sin against God?' So it was, as she spoke to Joseph day by day, that he did not heed her, to lie with her or to be with her. But it happened about this time, when Joseph went into the house to do his work, and none of the men of the house was inside, that she caught him by his garment, saying, 'Lie with me.' But he left his garment in her hand, and fled and ran outside. And so it was, when she saw that he had left his garment in her hand and fled outside, that she called to the men of her house and spoke to them, saying, 'See, he has brought in to us a Hebrew to mock us. He came in to me to lie with me, and I cried out with a loud voice. And it happened, when he heard that I lifted my voice and cried out, that he left his garment with me, and fled and went outside.' So she kept his garment with her until his master came home. Then she spoke to him with words like these, saying, 'The Hebrew servant whom you brought to us came in to me to mock me; so it happened, as I lifted my voice and cried out, that he left his garment with me and fled outside.' So it was, when his master heard the words which his wife spoke to him, saying, 'Your servant did to me after this manner,' that his anger was aroused. Then Joseph's master took him and put him into the prison, a place where the king's prisoners were confined. And he was there in the prison. / GENESIS 39:6–20

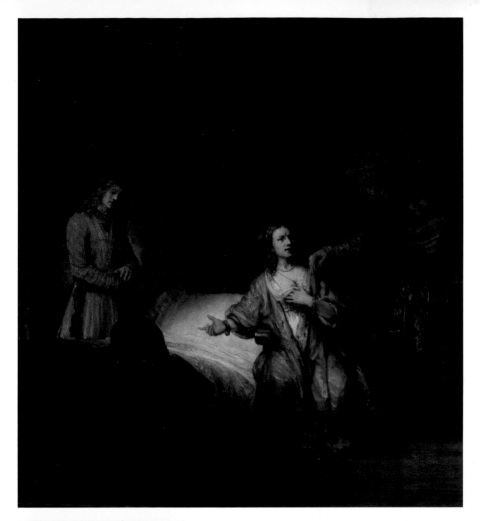

It is unusual for the three protagonists to be shown together when Potiphar's wife accuses Joseph of trying to violate her, but the composition encapsulates the story, especially for Rembrandt's contemporaries, who would have been familiar with the biblical account. Rembrandt may have found inspiration from a play by his contemporary and fellow-townsman Joost van den Vondel, where this was likewise the case (*Joseph in Egypt*). He took some measure of artistic licence with biblical texts in order to add impact to his paintings. Here, for instance, he located the scene in the bedroom.

Holding her hand to her heart, Potiphar's wife points at Joseph's red robe. This, she feels, supports of her allegation regarding his unsolicited advances. Light falls on her and on the bed in which her fabricated story is supposed to have taken place. Risqué scenes of women seducing men were more common in art than the kind of accusation we see here.

JUDITH

Andrea Mantegna or follower, c. 1431–1506
Judith with the Head of Holofernes,
c. 1495–1500
Panel, 30 x 18 cm
National Gallery of Art, Washington

Unlike Judith, the elderly maid looks on as the head is deposited into the bag she holds open for her mistress. Judith seems unperturbed and clutches Holofernes' head by the hair (cf. p. 166). We see mainly the back of the head.

Nebuchadnezzar – elsewhere in the Bible the king of Babylon but in the Book of Judith he is king of the Assyrians – sent an expedition led by Holofernes to punish the Jews. The soldiers besieged the city of Bethulia. And then Judith stepped in. She arrayed herself 'to allure the eyes of all men'. Accompanied by her maid, she went to the enemy camp, saying she had information to give Holofernes. On the fourth day, Holofernes invited her to a banquet intending to seduce her, and became inebriated.

And when it was grown late, his servants made haste to their lodgings, and Vagao shut the chamber doors, and went his way. And they were all overcharged with wine. And Judith was alone in the chamber. But Holofernes lay on his bed, fast asleep, being exceedingly drunk. And Judith spoke to her maid to stand without before the chamber, and to watch: And Judith stood before the bed praying with tears, and the motion of her lips in silence, saying: 'Strengthen me, O Lord God of Israel, and in this hour look on the works of my hands, that as thou hast promised, thou mayst raise up Jerusalem thy city: and that I may bring to pass that which I have purposed, having a belief that it might be done by thee.' And when she had said this, she went to the pillar that was at his bed's head, and loosed his sword that hung tied upon it. And when she had drawn it out, she took him by the hair of his head, and said: 'Strengthen me, O Lord God, at this hour.' And she struck twice upon his neck, and cut off his head, and took off his canopy from the pillars, and rolled away his headless body. / JUDITH 13:1–10

Holofernes' head was hung from the city walls. At the sight of it the besieging army fled in fright.

The artist was faithful to the biblical text: Judith was alone in the tent with Holofernes when she committed her gruesome deed. Her maid waited outside. Judith still holds Holofernes' sword and looks away as she deposits his head in the bag. Judith epitomized the heroic woman who outwits a barbarian. The religious message – a chaste, courageous woman defeats evil in the shape of an unbeliever and saves the Israelites – was often eclipsed. In Florence, for instance, Judith came to symbolize the Republic's commitment to liberty and intolerance of tyranny.

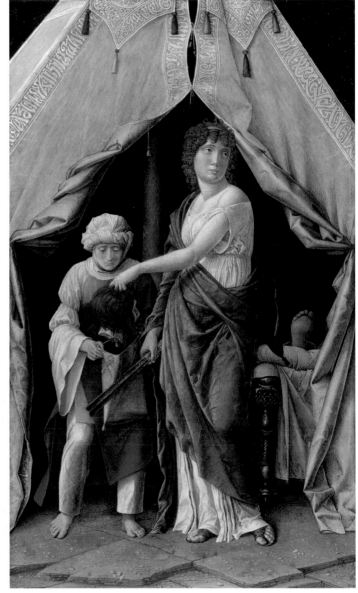

Inside the dark tent the headless body of Holofernes still lies on the bed. The Bible, however, says that Judith had 'rolled away his headless body'. The bed is described in an earlier passage: 'Holofernes [was] sitting under a canopy, which was woven of purple and gold, with emeralds and precious stones' (Judith 10:19). In art rulers from the East were usually depicted as wealthy and opulent.

JUDITH

Caravaggio, 1573–1610
Judith Beheading Holofernes, 1597–1600
Canvas, 145 x 195 cm
Palazzo Barberini, Galleria Nazionale d'Arte Antica, Rome

Caravaggio depicted the grisly execution in a work of strongly contrasting images: a beautiful young woman, to all appearances aloof and impassive, kills a helpless, barbaric-looking man. Terrified and obviously in excruciating pain, he struggles in vain to rise.

The stinging realism of this painting of Holofernes in the throes of death prompted speculation that Caravaggio had himself witnessed executions in Rome. The observer is spared nothing: we see the sword sinking into the victim's neck and blood spurting from the wound.

Caravaggio departed from the biblical text by bringing Judith's servant into the scene of the execution. She stands by, ready to receive the head. The old, tawny-faced woman is a foil to the beautiful, young, fair-complexioned Judith, who had dressed in her finery for the banquet in Holofernes' tent. Her body expresses determination as well as revulsion.

Sandro Botticelli, 1446–1510
The Return of Judith, c. 1470–72
Panel, 31 x 25 cm
Galleria degli Uffizi, Florence

Judith has left the enemy camp
and returns to her city Bethulia.
In her right hand she holds the
deadly sword and in her left
an olive branch, a conventional
symbol of victory and peace.
Her maid walks behind her,
carrying Holofernes' head.
This early work by Botticelli
was part of a diptych. The second
panel showed Holofernes' soldiers
discovering the decapitated body.

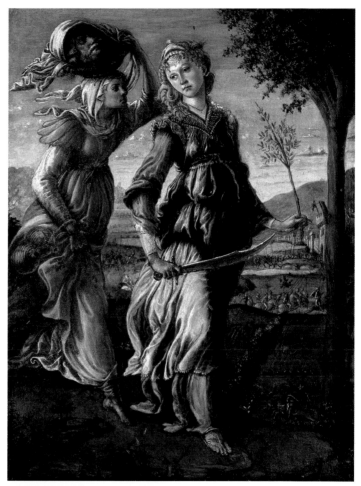

The servant in Botticelli's painting
is a young woman, like Judith.
She balances Holofernes' head
unsteadily on her own. It is not
packed in a bag but wrapped in a
sheet of canvas, so that it can still
be seen by the observer. The maid
also carries two water flasks
around the wrist of her right hand.
She and Judith had spent four
days in the enemy camp.

In the distance Holofernes' army
is preparing to take revenge.

JULIUS CIVILIS

Rembrandt, 1606–1669
The Conspiracy of Julius Civilis, c. 1666
Canvas, 196 x 309 cm
Nationalmuseum, Stockholm

Tacitus mentions that Julius Civilis, a 'shrewd' man 'of royal birth', possessed only one eye, and that is how Rembrandt portrayed him. He also gave him an exotic-looking headdress. In any event, Rembrandt's Civilis and his Batavian cohorts look more like barbarians than Romans. This might be one of the reasons why the painting was removed soon after being hung in the Town Hall.

PAINTING FOR THE TOWN HALL
Rembrandt's canvas was made for the new Town Hall (now the Royal Palace) of Amsterdam, in itself an accolade to the glory of the Dutch Republic. The commission for a cycle of paintings illustrating the Batavian uprising against Rome was initially awarded to Rembrandt's pupil Govert Flinck, but after Flinck's untimely death the work was shared among four artists. Rembrandt was one of them. The painting before us – Simon Schama described it as the most awe-inspiring ruin in the history of European painting – is no more than a fragment of Rembrandt's rejected original. It shows the conspirators assembled in a lofty hall overlooking a wood, as we know from what is believed to have been a preliminary study.

In AD 69 Rome's allies, the Batavians, rebelled against Rome, led by the shrewd Julius Civilis (who, through a clerical error, is also known as Claudius Civilis). The only written account of this story comes from the historian Tacitus.

Civilis summoned to a sacred grove the chieftains and the boldest men, ostensibly for a banquet. The night wore on and the men were inflamed by the conviviality of the company, and it was then that Civilis spoke to them of the honour and glory of their tribe. He enumerated, too, the many injustices, humiliations and tribulations of enslavement. 'No longer are we allies as of old,' he said. 'We are lackeys at the mercy of officers and soldiers who profit from our booty and our blood. And when they are discharged, others, no better than they, find new ways to enrich themselves and devise new ruses to plunder.' Civilis' words met with cheers of approval. Then he bound his men to him with barbaric rites and ancestral oaths.

/ TACITUS, *Histories*, 4, 14–15

The Romans soon put an end to the rebellion and restored the old alliance. Civilis' fate is unknown.

Tacitus does not describe the swearing of the oath. In the painting the rebel leaders cross swords. That is how Rembrandt pictured Tacitus' *barbaro ritu*, or 'barbaric rites'. More conventional painters showed the men shaking hands.

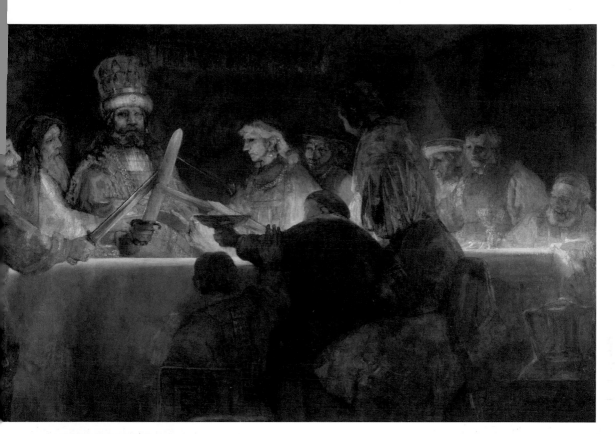

Rembrandt's painting captures the exhilaration of this stirring moment from the story of the Batavian rebellion. The scene is not particularly noble or heroic, but it does conjure up the mood of elation that Tacitus describes. A group of slightly sinister-looking characters are gathered around a table, some holding drinks in their hands. The Batavian rebellion – the uprising of a band of freedom fighters against a tyrannical authority – was in fact a relatively minor incident in history. Nevertheless, centuries later it was invoked by Dutch propagandists who likened the rebellion to the Dutch Revolt, when the Northern Netherlands shook off the yoke of Spanish domination and by the Peace of Münster of 1648 established an independent republic. The story was supposed to demonstrate what freedom would bring to the new Dutch Republic. The problem, however, was that Rembrandt's work failed to do this.

Another problem was that the rebels swore their oath of allegiance while feasting and carousing in a wood at night, but this was not the image that the Amsterdam elite, who wanted to be identified with them, would have wished to cultivate for themselves. Rembrandt's characters look too much like drunks.

Leda, one of Leonardo's few nudes, smiles – timidly, perhaps – at her four newborn children on the left, while the ardent swan, on the right, cranes its neck to kiss her. Leonardo's numerous drawings demonstrate that he was interested in birds and flight, and in the beginnings of new life.

LEDA

After Leonardo da Vinci, 1452–1519
Leda and the Swan, c. 1505–07
Panel, 130 x 77.5 cm
Galleria degli Uffizi, Florence

My fatherland is glorious Sparta and my father was Tyndareos. But the story told is that Zeus in the guise of a swan flew to my mother Leda, feigning that he was being pursued by an eagle. And she, thus deceived, at least if that is true, lay with him. I was named Helen.

This is how the tragic dramatist Euripides summarizes the fantastic origins of Helen in the play of that name. The surviving classical sources on Greek and Roman myths are often brief and in many cases contradictory. The story of Helen's mother Leda is a case in point. Ovid says nothing more than that 'Arachne depicted Leda lying between the wings of a swan'. More details can be found in Italian translations and reworkings of Ovid's Metamorphoses *and in commentaries on his writings. Those were the sources that artists like Leonardo da Vinci and Titian used. Boccaccio's 'Pantheon of the Heathen Gods'* (De genealogia deorum gentilium) *also contained a more elaborate version of the story. Since the days of antiquity sculptors and painters have used the story as a pretext to represent sensual, if not overtly erotic scenes of the naked Leda and her swan-god. She may be standing, kneeling or, as in most cases, reclining, sometimes with the swan nestling between her legs and reaching up to kiss her. For many years this was one of the most candid representations of the sexual act. It escaped censorship because of Jupiter's disguise as a swan. The scene was especially popular in 16th-century Italian art. In the late Middle Ages the story of Leda was likened to the episode of the Virgin Mary being visited by an angel and the Holy Ghost in the guise of a dove, who announced that she would conceive a child (see p. 246).*

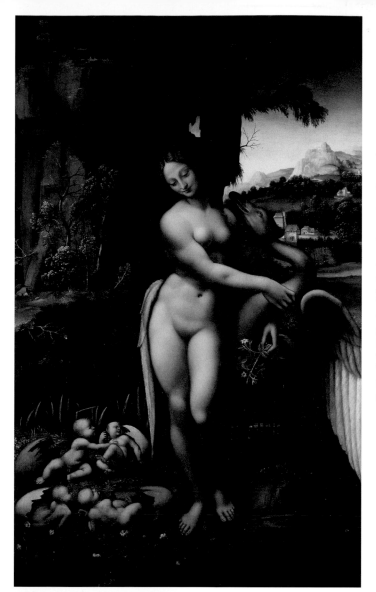

Leonardo's original panel was in the French Royal Collection for many years, along with the *Mona Lisa*. It was evidently lost in the 18th century. But a few preliminary drawings and copies of the painting have survived. The work shown here may have been made by Leonardo's assistant Ferrando Spagnolo. It was more practical, especially for sculptors, to represent the nude Leda standing with the swan at her side than to show a reclining figure in the embrace of a bird. In the painting the bird enfolds her with its wing and she caresses it with both hands. The two are shown here on the flowery banks of a river, as described in the classical texts. Leonardo made a second version, which shows Leda kneeling. That work has also been lost but is known from a copy by an assistant.

On the flowery banks of the river – the detailed rendering of the landscape recalls the 'Flemish Primitives' – Leonardo depicted a scene from one version of the classical myth when, as a result of her extraordinary liaison with the swan-god, Leda produced two eggs. Here, she is at once victim, lover and mother. As in many vernacular translations of Ovid, the boys, Castor and Pollux, and the girls, Helen and Clytaemnestra, form two distinct pairs.

LOT

Anonymous (Antwerp?)
Lot and his Daughters, first half 16th century
Panel, 48 x 34 cm
Musée du Louvre, Paris

Lot and his daughters, leading an ass, flee over the river Jordan. The figure left behind on the bridge is Lot's wife. She disobeyed the angels' warning not to look back and was turned into a pillar of salt.

Having heard of the iniquity of the cities of Sodom and Gomorrah, the Lord sent two angels to Sodom. Lot, a newcomer to the city, welcomed them into his home. In so doing, he incurred the wrath of the men of Sodom, who lusted after the visitors. The angels told Lot to take his wife and two daughters and flee from the city, which was going to be destroyed. But they were not to look back before they reached the safety of Zoar.

The sun had risen upon the earth when Lot entered Zoar. Then the Lord rained brimstone and fire on Sodom and Gomorrah, from out of the heavens. So He overthrew those cities, all the plain, all the inhabitants of the cities, and what grew on the ground. But his wife looked back behind him, and she became a pillar of salt. And Abraham went early in the morning to the place where he had stood before the Lord. Then he looked towards Sodom and Gomorrah, and towards all the land of the plain; and he saw, and behold, the smoke of the land which went up like the smoke of a furnace. And it came to pass, when God destroyed the cities of the plain, that God remembered Abraham, and sent Lot out of the midst of the overthrow, when He overthrew the cities in which Lot had dwelt. Then Lot went up out of Zoar and dwelt in the mountains, and his two daughters were with him; for he was afraid to dwell in Zoar. And he and his two daughters dwelt in a cave. Now the firstborn said to the younger, 'Our father is old, and there is no man on the earth to come in to us as is the custom of all the earth. Come, let us make our father drink wine, and we will lie with him, that we may preserve the lineage of our father.' So they made their father drink wine that night. And the firstborn went in and lay with her father,

Lot and his daughter, beautifully attired in the fashion of the artist's day, are seated before a scarlet tent (in the biblical account they were at the mouth of a cave). Night has fallen and a lamp burns. This tale of seduction is often depicted as an erotic scene with nude figures.

and he did not know when she lay down or when she arose. It happened on the next day that the firstborn said to the younger, 'Indeed I lay with my father last night; let us make him drink wine tonight also, and you go in and lie with him, that we may preserve the lineage of our father.' Then they made their father drink wine that night also. And the younger arose and lay with him, and he did not know when she lay down or when she arose. Thus both the daughters of Lot were with child by their father. The firstborn bore a son and called his name Moab; he is the father of the Moabites to this day. / GENESIS 19:23–26, 30–36

Lot's daughters bore two sons whose tribes were hostile to the Israelites.

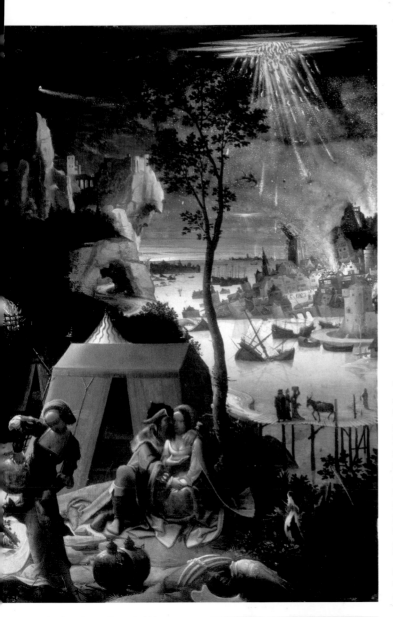

This painting shows the main episodes of the story of Lot as if they occurred simultaneously. Across the river Jordan a rain of fire and brimstone falls from the sky, destroying the city in the distance. In the foreground one of Lot's daughters pours wine from a jar, intending to get her father drunk. The other allows Lot to fondle her. This was not the first time in the Bible that God punished humankind (see p. 32). Though the painting was attributed to Lucas van Leyden for many years, it was probably the work of an Antwerp painter.

Lot's daughters have laid in an abundance of liquor. One pours wine from a jar, while two more jars stand on the ground.

LUCRETIA

Tintoretto, 1518–1594
Tarquinius and Lucretia, 1578–80
Canvas, 171 x 151.5 cm
The Art Institute of Chicago

Lucretia's necklace has snapped and pearls fall to the floor. The motif is a brilliant addition to the standard imagery of this theme.

Lucretia was the beautiful wife of the Roman Collatinus. Carousing and inebriated, he and his companions boasted of the virtue of their wives, each trying to surpass the other. They agreed that the surest test was to take their wives by surprise. The prize of this contest in womanly virtues fell to Lucretia, whose conduct was beyond reproach, unlike that of the wives of the princes and other notables. During a meal, Sextus Tarquinius, the eldest son of King Tarquinius Superbus, was seized with a wicked desire.

Some days later, unbeknown to Collatinus, Sextus Tarquinius took a single attendant and went to Collatia. He was warmly welcomed, for none suspected his purpose, and after the meal he was conducted to the guest room. Later that night, having assured himself that all were sound asleep, Tarquinius drew his sword and approached the sleeping Lucretia. With his left hand on her breast, he restrained her and said, 'Be still, Lucretia! I am Sextus Tarquinius and I have a sword in my hand. Utter a sound and you shall die!' Lucretia awakened in terror. Death stared her in the face, and no help was at hand. Tarquinius began to proclaim his love for her, entreating and intimidating her at once. Her woman's heart wavered, but she remained steadfast, even though her life was in peril. But Tarquinius persisted and threatened to dishonour and kill her. He would murder his slave as well, he said, and lay his naked body at her side, so that all would say she had been slain while committing adultery with a slave. Lucretia trembled at the prospect. Her will faltered and her virtue was overcome by Tarquinius' triumphant lust. Then the victorious Tarquinius left her, crowing with jubilation at having ravished a woman.
/ LIVY, *From the Founding of the City*, 1, 58

The distraught Lucretia sent for her father and her husband, who vowed to avenge her honour. But notwithstanding their efforts to console her, before their very eyes she took a knife and drove it through her heart. According to the historian Livy, her tragic fate fuelled the conflict that led to the overthrow of the monarchy and the proclamation of the Republic of Rome in 509 BC.

The sword with which Tarquinius threatened Lucretia has already fallen to the ground. Tarquinius needs both hands to subdue his victim. The sword is sometimes understood as an allusion to the knife with which Lucretia will take her life the following day.

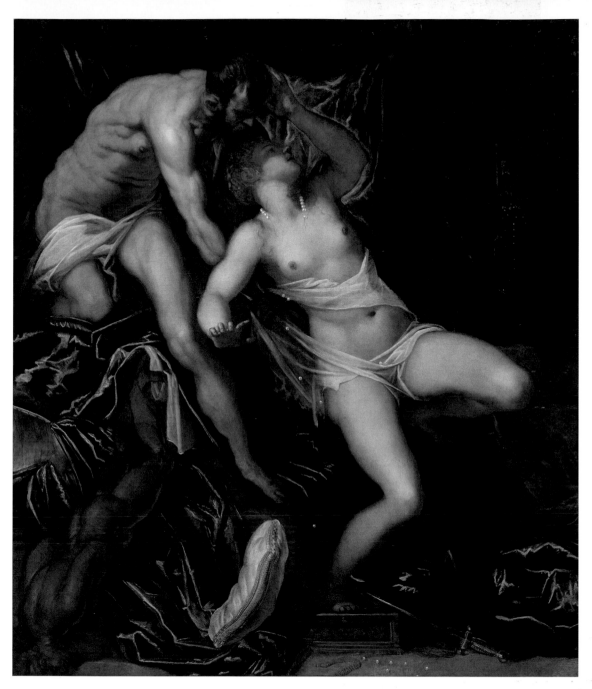

Lucretia's suicide and the moment just before she takes her life were widely represented by the Old Masters all over Europe. Tintoretto's painting is an early and highly original interpretation of the less popular scene, where Tarquinius threatens and rapes Lucretia. Livy makes no mention of this violence. The naked Tarquinius tears the few flimsy fragments of cloth from Lucretia's body. One of the sculptures decorating the bed has been dislodged in the struggle and a pillow falls to the ground. The faces of the two protagonists are mostly hidden from view, but their expressive movements speak volumes.

MARY, THE HOLY VIRGIN

Fra Angelico, c. 1399–1455
The Annunciation, c. 1432–34
Panel, 175 x 180 cm
Museo Diocesano, Cortona

An angel with a sword drives Adam and Eve out of the Garden of Eden. Mary's acquiescence initiates humankind's redemption from original sin, the legacy of the first couple. That explains their presence here. The walled garden (*hortus conclusus*) and the flowers growing there allude to Mary's virginity.

ALTERNATIVE VERSIONS?

This story, too, appeared in apocryphal texts, in different versions and with different anecdotal details. This is also reflected in art. For example, some paintings show Mary with a distaff or a basket of wool, alluding to the legend that in her youth she spun and wove the priests' vestments in the temple of Jerusalem. However, as the evangelist Luke described the event in detail, those other versions had little impact on the work of prominent masters.

Luke is the only one of the four evangelists who describes the moment when Mary learns that she will bear the son of God. Her acquiescence marks the beginning of God's plan for the redemption of humankind from the original sin committed by Adam and Eve, through the incarnation, death and resurrection of Christ (see p. 26).

Now in the sixth month the angel Gabriel was sent by God to a city of Galilee named Nazareth, to a virgin betrothed to a man whose name was Joseph, of the house of David. The virgin's name was Mary. And having come in, the angel said to her, 'Rejoice, highly favoured one, the Lord is with you; blessed are you among women!' But when she saw him, she was troubled at his saying, and considered what manner of greeting this was. Then the angel said to her, 'Do not be afraid, Mary, for you have found favour with God. And behold, you will conceive in your womb and bring forth a Son, and shall call His name Jesus. He will be great, and will be called the Son of the Highest; and the Lord God will give Him the throne of His father David. And He will reign over the house of Jacob forever, and of His kingdom there will be no end.' Then Mary said to the angel, 'How can this be, since I do not know a man?' And the angel answered and said to her, 'The Holy Spirit will come upon you, and the power of the Highest will overshadow you; therefore, also, that Holy One who is to be born will be called the Son of God. Now indeed, Elizabeth your relative has also conceived a son in her old age; and this is now the sixth month for her who was called barren. For with God nothing will be impossible.' Then Mary said, 'Behold the maidservant of the Lord! Let it be to me according to your word.' And the angel departed from her. / LUKE 1:26–38

As in many depictions of this theme by Italian masters, the event takes place in a loggia. The gospel refers vaguely to 'Mary's house'. The angel Gabriel has just arrived. Inscriptions between the angel and Mary, who has a prayer book on her lap, summarize the dialogue quoted by Luke. Mary inclines towards the angel and folds her arms across her breast, expressing humble acquiescence. In the lower section, on the predella or base of the altarpiece, we see five scenes from her life. The annunciation of Christ's birth, a moment of fundamental importance in Christianity, has been richly represented in the visual arts.

With one hand the angel points at Mary and with the other at the representation of God the Father in the spandrel. The gesture links the heavenly (God's decision) with the earthly realm (Mary's acceptance). Beneath God, in the form of a dove, is the Holy Spirit who, according to the gospel, 'will come upon' Mary. She therefore conceives at the moment of the annunciation.

Workshop of Rogier van der Weyden, c. 1399/1400–1464
The Annunciation, c. 1435–40
Centre panel of a triptych, 86 x 93 cm
Musée du Louvre, Paris

As in many Northern European paintings, the event takes place in Mary's modest bedroom, following the medieval interpretation. The kneeling Virgin was clearly engaged in prayer. It is spring (to be precise, 25 March, nine months before Christmas, the day of Christ's birth), and no fire burns in the hearth. The fireplace is screened off by a wooden panel, and a bench stands before it. The presence of God the Father and the dove is not visible, but their 'divine' light pours into the room. The winged archangel Gabriel wears opulent canonicals with a chasuble of gold brocade.

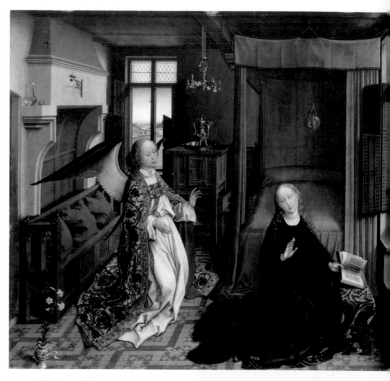

Mary expresses astonishment at the angel's sudden appearance and the message he conveys. As Luke writes: 'She was troubled at his saying.' Other painters emphasized her humility ('Let it be to me according to your word') or uncertainty ('How can this be?'). But all who illustrated this story were inspired by the gospels and the many medieval commentaries and interpretations.

A common feature of the work of the Flemish Primitives is the hidden symbolism in ostensibly everyday objects: the lily, like the carafe on the mantelpiece, the washbasin and the candelabrum are familiar symbols of Mary's chastity. The flower is also a reminder that it is spring.

Lorenzo Lotto, 1480–1557
The Annunciation, c. 1527

Canvas, 166 x 114 cm
Pinacoteca Civica, Recanati

Lotto, too, included symbols alluding to Mary's purity and virginity, like the lily carried by the angel and the enclosed garden that we see through the window.

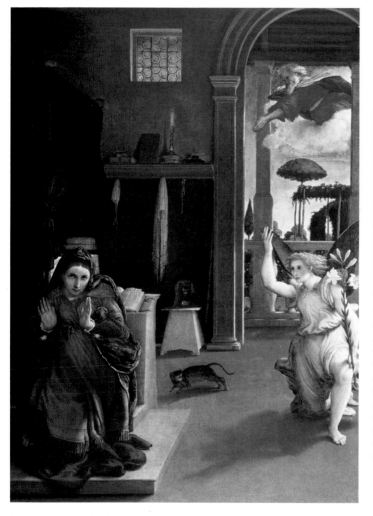

The frightened cat fleeing from the angel might be a symbol of the devil, who will suffer as a result of this event: Christ, who will be born in nine months' time, will deliver humankind from original sin. According to Christian doctrine, the term refers to the cause – the original sin of the first man and woman (see p. 26) – as well as the consequences of it, the fact that man is born in a state of sin.

In Lorenzo Lotto's idiosyncratic version of the Annunciation, the barefoot Mary, who was reading the Bible, turns away from Gabriel, who has just alighted in her bedroom, his hair still streaming behind him. Mary looks out at the observer, apprehensive, bewildered and imploring. Above Gabriel, who points upwards, God descends on a cloud and unequivocally indicates Mary. The décor and the realistically rendered 'still life' on the shelf suggest the influence of Flemish art.

MARY

..................

Perugino, 1446–1523
The Betrothal of the Virgin, c. 1501–04
Panel, 234 x 185 cm
Musée des Beaux-Arts, Caen

The high priest stands in the centre of Perugino's work and in Raphael's later interpretation of the subject. He joins the hands of the new couple and looks on as Joseph slips the ring on the Virgin's finger. The entrance to the temple is directly above the priest's head.

From the time of her third birthday, Mary was brought up 'in the temple of the Lord'. By the conventions of her day, she was now of an age to marry.

When she was in her thirteenth year, the priests held council, and said, 'Behold, Mary has reached her thirteenth year in the temple of the Lord. What must we do that her uncleanliness shall not defile the temple of the Lord?' They said to the high priest, 'You stand at the altar of the Lord. Go within and pray concerning her. What the Lord reveals to you we shall do.' And the priest took the vestment with the twelve bells, and entered the Holiest Sanctuary and prayed concerning Mary. And lo, an angel of the Lord appeared, saying to him, 'Zechariah, Zechariah, go out and summon together the widowers among the people. Each shall bring a rod, and she shall be the wife of him to whom the Lord gives a sign.' Heralds went forth and spread the word throughout Judaea. The trumpet of the Lord sounded, and all hastened to it. Joseph, too, threw down his axe and went out to join the assembly. And when they were gathered together, they brought their rods to the high priest. The priest took the rods and entered the temple to pray. Then, when he had prayed, he took the rods again and went out and returned them. But no sign appeared on the rods. Joseph received the last rod and behold, a dove came out and flew to Joseph's head. Then the high priest said to Joseph, 'To you has fallen the fate to take the virgin of the Lord into your care.' But Joseph protested, saying, 'I am old and already have sons, and she is a young girl. I fear lest the children of Israel shall mock me.' But the priest said to Joseph, 'Fear the Lord thy God, who punishes disobedience. Beware, Joseph, that the same fate does not befall your house.' Then Joseph was afraid and took Mary into his care. And he spoke to her, saying, 'Behold, I have received you from the temple of the Lord. Now I shall leave you in my home and go forth to build my houses, and when that is done, I shall return. The Lord shall watch over you.' / INFANCY GOSPEL OF JAMES 8:2–9

One of the young contenders who lost to the older Joseph expresses his disappointment by breaking his staff. The men are shown here gathered around Joseph; the women, who were brought up in the temple with Mary, are on the other side.

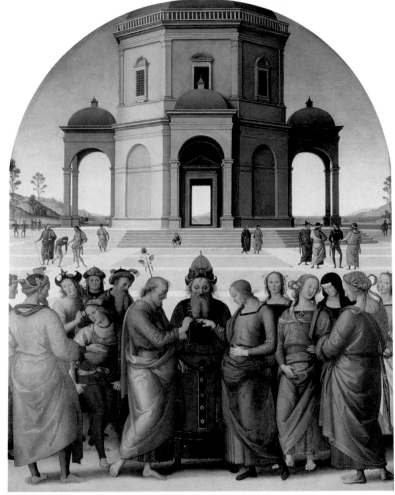

The dove mentioned in the apocryphal story is not shown here, but Joseph's rod spontaneously bursts into flower. This version of the episode gained currency in the Middle Ages, notably through the *Golden Legend*. Mary subsequently conceived a child without losing her virginity.

Most stories about the Virgin are not related in the four canonical gospels. They originate from a variety of apocryphal manuscripts dating from late antiquity which were reworked and augmented in medieval texts such as the *Golden Legend* (see p. 229). The story of Mary's betrothal is an example. Perugino painted this panel for the cathedral of Perugia, where Mary's engagement ring was kept as a relic. The event takes place in a sunny square with an octagonal temple representing the temple in which Mary spent her childhood. A short time later, in 1504, Perugino's pupil Raphael made a painting of the same subject, inspired by Perugino's work, for a church near Perugia.

MERCURY

Peter Paul Rubens, 1577–1640
Mercury and Argus, 1635–38
Panel, 63 x 87.5 cm
Gemäldegalerie Alte Meister, Staatliche Kunstsammlungen,
Dresden

Mercury's gaze is fixed on Argus' neck. As this detail from Ovid was lost in the Dutch translations of Rubens' time, we may conclude that Rubens was among the few painters who had read the original text in Latin. The instrument Mercury plays is not a reed-pipe (cf. p. 254) but a contemporary recorder, which would have been more familiar to the public in Rubens' day. Ovid also says that Mercury removed his winged cap. Rubens may have left it on to help the observer to recognize Mercury and identify the scene.

Once again Jupiter's eye fell on a mortal, a girl called Io (see also pp. 36, 156, 184, 214, 240). This time he disguised himself as a cloud to conceal his infidelity from his wife Juno. But when she discovered his ruse, Jupiter turned Io into a heifer. Juno cunningly asked for her rival as a gift, and then gave it to the hundred-eyed giant Argus to guard. Unable to bear Io's distress, Jupiter ordered Mercury to kill Argus.

At once Mercury bound wings to his feet, donned his cap, and took in his powerful hand the magic wand that brings sleep. In this array, Jupiter's son sprang from the citadel and descended to earth. There he removed his cap and laid aside his wings, keeping only his wand. In the guise of a herdsman, he drove his goats and played a melody on his reed-pipes. Argus, Juno's watchman, was enchanted by that strange sweet sound: 'Whoever you are,' he called, 'you may sit with me here on this rock. Nowhere is there more verdant grass to feed your herd, nor more welcome shade for a herdsman.' So Mercury sat, and with conversation whiled away the time, playing on his pipes to bring sleep to Argus' watchful eyes. Argus, however, resisted the sweet lure of slumber, and though some of his eyes were overcome with sleep, others remained vigilant. He asked where the pipes came from, for the invention was new.

But the answer was never told, for halfway through the tale Argus succumbed to sleep.
Once all his eyes were closed, Mercury stopped short, and, soothing those lids with his magic wand, deepened Argus' sleep. Quickly then he struck the slumberous watchman with the blade of his sharp sword, where his head and neck were joined, and hurled the bloodied body from the rock. / OVID, *Metamorphoses*, 1, 671–688, 713–719

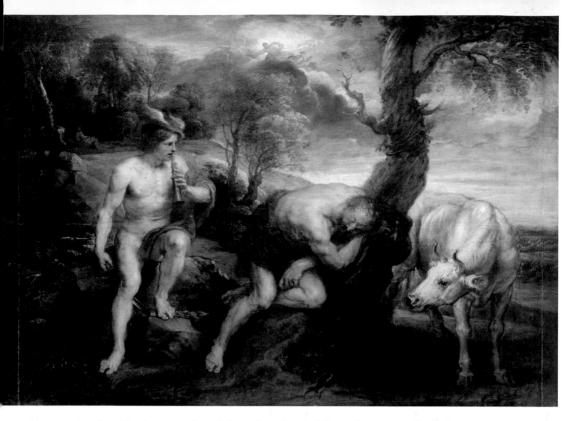

Mercury still plays his pipe, even though Argus has already fallen asleep. According to Ovid he closed his eyes only when Mercury started to tell his tale. But in this respect Rubens and most other artists departed from the text to paint a scene that was visually more interesting. Moreover, Mercury is already reaching for his sword, which adds to the suspense and heightens the contrast between this seemingly idyllic scene and the gruesome ending of the story. Argus is usually shown with only two eyes. He was said to have possessed one hundred, but that was perhaps more than painters could cope with.

Argus was guarding Io before Mercury arrived. Though he lies with his back turned to her, she is never out of sight of his one hundred eyes. Rubens was faithful to Ovid's description: 'Though Argus was turned away from Io, yet he saw her before him.'

Juno rides through the sky in her peacock chariot, but can do nothing to save the life of her servant Argus.

The heifer looks on with interest. Io continued to think and feel like a mortal, and after long wanderings regained her human form.

King Midas wears a red robe and a crown. Though Apollo still plays his instrument, Midas' punishment has already been imposed, as he has the ears of an ass. This was the only way the painter could show Apollo's superior artistry and Midas' foolishness at the same time.

Apollo wears a purple robe and the victor's laurel wreath. Instead of a lyre, he plays a contemporary instrument: the violin.

MIDAS

Abraham Bloemaert, 1564–1651
The Judgement of Midas, 1635–40
Canvas, 194 x 264 cm
Jagdschloss Grünewald, Berlin

On the steep slopes of Mount Tmolus Pan played joyous airs on his reed-pipe and flaunted his artistry to the gentle nymphs. He spoke with scorn of Apollo's music, no match for his own, and desired to measure his talent against the god's lesser skill. A contest was arranged with the ancient Tmolus as the judge. The old man settled himself on the ridge of his mountain and removed the trees from his ears. He was left with only a patch of oak forest on the crown of his cyan head and a few acorns dangling at his temples. He turned his gaze to Pan, the god of shepherds and flocks. 'Commence,' he said, 'the jury awaits.'

Pan took up his pipes and played a melody. His strange song pleased Midas, who chanced to be present at the contest. When the last notes had died away, Tmolus turned his venerable head to Apollo, sweeping the forest along with the movement. A wreath of laurel from Parnassus adorned the god's blond hair and his robe of priceless purple trailed over the ground. The lyre resting on his left arm was studded with ivory and precious gems. In his right hand he held the plectrum. His demeanour alone proclaimed the true artist. He played beautifully and from the strings of his lyre drew forth dulcet tones that touched Tmolus' heart. And so the god spoke his judgement: the music from Apollo's lyre surpassed Pan's reed-pipe.

All applauded Tmolus' decision, save one: Midas protested and pronounced it unreasonable. Unable to endure the sight of foolish ears resembling those of mortals, Apollo drew them out, covered them with grey fur, and made the lower ends droop and flap. In all else Midas remained a man. His punishment bore upon that one organ only, and ever since he has had the ears of an idle ass. / OVID, *Metamorphoses*, 11, 152–184

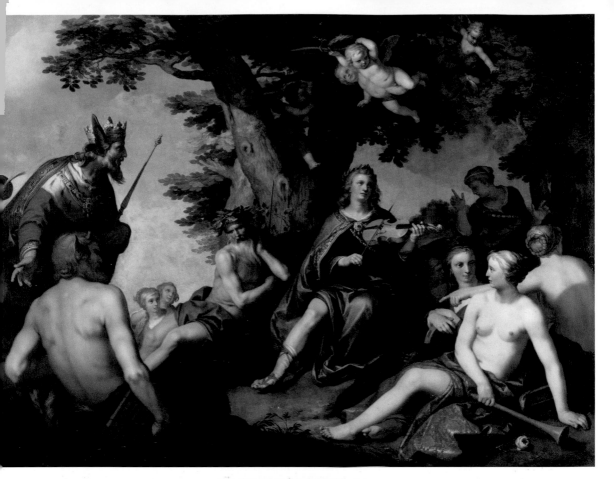

Midas later wore a turban to conceal his ass's ears. But his aim was defeated, Ovid tells us, as the attendant who dressed his hair – possibly the man we see here – confided the tale to a well. And though he took pains to fill it with water, reeds began to grow on that spot and betrayed the secret in the sound of their rustling.

The four main characters are accompanied by seven Muses, three of whom are shown with their attributes: a trumpet, a tambourine, and books. Or are these the 'gentle nymphs' that Ovid mentions?

Apollo plays his lyre – as in most representations of this scene – while Tmolus, wreathed with oaks, leans against a tree and listens to the music. Midas indicates Pan, the god of the mountain wilds, who holds his reed-pipe in his hand. The moral of the story was that it is better to choose godly above worldly values. The imagery relating to this musical contest often incorporates motifs from the story of Apollo and Marsyas, who engaged in a similar competition (see p. 38). The Muses, for example, who seem to be present here as well.

In Poussin's painting Moses' father Amram and his brother Aaron are also present. Amram turns away in sorrow; Aaron glances back as his little brother starts to drift down the Nile.

Miriam, who the Bible says was present at the scene, draws our attention to the pharaoh's palace and so gives us a clue as to what will happen next. The pharaoh's daughter, who can already be seen with her attendants in the garden, will rescue Moses and bring him up as her son. Miriam puts a finger to her lips to hush the child, in an aside that can only be meant for the observer.

MOSES

Nicolas Poussin, 1594–1665
The Exposition of Moses, 1654
Canvas, 149.5 x 204.5 cm
The Ashmolean Museum, Oxford

The Egyptian pharaoh feared the influence of the growing Israelite population in his country and gave orders for all their newborn sons to be drowned in the Nile; their daughters were allowed to live. The sister referred to in the following passage was Miriam.

And a man of the house of Levi went and took as wife a daughter of Levi. So the woman conceived and bore a son. And when she saw that he was a beautiful child, she hid him three months. But when she could no longer hide him, she took an ark of bulrushes for him, daubed it with asphalt and pitch, put the child in it, and laid it in the reeds by the river's bank. And his sister stood afar off, to know what would be done to him. Then the daughter of Pharaoh came down to bathe at the river. And her maidens walked along the riverside; and when she saw the ark among the reeds, she sent her maid to get it. And when she opened it, she saw the child, and behold, the baby wept. So she had compassion on him, and said, 'This is one of the Hebrews' children.' Then his sister said to Pharaoh's daughter, 'Shall I go and call a nurse for you from the Hebrew women, that she may nurse the child for you?' And Pharaoh's daughter said to her, 'Go.' So the maiden went and called the child's mother. Then Pharaoh's daughter said to her, 'Take this child away and nurse him for me, and I will give you your wages.' So the woman took the child and nursed him. And the child grew, and she brought him to Pharaoh's daughter, and he became her son. So she called his name Moses, saying, 'Because I drew him out of the water.' / EXODUS 2:1–10

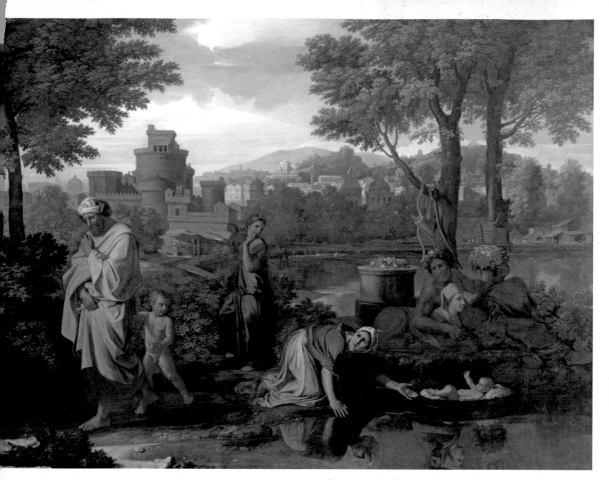

The reclining male figure embracing the sphinx and holding a cornucopia represents a river god, at least as the Romans imagined them. He symbolizes the Nile, the artery of Egypt, and, along with the sphinx, adds to the *couleur locale*.

The first of the two events in this story, the dramatic account of Moses being hidden among the bulrushes, was seldom represented in art. Poussin's profoundly moving painting shows the heartbroken Jochebed setting her child adrift on the Nile, but it also hints at the second, more auspicious and more popular event, where pharaoh's daughter discovers and rescues him. The city in the background is a composite of ancient Roman buildings, including the Castel Sant'Angelo. The story of the pharaoh who ordered the massacre of the infant sons of the Israelites is an example of a prefiguration, or antecedent. The concept relates to the theological doctrine of typology, whereby characters or events in the Old Testament are seen as foreshadowing characters or events in the New Testament. The story of Moses was understood as a prefiguration of the Massacre of the Innocents in Bethlehem (see p. 76). For other examples of biblical typology, see pp. 15, 51, 88, 101, 266.

Pharaoh's adviser insists that the child must die. From his unsavoury appearance and the gesture he makes towards Moses it is clear that his intentions are evil. The somewhat corpulent pharaoh – bereft of his crown – is torn between his adviser's counsel and his daughter's wishes.

MOSES

Jan Steen, 1626–1679
Moses Tramples the Pharaoh's Crown, c. 1670
Canvas, 78 x 79 cm
Private collection, Amsterdam

The Israelite Moses was abandoned in infancy in the hope that he would be found. He was discovered and adopted by the pharaoh's daughter.

Thermuthis had no child of her own and one day took Moses to show him to her father. She was anxious that God might not grant her offspring, she said, and, fearing for her lineage, she nursed the infant which looked like a god and possessed the gift of wisdom. She told her father, too, that she had received the child as a wondrous gift from the Nile. 'I believed it was right to take him for my own and bring him up to be your successor.' And with those words she laid the infant in her father's arms. He took the child, fondled it against his breast, and placed his crown on Moses' head, all for the sake of his daughter. But, in his childish innocence, Moses took the crown, cast it to the ground and trampled upon it, and all who beheld the inauspicious incident were alarmed. Among them was the priest and scribe who had prophesied that the birth of Moses would destroy Egypt's dominion over its own lands. He saw what had passed and cried, 'Majesty, God has spoken and commanded us to destroy this infant, if we are to live without fear. The child has shown us the truth by his own doings, by trampling on your crown, the very symbol of your power. Death to him! Deliver the Egyptians from their fear of him, and deny the Hebrews their faith in his being.' But Thermuthis, swifter than he, seized the child and made off with him, leaving the king at a loss to know what to do. / FLAVIUS JOSEPHUS, *Antiquities of the Jews*, 2, 232–236

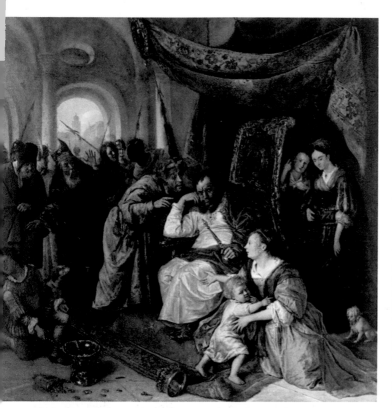

The story of Moses being discovered and adopted by pharaoh's daughter is told in the Bible. This incident, however, is one of the many legends from non-biblical Jewish literature concerning Moses' youth. Different versions of the story were in circulation, and the subject was often represented in art. Master storyteller Jan Steen painted it as an animated scene.

The most important object in the story, the pharaoh's crown, lies on the ground. A piece of it has broken off.

The pot and the purse with coins allude to the sequel to this episode, which is not in the account of the Jewish historian Flavius Josephus: Moses was made to choose between glowing embers and gold coins to decide whether he had trampled on the crown on purpose. He chose the embers and, as a result, saved his life, though he managed to burn his tongue (Steen shows him pointing to his mouth). This incident offers an explanation for Moses' words to God: 'Then Moses said to the Lord, "O my Lord, I am not eloquent, neither before nor since You have spoken to Your servant; but I am slow of speech and slow of tongue"' (Exodus 4:10).

MOSES

Nicolas Poussin, 1594–1665
The Israelites Gathering Manna
in the Wilderness, 1639
Canvas, 149 x 200 cm
Musée du Louvre, Paris

Moses points to the heavens,
acknowledging where the manna
came from. His brother Aaron,
in a white robe, stands behind him
and prays.

Suffering from hunger on their journey from Egypt to
the Promised Land, the Israelites complained to Moses.
Then the Lord said to Moses, 'Behold, I will rain bread from heaven for you. And the people shall go out and gather a certain quota every day, that I may test them, whether they will walk in My law or not. And it shall be on the sixth day that they shall prepare what they bring in, and it shall be twice as much as they gather daily.' So it was that quails came up at evening and covered the camp, and in the morning the dew lay all around the camp. And when the layer of dew lifted, there, on the surface of the wilderness, was a small round substance, as fine as frost on the ground. So when the children of Israel saw it, they said to one another, 'What is it?' For they did not know what it was. And Moses said to them, 'This is the bread which the Lord has given you to eat. This is the thing which the Lord has commanded: "Let every man gather it according to each one's need, one omer for each person, according to the number of persons; let every man take for those who are in his tent."' Then the children of Israel did so and gathered, some more, some less. So when they measured it by omers, he who gathered much had nothing left over, and he who gathered little had no lack. Every man had gathered according to each one's need. And Moses said, 'Let no one leave any of it till morning.' Notwithstanding they did not heed Moses. But some of them left part of it until morning, and it bred worms and stank. And Moses was angry with them.

On the sixth day the Israelites were told to gather twice the usual amount so that they would
be free to rest on the Sabbath.

And the house of Israel called its name Manna. And it was like white coriander seed, and the taste of it was like wafers made with honey ... And the children of Israel ate manna forty years, until they came to an inhabited land; they ate manna until they came to the border of the land of Canaan. / EXODUS 16:4–5, 13–20, 31, 35

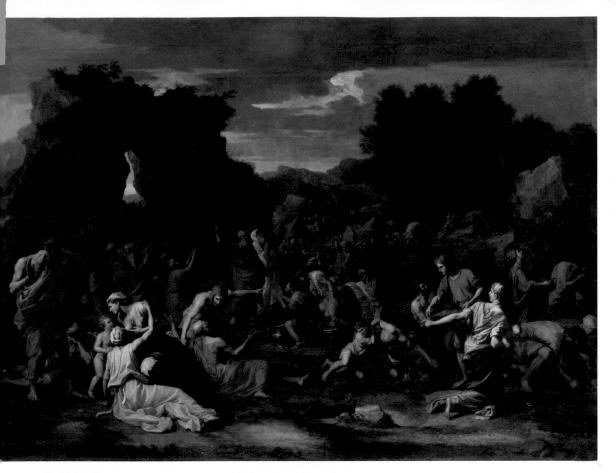

A woman comforts her child and at the same time feeds her own mother. This motif recalls the story of Cimon and Pero (see p. 152).

Two youths fight over the manna. One pushes his smaller companion aside so that he can gather a bigger share. Poussin's work sparked off a debate as to how much liberty a painter could justifiably take when rendering a written text.

By the first light of dawn, a multitude of people in a desolate landscape discover a white substance resembling dewdrops on the ground. It is the manna that God sent from heaven. Men, women and children react in different ways. They pray, scramble for the manna, steal from each other, squabble with their companions, or simply eat their fill. Poussin's intention, by his own account, was to show their hunger and misery as well as their joy. The rain of manna was understood as a prefiguration of the Eucharist, in which the body of Christ is the true 'food from heaven'. The quail mentioned in the Bible began to disappear from art in the late Middle Ages.

MOSES

Jan Steen, 1626–1679
Moses Striking the Rock, c. 1660–61
Canvas, 95 x 98.5 cm
Philadelphia Museum of Art, John G. Johnson Collection

Moses, holding his staff in his right hand, gazes up to heaven and gives thanks. His brother Aaron stands beside him. Moses is often, mistakenly, depicted with horns, which in the painting resemble rays of light. The confusion stems from an error in the Vulgate, Saint Jerome's Latin translation of the Bible. The Hebrew text, which says that Moses' face 'glowed' after he had spoken to God, was mistranslated to read 'was horned'.

The people of Israel, led by Moses, were on their way from Egypt to the Promised Land.

Then all the congregation of the children of Israel set out on their journey from the Wilderness of Sin, according to the commandment of the Lord, and camped in Rephidim; but there was no water for the people to drink. Therefore the people contended with Moses, and said, 'Give us water, that we may drink.' So Moses said to them, 'Why do you contend with me? Why do you tempt the Lord?' And the people thirsted there for water, and the people complained against Moses, and said, 'Why is it you have brought us up out of Egypt, to kill us and our children and our livestock with thirst?' So Moses cried out to the Lord, saying, 'What shall I do with this people? They are almost ready to stone me!' And the Lord said to Moses, 'Go on before the people, and take with you some of the elders of Israel. Also take in your hand your rod with which you struck the river, and go. Behold, I will stand before you there on the rock in Horeb; and you shall strike the rock, and water will come out of it, that the people may drink.' And Moses did so in the sight of the elders of Israel. / EXODUS 17:1-6

The camels add an exotic note to this scene filled with figures in contemporary costume.

The travellers come to fetch water with vessels of every kind, ranging from simple earthenware beakers to large copper bowls, which reflect their social status. This woman drinks from a beautiful nautilus cup.

Jan Steen was best known for his humorous genre scenes, but he also painted stories from the Bible (see p. 259). This work represents the moment after the miracle occurred: water is already gushing from the rock. The Israelites, desperate and suffering from thirst, come to fetch water. Everyone reacts differently. They now have water in abundance, and even the dog in the foreground can quench its thirst. The much loved story of the miracle of the rock was seen as an antecedent of the Eucharist, with the water that saved the people of Israel signifying the wine that turned into Christ's blood to save mankind. The miracle was also associated with the rite of baptism.

The woman offering fruit to a man calls to mind the Fall of Adam and Eve and man's original sin (see p. 26). Both stories are about man's disobedience to God.

MOSES

Lucas van Leyden, 1494–1533
Triptych with the Adoration of the Golden Calf, c. 1530

Panel, 93 x 67 cm and 91 x 30 cm (wings)
Rijksmuseum, Amsterdam

During the Israelites' exodus from Egypt God commanded their leader Moses to climb Mount Sinai, where he gave him his laws and commandments on two stone tablets and sealed his covenant with the people of Israel. If they obeyed those laws, they would be led to the land God had promised them. But Moses stayed away for forty days and the people grew impatient.

Now when the people saw that Moses delayed coming down from the mountain, the people gathered together to Aaron, and said to him, 'Come, make us gods that shall go before us; for as for this Moses, the man who brought us up out of the land of Egypt, we do not know what has become of him.' And Aaron said to them, 'Break off the golden earrings which are in the ears of your wives, your sons, and your daughters, and bring them to me.' So all the people broke off the golden earrings which were in their ears, and brought them to Aaron. And he received the gold from their hand, and he fashioned it with an engraving tool, and made a moulded calf. Then they said, 'This is your god, O Israel, that brought you out of the land of Egypt!' So when Aaron saw it, he built an altar before it. And Aaron made a proclamation and said, 'Tomorrow is a feast to the Lord.' Then they rose early on the next day, offered burnt offerings, and brought peace offerings; and the people sat down to eat and drink, and rose up to play.

God was angered by what they had done, but Moses managed to appease him.

And Moses turned and went down from the mountain, and the two tablets of the Testimony were in his hand. The tablets were written on both sides; on the one side and on the other they were written. Now the tablets were the work of God, and the writing was the writing of God engraved on the tablets. And when Joshua heard the noise of the people as they shouted, he said to Moses, 'There is a noise of war in the camp.' But he said: 'It is not the noise of the shout of victory, nor the noise of the cry of defeat, but the sound of singing I hear.' So it was, as soon as he came near the camp, that he saw the calf and the dancing. So Moses' anger became hot, and he cast the tablets out of his hands and broke them at the foot of the mountain. Then he took the calf which they had made, burned it in the fire, and ground it to powder; and he scattered it on the water and made the children of Israel drink it. / EXODUS 32:1–6, 15–20

God punished the Israelites by commanding them to kill three thousand of their kin.

Lucas van Leyden focused on the lively celebration. The picture is filled with light-hearted motifs of people feasting, drinking, dancing and courting – its purpose was to show the pious how *not* to behave. The subject-matter and the format suggest that the painting was made for private devotion, in which case it would have hung in a private home or chapel.

The painting is true to the biblical text: 'Then Moses went up into the mountain, and a cloud covered the mountain' (Exodus 24:15). God summoned Moses from within the cloud, and Moses entered the cloud.

The golden calf can be seen in the background, with revellers dancing around it. Behind them Moses and his successor Joshua descend hastily from the mountain. Moses is enraged and threatens to destroy the stone tablets. The first of the Ten Commandments, which were inscribed on the tablets, reads: 'Thou shall have no other gods before me.'

MOSES

Anthony van Dyck, 1599–1641
The Brazen Serpent, c. 1620
Canvas, 205 x 235 cm
Museo Nacional del Prado, Madrid

Moses is shown from the back with his face in the shadows. He holds up the rod to which the imitation serpent is attached. The figure behind him might be his brother Aaron, who, with Moses, led the Israelites to the Promised Land. Here, too, Moses is depicted with two small horns (cf. p. 262).

Moses led the Israelites out of Egypt and through the wilderness to the land God had promised them. The journey was long and fraught with danger, and in some parts the travellers were refused passage. In despair, they complained to God.

And the people spoke against God and against Moses: 'Why have you brought us up out of Egypt to die in the wilderness? For there is no food and no water, and our soul loathes this worthless bread.' So the Lord sent fiery serpents among the people, and they bit the people; and many of the people of Israel died. Therefore the people came to Moses, and said, 'We have sinned, for we have spoken against the Lord and against you; pray to the Lord that He take away the serpents from us.' So Moses prayed for the people. Then the Lord said to Moses, 'Make a fiery serpent, and set it on a pole; and it shall be that everyone who is bitten, when he looks at it, shall live.' So Moses made a bronze serpent, and put it on a pole; and so it was, if a serpent had bitten anyone, when he looked at the bronze serpent, he lived. / NUMBERS 21:5–9

The Book of John refers to the episode of the serpent as a prefiguration of the Crucifixion and a metaphor for man's redemption through Christ.

And as Moses lifted up the serpent in the wilderness, even so must the Son of man be lifted up: That whosoever believeth in him should not perish, but have everlasting life. / JOHN 3:14–15

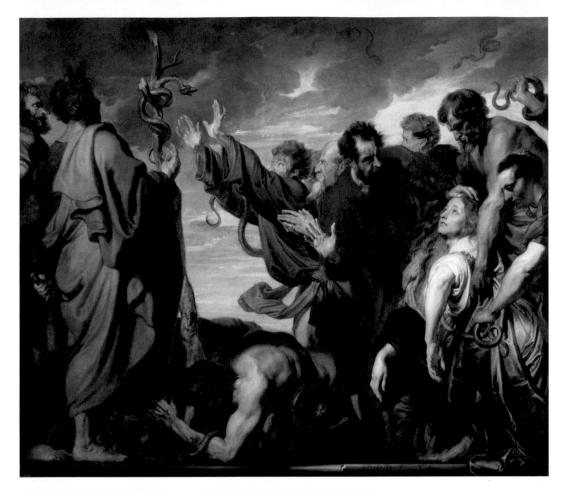

Van Dyck's illustration of the story is charged with emotion. As we see from their expressions and gestures, the people who have been bitten by serpents seek deliverance from the image which Moses has made and attached to a rod. The naked man kneeling on the ground appears to have lost his battle against the serpents and prays for salvation.

The woman is brightly illuminated and draws the observer's attention. She has lost her strength and her arms are limp; her companions offer support. She, too, lifts her eyes to gaze upon Moses' serpent. God promised that whoever set eyes on it would live.

The serpents fall from an ominous sky. God sent them to punish the Israelites.

MUCIUS SCAEVOLA

Hans Baldung Grien, 1484–1545
Mucius Scaevola, 1531
Panel, 98 x 68 cm
Gemäldegalerie Alte Meister, Staatliche Kunstsammlungen,
Dresden

With his right hand in the flames
Gaius Mucius looks defiantly at
the king. The king returns his gaze.
Mucius was subsequently called
'Scaevola', or 'left-handed'.

Rome was besieged by the Etruscan armies of King Lars Porsenna. Gaius Mucius, a young Roman of noble birth, resolved to take revenge. With the Senate's approval, he infiltrated the enemy camp with a sword concealed beneath his cloak.

When he came to the place he mingled with the throng gathered around the king's seat. It was the time that the soldiers were receiving their wages and there, seated beside the king and attired as he, was the secretary conducting that business, and the soldiers came up to him to be paid. Mucius ventured not to ask which of the two men was Porsenna for fear that his ignorance would betray him. Trusting to fortune, he hazarded a guess, but took the secretary's life instead of the king's. Boldly, he strode away, with the bloodied sword still in his hand. The crowd screamed in alarm and the king's guards, hearing the clamour, swarmed to the scene and seized Mucius and hauled him up before the king. Mucius was powerless to defend himself, yet he felt no fear, and even in that dire predicament his presence caused those around him to tremble.

Mucius addressed the king saying that the Romans were valiant men and that not only he, but hundreds more were willing to sacrifice their lives to assassinate him. Porsenna's life was at risk.

The king, at once angered and fearful of the danger to his life, threatened to burn the young man at the stake unless he told him at that instant what conspiracy was afoot. In reply, Mucius said to him: 'Pay heed and you shall see how vain is the flesh to those who aspire to glory.' With those words he put his right hand into the flame of the sacrificial altar, and gave no sign of pain as it seared his flesh. The king was filled with awe. / LIVY, *History of Rome*, 2, 12

Porsenna ordered his guards to lead Mucius away from the altar and allowed him to go unpunished. He sent his envoys to Rome to negotiate a peace.

Gaius Mucius assassinated the king's secretary whom he mistook for the king. The secretary was wounded in the neck and chest, and is either dead or dying. He and the king wear similar costumes, as in Livy's account.

Hans Baldung set the scene in his own day, with contemporary costumes, furnishings and architecture. The incident takes place in front of King Porsenna's tent. During the Renaissance Mucius Scaevola's heroism was held up as a paradigm of steadfastness, patience and patriotism. His willingness to sacrifice his own life was likened to Christ's death on the cross.

These are the soldiers who, as Livy explains, have come to collect their wages. The money can be seen near the tent.

NARCISSUS

Nicolas Poussin, 1594–1665
The Death of Narcissus,
c. 1630

Canvas, 74 x 100 cm
Musée du Louvre, Paris

Growing around Narcissus' head are
the gold-centred white flowers that
bear his name. Ovid writes that the
flower grew where his body had lain.

How does an artist represent a
woman who has 'turned into stone'
and exists only as a voice? Poussin's
Echo is an ethereal being, at one with
nature and seemingly made from the
same clay.

*Narcissus was a handsome youth of sixteen. His mother
was told that he would live 'for as long as he shall not
know himself'. One of his many doting admirers was
the nymph Echo, who suffered from a strange affliction:
the only words that passed her lips were those that others
had spoken first. Narcissus rejected her advances and fled.*
Then Echo, spurned and shamed, sought refuge in the
wood. She covered herself in foliage and took shelter in
grottoes. But her love remained steadfast and grew yet
stronger, inflamed by the pain of her loss. Consumed with
sorrow and unable to sleep, she pined away day by day.
Her flesh withered and the saps of life flowed from her
body. All that was left were her bones and the sound of
her ringing voice. And her bones, it is said, turned into
stone. From that time on, Echo hid in woods and on
mountain slopes, living on, unseen, in her lingering
voice.

*One day Narcissus saw his reflection on the surface of
a pool of clear water and at once fell passionately in love
with himself. Like Echo, he refused to take food or rest,
and gradually faded away.*
His fair skin lost its gleam, his rosy blush paled, all strength
ebbed from his body. His beauty, all that Echo had yearned
to possess, was gone. She saw Narcissus and her anger,
though not forgotten, waned as she grieved for her love.
She heard his sorrowful cries, 'Alas, alas!', and, returning
his call, whispered softly, 'Alas!' And when he beat his
breast, she returned the same mournful sound. Gazing
still in the pool, he murmured his last words, 'Dear boy,
whom I loved in vain.' And from the woods came the echo
of his lament. 'Farewell,' he wept, laying his weary head
on the grass, his eyes drinking in their master's beauty up
to the moment that death finally closed them. / OVID,
Metamorphoses, 3, 393–401, 491–503
*Wood nymphs chancing upon the place where Narcissus
had lain discovered there a flower of gold surrounded
by a cluster of white petals.*

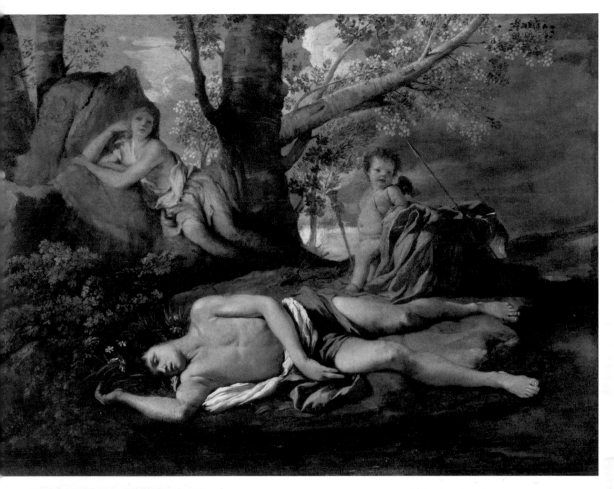

The plump little putto who witnesses the drama is an addition by Poussin and probably represents Cupid. The blazing torch might allude to the death of Narcissus – in ancient Rome torches were used to light a funeral pyre – or to the fire of love.

Poussin illustrated the tragic end of Ovid's story with Narcissus lying lifeless beside the pool of water where he fell in love with his own image. Some painters demonstrated their skill by showing him gazing at his reflection in the pool. The goddess of revenge punished Narcissus for his indifference to the feelings of others.

NOAH

Michelangelo, 1475–1564
The Flood, 1509
Fresco, 280 x 570 cm
Sistine Chapel, Vatican, Rome

Michelangelo's painting of the tragedy includes motifs from everyday life. People flee from the rising waters taking with them their meagre possessions – a bundle of clothes, a frying pan and, on an upturned stool, bread, eating utensils and earthenware.

The makeshift, overcrowded boat heels dangerously as people try to scramble to safety, while those who are already aboard drive them away.

Reflecting on man's wickedness, God regretted ever having created him. He resolved to destroy everything and everyone except the righteous Noah, who led an exemplary life. God told him to build an ark and entered into a covenant with him.

In the six hundredth year of Noah's life, in the second month, the seventeenth day of the month, on that day all the fountains of the great deep were broken up, and the windows of heaven were opened. And the rain was on the earth forty days and forty nights. On the very same day Noah and Noah's sons, Shem, Ham and Japheth, and Noah's wife and the three wives of his sons with them, entered the ark – they and every beast after its kind, all cattle after their kind, every creeping thing that creeps on the earth after its kind, and every bird after its kind, every bird of every sort. And they went into the ark to Noah, two by two, of all flesh in which is the breath of life. So those that entered, male and female of all flesh, went in as God had commanded him; and the Lord shut him in. Now the flood was on the earth forty days. The waters increased and lifted up the ark, and it rose high above the earth. The waters prevailed and greatly increased on the earth, and the ark moved about on the surface of the waters. And the waters prevailed exceedingly on the earth, and all the high hills under the whole heaven were covered. The waters prevailed fifteen cubits upward, and the mountains were covered. And all flesh died that moved on the earth: birds and cattle and beasts and every creeping thing that creeps on the earth, and every man. All in whose nostrils was the breath of the spirit of life, all that was on the dry land, died. So He destroyed all living things which were on the face of the ground: both man and cattle, creeping thing and bird of the air. They were destroyed from the earth. Only Noah and those who were with him in the ark remained alive. And the waters prevailed on the earth one hundred and fifty days. / GENESIS 7:11–24

Michelangelo's dramatic representation of the Flood comprises four scenes set in a bleak, windswept landscape. Those in danger in the foreground scramble frantically to higher ground, seeking refuge from the rising waters; others clamber into a boat; those on the right have pitched a makeshift tent on a rocky island; and in the background the ark floats on the water. This was the first of the nine frescos that Michelangelo painted on the ceiling of the Sistine Chapel. It is the penultimate episode of the narrative that starts with the Creation of the World and ends with the story of Noah. More than the biblical text, the painting focuses on the victims' reactions to the catastrophe.

The bearded Noah, wearing a scarlet robe, leans out of a window in the ark and scans the heavens for some sign of an end to their suffering. In Michelangelo's day the flooding of the rivers Arno and Tiber were believed to be punishments from God.

An elderly man, his own fate sealed, carries his lifeless son to one of the last remaining patches of land. These are the only figures that can be firmly attributed to Michelangelo; the others may be the work of an assistant.

Ham, in the centre of the composition, is the son who mocks his father and whose own son will be punished for that sin. His caricatural face, more brightly lit than those of his brothers, speaks volumes. He places his hands on his brothers' arms as if to implicate them in his deplorable deed.

The grapes were the cause of Noah's drunkenness, but as a symbol of wine they also allude to the New Testament and to Christ, who called himself 'the true vine' (see p. 112).

NOAH

Giovanni Bellini, c. 1431–1516
The Drunkenness of Noah, 1513–14
Canvas, 103 x 157 cm
Musée des Beaux-Arts, Besançon

Now the sons of Noah who went out of the ark were Shem, Ham and Japheth. And Ham was the father of Canaan. These three were the sons of Noah, and from these the whole earth was populated. And Noah began to be a farmer, and he planted a vineyard. Then he drank of the wine and was drunk, and became uncovered in his tent. And Ham, the father of Canaan, saw the nakedness of his father, and told his two brothers outside. But Shem and Japheth took a garment, laid it on both their shoulders, and went backward and covered the nakedness of their father. Their faces were turned away, and they did not see their father's nakedness. So Noah awoke from his wine, and knew what his younger son had done to him. Then he said:

'Cursed be Canaan;
A servant of servants
He shall be to his brethren.'
And he said:
'Blessed be the Lord,
The God of Shem,
And may Canaan be his servant.
May God enlarge Japheth,
And may he dwell in the tents of Shem;
And may Canaan be his servant.'

And Noah lived after the flood three hundred and fifty years. So all the days of Noah were nine hundred and fifty years; and he died. / GENESIS 9:18–28

Wine is about to spill from the unsteady beaker set conspicuously in the foreground.

With his eyes discreetly averted from his father, who is sprawled on the ground, Japheth covers Noah's loins. Shem, on the left, adjusts his father's robe.

Naked and vulnerable, the elderly Noah, drunk from wine, lies asleep in a vineyard in the presence of his three sons. The middle son, Ham, looked upon his father's nakedness and remarked on it to his brothers. Like many episodes from the Old Testament, this tale was understood as a prefiguration of an event in the New Testament, in this case the mocking of Christ before the crucifixion. Bellini was in his eighties when he painted this poignant scene, whose claustrophobic density heightens the dramatic impact of the story. The work is unfortunately in poor condition.

ORPHEUS

Peter Paul Rubens, 1577–1640
Orpheus and Eurydice, 1636–38
Canvas, 194 x 245 cm
Museo Nacional del Prado, Madrid

Orpheus takes Eurydice's hand. He tries to catch a glimpse of her through the corner of his eye, but resists the temptation to turn around. He carries his lyre in his other hand. He was sometimes represented with a violin or another contemporary instrument, but not by an erudite artist with a classical training such as Rubens.

On the day of her marriage to the legendary poet Orpheus, Eurydice died from the bite of a poisonous snake. Orpheus sought her in the kingdom of the dead, where he pleaded with Pluto and Proserpine.

As he spoke these words, he drew music from his lyre: 'O deities of the underworld, where all mortals come to rest, grant, if you please, that I may speak the simple truth. I have come not to contemplate the gloom of hell, nor to constrain the bristly three-headed Cerberus. I have come for my wife alone. A viper trodden underfoot filled her with venom and sent her hither in the very bloom of her life. I strove to endure this fate, but Cupid was stronger than I. He is a god all too familiar to mortals, as he is here, I assume, for if the ancient legend of your elopement is not a lie, you, too, were united in love. Here, in this fearsome empire, in the desolate stillness of your infinite domain, reverse, I pray, the destiny of Eurydice, for she is gone too soon.

Orpheus' words melted the hearts of the gods and the denizens of the underworld, and all fell silent. Eurydice was restored to Orpheus, providing that he vowed not to glance back to see her before they reached the upper world. Should he not keep his word, the gift would come to naught. A path, steep, sunless and shrouded in mist, led upwards. As they neared the rim of the earth, Orpheus, fearing lest Eurydice had fallen behind and unable to still his yearning to see his bride, turned his tender gaze upon her. At once she fell to the ground. She reached out, clutching, grasping for support, but her hands found only thin air. Though she died once again, no reproach passed her lips, for how could she complain that her beloved loved her? Orpheus heard only the murmur of her final farewell as she returned to the place whence she came. / OVID, *Metamorphoses*, 10, 16–31, 50–63

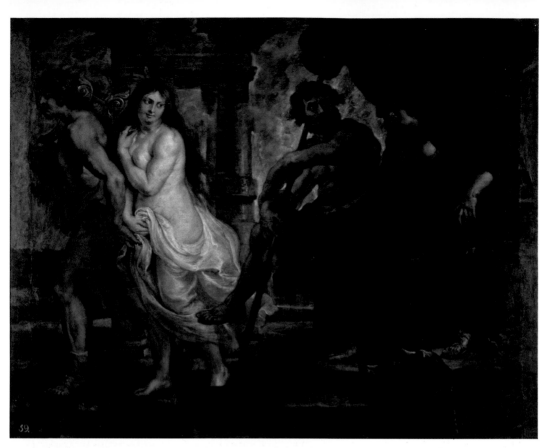

The three-headed dog Cerberus, the guardian of the entrance to the underworld, does not stir. He lies on the ground, meek as a lamb.

Proserpine was consigned to the underworld against her will when Pluto took her there by force. Abduction was apparently a favourite pastime of the classical gods: the mythologies of Greece and Rome abound with stories of rape (see pp. 184, 308). Such acts were neither sanctioned nor condemned.

The wonderful singer and poet Orpheus is usually depicted playing his lyre to animals and mesmerizing them with the charm of his music. He may also be shown at the threshold of the underworld just after turning back to look at Eurydice. Rubens, however, chose the moment after the deities of the underworld had agreed to let her return with him. Eurydice, bathed in light, also glances back. Proserpine and Pluto, with the fires of hell behind them, are seated on their thrones.

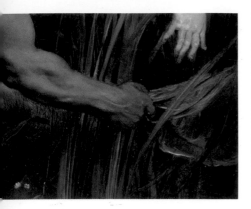

We do not see Syrinx' transformation into a reed. Many artists found this kind of metamorphosis too implausible to envisage. Pan, however, clutches nothing but reeds in his grasping hands. His wild pursuit of Syrinx was futile.

The goat-like deity Pan is swarthy and powerfully built. In art and literature he is represented as a man with horns and hoofs.

PAN AND SYRINX

Peter Paul Rubens and Jan Brueghel the Elder,
1577–1640 and 1568–1625
Pan and Syrinx, c. 1617
Panel, 29 x 59.5 cm
Gemäldegalerie Alte Meister, Staatliche Museen Kassel

Among the nymphs in the bleak mountains of Arcadia lived one who was known far and wide. The naiads called her Syrinx. Time and again she eluded the advances of amorous satyrs and the deities who dwelt in shady woods or fertile fields. She held in honour the goddess Diana and desired, like her, to remain chaste. Dressed like Diana, she could be, indeed *was*, taken for the goddess herself. All that set them apart was that Syrinx possessed a bow of horn and Diana a bow of gold. Pan, crowned with a wreath of pine, spied the nymph Syrinx on his return from Mount Lycaeus. No sooner had a word passed his lips than she fled to the fields, hastening her steps, nor stopping to rest. At length she reached the gentle waters of the sandy Ladon and there, her flight barred by the river, she called to her aid her sisters, the naiads, and entreated them to change her appearance. Pan, drawing closer and believing he had captured Syrinx, found in his grasp not the form of a nymph but in her stead a handful of marsh reeds. He sighed, and heard the plaintive sound of his breath stirring through the reeds. Moved by the softness of its tone, Pan uttered these words: 'So shall you hear me forever.' And so Syrinx' name lived on in a pipe made from reeds of different lengths bound together with wax. / OVID, *Metamorphoses*, 1, 689–712

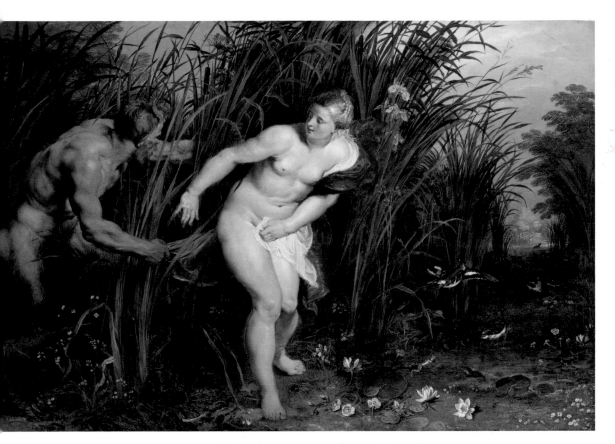

Her path blocked by the river, the fleeing Syrinx stands on the marshy bank of the Ladon. Pan is about to ravish her when she turns into a reed. This small panel depicting a beauty and a beast reflects the specialization and collaboration typical of 17th-century Flemish art. Rubens painted the figures and his friend Jan Brueghel completed the landscape with tall marsh reeds. The figure of the fair-skinned Syrinx derives from scenes from antiquity. The nymph bends forward, using one hand to cover her loins and with the other waves Pan away.

A teal takes to the air, casting a backward glance at the scene, and frogs make for the pool of water. Nature, too, flees from Pan's violence. But whereas the animals could take refuge in water or air, Syrinx had no means of escape.

PARIS

Lucas Cranach the Elder, 1472–1553
The Judgement of Paris, c. 1527
Panel, 50.5 x 38 cm
Statens Museum for Kunst, Copenhagen

According to the medieval version of the myth – the one illustrated here – Paris was hunting in the woods when he lost his way. He grew weary, tethered his horse to a tree, and lay down to rest. In a dream Mercury presented the three goddesses and asked him to judge which was the most beautiful. Cranach painted other versions of the myth which show Paris either lying asleep or sitting with a dazed expression.

The Judgement of Paris is one of several well-known myths that are mentioned only in passing in Homer's epics and Ovid's Metamorphoses *(for another example, see Leda and the Swan, p. 240). More detailed accounts can be found in the* Heroines *by Ovid and texts from the 2nd century BC. The mythographer Hyginus summarizes the story as follows.*

It was said that Jupiter invited all the gods to attend the wedding of Peleus and Thetis, save for Eris, the goddess of discord. When she arrived only to be turned away, she stood at the door and hurled an apple into the room, saying that it should belong to whoever possessed the greatest beauty. At once, Juno, Venus and Minerva fell upon the fruit, each claiming it as her right. To put an end to the dispute Jupiter ordered that the three goddesses be taken to Mount Ida in Phrygia, where Paris would judge who was the fairest. If he chose her, Juno vowed, Paris would rule the world and possess wealth beyond compare. Minerva offered prowess in battle and skill in the arts. Venus, finally, promised to reward him with Helen of Troy, the most beautiful woman on earth. As it happened, Paris declared Venus the loveliest of the three goddesses and so won the hand of Helen. Juno and Minerva retaliated by turning against Troy. At Venus' instigation, Paris abducted Helen from the home of her husband Menelaus in Sparta and carried her off to Troy. / HYGINUS, *Myths*, no. 92

Though the contest is not mentioned in Ovid's Metamorphoses, *it is described in detail in translations of and commentaries on his work, often accompanied by illustrations. In medieval times the myth gained currency through the many anecdotes and chronicles of Troy. Paris, a prince of Troy, brought his country to ruin by choosing an amorous adventure instead of wisdom, power and wealth. As a result, he came to exemplify the unreliability and corruptibility of judicial powers.*

Mercury, now old and bearded (cf. pp. 253, 282–283), wears a knight's armour, like Paris, and looks more like a 16th-century German soldier than the messenger of the gods. He holds a glass globe in his hand instead of an apple, and explains what Paris has to do. Jupiter sent Mercury to tell Paris to judge the contest so as to avoid doing it himself.

The three goddesses – typical Cranach nudes – defy identification. Triads of this kind appealed to artists and philosophers. The goddesses were sometimes endowed with symbolic significance, Juno representing a life of meditation, Minerva personifying action, and Venus, sensuality.

The Italian Raphael was probably the first of many artists who illustrated this story by depicting 'divine' nudes from three different angles: from the back, the front, and in profile or semi-profile. Mythological subjects often offered a pretext to produce erotic art, and that was undoubtedly one of the reasons for the popularity of this story. Cranach made several variants of the Judgement of Paris. Nudity was first mentioned in this context in a humorous version of the myth by the Greek writer Lucian (2nd century AD). According to Lucian, moreover, Eris' inauspicious message – 'For the most beautiful' – was inscribed on the apple and not delivered by word of mouth. Hovering in the air above the goddesses, Cupid aims his love arrow at his mother Venus.

PARIS

Peter Paul Rubens, 1577–1640
The Judgement of Paris, c. 1632–35
Panel, 145 x 193.5 cm
The National Gallery, London

Like Cranach, Rubens made several variants of the *Judgement of Paris*, two of which are at the National Gallery in London.
In this picture the herdsman Paris has just announced his decision and now presents the prize to Venus. She stands between Juno and Minerva, and steps towards Paris. Behind Paris is the god Mercury, who can be identified by his winged cap and his staff with a snake entwined around, known as a caduceus. Rubens' young, second wife Helena Fourment may have been the model for Venus. Those in the know described her as 'the most beautiful woman in all Antwerp'.

Minerva, the goddess of war, can be recognized by her shield and the helmet at her feet. Her shield bears an image of the head of Medusa. Anyone who set eyes on Medusa was turned into stone.

The goddess of discord hovering above observes the drama being played out on earth, which will ultimately spark off the Trojan War. With Venus' help, the Trojan Paris abducted Helen from her Greek husband Menelaus, for which the Greeks exacted a bloody revenge.

Juno can be identified by her attribute, the peacock. The bird is angry because his mistress lost the contest and now pecks at Paris' foot.

Jean-Antoine Watteau, 1684–1721
The Judgement of Paris, c. 1718–21
Canvas, 47 x 31 cm
Musée du Louvre, Paris

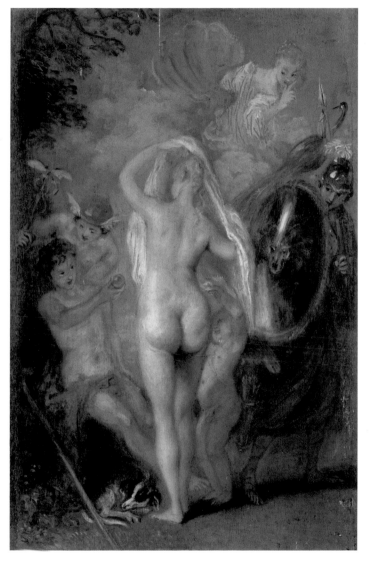

In Watteau's painting Venus is the only goddess who is depicted nude. This is also the case in works by other painters, but not in the pictures by Cranach and Rubens reproduced here. Minerva can be recognized by her armour and her shield with the head of Medusa.

Paris is seated with his dog at his feet and his shepherd's staff at his side. The dog, which is normally a symbol of marital fidelity, adds an ironic note to the scene: as a result of this incident, Paris will abduct Helen from her husband Menelaus and take her off to Troy.

Watteau illustrated the same moment in the story as Rubens. The bashful Paris – who is naked in this version – awards the golden apple to Venus. Her rivals in the contest withdraw. Venus is shown from the back, with Cupid at her side.

PAUL

Caravaggio, 1573–1610
The Conversion of Saul, 1600–1601

Canvas, 230 x 175 cm
Santa Maria del Popolo, Rome,
Cerasi Chapel

Saul's costume and weapons are those of an ordinary Roman soldier. When this incident took place he was on his way to Damascus to capture and imprison Christians. His conversion was all the more meaningful for this reason, as it implied that even the fiercest opponents of Christianity could be redeemed.

Then Saul, still breathing threats and murder against the disciples of the Lord, went to the high priest and asked letters from him to the synagogues of Damascus, so that if he found any who were of the Way, whether men or women, he might bring them bound to Jerusalem. As he journeyed he came near Damascus, and suddenly a light shone around him from heaven. Then he fell to the ground, and heard a voice saying to him, 'Saul, Saul, why are you persecuting Me?' And he said, 'Who are You, Lord?' Then the Lord said, 'I am Jesus, whom you are persecuting. It is hard for you to kick against the goads.' So he, trembling and astonished, said, 'Lord, what do You want me to do?' Then the Lord said to him, 'Arise and go into the city, and you will be told what you must do.' And the men who journeyed with him stood speechless, hearing a voice but seeing no one. Then Saul arose from the ground, and when his eyes were opened he saw no one. But they led him by the hand and brought him into Damascus. And he was three days without sight, and neither ate nor drank.

Saul became a zealous evangelist, proclaiming Christ as the Son of God.
Further on in the Acts, Saul, or Paul as he was called after embracing Christianity, tells the story of his conversion in his own words.

Suddenly a great light from heaven shone around me. And I fell to the ground and heard a voice saying to me, 'Saul, Saul, why are you persecuting Me?' So I answered, 'Who are You, Lord?' And He said to me, 'I am Jesus of Nazareth, whom you are persecuting.' And those who were with me indeed saw the light and were afraid, but they did not hear the voice of Him who spoke to me. So I said, 'What shall I do, Lord?' And the Lord said to me, 'Arise and go into Damascus, and there you will be told all things which are appointed for you to do.' And since I could not see for the glory of that light, being led by the hand of those who were with me, I came into Damascus. / ACTS 9:1–9, 22:6–11

The dramatic conversion of Saul, the persecutor of Christians, was often represented in art. Most painters set the scene in a landscape, with Christ and an angel descending from heaven. Caravaggio's dense composition is entirely unconventional. It differs, too, from his earlier, more orthodox rendering of the miraculous scene. The only source of illumination is the 'great light' mentioned in the Bible. The background, as in most of his paintings, is empty and dark. The looming hindquarters of Saul's horse occupy most of the picture space. There is no reference to a horse in the Scriptures, but in art Saul was usually portrayed as a fallen horseman, like the medieval personification of Pride.

Whereas the prostrate Saul looks upwards, the servant standing beside him, one of Caravaggio's typically rustic types, looks down while he tends to the horse. He cannot see what is happening around him, nor is he lit by the light falling from heaven. In this respect, the painting is consistent with the second version of the story (Acts 22), in which Saul's companions on the journey were unable to hear Christ's voice. In other words, they were not graced with God's mercy.

Saul lies helplessly on the ground with his eyes closed. Though he is blinded by the light, his outstretched arms suggest that he can nevertheless 'see' and that he is willing to receive God's mercy. His vision is a religious experience which only he can perceive. It is not by chance that he lies with his head towards the observer.

PENELOPE

Joseph Wright of Derby, 1734–1797
Penelope Unravelling the Shroud, 1783–84
Canvas, 106 x 131 cm
The J. Paul Getty Museum, Los Angeles

A poignant moment in Homer's *Odyssey* occurs when Odysseus returns from his travels in disguise and his old dog Argos recognizes him and wags his tail. Shortly afterwards, the animal dies. Here, he keeps Penelope and Telemachus company.

While King Odysseus was away from home for twenty years, his wife, awaiting his return, was plagued by suitors. Loyal to her husband, she devised a scheme to avoid remarrying. In the following passage she addresses Odysseus. He has returned to the palace, but with Athena's help, he has come disguised as a beggar to outwit the pretenders to the throne. Even Penelope is unaware of his identity and talks to him as she would to a stranger.

My heart yearns for Odysseus and I languish from sorrow. Suitors jostle to win my hand and I can do nothing but devise schemes to escape their attentions. A god intimated that I employ my beautiful loom in the palace and upon it weave a great cloth of the finest thread. And to those who woo me, I should say, 'My lords, I, too, fear that my husband no longer lives. You are impatient to marry me, but be not hasty, I pray. First I would finish this shroud for Odysseus' father Laertes, that I have not toiled for naught, lest on the day he is destined by grievous fate to die, I am rebuked by the women of this place for allowing so fortuned a man to lie without a shroud.' So indeed I spoke to them and their wise hearts were won over. And for three years I sat weaving by day, and by torchlight at night I unravelled the fruits of my labours. Thus I managed to keep my suitors at bay. The months went by, countless days passed, but in the fourth year, the slaves – oh, heartless brutes – betrayed me. Crying out, my suitors came upon me and exposed my ruse, leaving me no choice but to complete my cloth. Now my fate is sealed and I am bound to marry. / HOMER, *Odyssey*, 19, 135–158

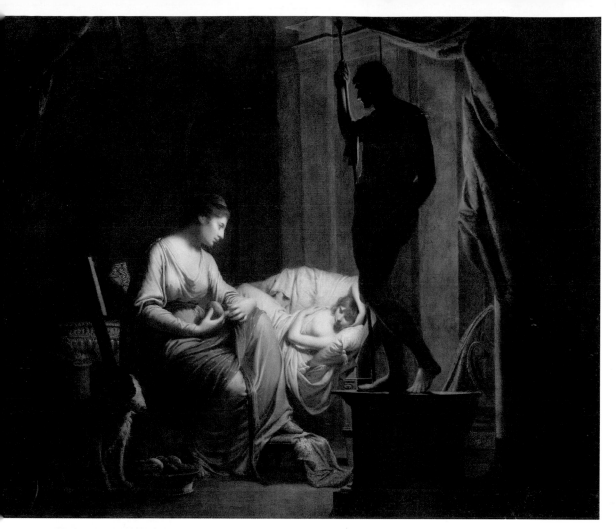

The statue of Odysseus in the shadows invokes his presence. Both Penelope and the sculpture watch over the sleeping Telemachus.

This painting by Wright of Derby is an atmospheric night scene. Light from an unseen source creates the strong chiaroscuro contrasts that characterize this work. The son of Penelope and the absent Odysseus, Telemachus – who is surprisingly young here – lies asleep in the light. Penelope winds the thread she has unravelled from her day's work. The painting was commissioned by the pottery designer and manufacturer Josiah Wedgwood as a tribute to female loyalty and industry.

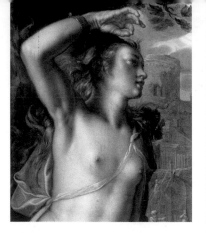

PERSEUS AND ANDROMEDA

Joachim Wtewael, 1566–1632
Perseus and Andromeda, 1611
Canvas, 181 x 151 cm
Musée du Louvre, Paris

The female nude was a prestigious genre in Wtewael's day, and symbolized the beauty of painting as such. For this story, artists had the benefit of Ovid's text, which describes Andromeda's beauty in detail. She is usually shown in this pose, with one arm raised above her head and the other at her side. Elsewhere Ovid describes the ivory-skinned Andromeda as 'dusky'. But then the incident took place in Africa.

After slaying the terrifying Medusa, the hero Perseus, the son of Jupiter and Danaë (see p. 156), touched down in Africa on his way back to Greece.

Perseus took up his wings and bound them to his ankles, girded his curved sword, and with his plumed feet clove a path through the radiant sky. He left behind him countless lands, finally alighting in the territory of the Ethiopians and King Cepheus, where Andromeda was unjustly condemned to suffer for her mother's idle tongue. There she stood with her arms shackled to a rock. Were it not for a breeze that stirred her hair and the tears that streamed from her eyes, she might have been a marble statue. The very moment Perseus set eyes upon her, before he knew, he fell in love with her. Dazzled by her beauty, he almost forgot to bear himself aloft.

There followed a brief exchange, during which Andromeda told Perseus that she was being punished for her mother's boastful words about her beauty, when suddenly:

The sea rumbled and from its depths a frightful monster appeared, its back covering a vast area of water. Andromeda screamed. Her distraught father stood close by with her mother. Both were distressed, though she with more cause, and neither was able to help. They could but weep and lament and cling fast to their fettered daughter.

Perseus came to the rescue, but wanted the parents' word that if all ended well he would win the hand of their daughter.

The monster clove swiftly through the waves and was but a bowshot from the rock when the young hero sprang from the earth and soared into the sky. The savage beast saw his shadow fall on the surface of the water, and threw himself upon it. Like an eagle that spies a snake, Perseus swooped headlong through the air with the speed of an arrow, leapt on the monster's back and plunged his crescent blade into the right flank of the trembling creature. / OVID, *Metamorphoses*, 4, 665–720

A desperate struggle ensued, but Perseus emerged victorious and Andromeda was freed from her chains.

Wtewael's spirited canvas contains all the conventional elements found in illustrations of the tale from Ovid's *Meta-morphoses*. We see the beautiful Andromeda, naked and vulnerable, chained to a rock; the sea monster threatening to devour her; and the winged Perseus heroically coming to the rescue. To judge by the skulls, the monster has struck several times before. The formula – a beautiful, helpless girl, a dashing hero, and a monster – is both archetypal and erotic. Wtewael also depicted an array of striking shells on the beach, which in this context undoubtedly allude to the pudenda. Andromeda's foot rests on one of them.

The girl's parents look on from a distance. Andromeda pointing what looks like an accusing finger at her mother must surely be significant.

In most paintings of Perseus and Andromeda the hero is shown on the winged horse Pegasus. In the classical texts, however, he wears Mercury's winged sandals and is thus able to fly. Even in medieval accounts, confusion arose between the stories of the heroes Perseus and Bellerophon, who did in fact ride Pegasus. One reason was that Perseus killed Medusa, and Pegasus was born from her blood. But the problem may have been aggravated by the appeal of the spectacle of an attack launched from the back of a flying horse.

PETER

Hendrick ter Brugghen, 1588–1629
The Liberation of Peter, 1624
Canvas, 105 x 85 cm
Koninklijk Kabinet van Schilderijen Mauritshuis, The Hague

Peter is portrayed as an old man: he is toothless, his eyes are sunken, his nose is red, and his hair is grey and dishevelled. His face expresses his astonishment. According to the Book of Acts, he was still drowsy from sleep and thought he was seeing a vision.

King Herod Agrippa I persecuted the early Christian community in Palestine.

Now about that time Herod the king stretched out his hand to harass some from the church. Then he killed James the brother of John with the sword. And because he saw that it pleased the Jews, he proceeded further to seize Peter also. Now it was during the Days of Unleavened Bread. So when he had arrested him, he put him in prison, and delivered him to four squads of soldiers to keep him, intending to bring him before the people after Passover. Peter was therefore kept in prison, but constant prayer was offered to God for him by the church. And when Herod was about to bring him out, that night Peter was sleeping, bound with two chains between two soldiers; and the guards before the door were keeping the prison. Now behold, an angel of the Lord stood by him, and a light shone in the prison; and he struck Peter on the side and raised him up, saying, 'Arise quickly!' And his chains fell off his hands. Then the angel said to him, 'Gird yourself and tie on your sandals'; and so he did. And he said to him, 'Put on your garment and follow me.' So he went out and followed him, and did not know that what was done by the angel was real, but thought he was seeing a vision. When they were past the first and the second guard posts, they came to the iron gate that leads to the city, which opened to them of its own accord; and they went out and went down one street, and immediately the angel departed from him. And when Peter had come to himself, he said, 'Now I know for certain that the Lord has sent His angel, and has delivered me from the hand of Herod and from all the expectation of the Jewish people.' / ACTS 12:1–11

Peter presumably went to Rome, where his chains are now kept as relics in the Church of San Pietro in Vincoli. This story gave comfort and hope to persecuted Christians.

Whereas most painters tried to incorporate every detail of the narrative – the prison, the guards, the appearance of the angel, Peter's consternation and his escape – Hendrick ter Brugghen, like his example Caravaggio, focused on the two main characters and the moment of their encounter: 'Now behold, an angel of the Lord stood by him.' This story about a miracle gave painters an opportunity to produce melodramatic scenes, set at night as the gospels say, with the chiaroscuro effects that were popular with the Caravaggists. Ter Brugghen's painting also presents a realistic contrast between the fine complexion of the young man-angel and the haggard face of the elderly Peter.

Angels are mediators between heaven and earth. This 'angel of the Lord', whose wings can only just be discerned in the background, fulfils that role. With his left hand he points to heaven: he has been sent by God.

According to the gospel, Peter was bound with chains between two soldiers. In a moment, they will 'fall from his hands'.

In a prologue to Phaeton's story Ovid describes the sun god's entourage, which consisted of deities who were in one way or another connected with time. Among them were the winged goddesses of the seasons. In the painting they guide the horses, but this is Rubens' invention. Their terror at the sight of the conflagration below heightens the impact of this cosmic catastrophe.

PHAETON

Peter Paul Rubens, 1577–1640
The Fall of Phaeton, 1605
Canvas, 98.5 x 131 cm
National Gallery of Art, Washington

Phaeton, the child of the Sun, persuaded his father to allow him, just once, to drive the sun chariot across the sky. The adventure was doomed to end in disaster. The three Horae (Hours), the goddesses of the seasons, spanned the fiery horses, and Phaeton took the reins. But the horses bolted out of control and scorched everything in their path. Heaven and earth burst into flame and Jupiter was compelled to intervene.

Jupiter ascended to the highest reaches of heaven, whence he was wont to disperse clouds over the expanse of land below and discharge rolls of thunder and forks of lightning. But in that moment of need no clouds he had to shroud the earth, nor rain to send from heaven. He roared thunder and hurled a bolt which flung Phaeton from the chariot and so ended his life. Jupiter extinguished flame with fire. The horses took fright and reared, flung off the yoke and tore the reins, leaving the debris in their wake. There lay the bridle, there the sundered axle, and there the spokes from the shattered wheels. The wreckage was strewn far and wide. Phaeton fell headlong, with flames singeing his tawny hair. Descending in a wide arc through the air, he came to rest, far from home, in the great river Eridanus, whose waters embraced him and cleansed his scorched face. Water nymphs bore his body, still redolent of fire, to a grave on which they inscribed an epitaph: 'Here lies Phaeton, his father's charioteer. Great was his enterprise, and great his fall.' / OVID, *Metamorphoses*, 2, 306–328

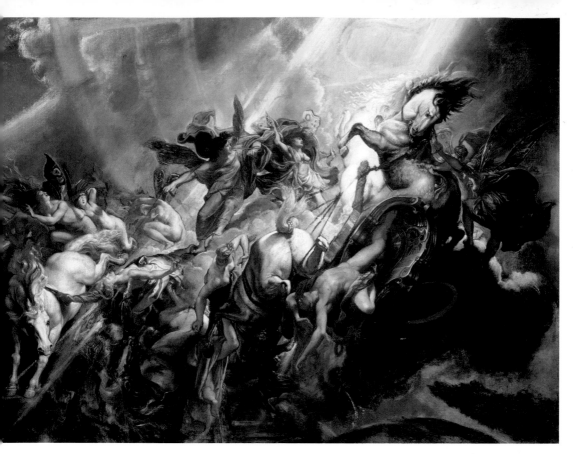

Ominous clouds gather as the unseen Jupiter hurls his thunder, represented here by a shaft of light. The horses bolt in panic and Phaeton falls headlong from the chariot. Several women are present in this wonderfully dynamic composition. The story of Phaeton served to warn the young against arrogance and reckless ambition. It was also an example of the damage that can result from the carelessness of those who wield power. As the story takes place in the heavens, the scene was often used to decorate ceilings in the 17th century. It is not known where Rubens' relatively small canvas was originally intended to be displayed.

Phaeton, his hair ablaze, tumbles from the chariot. Rubens drew inspiration for the painting from a variety of sources, among them a ceiling fresco by Giulio Romano in Mantua, where he stayed in 1605. He also used drawings of Phaeton by Michelangelo, battle scenes with falling horses, and paintings by Tintoretto, which influenced his rendering of light.

Earth is a blazing inferno. In Ovid's account, Mother Earth begs Jupiter to come to the rescue before the planet is totally destroyed.

PHILEMON AND BAUCIS

Adam Elsheimer, 1578–1610
Jupiter and Mercury in the House of Philemon and Baucis, 1608–09
Copper, 17 x 22.5 cm
Gemäldegalerie Alte Meister, Staatliche Kunstsammlungen, Dresden

Mercury has settled himself comfortably; only the wings on his helmet identify him as a god. Jupiter, whom we see in profile, is clearly a man of distinction, but there is nothing to show that he, too, is a deity. For that reason, the painting could be mistaken for a genre piece.

Jupiter and his son Mercury, his wings laid aside, came once to Phrygia in mortal guise. They approached a thousand houses seeking a place to rest, but all were locked against them. At last they knocked on the door of a lowly cottage with a roof of reeds and straw, and were invited to enter. It was the home of the pious Baucis and Philemon who had wed in their youth and spent their many years there together. Reconciled to privation and bearing hardship with grace, they lightened the burden of their poverty. Ask not who was master and who servant. They alone formed the household, at once master and menial. When the denizens of heaven came to this humble home and, stooping, passed through the low doorway, the old man set out a bench and bade them rest. The diligent Baucis draped over it a simple cloth, swept aside the still warm ash in the hearth, and rekindled yesterday's embers, coaxing a flame with leaves and bark, and fanning it with her old breath. She scrubbed a cabbage that Baucis had brought from their garden, and with a pitchfork lifted from a blackened rafter a long-preserved chine of smoke-darkened meat. From this she cut a piece and put it in water to boil.

The guests – deities, unbeknown to the elderly Baucis and Philemon – now refreshed, took their seats, and ate their humble meal with relish.

Meanwhile, though they drained the jar, the couple saw that the wine replenished itself. The liquor remained undiminished. In wonder and awe, they lifted their hands and prayed, begging pardon for the meagre meal and their humble abode. A single goose they possessed, the guardian of their small domain, and that they thought to slaughter for their heavenly guests. But they were too slow for the fleet-winged creature. The bird wore them out, made its escape, and sought refuge with the gods themselves. The gods forbade them to kill the goose. 'We are deities,' they said, 'and this iniquitous land will receive its just retribution. But you shall remain unharmed. Follow us where we go, climb with us the mountain.' / OVID, *Metamorphoses*, 8, 626–693

Then came a flood that destroyed everything but the cottage of Philemon and Baucis, which was transformed into a splendid temple. The couple became priests and lived many years after.
When their time came at last, on one and the same day, Baucis turned into an oak and Philemon into a linden.

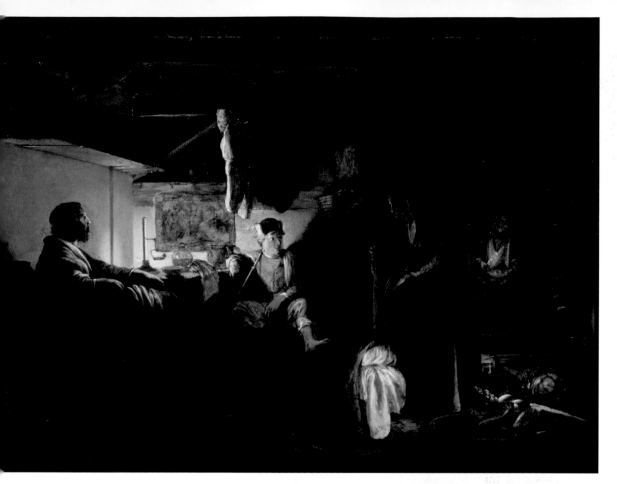

Philemon and Baucis are hard at work: Philemon brings in bedcovers, while her husband appears with provisions from the pantry. The deities are clearly content with the hospitality they receive. The painting is a night piece with an interior illuminated by two oil lamps. The humble, windowless cottage is just as Ovid describes it. Artists before Elsheimer depicted one of the outdoor scenes from the story, like the gods knocking on the door, or the flood. The theme of a couple saved from divine retribution as a reward for their piety was common in popular legend.

This is the wine jar in Ovid's story which repeatedly replenished itself.

The only goose that Philemon and Baucis possessed, the one they intended to slaughter for the meal, heads in Jupiter's direction.

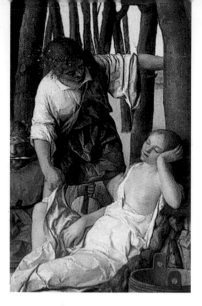

PRIAPUS

Giovanni Bellini, c. 1431–1516
The Feast of the Gods, 1514
Canvas, 170 x 188 cm
National Gallery of Art, Washington, Widener Collection

The garlanded and visibly aroused Priapus supports himself on a tree while lifting the hem of Lotis' pristine white robe.

The Fasti *or* Roman Calendar *by Ovid describes the rites associated with various Roman festivals. On one such occasion an ass was sacrificed to Priapus, the god of virility.*

The reason is shaming to tell, but befitting to this god. Every alternate winter, without fail, the Greeks held a celebration to honour Bacchus, the god of the vine. All who loved merriment attended: Pandean deities of woodlands and meadows, lusty young satyrs, goddesses who dwelt in rivers and lonely haunts. Old Silenus arrived on an ass with a broken back, and Priapus, scaring the birds with his rosy member. There in the wood they reclined on a couch of grass. Bacchus brought wine, all wore their festal garlands, and a stream flowed richly forth with water to blend the wine. Naiads came, too, some with tousled locks, others with tresses artfully bound. One, who served the revellers, girdled her tunic that her limbs might be seen, another draped her loose, flowing garment to bare her breast; here, a naiad with her shoulder revealed, and another, unshod, trailing her robe over the grass. The satyrs grew feverish. Pan's fire was lit, insatiable Silenus was inflamed, and scarlet Priapus lost his heart to Lotis. Consumed with desire, he yearned for her, sighed for her alone, and nodded and signalled in her direction. But fair maidens grow proud, their beauty begets disdain. She derided him and cast him a scornful glance.

Night fell, and the merrymakers, drowsy from wine, settled themselves on the grass and succumbed to sleep. Lotis, too, weary from her capers, slumbered soundly under an ash. Her suitor arose and, holding his breath, stole closer on the tips of his toes. At the lonely bed of the snow-white nymph he stifled the whisper of air from his lungs. Now close, he stood poised beside her, but she continued to sleep on soundly. His joy knew no bounds! He drew back the cloth that covered her foot and beheld the object of his desire. But just at that ill-fated moment Silenus' ass emitted a raucous bray. The nymph awoke in fright and, seeing Priapus, gave a cry of dismay and put him to flight. But the sound rang through the glade and alerted the entire company. All jeered at the sight of the god's flagrant arousal, exposed by the light of the moon. And the ass that brayed paid with its life. / OVID, *The Roman Calendar*, 1, 392–440

Bellini illustrated the moment just before the ass started to bray. The protagonists can be seen in the lower right corner. On the left are the ass and its master Silenus, who wears a bright orange tunic and has a wine cask at his side. Between them are the gods, with fauns and beautiful nymphs pouring wine, as Ovid describes. Bellini captured the tone of Ovid's elegant tale. The painting was made for Duke Alfonso d'Este of Ferrara. Titian produced three works for the same *camerino* in the duke's palace, including a *Bacchus and Ariadne* (see pp. 48–49). He completed Bellini's painting as well: the landscape on the left is by his hand.

GODS OR MORTALS?

Bellini's main source was probably not Ovid but an Italian translation of and commentary on the Metamorphoses. *That work describes a feast held by mortals in Thebes to celebrate the festival of Bacchus, where Priapus, who also happened to be present, tried to seduce Lotis until he was disturbed by an ass. If that is true, then Bellini was not representing gods, but Thebans dressed for a festival, with Priapus' escapade as a motif on the side. In that event, the attributes that transform the humans into gods – and the scene into an episode from Ovid – would have been added later, either by Bellini himself or perhaps by Titian. This would in any event explain why the figures look so little like gods.*

The gods, from left to right, are the young Bacchus, who fills his wine jar; Mercury with his caduceus, or herald's staff, but without his winged helmet and sandals; and Jupiter drinking, with his eagle. Kneeling in front of Jupiter is Amphitrite, who holds a quince, the symbol of marriage, and puts an arm around the shoulders of her husband Neptune, who can be identified by the trident at his feet. Beside them are Apollo, with a crown of laurel and an anachronistic violin, who is normally portrayed as a handsome young god but appears here as a comical gnome; and Ceres, the goddess of agriculture, with a garland of wheat.

PROMETHEUS

**Peter Paul Rubens and Frans Snyders,
1577–1640 and 1579–1657**
Prometheus Bound, c. 1611–12
Canvas, 243 x 210 cm
Philadelphia Museum of Art, purchased with a grant
from the W. P. Wilstach Fund

Rubens produced this work in collaboration with Frans Snyders, a celebrated animal painter from Antwerp. Snyders' golden eagle, with its extraordinary wingspan – the size of the bird heightens the picture's impact – digs its claws into Prometheus' brightly lit lower abdomen and agonized face, narrowly missing his eye.
As described in the text, it proceeds to devour part of his liver, which in ancient times was regarded as the seat of life. The contrast between the man's soft flesh and the bird's jagged beak and claws makes the pain almost physically palpable. It was precisely that awful moment that Rubens depicted. The eagle was the attribute of Prometheus' tormentor Zeus (see also p. 36).

Zeus bound Prometheus with chains, excruciating shackles driven through a pillar, and sent a wide-winged eagle to devour his liver. But Prometheus was immortal and his liver restored each night all that had been gorged during the day. The bird was finally slain by Hercules, the stalwart son of Alcmene, known for her shapely ankles. He released Prometheus from that agonizing torment and delivered him from his sufferings.

This passage comes from Hesiod's introduction to the Titan Prometheus in The Birth of the Gods *(7th century BC). Zeus' anger with Prometheus finally subsided. Hesiod reveals only later Zeus' reason for punishing Prometheus. In the course of a sacrificial meal Prometheus had tried to deceive the father of the gods. This is what happened next.*

Zeus steadfastly nursed his anger at the deception and withheld from the trees the power of unfaltering fire given for the benefit of mortals who dwelt on earth. But Prometheus, the son of Iapetus, defied him and stole an ember from the flames, concealing it in the hollow stem of a spray of fennel. The ruse plagued Zeus and he answered with thunder, but his heart filled with rage when he beheld man in possession of fire, its glow visible from afar. / HESIOD, *The Birth of the Gods*, 521–528, 562–569

In Rubens' day various meanings were ascribed to the figure of Prometheus. He was a benefactor to humankind, but also a rebel against authority, and a blasphemer. He was admired for his intellect – bringing fire to mortals he also gave civilization – but at the same time he was overambitious, reckless and arrogant. The dramatic and visually compelling scene of his punishment in the Caucasus was widely represented in art.

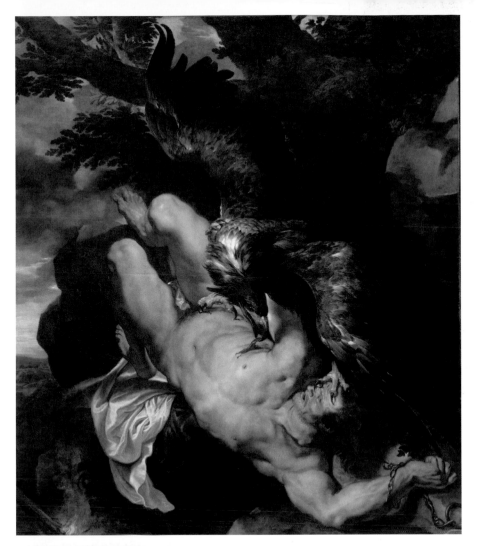

Rubens' Herculean Prometheus lies chained beneath a tree at the edge of a precipice. Despite his prodigious strength, he struggles in vain to escape from his horrific torments. The image is sensational: it looks as if Prometheus is about to plunge headlong into our space. Rubens painted a number of falling figures in this period and several horribly cruel scenes. His Prometheus reflects the influence of classical sculpture, recalling in particular the ancient Laocoön group (now in the Vatican Museums), which he had studied in Rome. That famous marble, too, represents a scene of unendurable suffering and a mortal struggle between man and animal.

Prometheus' offence: Hesiod writes that Prometheus stole fire from the gods and gave it to man, giving us the power to create civilization on Earth. That was the reason for his punishment. The theme was chosen to appeal to an erudite public. The section on the left, with the blazing torch and the view into the distance, was added later.

PSYCHE

Giuseppe Maria Crespi, 1665–1747
Cupid and Psyche, c. 1709
Canvas, 130 x 215 cm
Galleria degli Uffizi, Florence

The knife with which Psyche armed herself in Apuleius' story, uncertain of what she would encounter, is not shown in Crespi's painting. Psyche holds the oil lamp in one hand and lifts a corner of the curtain with the other. Every move betrays her curiosity.

The beautiful princess Psyche was worshipped as if she were the love goddess Venus herself. Her jealousy inflamed, Venus bade her son Cupid to make Psyche fall in love with the ugliest man on earth. But Cupid himself lost his heart to Psyche. He took her to his palace and surrounded her with splendour and devotion, but forbade her ever to lay eyes on him. Her malicious sisters convinced her that her husband was a monster and persuaded her to kill him. One night Psyche, with a lamp in one hand and a knife in the other, sought out the 'monster'.

And what did she see? The gentlest and loveliest monster in the world, the beautiful, divine Cupid lay there asleep. The lamp burned brighter from joy, and the knife lamented the fiendish sharpness of its blade. As her gaze fell upon Cupid, Psyche all but swooned in wonder. Trembling and pale, she fell to her knees … His golden hair was drenched in nectar. Stray locks of hair twined and curled around his creamy neck and rose-blushed cheeks, their bright gleam causing even the lamplight to flicker and fade. Dewy feathers glimmered on his glorious winged shoulders. His lustrous body was smooth: he was a worthy son to Venus. At the foot of his bed lay his bow, quiver and arrows, sweet weapons of the sublime god. They aroused Psyche's interest and she inspected them. She tested the sharpness of one of his arrowheads against her thumb, but her hands shook, she pressed too hard, and the point pierced her skin. Small beads of blood appeared and she fell in love … with Love. Consumed by a fiery yearning for Cupid, she bent over him in ecstasy and kissed his lips fiercely and passionately, hastily too, for fear that he should awaken. As she yielded to such beauty, her aching heart bewildered, her lamp was extinguished – wretched traitor! Was it jealous, wishing itself to caress and embrace such a body? A searing drop of oil fell on the god's right shoulder! / APULEIUS, *The Golden Ass*, 5, 22–23

The wounded Cupid spread his wings and flew away without uttering a single word.

According to the Roman writer Apuleius, Cupid was roused from his sleep only when a drop of burning oil fell on his shoulder. However, in this night piece by the Bolognese painter Crespi he appears to have woken the moment that the astonished Psyche first set eyes on him. The story of Psyche – her name means *soul* in Greek – and Cupid, is more legend than myth. It gained currency through the writings of mythographers like Boccaccio. *The Golden Ass* by Apuleius, which includes this popular story, was widely read and often translated and reworked. It had a strong influence on art.

Cupid lifts his hand, in the centre of the painting, as if to ward off what has already happened. Psyche disobeyed his exhortation never to set eyes on him. At any moment he will fly away without uttering a word.

Cupid is identified by his brightly lit wings and the bow and quiver lying in the shadow beside him on the bed.

PSYCHE

Anthony van Dyck, 1599–1641
Cupid and Psyche, 1638–40
Canvas, 199.5 x 192 cm
Her Majesty Queen Elizabeth II

Cupid descends to earth and alights with his wings still fluttering and his robe billowing in the rush of air. He sees his beloved Psyche for the first time after their long separation. He gazes at her and reaches out to touch her. He holds his bow but his quiver has fallen to the ground.

Psyche had been parted from her beloved Cupid (or Amor), who was held captive by his mother Venus. She searched for him everywhere. When Venus learned that her son loved Psyche, she resolved to punish the heartbroken girl. She set the pregnant Psyche three impossible tasks, which, contrary to all expectations, Psyche managed to accomplish. Venus then put her to the final test. She gave her a casket and sent her to bring back some of the beauty of Proserpine, the goddess of the underworld. Against all odds Psyche succeeded once again, but still she was in a quandary: she had been expressly forbidden to open the box.

Hastening to complete her task, Psyche was overcome with a burning curiosity. 'What,' she said, 'I hold this divine beauty in my hands. Shall I not be allowed to take just a little for myself, the better to please my beautiful love?' No sooner were the words spoken than she opened the casket. But it held nothing that resembled beauty, indeed, nothing but a deathly torpor which overpowered her the moment she removed the lid and plunged her into a deep slumber. Caught unawares, she fell where she stood, in the middle of the path, and lay there motionless, as if in eternal repose. In the meanwhile, Cupid had recovered from his wound, and his condition improved. Unable to endure his long separation from Psyche, he stole through the window high in the cell of his prison. Now rested and healed, his wings bore him swiftly to Psyche. He brushed the slumber from her body and returned it to the casket whence it had come. Then, stroking her gently with the tip of his arrow, he raised her from her sleep. / APULEIUS, *The Golden Ass*, 6, 20–21

So Psyche could take Proserpine's gift to Venus after all.

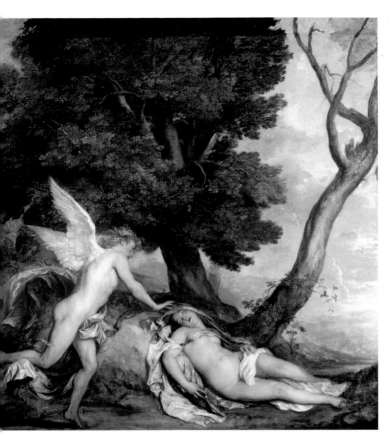

The story was first told in the 2nd century AD by the Roman writer Apuleius. 'As if in eternal repose' are the words he used to describe Psyche's supine body. Van Dyck shows Cupid floating down to earth. He reaches out to 'brush the slumber' from Psyche and awaken her with the tip of his arrow. The scene conjures up a clandestine rendezvous in a wood, which in fact it is at this point in the story.

In the Renaissance the tale of Cupid and Psyche was understood as an allegory: the soul (*psyche* in Greek) yearns to be united with erotic love (Cupid or Amor). The story appealed to Charles I of England, for whom the painting was made. It was also seen as a Christian parable, where the soul must endure numerous ordeals before reaching Paradise and everlasting life. At the end of Apuleius' account, Jupiter makes Psyche immortal.

Psyche's right hand rests lightly on the box she has been forbidden to open. It holds the secret to the beauty of Proserpine, the goddess of the underworld.

One of the trees is leafy and green, the other dry and barren. The two have been taken to represent Psyche's condition: though asleep and seemingly lifeless, she is not actually dead.

From left to right, we see Pluto, the god of the underworld, Neptune the sea god, and the pensive Jupiter, father of all the deities. Pluto can be recognized by his black hair and two-pronged fork, Neptune by his trident. Jupiter is accompanied by his customary eagle. Behind him are his two daughters, Diana (with crescent moon) and Minerva (in armour); his wife Juno sits with her attribute, the peacock.

PSYCHE

Raphael and Giulio Romano, 1483–1520 and c. 1495–1546
The Marriage of Cupid and Psyche, 1518
Fresco
Villa Farnesina, Rome

At the end of the story about the ill-fated love between the god Cupid and the mortal Psyche, Cupid sought Jupiter's consent to marry his beloved. Jupiter agreed and summoned all the gods – on pain of a fine – to a banquet. Cupid's mother Venus was opposed to the liaison and, to appease her, Jupiter invited Psyche to attend.

Jupiter sent Mercury to fetch Psyche to the heavens, where he served her a goblet of nectar. 'Drink, Psyche,' he urged, 'for the liquor will render you immortal. Never shall Cupid sever the bonds of your union; your marriage shall last forever.' Without delay, a lavish nuptial banquet was held. The bridegroom reclined on the seat of honour embracing Psyche in his arms. So, too, lay Jupiter and Juno, and after them all the gods, each according to his rank. Ganymede, erstwhile shepherd and now cupbearer to the father of the deities, filled Jupiter's goblet with nectar, and Bacchus attended to the rest of the company, dispensing the wine of the gods. Vulcan prepared the feast, while the Seasons conjured up roses and other blooms, colouring all in a purple hue. The Graces filled the air with balsam; the Muses lifted their voices in sweet song; and Apollo, too, sang a melody to the strains of the lyre. Venus performed a delightful dance to the measure of the music: at her bidding, the Muses chanted a chorus, a satyr played the flute, and a small Pan coaxed a tune from his pipes. And so Psyche and Cupid were married. And when the time came, Psyche brought forth a daughter, whose name we call Pleasure. / APULEIUS, *The Golden Ass*, 6, 32

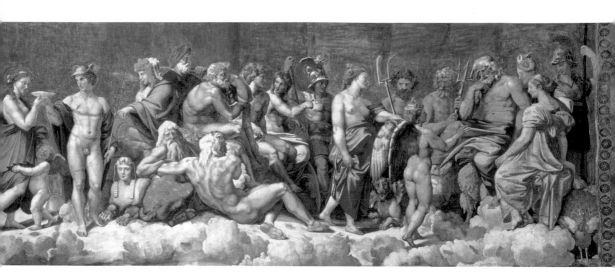

A group of gods and heroes are shown on a cloud, standing, seated or reclining. They can be identified by their attributes: Apollo holds a lyre, Bacchus wears a crown of laurel, and Hercules carries his club. The gods of classical mythology are known to have assembled on several festive occasions. These gatherings gave painters an opportunity to represent large groups of revellers. Raphael painted a cycle of episodes from the story of Cupid and Psyche in Villa Farnesina, to mark the marriage of the architect and banker Agostino Chigi and Francesca Ordeaschi. The work discussed here represents the climax of the story. The subject was especially appropriate for the occasion as the bride came from a lower social class than her husband.

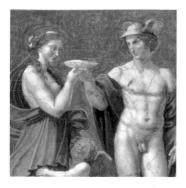

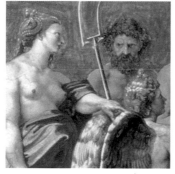

On the far left of the fresco, Mercury, the god of commerce (wearing his winged helmet and holding his caduceus), hands Psyche a cup. In Apuleius' account, it was Jupiter who gave her a drink. The child clinging to her legs is a cherub. The nectar of the gods will render Psyche immortal.

The naked, winged boy approaching Jupiter is the young bridegroom Cupid. His mother Venus stands beside him, and behind her is her cohort Mars, the god of war. Venus and Cupid gesture to attract Jupiter's attention.

REBECCA

Bartolomé Esteban Murillo, 1617–1682
Rebecca and Eliezer at the Well, c. 1650
Canvas, 107 x 171 cm
Museo Nacional del Prado, Madrid

Rebecca averts her gaze while the stranger drinks his fill, but the young woman standing beside them cannot contain her curiosity. Murillo was famed for the elegance and grace of his female figures and for his skill in combining the spiritual with the mundane realities of everyday life. This story also gave him the scope to depict a variety of poses, movements and facial expressions.

The elderly Abraham sent his servant to his native Mesopotamia to seek among his Jewish kin a wife for his son Isaac.

Then the servant took ten of his master's camels and departed, for all his master's goods were in his hand. And he arose and went to Mesopotamia, to the city of Nahor. And he made his camels kneel down outside the city by a well of water at evening time, the time when women go out to draw water. Then he said, 'O Lord God of my master Abraham, please give me success this day, and show kindness to my master Abraham. Behold, here I stand by the well of water, and the daughters of the men of the city are coming out to draw water. Now let it be that the young woman to whom I say, "Please let down your pitcher that I may drink," and she says, "Drink, and I will also give your camels a drink" – let her be the one You have appointed for Your servant Isaac. And by this I will know that You have shown kindness to my master.' And it happened, before he had finished speaking, that behold, Rebecca, who was born to Bethuel, son of Milcah, the wife of Nahor, Abraham's brother, came out with her pitcher on her shoulder. Now the young woman was very beautiful to behold, a virgin; no man had known her. And she went down to the well, filled her pitcher, and came up. And the servant ran to meet her and said, 'Please let me drink a little water from your pitcher.' So she said, 'Drink, my lord.' Then she quickly let her pitcher down to her hand, and gave him a drink. And when she had finished giving him a drink, she said, 'I will draw water for your camels also, until they have finished drinking.' Then she quickly emptied her pitcher into the trough, ran back to the well to draw water, and drew for all his camels. And the man, wondering at her, remained silent so as to know whether the Lord had made his journey prosperous or not. So it was, when the camels had finished drinking, that the man took a golden nose ring weighing half a shekel, and two bracelets for her wrists weighing ten shekels of gold. / GENESIS 24:10–22

The servant was welcomed into her home; Rebecca accepted the jewellery from him and received permission from her father and brother to accompany him to Isaac.

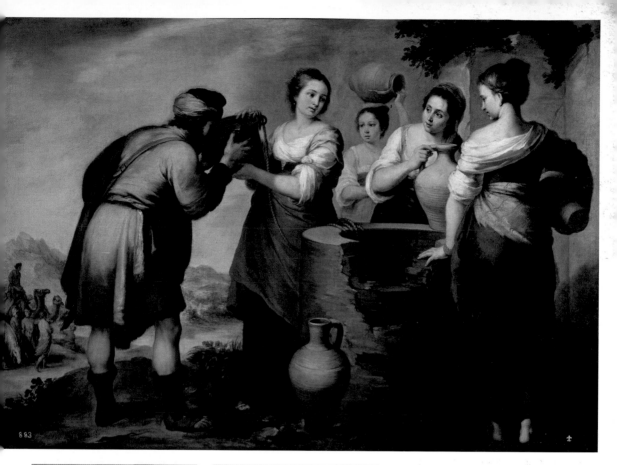

In the background we see the camels, a sign of wealth in the Old Testament, and the party accompanying the servant, which is not mentioned in the Bible. Eliezer's companions will also receive water from Rebecca.

Murillo illustrated the moment when the thirsty servant drinks the water that Rebecca gave him. This painting contains no reference to the jewellery he has brought for her. Some paintings do, but they represent the following scene, when the servant announces that Rebecca is the bride he is seeking for Isaac.

Isaac is a more elusive figure than either his father Abraham or his son Jacob, in art as well as the Bible, but the story of the servant Eliezer – the Scriptures do not actually mention his name – being sent to find him a bride gained currency in the 16th and 17th centuries. Rebecca was the epitome of virtue. The sign that the servant received – a woman who gave water to him and his camels – was understood as a prefiguration of the Annunciation to the Virgin Mary (see p. 246). Murillo set the scene in an Arcadian landscape.

SABINES

Nicolas Poussin, 1594–1665
The Rape of the Sabine Women, c. 1633–34
Canvas, 154.5 x 210 cm
The Metropolitan Museum of Art, New York

In the foreground, an elderly woman and a child look on as the child's mother is swept off her feet and carried away. The helpless old woman is distraught; the mother struggles in vain in the arms of her abductor. The melodramatic gestures and facial expressions were clearly influenced by the debate regarding the representation of human emotions and affects which preoccupied artists in the 17th century.

The historian Livy tells of the greatness of early Rome under its founder Romulus. The city could rival any other along its borders. The only problem was that it suffered from a shortage of women, partly because of its neighbours' distrust. Romulus devised a plan and invited all in the vicinity to a celebration in honour of Neptune.

All the Sabines came, bringing their women and children. Received with hospitality and welcomed into people's homes, they saw the city, its walls, and its many buildings, and marvelled that Rome had grown so fast. When the pageant was about to begin, and all were eagerly awaiting that moment, the plan was put into effect and mayhem broke loose. At a sign, Rome's young men scattered in all directions to carry off the women. Many were seized at random, but the fairest among them were destined for the most distinguished senators, and were taken to their houses by men entrusted with that task. The most beautiful woman of all was seized by the band of a certain Thalassius. Many were curious to know her fate, but her captors would say no more than that she was not to be touched: she was intended 'for Thalassius'. Those words live on to this day, and are spoken whenever Romans wed.

Panic erupted and the feast came to an end as the women's grief-stricken parents took to their heels. They complained that the tradition of hospitality had been broken, and invoked the god in whose honour they had attended the feast only to be deceived. The ravished women were distressed and as indignant as they. / LIVY, *History of Rome*, 1, 9

The women's anger soon subsided, Livy continues, and Romulus married Hersilia. When later the Sabines threatened to take up arms against Rome, the women, now wives and mothers, intervened to maintain peace, and for this their husbands and parents 'loved them more dearly than ever'.

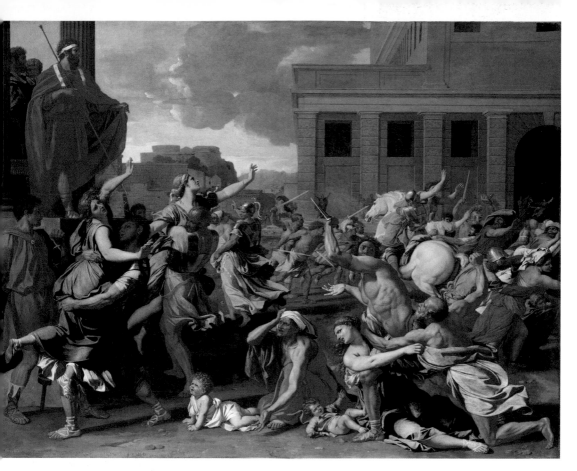

In the centre of the canvas Poussin offers a glimpse of the future: the Sabines will soon be reconciled to their fate and marry Roman men. This couple have made their peace. The Roman shows his woman the glorious city where she will spend the rest of her life.

A man tries to rescue his daughter from the clutches of a Roman and clings to his tunic. The abductor threatens to use his dagger.

The French painter Poussin, who spent most of his life in Italy, had an expert knowledge of classical literature and art. However, his depiction of an established city as the setting for this story from the early days of Rome, is deliberately anachronistic. Romulus, on the left, towers above the crowd, and takes no part in the orgy. This was one of several incidents involving the abduction of women in Greek and Roman antiquity (cf. the story of Europa, p. 184).

SOLOMON

Nicolas Poussin, 1594–1665
The Judgement of Solomon, 1649
Canvas, 101 x 150 cm
Musée du Louvre, Paris

Solomon looks at the real mother and points in her direction. He has uncovered the truth. He is seated on a throne made of ivory and gold and decorated with lions, which, in the Bible, he possessed only once he had acquired his fortune.

As a young man, King Solomon asked God to grant him the ability to discern between right and wrong so that he could govern his people well. God appeared to him in a dream and gave him perfect wisdom.

Now two women who were harlots came to the king, and stood before him. And one woman said, 'O my lord, this woman and I dwell in the same house; and I gave birth while she was in the house. Then it happened, the third day after I had given birth, that this woman also gave birth. And we were together; no one was with us in the house, except the two of us in the house. And this woman's son died in the night, because she lay on him. So she arose in the middle of the night and took my son from my side, while your maidservant slept, and laid him in her bosom, and laid her dead child in my bosom. And when I rose in the morning to nurse my son, there he was, dead. But when I had examined him in the morning, indeed, he was not my son whom I had borne.' Then the other woman said, 'No! But the living one is my son, and the dead one is your son.' And the first woman said, 'No! But the dead one is your son, and the living one is my son.' Thus they spoke before the king. And the king said, 'The one says, "This is my son, who lives, and your son is the dead one"; and the other says, "No! But your son is the dead one, and my son is the living one."' Then the king said, 'Bring me a sword.' So they brought a sword before the king. And the king said, 'Divide the living child in two, and give half to one, and half to the other.' Then the woman whose son was living spoke to the king, for she yearned with compassion for her son; and she said, 'O my lord, give her the living child, and by no means kill him!' But the other said, 'Let him be neither mine nor yours, but divide him.' So the king answered and said, 'Give the first woman the living child, and by no means kill him; she is his mother.' And all Israel heard of the judgment which the king had rendered; and they feared the king, for they saw that the wisdom of God was in him to administer justice. / 1 KINGS 3:16–28

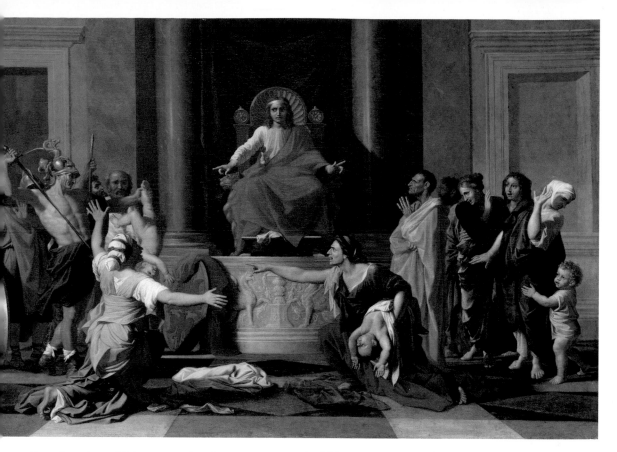

Poussin portrayed Solomon as a handsome young man: the Bible describes him as 'young and inexperienced'. He is seated in a palatial hall with dignitaries and onlookers standing on either side of his throne. In front of him we see the angry confrontation between the two women, both of whom gesticulate wildly. The composition incorporates different moments from the story: the soldier on the left holds the infant by the foot and still has his sword drawn, while the king hands down his final judgment. Poussin systematized the composition by giving the dead child to the untruthful woman so that the painting is easier to read. The Judgement of Solomon is one of the best-known stories of the Old Testament. Like the Judgement of Cambyses (see p. 54), it was the perfect subject to display in tribunals or other public rooms where officials administered justice in order to remind them of their duty to be impartial.

The dishonest mother clutches the child, her face drawn with hate. The real mother turns to Solomon and throws her arms up in despair.

SAMSON

The inquisitive old woman anticipates Samson's downfall with glee, while the young servant looks on in horror. Elderly women were often cast as matchmakers in art, and were sometimes included in scenes where the role was appropriate.

In some translations of the Bible Delilah cuts Samson's hair herself, in others a barber does the work. Both versions are represented in art.

Anthony van Dyck, 1599–1641
Samson and Delilah, 1618–20
Canvas, 149 x 229.5 cm
Dulwich Picture Gallery, London

Samson, a judge of Israel, loved the Philistine (?) Delilah. The Philistines were at war with the Israelites, and their leaders persuaded Delilah with an offer of riches to discover the secret of Samson's strength. She was to render him defenceless and deliver him to the enemy. Three times she asked him where his strength came from, and three times he told her a lie. And each time the Philistines' plan to capture him failed.

Then she said to him, 'How can you say, "I love you," when your heart is not with me? You have mocked me these three times, and have not told me where your great strength lies.' And it came to pass, when she pestered him daily with her words and pressed him, so that his soul was vexed to death, that he told her all his heart, and said to her, 'No razor has ever come upon my head, for I have been a Nazirite to God from my mother's womb. If I am shaven, then my strength will leave me, and I shall become weak, and be like any other man.' When Delilah saw that he had told her all his heart, she sent and called for the lords of the Philistines, saying, 'Come up once more, for he has told me all his heart.' So the lords of the Philistines came up to her and brought the money in their hand. Then she lulled him to sleep on her knees, and called for a man and had him shave off the seven locks of his head. Then she began to torment him, and his strength left him. And she said, 'The Philistines are upon you, Samson!' So he awoke from his sleep, and said, 'I will go out as before, at other times, and shake myself free!' But he did not know that the Lord had departed from him. Then the Philistines took him and put out his eyes, and brought him down to Gaza.

/ JUDGES 16:15–21

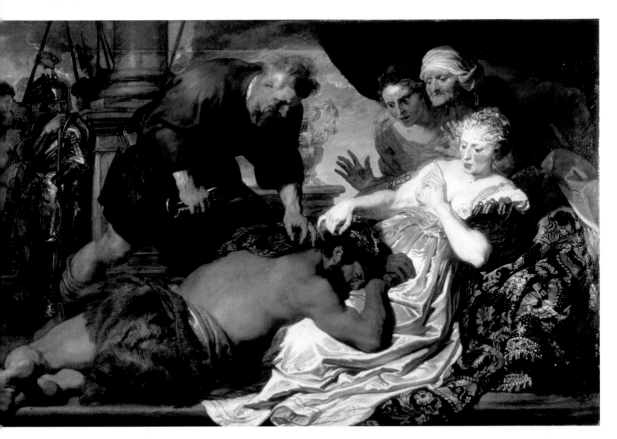

The painting is true to the account in the Bible: the mighty Samson sleeps with his head in Delilah's lap while a Philistine prepares to cut his hair. With one hand Delilah motions the barber to silence, and with the other brushes Samson's hair to one side. The scene, which takes place in an open loggia, is filled with suspense: Samson's life hangs in the balance. The lesson drawn from the story was that men who are blinded by love fall prey to faithless women. Combining excitement, eroticism, betrayal and violence, the scene was often illustrated in the 17th century. It could be understood in either a religious or secular context.

As ominous clouds gather overhead, armed Philistine soldiers stand behind a pillar waiting to invade and capture Samson.

The phallic satyr or faun forming the handle of the ornate cup underlines the erotic nature of the story. According to one version of the narrative, Samson fell asleep under the influence of wine.

SATURN

Francisco de Goya, 1746–1828

Saturn, 1820–23
Canvas (originally on plaster), 146 x 83 cm
Museo Nacional del Prado, Madrid

The bearded face of the crazed, wide-eyed giant Saturn bears a close resemblance to Goya's drawing of an ancient comedy mask. This, however, is a chilling image of a father devouring his children. In a different guise, Saturn is also the personification of Time. In that role, he is often portrayed as an old man carrying the sickle or scythe with which he castrated his father Uranus.

DARK YEARS

In 1818, already in his 70s and deaf for many years, Goya moved to the countryside west of Madrid. He lived in a villa known as the Quinta del Sordo, or Deaf Man's House. There he produced the disturbing and enigmatic murals now known as the Black Paintings. They were severely damaged by moisture after his death, and to preserve them they were transferred to canvas and painstakingly restored. One was this painting of Saturn. The series is among Goya's boldest projects.

The Titans Cronos (Lat. Saturnus) and Rhea were the offspring of the deities Ouranos (Uranus) and Gaia (Gaea). Ouranos hated his children and incarcerated them deep in the earth. His son Cronos took revenge by castrating him. This is what happened to the next generation.

Rhea yielded to Cronos and bore wondrous children: Hestia, Hera with golden sandals, Demeter too and mighty Hades, the heartless, who dwells in his subterranean realm. It is he, the dark god, who causes the earth to quake. Zeus, too, she brought forth, the wise god and father of gods and mortals, whose thunder causes the earth to tremble. Cronos devoured his children one by one as they emerged from their mother's womb. His sole purpose was to ensure that none of those proud denizens of heaven would gain sway in his place. For Gaia and Ouranos had spoken these words: 'It is your destiny to be overthrown by your own son, however mighty you may be, for it is writ and so it shall be.' In response, Cronos was vigilant. He consumed all his progeny, as Rhea looked on in dismay. But when her time came to bear Zeus, Rhea sought her parents' counsel.

Rhea's parents advised their daughter to give birth to Zeus on Crete, and there she hid her child in a cave.

To Cronos, the king of the earlier gods, she gave a great rock wrapped in cloth. He took it from her hands and, oh horror, thrust it into his mouth and swallowed it – now unaware that his son was safe and unharmed! Zeus had been replaced by a stone and so his life was spared. He would soon vanquish his father, strip him of his honour and take his place as chief of the gods. / HESIOD, *The Birth of the Gods*, 453–491

Some time later, Cronos spewed out the stone and all his children.

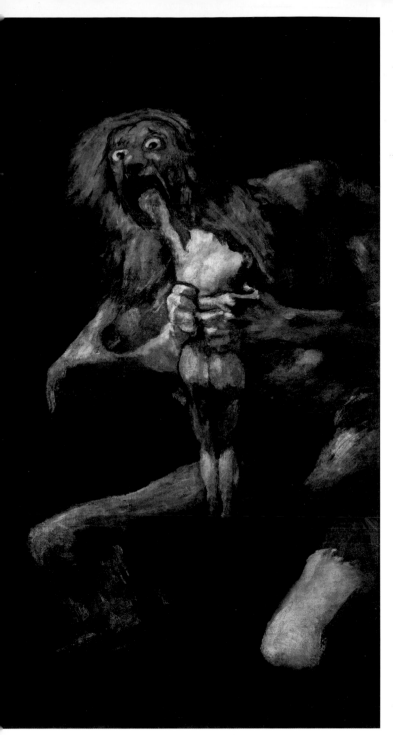

Much of Goya's oeuvre is sombre and disquieting. His later works in particular reflect a growing preoccupation with the dark side of life. Goya's despondency is apparent in this work too, which was painted in the largest room on the ground floor of his country home, as the pendant to a painting of the biblical heroine Judith (see p. 234). In the literature on Goya, this *Saturn* is the iconic work of the master's late period.

The area around Saturn's lower limbs is badly damaged. From old photographs we know that he was sexually aroused. This lends emphasis to the idea that the father who bestows life also destroys that life.

SELENE AND ENDYMION

Cima da Conegliano, c. 1459–1517/18
The Sleeping Endymion, c. 1505–10
Panel, diam. 24.5 cm
Galleria Nazionale, Parma

Every detail of the sleeping figure corresponds to Lucian's description: Endymion lies on his robe with his right arm cradling his head in a pose typically used in classical art to represent a sleeping figure.

More often than not, the goddess Diana, who was associated with the moon in classical times, watches over Endymion, either close by or from a distance. Cima alludes to this by showing the moon itself, rather than its personification, apparently descending from the sky.

The Greek writer Lucian (2nd century AD) tells the story of Endymion in one of his Dialogues of the Gods.
The following conversation takes place between Aphrodite, the goddess of love, and the moon goddess Selene.

Aphrodite: In truth, Selene, what do I hear about you? It is said that each time your path takes you through Caria you rein in your horses to gaze upon Endymion lying asleep under the skies, as hunters are wont to do. On occasion, I am told, you have broken your journey to make your way down to him.

Selene: Ah, Aphrodite, that you must ask of your son Cupid, for it is he who has brought me to this.

Aphrodite: To be sure, he is shameless! But tell me now, is your Endymion handsome? For if he is, you might find consolation in your misfortune.

Selene: In my eyes, Aphrodite, he is beautiful indeed, no more so than when asleep on a rock with his robe spread out beneath him, his spears lying to his left, slipped from his grasp, and his right arm over his radiant face, cradling his head. In repose he is calm and breathes like a god. It is then that I descend and go to him, quiet as a mouse on the tips of my toes, so as not to arouse and startle him. What follows I need not tell, for you know as well as I, save for this: I am consumed with desire. / LUCIAN, *Dialogues of the Gods*, 11

In ancient times various explanations were given for Endymion's eternal sleep, which Lucian does not mention explicitly. Selene may have put him to sleep, or Endymion may himself have asked this of Jupiter to preserve his beauty and his liaison with Selene. The story of Endymion was known mainly through the writings of Boccaccio, though Humanists also read Lucian.

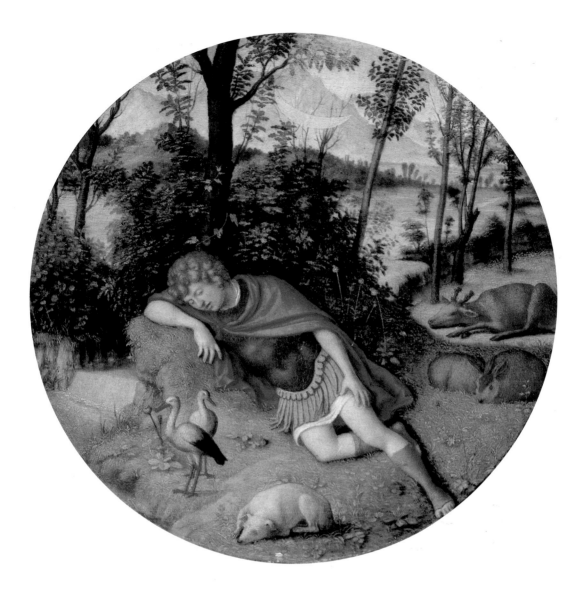

Endymion lies asleep in a moonlit landscape, attired as a hunter or soldier. The animals he might hunt by day sleep behind him, and a hound lies in the foreground. All is still. The theme of a woman falling in love with a sleeping man is unusual in classical mythology. Like most myths, the story of Endymion later acquired a symbolic meaning: eternal sleep (death) delivers us from our earthly existence. It was an ideal subject to decorate bedrooms.

SENECA

**Peter Paul Rubens,
1577–1640**
The Death of Seneca,
c. 1614
Panel, 181 x 152 cm
Alte Pinakothek, Munich

Seneca's features derive from a
classical marble bust in Rubens'
private collection which at the time
was mistakenly believed to be
a portrait of Seneca.

The physician appears to be severing Seneca's veins
with a scalpel, though according to Tacitus he had
prepared a potion to hasten his death. In Rubens' day,
depicting a true suicide – a mortal sin according to
Roman Catholic doctrine – would have undermined
Seneca's reputation.

*The philosopher Seneca was implicated in a conspiracy
against the Emperor Nero and was condemned to take his
own life. A centurion was sent to deliver the order. Seneca
maintained his composure and asked his friends to die
with him, upholding the Stoic principles to which they
subscribed. His wife Paulina wanted to die with her
husband but Nero's soldiers removed her to prevent
her from doing so.*

They severed the arteries of their wrists with a single
stroke of the sword. Seneca's blood trickled away drop by
drop, for he was old and emaciated from his meagre sub-
sistence. Thereupon, he incised too the arteries at his
ankles and in the hollows of his knees; the excruciating
pain sapped his strength. He sent his wife from the room
to spare her the sight of his agony and himself the pain of
witnessing her anguish. He remained lucid to the end, and
could make himself understood, so he sent for his secret-
aries and dictated to them his last thoughts.

*Nero ordered that Paulina must live so as to deny Seneca
the glory of true martyrdom.*

As death was slow to come, Seneca turned to Statius
Annaeus, who was a good physician and his trusted friend
of many years, and asked him to bring the potion he had
prepared well in advance. The substance was the same as
that administered to Socrates and others condemned to
death in Athens. The liquor was brought to him and he
emptied the beaker, yet it produced no effect, for his body
had grown cold and no longer absorbed the bane. At
length he immersed himself in a basin of warm water,
some of which he sprinkled on the servants at his side,
saying it was a libation to Jupiter the Redeemer. The end
finally came when he was placed in a steam bath, where
the vapours caused him to suffocate. / TACITUS, *The Annals*,
15, 63, 3 and 64, 3

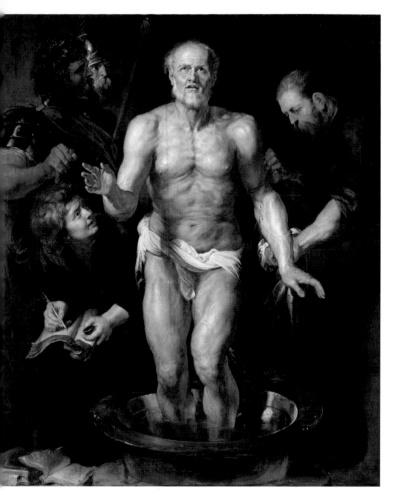

Seneca, the Roman philosopher of Spanish descent whom the tyrannical Nero had condemned to death, stands in a tub of hot water and dictates his last words to a young man. A physician is in attendance, and the two soldiers who came to deliver Nero's order look on from a distance. The erudite Rubens associated with the circle around the humanist scholar Justus Lipsius. Both he and Seneca were exponents of the Christian neostoic philosophy which advocated the sovereignty of reason and the disciplined control of emotion. In that milieu Seneca enjoyed the status of a Christian martyr. Rubens' painting of Seneca's death was extremely influential.

The young man records Seneca's dying words. Other manuscripts lie on the ground. Seneca's wife is not shown in Rubens' picture, though later artists included her to heighten the pathos of the scene.

SUSANNA

Lorenzo Lotto, 1480–1557
Susanna and the Elders, 1517
Panel, 66 x 50 cm
Galleria degli Uffizi, Florence

'I would die rather than sin. Woe is me'. Those are the words on the banner behind the chaste Susanna. She raises her arm to ward off the men.

Joachim was a wealthy Jew who lived in Babylon with his wife, the beautiful and pious Susanna. Two elders were frequent guests in their home, where they would see Susanna walking in the garden. Both desired her, but kept their thoughts to themselves.

They said to each other, 'Let us go home, for it is mealtime.' And when they went out, they parted from each other. But turning back, they met again; and when each pressed the other for the reason, they confessed their lust. And then together they arranged for a time when they could find her alone. Once, while they were watching for an opportune day, she went in as before with only two maids, and wished to bathe in the garden, for it was very hot. And no one was there except the two elders, who had hid themselves and were watching her. She said to her maids, 'Bring me oil and ointments, and shut the garden doors so that I may bathe.' They did as she said, shut the garden doors, and went out by the side doors to bring what they had been commanded; and they did not see the elders, because they were hidden. When the maids had gone out, the two elders rose and ran to her, and said: 'Look, the garden doors are shut, no one sees us, and we are in love with you; so give your consent, and lie with us. If you refuse, we will testify against you that a young man was with you, and this was why you sent your maids away.' Susanna sighed deeply, and said, 'I am hemmed in on every side. For if I do this thing, it is death for me; and if I do not, I shall not escape your hands. I choose not to do it and to fall into your hands, rather than to sin in the sight of the Lord.' Then Susanna cried out with a loud voice, and the two elders shouted against her. And one of them ran and opened the garden doors. When the household servants heard the shouting in the garden, they rushed in at the side door to see what had happened to her. / From a Greek addition to the BOOK OF DANIEL, B:13–26 – New Revised Bible)

The elders' ploy seemed to work and Susanna was condemned to death. But God heard her prayer and through Daniel's intervention the old men's lie was exposed and they were executed.

These are the two maids that Susanna sent to fetch oil and balsam in the episode preceding the bathing scene. They left the garden by the door behind their mistress and are now on their way to town.

'We caught her in the arms of a young man. Do our bidding or die through our witness'. The first sentence, 'spoken' by the man in purple, is addressed to the servants hastening to the scene. The second, which chronologically precedes it, is meant for Susanna and comes from the man in red descending the stairs.

The painting presents a sequence of episodes from the story. The main scene is staged in the bathing enclosure in the foreground. Banderoles explain the dramatic event. Two men, neither of them particularly old, take the naked Susanna by surprise. Just at that moment, her servants arrive at the bath, alarmed by Susanna's cries, but also eager to see the sight that awaits them.

SUSANNA

Albrecht Altdorfer, c. 1480–1538
Susanna and the Elders, 1526
Panel, 75 x 61 cm
Alte Pinakothek, Munich

In Altdorfer's painting the robed Susanna modestly bathes her feet in a basin. She is surrounded by her maids, one of whom combs her long hair. The two elders spy on Susanna from their hiding-place among the bushes.

Altdorfer devoted most of the panel to the gardens and the palatial home and terrace of the wealthy Joachim and Susanna, with a multitude of people all about. Like Lorenzo Lotto, he illustrated different scenes from the story: Susanna's bath, the trial against the elders (far right), and their execution by stoning.

This is the end of the story. The two elders were executed by the crowd – by stoning – after Daniel unmasked their lie. Onlookers survey the scene from every storey of the building.

Rembrandt, 1606–1669
Susanna and the Elders, 1647
Panel, 76.5 x 93 cm
Staatliche Museen zu Berlin, Gemäldegalerie

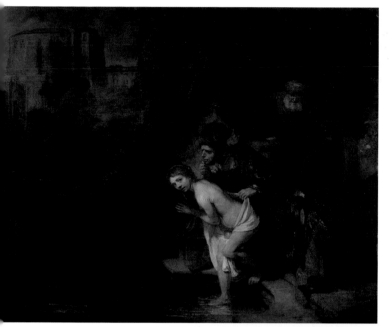

The second elder, who wears a turban, enters through the garden door, with his lecherous gaze fixed on his defenceless victim. The tale was often represented in art: paintings like this allowed viewers to enjoy vicariously pleasures that were otherwise forbidden. Nevertheless, the moral of the story was that, with God's help, chastity and justice will prevail.

Like many other painters, Rembrandt illustrated the dramatic climax of the tale: his Susanna – who is not a classical beauty – has laid her garments over a wall and is about to step into the water. This particular moment is not described in the Bible, and as a result artists were at liberty to portray Susanna nude, thereby emphasizing the themes of lust and imperilled virtue. Unable to escape, Susanna gazes helplessly at the observer, so that we, too, are inadvertently voyeurs. Her assailant tugs at the cloth with which she covers herself and makes an obscene gesture with his right hand.

In Rembrandt's day slippers were a well-known symbol of a woman's sex. Here, they allude to the erotic content of the tale.

TOBIAS

Antonio and Piero del Pollaiuolo,
c. 1432–1498 and c. 1441–1496
Tobias and the Archangel Raphael, 1460s?
Panel, 187 x 118 cm
Galleria Sabauda, Turin

The beardless young Raphael dominates the scene. His halo and wings identify him as an angel, though these attributes are not mentioned in the Bible. On the contrary, Raphael's true identity is revealed only at the end. He holds a medicine box in the palm of his right hand.

The elderly Tobit, his wife Anna and their son Tobias were Israelites living in exile in Nineveh. Tobit lost his sight and all his possessions, and prayed to God that he might die. Meanwhile, unbeknown to him, his distant kinswoman Sarah in Ekbatana, Media, asked the same of God. She was possessed by a demon and had lost seven husbands. God heard both their prayers and sent the archangel Raphael to restore Tobit's sight and bring Sarah and Tobias together as husband and wife. Tobit sent his son to Media to fetch some money that belonged to him.

Then Tobias going forth, found a beautiful young man, standing girded, and as it were ready to walk. And not knowing that he was an angel of God, he saluted him, and said: 'From whence art thou, good young man?' But he answered: 'Of the children of Israel.'

Tobit gave his son permission to go with Raphael, who said he knew Media well.

And Tobias went forward, and the dog followed him, and he lodged the first night by the river of Tigris. And he went out to wash his feet, and behold a monstrous fish came up to devour him. And Tobias being afraid of him, cried out with a loud voice, saying: 'Sir, he cometh upon me.' And the angel said to him: 'Take him by the gill, and draw him to thee.' And when he had done so, he drew him out upon the land, and he began to pant before his feet. Then the angel said to him: 'Take out the entrails of the fish, and lay up his heart, and his gall, and his liver for thee: for these are necessary for useful medicines.' / TOBIT 5:5–7, 6:1–5

After returning to Ekbatana, Tobias burnt the heart and liver, thus expelling the demon from Sarah, who then married him. Raphael collected Tobit's money in Media, and Tobias returned home. He applied the gall to his father's eyes, and so restored his sight.

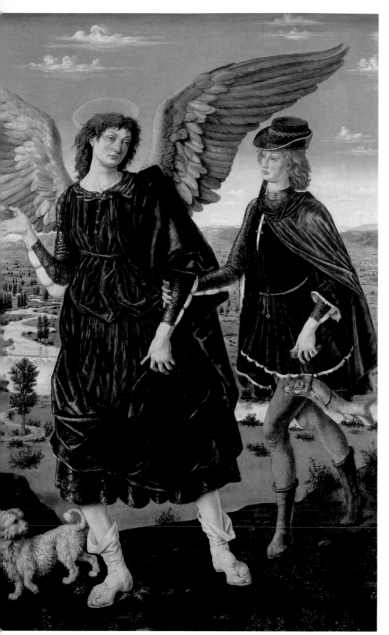

Several episodes from this fable-like story have been illustrated in art, the most popular being the scene of the archangel Raphael accompanying and protecting Tobias on his journey. The two are depicted here in the Florentine fashion of the Pollaiuolo brothers' time, in a typically Tuscan landscape (see also pp. 41, 87). In his left hand Tobias carries the fish – smaller than one would expect – which the angel told him to catch, and with his right hand he holds Raphael's arm. In Tuscany Raphael's help was invoked by pilgrims and in times of illness or other adversity.

As in the biblical text, Tobias' dog accompanies his master on the journey.

The handsome young Tobias is dressed for the journey and wears a hat. Florentine merchants often acquired pictures of this scene as a memento of their sons' first business trip. An analogy was drawn between Tobias, who restored his father's sight, and Christ, who brought light to the world.

The fragrance Homer refers to emanates from this tripod burner. This is one of the many motifs that attest to David's fastidious attention to detail in his history paintings. Like the burner, the two graceful figures were also inspired by classical examples. The stand decorated with caryatids is a painted version of a Renaissance sculpture.

RARE

This erotic episode from Homer's Iliad *is far less often represented in art than the Judgement of Paris (see p. 280) or the Abduction of Helen. David, however, painted at least two almost identical versions of this subject. The serious and meticulous interpretation of the myths inherent in David's Neoclassicism marks a departure from the frivolous approach of many of his predecessors in France who were mainly interested in depicting amorous escapades.*

TROY

Jacques-Louis David, 1748–1825
The Love of Paris and Helen, 1789
Canvas, 146 x 181 cm
Musée du Louvre, Paris

The Trojan prince Paris abducted Helen, the beautiful wife of the Greek Menelaus, and took her home to Troy. This incident precipitated the Trojan War, in the course of which the frightened Paris met Menelaus in single combat in an attempt to end the conflict. He had all but lost the battle when the love goddess Aphrodite came to his rescue and transported him to his 'wonderfully fragrant' room. Aphrodite compelled the protesting Helen to go to the vanquished Paris.

Helen wrapped herself in her lustrous white robe and, silently, eluding the gaze of the Trojans, followed behind the goddess. Once they had arrived at Paris' splendid palace, the two maidservants set to work without delay. Helen, divine woman, daughter of Zeus, mounted the stairs to the bedroom above. With a smile, Aphrodite brought her a chair and set it beside Paris. Helen sat upon it, turned her eyes from her husband's face, and proceeded to scold him.

Helen rebuked Paris for his defeat and tried to persuade him to challenge Menelaus to another duel. But she also had her reservations.

'But no, pray put an end to that combat. It would be fool-hardy to engage with fair-haired Menelaus again, for his spear will pierce you through.' Paris answered her with the following words: 'Woman, you reproach me too harshly. This time, it is true, Menelaus has won, with the goddess Athena on his side; but next time I shall taste victory, for we too have the gods on our side. Come, let us retire and enjoy love's delights. The desire that grips me now is greater even than my yearning when I carried you off from lovely Sparta and we sailed on our ships to the isle of Kranae. Oh, how we two were united in love. So I long for you now, driven by sweet passion.' With those words, Paris led the way and his wife followed, and they lay down together on the hide-thonged bed. / HOMER, *Iliad*, 3, 487–526

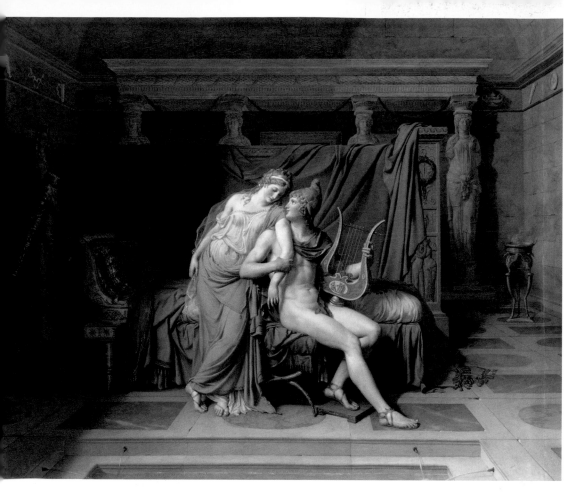

Paris holds a lyre. In the story, Aphrodite says to Helen: 'Paris is calling for you. He lies on his exquisite bed, radiant with beauty and clad in silken garments, not a man who has returned from battle, but more like one about to go to a dance or one resting after a dance.' Homer also refers to Paris as 'the lyre player'. A medallion on the base of the lyre shows the Judgement of Paris: the seated Paris awards the apple to Aphrodite (see p. 280).

In a bedroom decorated in the classical style and surrounded by erudite allusions to antiquity, the seated, almost naked Paris – wearing nothing more than a Phrygian cap – gazes passionately at Helen. She stands beside him, and he takes her by the arm. The ambivalence of the 'white-armed' Helen is expressed in her demeanour: though she leans towards Paris, her eyes are sad. Their love had fatal consequences.

The relief represents Cupid and Psyche (see pp. 300–305), a story in which love prevails in the end. The room contains other allusions to love, like the sculpture of *Venus Pudica* (the Modest Venus) on the left and the gilt relief of Helen's parents Zeus and Leda (see p. 240).

Angelica Kauffmann, 1741–1807
Hector Taking Leave of Andromache, 1768
Canvas, 134 x 176 cm
The Morley Collection (The National Trust), Saltram House

Hector is now wearing the helmet which he had removed to allay his son's fear, as Homer writes. Hector is about to set off on a voyage from which he will never return: he will lose his life on the battlefield. Knowing what lies in store, the parting is profoundly tragic. One of Kauffmann's sources was Alexander Pope's translation of Homer.

The Trojan hero Hector prepares to set off for battle.
At the city walls he takes leave of his wife Andromache
and their son Astyanax.

Andromache hastened to meet him. Beside her was the maid who held the small boy in her arms – Hector's beloved child! Hector's face lit up at the sight of his son, though not a word passed his lips. But Andromache, now at his side, wept bitterly. She clasped his hand in hers and implored, 'O, fearless husband, your courage will be my downfall. Have pity on us, the hapless child and bereft wife you leave behind. The Greek hordes will soon be upon you, howling for your blood. Rather would I perish and be consigned to the earth than live on without you. No solace awaits me, but grief for all my days.'

The Greek Achilles had murdered Andromache's family,
but she implores Hector not to go to war: 'Do not leave your son a fatherless child and your wife
a widow.' Her pleas were in vain. Hector knew only too well what fate awaited them, but honour
compelled him to take up arms for Troy.

After he had spoken these words, the radiant Hector reached out to embrace his son. But the child cowered and clung to the folds of the maid's comely gown, terrified of the bronze helmet and the sweeping plume on its crest. His father and noble mother could not but smile, and glorious Hector removed his dazzling helmet and set it down on the ground. He kissed his little boy, cradled him in his arms, and lifted a prayer to Zeus and the other gods. Then he laid the child in his mother's arms. She pressed the boy to her fragrant breast and smiled through her tears. Hector's heart melted at the sight. He caressed her face tenderly and said, 'Unhappy Andromache, yield not to sorrow. None shall dispatch me to my death should it not be my fate: no mortal, be he of humble or noble blood, defies the destiny ordained at his birth. Return home and attend to your duties, your shuttle and loom, and put your maids to their tasks. War is the work of men.' / HOMER, *Iliad*, 6

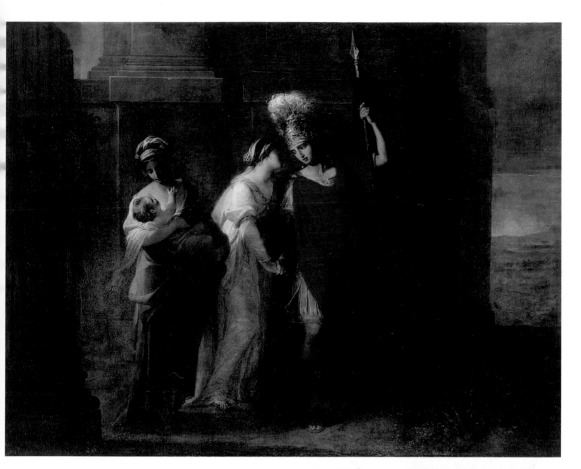

Against the background of a building reminiscent of a temple, we see on the left the maid with Astyanax in her arms, and beside her Andromache and Hector. Their archaic costumes recall those of classical antiquity. Hector wears a blood-red tunic and holds a spear, signalling his resolve to go to battle. This is one of the paintings that established Angelica Kauffmann's reputation as a history painter in Britain. It forms part of an ambitious series made for Saltram House, where it hangs to this day.

Andromache's futile desire to prevent her husband from going to war is expressed by the yearning in her eyes and her hand clasping his. The painting conveys the essence of the story.

The infant Astyanax has turned his attention away from his parents and gazes at the maid. A short while before he was in Hector's arms.

The old priest Laocoön lies on the ground fighting for his life. Virgil described two monstrous serpents that *strangled* Laocoön and his sons, but those in the painting appear to be a species that inject venom.

The legendary 'Trojan horse' is depicted here as an ordinary horse making its way to Toledo. There is some speculation as to why El Greco included a view of contemporary Toledo in a mythological scene. Was he alluding to the religious war raging at the time, or perhaps to the legend that the Trojans founded Toledo?

El Greco, 1541–1614
Laocoön, c. 1610–14
Canvas, 137.5 x 172.5 cm
National Gallery of Art, Washington, Samuel H. Kress Collection

After ten years of war, the Greeks left a huge wooden horse on the shores of the city of Troy saying it was a sacrifice to Minerva. Neptune's priest Laocoön warned the Trojans not to accept it and hurled his spear at it. The Trojan Aeneas tells the story:

With solemn pomp Laocoön was slaughtering a mighty steer for the sacrificial ceremony when, to my astonishment – I still tremble at the thought – two sea serpents, ranked abreast, rose up from the deep. Circling wide, they skimmed the water, making for the coast, their blood-stained crests raised high above the waves, their bellies gliding through the sea below, their bodies huge and convoluted. And as they reached the shore in a surge of seething foam, their eyes blazed with blood and fire, and their flickering tongues licked their hissing jaws. Deathly pale at the sight, we dispersed and fled; they slithered unwavering towards Laocoön. First the writhing creatures coiled themselves around the bodies of his two sons, and with their fangs tore them asunder. Then, when Laocoön ran to their aid, armed with weapons, they seized him and crushed him in their vast whorls. Twice they twined around his waist, twice coiled their scaly backs around his throat. Their heads poised on rigid necks towered over him. He laboured to loosen the knots with his hands – his fillet drenched with blood and black venom – and let out a reverberating roar of anguish. / VIRGIL, *The Aeneid*, 2, 201–222

Laocoön was condemned because his words offended the gods. But that same night he was proved right: the wooden horse harboured Greek soldiers who captured Troy and razed the city to the ground.

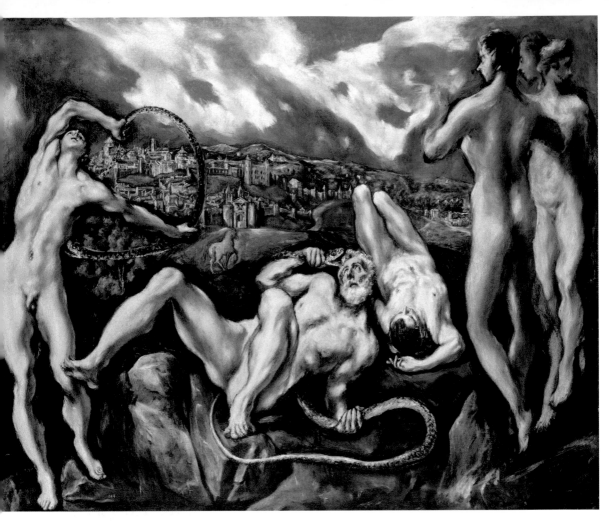

Every representation of the story of Laocoön is measured against the famous and immensely influential ancient sculpture excavated in Rome in 1506. El Greco, who would surely have seen it, has evoked a sense of apocalyptic doom, with ashen, eerie colours, spectral figures, a bizarre composition scheme, and every other means at his disposal. One of Laocoön's sons lies lifeless on the ground, while his father and brother wrestle with the serpents. The three figures are connected, though far less closely than in the ancient sculptural group. This is the only mythological theme El Greco is known to have painted. The city in the background is Toledo in Spain, where El Greco lived and worked.

Various hypotheses have been put forward regarding the identity of these unfinished figures. One possibility is that they represent deities who have come to witness the revenge they exacted.

A man appears to be driving a spear into the horse's body, as Homer mentions in passing: 'The men of Troy frantically discussed three propositions: whether to skewer the monster with a merciless bronze spear ...' (*Odyssey*, 8, 507).

Giovanni Domenico Tiepolo, 1727–1804
The Procession of the Trojan Horse
into Troy, c. 1760
Canvas, 39 x 67 cm
The National Gallery, London

Having held siege to Troy for ten years to no avail, the Greek warriors prepared to abandon the city. But before setting sail they left an immense wooden horse on the beach, a votive offering, they said, to the goddess Athena, as they had plundered her statue from Troy. The cunning Odysseus had devised the plan. The Trojans were in two minds: should they take the horse into their stronghold? Many years later, the Trojan Aeneas, who had been there at the time, recounted the event in the palace of Queen Dido.

As one they proclaimed that the horse should be brought to the temple and prayers offered to the goddess. So we hewed a hole in the wall and breached the ramparts of the city. All laboured at the task. They secured wheels under the hoofs and drew flax cables around the animal's neck. The deadly contraption was hoisted, its belly pregnant with arms. Choirs of virgins and young men sang songs of praise all about and rejoiced merely to touch the rope. The horse inched its way up and rolled ominously through the city. O Troy, my fatherland, home of the gods, city whose walls have won fame through war! Four times the horse faltered before the city gate and from its belly was heard the rumble of arms. Yet we continued, unheeding, blind in our excitement, and brought the cursed abomination into our sacred citadel. Cassandra warned us, there and then, prophesying the doom that awaited us. But at Apollo's godly bidding never would a Trojan believe her word. And we, hapless wretches, for whom that day would be our last, adorned with festal foliage all the sacred temples of Troy. / VIRGIL, *The Legend of Aeneas*, 2, 232–249

The hollow interior of the horse was filled with Greek warriors who emerged under cover of night and sacked Troy. Aeneas and his family fled as the city was razed to the ground.

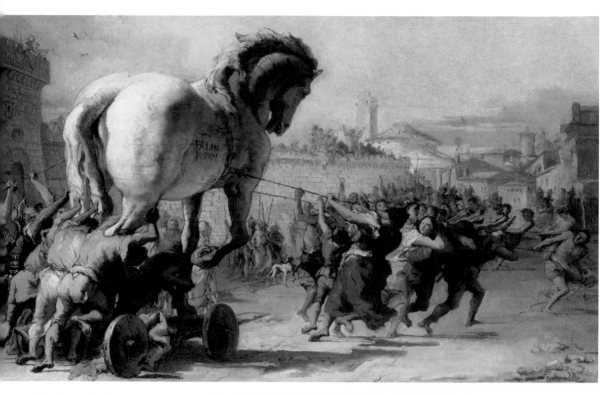

Giandomenico Tiepolo, the son of Giambattista, painted a series of sketches in oils illustrating the legendary account of the Trojan Horse. This canvas is one of them. The chronicle of Troy was known predominantly from Virgil's epic, although Homer tells the story as well. The horse is the main protagonist. In Virgil's account, the episode shown here occurs directly after the demise of the Trojan priest Laocoön (see p. 330).

Tiepolo followed Virgil's text closely: the horse is transported on a structure with wooden wheels. The populace has come out in force to propel it into the city. Homer does not mention wheels.

In just a few hours, Tiepolo's Italianate city of Troy will be sacked and burnt to the ground. The assault was launched at night. When the exultant Trojans had fallen into a drunken sleep, the Greek warriors emerged from the horse.

The Latin words 'Paladi [sic] votum', or 'Offering to Pallas' (Athena), are inscribed on the horse's body. By sending that message, which Virgil says was delivered by a Greek spy, the Greeks managed to trick the Trojans.

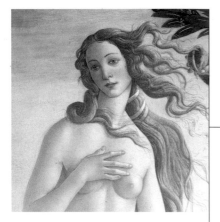

VENUS

Sandro Botticelli, 1446–1510
The Birth of Venus, c. 1485
Canvas, 172 x 278 cm
Galleria degli Uffizi, Florence

In his painting of Venus' arrival on Cyprus, the island dedicated to her in the days of antiquity, Botticelli makes no reference to the cruel events that preceded it (see Hesiod's text), although they are alluded to in the poetry of his contemporary source Poliziano and quite explicitly in medieval paintings. The shell was Venus' attribute from classical times.

ANTECEDENT?

Venus anadyomene – Venus rising from the sea – *by the Greek painter Apelles was a celebrated work of art in the days of antiquity, but we know little more than that it showed Venus wringing water from her hair. It appears to be unrelated to Botticelli's painting. Titian, however, drew inspiration from a description of Apelles' work.*

The birth of the love goddess Aphrodite (Lat. *Venus*) *is described in several classical writings.*

I will sing the praises of fair Aphrodite, wreathed with gold, the goddess who possessed as her birthright the mountains on the isle of Crete. The moist breath of the gentle zephyrs bore her to that island in a gentle cloud of foam, over the waves of the blustery sea. The Hours, with diadems of gold, awaited her with joy and covered her in celestial robes. / HOMERIC HYMNS, *Second hymn to Aphrodite*

Hesiod writes that Cronos castrated his father Ouranos (see p.314) at the bidding of his mother Gaia, as Ouranos had buried his children in the bowels of the earth.

Cronos severed the member with his steel sickle and flung it upon the surging water. There it drifted ever further and all around there appeared from the mighty god's phallus a luminous white froth, and within it there grew a young nymph. First she neared the sacred island of Kythera and from thence came upon Cyprus, the waters flowing about her all the while. On that spot the sublime goddess rose from the waves, and where she stepped there sprang up grass. Her name is called Aphrodite, goddess born of sea foam, and so she is known to mortals and deities alike. Eros was at her side, and the fair Himeros accompanied her soon after her birth, when she took her place among the pantheon of the gods. / HESIOD, *Theogony*, 188–202

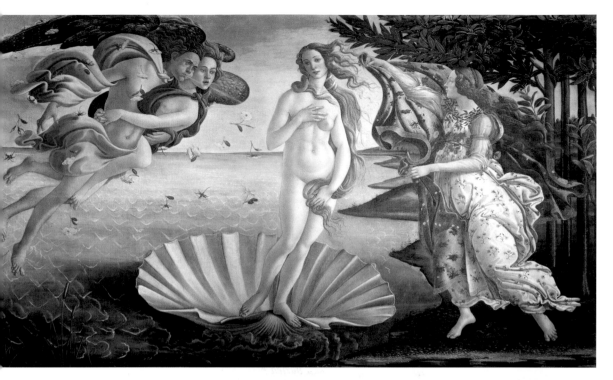

Along with Botticelli's *Spring* (*Primavera*), in which Venus is likewise the central figure, this painting is one of the first large images (after antiquity) of a classical god or goddess. Famous as they were – Botticelli's paintings embody the revival of antiquity during the Renaissance these complex works had little influence on later imagery. The painter drew inspiration for this painting from the writings and teachings of a contemporary, the humanist Angelo Poliziano, who had reinterpreted the Homeric Hymns. The present title, acquired in the 19th century, is not entirely accurate, as Venus has already been born. 'The arrival of Venus' would be more apt.

Winged Zephyr, the west wind, his cheeks filled with air, lends vibrancy to this scene, where pastel-petalled roses flutter on the breeze. Venus' pose recalls the classical *Venus pudica*, or 'Modest Venus', who covers her nakedness. The nymph at Zephyr's side blows gently to assist him.

According to the Homeric hymn, this must be one of the Hours, the goddesses of the seasons. Like the Graces, they were traditionally part of Venus' entourage. Her gown and the drape she holds for Venus are also decorated with spring flowers. The myrtle sprigs around her neck and the roses in her girdle were dedicated to Aphrodite. The goddess of love and life was associated with spring.

One of the little gods plays with a rabbit. Elsewhere in his work Philostratus writes: 'No one shoots a hare with an arrow; Aphrodite's most cherished gift, the hare, should be caught alive, for it is said that hares have much in common with Aphrodite.'

VENUS

Titian, c. 1487–1576
The Worship of Venus, 1518–19
Canvas, 172 x 175 cm
Museo Nacional del Prado, Madrid

The 'story' in this case is a description of a classical painting by the Greek writer Philostratus (3rd century AD).

What is there to be seen? Cupids gathering apples, and, not surprisingly, a multitude of them, for they, the children of nymphs, govern all mortalkind and mortals love many things. Do you not smell the fragrance that fills the garden? Then heed my words, for when I have spoken, you too will know the scent of apples. Trees form a procession of straight columns and between them are clearings where one can stroll at leisure. Grass covers the paths, so soft to the touch that one might lie as on a couch. At the ends of the branches, golden, red and sun-hued apples lure flocks of cupids who come to harvest them. Leaving their gilded quivers and arrows of gold on the branches, they flutter and gambol unencumbered. Their colourful, many-hued garments lie strewn in the grass and their coronets too are cast aside. Their wings – azure, purple and gold – beat the air in tuneful harmony. And oh, the baskets in which they gather their apples! A veritable treasure of sardonyx and emeralds and pearls! No ladders do they need to reach the treetops, for on wings they soar to the highest apples. And I must speak too of the tiny deities that dance or frolic or rest, and those that savour the luscious fruits.

But picture now Aphrodite. The nymphs have placed there her likeness, for it was she who made them the mothers of the gods of love, proud begetters of beautiful children. The silver mirror, the golden sandals, the precious brooches: all share a common purpose. 'For Aphrodite', is written there, and it says they are gifts from the nymphs. The cupids bring the first fruits of their harvest and, forming a circle, pray that their garden may remain beautiful. / PHILOSTRA-TUS, *Paintings*, I, 6

Titian followed Philostratus' description closely. His canvas shows a multitude of cupids eating apples, frolicking, resting and fluttering among the trees. On the right is a classical-looking sculpture of Venus (*Gr.* Aphrodite), the patron of the festival, and beside it are two nymphs, one of whom holds up a mirror. The avenue of trees where 'one can stroll at leisure' is the main feature of the composition. This was one of the paintings made for the *studiolo* of Duke Alfonso d'Este in Ferrara, who must have recommended that Titian use Philostratus as source of information. On the project, see also pp. 48, 297.

The cupids kissing and cuddling are a boy and, unusually, a girl, undoubtedly Titian's invention.

Philostratus wrote, 'No ladders do they need to reach the treetops, for on wings they soar to the highest apples.'

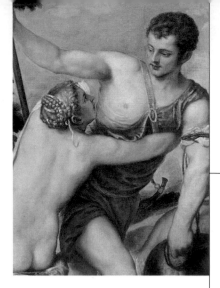

VENUS

Titian, c. 1487–1576
Venus and Adonis, 1553–54
Canvas, 196 x 207 cm
Museo Nacional del Prado, Madrid

This view of Venus, shown from the back, has a long list of precedents. It can be seen, for instance, in Correggio's *Io* (see p. 215), but also in reliefs from classical antiquity. Titian wrote about it in a letter to his patron Philip II: 'The Danaë that I have already sent Your Majesty [a variant of the version on p. 158] shows her from the front. I wanted to do something different in this new *poesia* and show the back of the body. It will enhance the room in which the paintings are to hang.'

The beautiful Adonis was born of the incestuous union between his mother Myrrha and her father. Venus, the goddess of love, conceived a helpless passion for him. Beguiled by the beauty of a mortal, Venus no longer visited her usual haunts, nor even heaven. Adonis was the sole star in her firmament. She was ever at his side, his constant companion. She who was wont to idle in the shade tending her beauty, now roamed through hills and woods and over rugged rocks, her tunic hitched knee-high, like Diana's. She urged on the hounds, and pursued harmless quarry – swift hare, antlered stag, and deer – but shunned strong boar, marauding wolves, bears armed with claws, and lions lusting for blood. She enjoined Adonis, too, to beware, trusting that he would heed her pleas. 'Do not be rash, my love, lest your boldness be my ruin. Do not confront beasts that nature has armed; seek not glory that would cost me dear. For lions will not yield to your youth and beauty, though they charm my heart. Lions, above all, I dread.' And when Adonis asked her the reason, she said, 'I shall tell you, but my unaccustomed toil has wearied me. I would rest with you here, in the welcoming shadow of this poplar, where the grass is like a couch.' She lay down on the ground beside him, her head on his breast, and told him this tale, stopping only to kiss him.

When she had finished, she took leave of Adonis.

'Beware of lions, my love, and of every savage beast that turns not from you, but meets your gaze, lest your courage be our doom.' With these parting words, she made her way through the skies, drawn by her team of swans. But rash Adonis did not heed her counsel. / OVID, *Metamorphoses*, 10, 529–559, 705–709

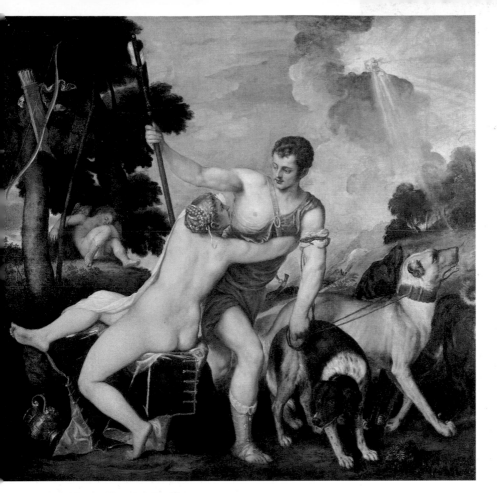

Venus' son Cupid has dozed off in the background. His bow and quiver hang idle in the tree above him, symbolizing the futility of Venus' love for Adonis. In some paintings of this subject Cupid is shown supporting his mother, or clinging to Adonis' legs or garments.

This is the tragic end of the story: Venus approaches in a chariot drawn by doves, or swans in Ovid's account. A shaft of light falls on the barely visible figure of the dying Adonis, who was mortally wounded while pursuing a wild boar.

This painting shows the fateful moment when Adonis prepares to go to the hunt and takes leave of the imploring Venus. He has already taken up his lance and the hounds are impatient. Titian was the first to depict this episode, and many artists followed suit. According to Ovid, Venus set off in her swan-drawn chariot *before* Adonis went to hunt. It has been argued that Titian's version might suggest Adonis had already lost interest in Venus. Or was he in fact trying to reassure her?

The sun god sees all. He has told the unsuspecting Vulcan about his wife's unfaithfulness and now lifts a corner of the green drapery over the bed. Ovid tells us that Venus will take revenge by making Apollo fall in love with Leucothea, the daughter of King Orchamus of Babylon – an affair that was doomed to end in disaster. Wtewael alludes to this in the picture: Cupid, to the left of Apollo, aims an arrow at the god.

Diana was the virgin goddess of the hunt; Saturn, the ancient god of time, holds a sickle in his hand. In Homer's version of the story the gods came to witness the spectacle, but the goddesses stayed away in shame. Ovid does not mention that detail.

VENUS

Joachim Wtewael, 1566–1632
Venus and Mars Surprised by Vulcan, c. 1606–10
Copper, 20.5 x 16 cm
The J. Paul Getty Museum, Los Angeles

This humorous story was first told by the Greek poet Homer. The Roman Ovid produced a shorter version eight centuries later.

The Sun [Apollo], so it is told, was the first to see Venus' adultery with Mars, for the Sun is the first to see all things. Saddened by what he had witnessed, he showed the blacksmith Vulcan the bed where his wife had wronged him. Vulcan's heart sank in despair and the work he was artfully crafting fell from his hands. At once he began to forge a net, a mesh of bronze chains so fine that they could not be seen, finer even than gossamer or the delicate web spun by a spider high on a beam. At the merest breath or whisper his net would capture its prey. Vulcan ingeniously arranged it around the bed, the new snare he had wrought to imprison his faithless wife and her adulterous lover, locked in embrace as they lay down in lust. He flung wide the ivory doors to admit the gods. And there lay the two, shackled together in shame. But in truth, not all the gods were outraged. On the contrary, it must be said that some wished themselves a mischief of that very kind. The gods of heaven chortled with mirth and savoured the tale of the scandal long after. / OVID, *Metamorphoses*, 4, 171–189

> *To add to the gods' merriment – this was the origin of the phrase 'Homeric laughter' – Mars, the swiftest of the gods, was caught by Vulcan, who had been lame from birth.*

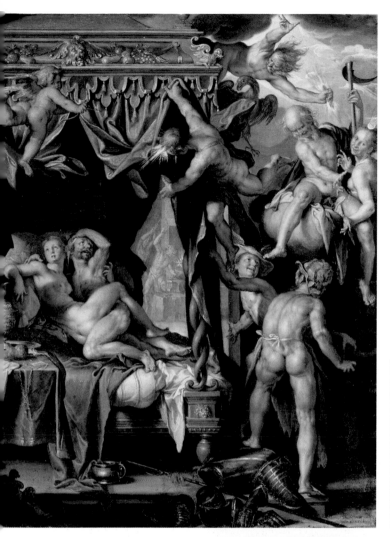

This is one of very few paintings of a man and woman, or gods in this case, depicted in the act of love. Mars, the god of war, and Venus, the divine personification of love, were caught red-handed. Venus' cuckolded husband Vulcan summoned the gods to witness her unfaithfulness, and then trapped the hapless lovers in his net. He stands at lower right with his back turned to us and his foot resting on the armour of his defeated rival. Given the risqué nature of its subject, this tiny painting on copper was probably made for an art cabinet. It was small enough to pick up and examine.

A chamber pot was often a symbol of female sexuality and fertility. Wtewael added a subtle touch by showing a corner of the bed linen trailing into it. He was the only Northern Netherlandish painter to represent this comical scene.

Jupiter arrives on the scene. He soars above with a thunderbolt in his hand. The eagle, his customary attribute, flies beneath him.

VENUS

Jacopo Tintoretto, 1518–1594
Venus and Mars Surprised by Vulcan, c. 1545
Canvas, 134 x 198 cm
Bayerische Staatsgemäldesammlungen, Alte Pinakothek, Munich

Tintoretto's unconventional painting of this story shows the moment before all is revealed. Venus' cuckolded husband, the lame, grizzled Vulcan, looks for evidence of his wife's adultery. In doing so, he uncovers her so that we see her naked. The adulterer Mars hides under a table. Tintoretto departed from the written account, where the lovers are caught red-handed. Vulcan's net is not shown either. The scene looks more like a domestic farce.

Venus and Mars' love affair has come to an abrupt end. Even Cupid, who tirelessly fires his love arrows at gods, heroes and mortals, has fallen asleep.

The dog, normally a symbol of marital fidelity, adds a touch of humour to the scene: growling and barking, it will probably betray Mars. A group of writers in Tintoretto's Venice took an irreverent view of high literary culture.

Mars, the god of war, apparently found time to put on his helmet and armour before scuttling under the table.

Diego Velázquez, 1599–1660
Apollo in Vulcan's Forge, 1630
Canvas, 233 x 290 cm
Museo Nacional del Prado, Madrid

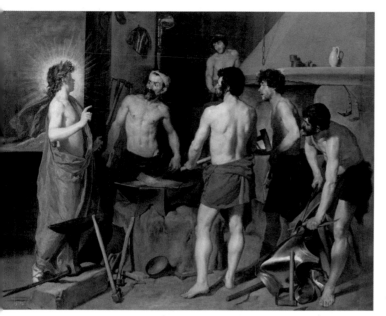

Velázquez illustrated the moment when the sun god Apollo comes to Vulcan to reveal what his wife Venus has been up to. The scene takes place in Vulcan's forge, which looks like an ordinary workshop. It is realistic and human, and has been described as satirical. The assistant working on a cuirass at lower right adds a poignant note. Vulcan was making a suit of armour at his wife's request, without realizing that it was for his rival Mars.

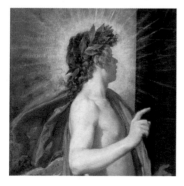

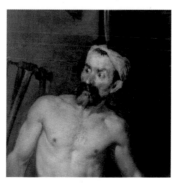

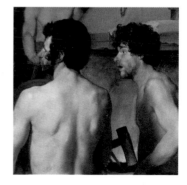

The rays of light and the laurel wreath around Apollo's head are the only clues that the main characters are gods. Velázquez' all-seeing sun god is a young, boyish figure in an orange robe, who stands out in every respect from the other figures in the scene.

Vulcan, depicted here as an ordinary labourer forging a sheet of molten iron, listens to Apollo's story with growing dismay. Velázquez possessed a talent for rendering mythological stories as familiar, everyday scenes.

In the myths, Vulcan's assistants are Cyclops. But Velázquez portrayed them as ordinary people. His young men are creatures of flesh and blood who listen with interest to what Apollo has come to say.

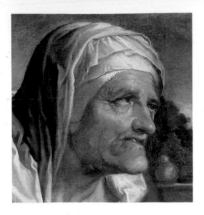

Elderly women were often portrayed as matchmakers in art. This kind of painting was therefore a warning to the young not to heed their advice. The old also served to remind people that life is short and every moment should be cherished.

Fruit was often used as an erotic metaphor. As it soon decays it also served as a moral injunction to procreate when the time is ripe.

VERTUMNUS AND POMONA

Hendrick Goltzius, 1558–1617
Vertumnus and Pomona, 1613
Canvas, 90 x 149 cm
Rijksmuseum, Amsterdam

Pomona was a woodland nymph who loved trees and plants and knew all there was to know about them. But she was indifferent to men and affairs of the heart. Vertumnus was one of her many suitors. He had already tried to win her affections in the guise of a husbandman, a vegetable gardener, a harvester of grapes. But he, like all his rivals, failed to move her.

One day he came to her in the guise of an old woman bent over a stick, with a gaily coloured scarf covering the grey curls he had donned. He entered Pomona's well-tended garden, commended her fine apples and murmured that she was the loveliest of them all. And with those words, he kissed her, but his kiss was not the kiss of an old woman. Then, having seated himself on the grass, he gazed up at the boughs heavy with the fruits of autumn, and chanced to see an elm with a vine clinging to it for support. He marvelled at the harmony of the two plants.

Vertumnus tried to persuade Pomona to taste the fruits of love.

'Oh, be wise, heed the words of an old woman and find yourself a good man. I care about you more than you can imagine and more than any other. Take a husband as I counsel. Take Vertumnus, for in truth I know him better than he knows himself.'

Vertumnus went on to proclaim his many virtues in the hope of winning Pomona's heart.

Having spoken these words in the way of old women, yet still failing to accomplish his purpose, Vertumnus cast off his disguise and there stood before Pomona a glorious young god, radiant as a sunbeam breaking through the clouds. No more forceful persuasion was needed. The nymph was as impassioned by his god-like beauty as he with hers. / OVID, *Metamorphoses*, 14, 654–771

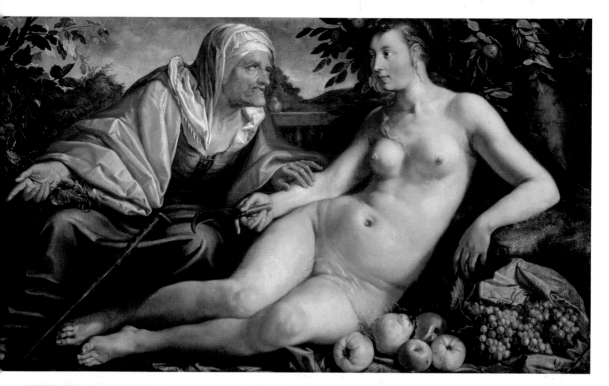

Vertumnus draws Pomona's attention to the sprig of vine in his right hand. In Ovid's account he extols the elm and the vine that 'live together in harmony'. In both art and literature of the 16th and 17th centuries a vine twined around an elm was an emblem of love and friendship.

Ovid: 'With a curved pruning hook she checked the growth of rampant branches and cut open bark to unite a new plant with the tree.' The pruning hook shown with the man-hating Pomona and the stick resting between Vertumnus' legs may have sexual connotations.

Many painters were drawn by the challenge of depicting the contrast between youth and old age. The eroticism of Goltzius' large figure of the naked Pomona is strengthened by the image of Vertumnus speaking to her and touching her. This is the classical representation of the episode from Ovid, which was especially popular in Dutch and Flemish art in the 17th century. Though this is essentially a tale with a happy ending about a young man trying to win the heart of the woman he loves, it was also understood as an admonition to marry when love was still capable of yielding progeny, and as an allegory of the fruitful coupling of the changing seasons (Vertumnus) and the earth (Pomona).

SOURCES

The original texts containing the passages quoted in this book were written between about 800 BC and AD 400. They fall into five categories.

I. THE OLD TESTAMENT

The Old Testament is a compilation of writings which comprise the following:
- the Pentateuch, which refers to the five books of Moses and includes the books of Genesis and Exodus;
- the wisdom books, which include the Book of Job, the Psalms and the Song of Songs;
- the historical books, among them the books of Samuel I and II, Kings I and II, Tobit, Judith and Esther. Tobit and Judith are deuterocanonical books, which form part of the Catholic Bible but are excluded from the Hebrew and most Protestant bibles;
- the Books of the Prophets, which include the books of Isaiah, Daniel and Jonah.

The principal sources for Old Testament subjects in art were the Latin Vulgate translation by the church father Jerome (c. 400) and translations based on his work.

II. THE NEW TESTAMENT

The New Testament was written for the most part in the 1st century AD. It consists of the four canonical gospels of Matthew, Mark, Luke and John; the Acts of the Apostles; epistles from prominent Christians to communities of Christians; and the Book of Revelation, also known as the Apocalypse.

III. APOCRYPHAL TEXTS

Many of the apocryphal (literally: 'hidden') gospels were written after the four canonical gospels, in the 2nd and 3rd centuries AD. In 297 they were officially excluded from the final list of New Testament texts. They formed an important source of inspiration in art, notably in the Middle Ages. This category further includes a large body of inauthentic epistles, acts and revelations.

The apocryphal texts quoted in this book derive from the following sources:
- the *Infancy Gospel of James*, which dates from around AD 130 and is one of the oldest apocryphal writings. It contains a detailed account of Mary's life, starting with her parents Joachim and Anna;
- the *Infancy Gospel of Matthew*, a more detailed version of James' writings which amplifies his account of Christ's birth and childhood;
- the *Infancy Gospel of Thomas*, a description of miracles performed by Christ in his childhood and youth, written at the end of the 2nd century;
- the *Gospel of Peter*, dating from the first half of the 2nd century. The only surviving fragment contains the Passion and Resurrection and was discovered in 1886-87.

IV. GREEK AND ROMAN MYTHS AND WRITINGS ON GREEK AND ROMAN MYTHS

The *Apollodori Bibliotheca* is a concise but comprehensive encyclopaedia of Greek mythology compiled by the Greek writer APOLLODORUS (1st or 2nd century AD). It is one of only two surviving mythological handbooks of classical times (see under Hyginus).

The novel *Metamorphoses*, also known as *The Golden Ass* (*Asinus aureus*), by the Latin author Lucius APULEIUS (c. 125–after AD 180), includes the well-known tale of Cupid and Psyche.

The 116 surviving poems (*carmina*) written by the Roman Gaius Valerius CATULLUS (c. 84–54 BC) include an account of the author's love affair with Lesbia.

Eighteen of the 75 plays which are believed to have been written by the Greek tragedian EURIPIDES (c. 485–406 BC) have survived complete. One of those is *Helen*.

Two works by the Greek epic poet HESIOD have come down to us: *Theogony* (*Theogonia*), a genealogy of the Greek gods, and *Works and Days* (*Opera et dies*), a didactic poem about agriculture and navigation.

The HOMERIC HYMNS (*Hymni Homerici*) is a compilation of 33 anonymous poems written in Greek between the 7th and 4th centuries BC (?). A celebration of the gods of Olympia and other deities, the hymns were attributed to Homer – hence the title of the collection.

The epic poems, *The Iliad* and *The Odyssey*, are traditionally said to have been written by HOMER (8th/7th centuries BC), the earliest Greek writer known by name. *The Iliad* describes an episode that took place in the last year of the Trojan War (the slaying of the Trojan Hector by the Greek Achilles in an act of revenge). *The Odyssey* recounts Odysseus' arduous journey back home to the island of Ithaca.

Myths (*Fabulae*), an abridged compilation of stories about the gods, is one of the extant works of the Roman scholar Gaius Julius HYGINUS (early 1st century AD; see also Apollodorus). It is uncertain whether this is the same Hyginus who wrote the treatise *Astronomy* (*Astronomia*).

Dialogues of the Gods (*Dialogi deorum*) is a satire of Greek mythology by the prolific Greek writer LUCIAN (c. AD 120–180).

OVID (Publius Ovidius Naso, 43 BC–AD 8) was a prolific Roman poet. His most influential works on mythology are *The Heroines* (*Heroides*), a collection of love letters written by mythological women; *The Roman Calendar* (*Fasti*), a compilation of legends about Roman festivals; and *Metamorphoses*, a reworking of many Greek myths.

The Eunuchs (*Eunuchus*) is one of six Latin comedies written by Publius Terentius Afer (c. 190–159 BC), better known as TERENCE.

The celebrated *Bucolics* (*Bucolica*), *The Georgics* (*Georgica*) and the epic *Aeneid* (*Aeneis*) were written by the Roman poet Publius Vergilius Maro (70–19 BC), known as VIRGIL. The *Aeneid* traces Aeneas' mythical journey from Troy to Italy and describes his laborious efforts to establish a new Troy.

V. GREEK AND ROMAN TEXTS ON PAINTING, ASTRONOMY AND HISTORICAL EVENTS

The founding of Rome by Romulus and Remus is patently a myth, but several writers whose works are included in this book describe this and other events as historical reality.

A treatise on astronomy, which also explains the origins of the signs of the Zodiac, is mistakenly attributed to the Greek philologist, poet and astronomer ERATOSTHENES (3rd century BC).

The Life of Constantine (*De vita Constantini*), a tribute to Constantine rather than a historically sound biography, is one of the many works written by the Greek Christian EUSEBIUS (c. AD 263–339).

The Antiquities of the Jews (*Antiquitates Judaicae*), written in Greek by the Jewish historian FLAVIUS JOSEPHUS (AD 37/38– after 100), chronicles the history of the world from a Jewish perspective, from Genesis to AD 66.

The Histories (*Historiae*) by the Greek historian HERODOTUS (c. 485– 425 BC) examines the relations between Asia and Europe, from the Trojan War (12th century BC) to the Persian Wars (5th century BC). The work is rich in narrative and anecdote.

Gaius Julius HYGINUS: see section IV.

On the Deaths of the Persecutors (*De mortibus persecutorum*) was written by LACTANTIUS (c. AD 245–320), a Christian author from North Africa. Originally in Latin, it describes the persecution of Christians, starting with Emperor Nero.

From the Founding of the City (*Ab Urbe condita*) by the Roman historian LIVY (Titus Livius, 59 BC–AD 17) traces the history of Rome. Arguably the most comprehensive literary work of classical times, it covers the period from Aeneas' arrival in Italy to 9 BC. Only fragments of the original work have survived.

Imagines was written by the Greek author Flavius PHILOSTRATUS (first half of 3rd century AD). It describes paintings from ancient times which have since been lost. The book is an important source of information for painting in antiquity.

Only fragments of the monumental *Histories* (*Historiae*) and *Annals* (*Annales*) by the Roman historian and politician Publius Cornelius TACITUS (c. AD 55–117) have survived. The two works chronicle the history of the Roman Empire from the death of Augustus to the reign of Domitian (AD 14–96).

Memorable Deeds and Sayings (*Facta et dicta memorabilia*), written by the Roman VALERIUS MAXIMUS (first half of 1st century AD), is a handbook of tales from history illustrating vices and virtues. The work remained popular well into the Renaissance.

Memorabilia by the Greek writer XENOPHON (c. 430–355 BC) is a philosophical defence of the author's teacher Socrates. Xenophon wrote several other philosophical and historical works.

LIST OF COLLECTIONS

INDEX

Thematic entries are set in **BOLD** type.
Names of artists whose work is reproduced are marked with a lozenge.
Greek/Roman equivalents of the ancient gods are listed under their Latin variant (e.g.: Zeus, *see* Jupiter).

PHOTOGRAPHIC CREDITS